Tamesis Studies in Popular
and Digital Cultures

Volume 3

THE MULTIMEDIA WORKS OF
CONTEMPORARY LATIN AMERICAN
WOMEN WRITERS AND ARTISTS

TAMESIS STUDIES IN POPULAR AND DIGITAL CULTURES

ISSN: 2752-3063 (print)
ISSN: 2752-3071 (online)

Series Editors

Thea Pitman – University of Leeds
Stephanie Dennison – University of Leeds

Editorial Board

Tori Holmes (Queen's University Belfast), Edward King (University of Bristol), Yeidy Rivero (University of Michigan), Paul Julian Smith (Graduate Center, CUNY), Nuria Triana Toribio (University of Kent), Luís Trindade (University of Coimbra), Eduardo Viñuela (University of Oviedo), Scott Weintraub (University of New Hampshire)

This new series aims to publish intellectually enriching and engaging research into the popular cultures of the Hispanic and Lusophone worlds, both analog and digital. Topics covered in the series include visual and audiovisual art forms (photography, graphic art, and comics, advertising, graffiti, animation, film, telenovelas, and television more generally), literature (folklore, mass-market novels and novellas, the 'middlebrow', visual novels), embodied arts (performance art, theatre, dance, popular and traditional music, body art, and fashion), as well as all the potentially 'viral' new genres of popular culture facilitated by the Internet and social media platforms (blogs, memes, YouTube videos, hashtag campaigns, video games, and so on). The series encompasses studies both of these particular manifestations and of the industries and practices that accompany them; and it analyses not only 'grassroots' cultural expressions but also the ways in which Hispanic and Lusophone cultural forms have been appropriated, commodified, and distributed transnationally. Providing a forum for cutting-edge studies on demotic forms of cultural production as well as the new cultural dynamics facilitated by digital technologies, the series seeks to advance scholarly understanding of how people creatively explore, debate, and challenge events, attitudes, ideas, and identities. The series is open to standard monographs and edited collections as well as short-form monographs.

Other books in the series may be viewed at https://boydellandbrewer.com/series/tamesis-studies-in-popular-and-digital-cultures.html

THE MULTIMEDIA WORKS OF CONTEMPORARY LATIN AMERICAN WOMEN WRITERS AND ARTISTS

Edited by Jane E. Lavery and Sarah E. L. Bowskill

TAMESIS

© Contributors 2023

All Rights Reserved. Except as permitted under current legislation no part of this work may be photocopied, stored in a retrieval system, published, performed in public, adapted, broadcast, transmitted, recorded or reproduced in any form or by any means, without the prior permission of the copyright owner

First published 2023
Tamesis, Woodbridge

ISBN 978 1 85566 394 7

Tamesis is an imprint of Boydell & Brewer Ltd
PO Box 9, Woodbridge, Suffolk IP12 3DF, UK
and of Boydell & Brewer Inc.
668 Mt. Hope Avenue, Rochester, NY 14620-2731, USA
website: www.boydellandbrewer.com

The publisher has no responsibility for the continued existence or accuracy of URLs for external or third-party internet websites referred to in this book, and does not guarantee that any content on such websites is, or will remain, accurate or appropriate

A CIP record for this title is available
from the British Library

This publication is printed on acid-free paper

Contents

List of Illustrations	vii
List of Contributors	ix
Acknowledgments	xi

Introduction: A Crosscurrent of Contemporary Latin American
Women Multimedia Writers and Artists 1
Sarah E. L. Bowskill and Jane E. Lavery

1. The Transliterary: The Novel and Other Multimedia Horizons
 Beyond (and Close to) the Textual 33
 Ana Clavel

2. Commentary on Fe/males: Sieges of the Post Human
 (Transmedia Installation) 53
 Eugenia Prado Bassi

3. An Anthropaphagic Ch'ixi Poetics 59
 Eli Neira

4. My Relationship with Artistic Creation Began with Words 63
 Regina José Galindo

5. imagetext 67
 Carla Faesler

6. Voices/Bodies 71
 Mónica Nepote

7. Redefining Meaning: The Interweaving of the Visual and Poetic 73
 Pilar Acevedo

8. The Territory Is Home 81
 Gabriela Golder and Mariela Yeregui

9. Reflections on a Multimedia Practice 89
 Jacalyn Lopez Garcia

10. Digital Weaving 99
 Lucia Grossberger Morales

VI CONTENTS

11. Eli Neira, Regina José Galindo, and Ana Clavel: "Polluting"
 Corporealities and Intermedial/Transliterary Crossings 107
 Jane E. Lavery

12. The Digital Condition: Subjectivity and Aesthetics in "Fe/males"
 by Eugenia Prado Bassi 129
 Carolina Gainza

13. The Transmedia, Post-Medium, Postnational, and Nomadic
 Projects of Pilar Acevedo, Rocío Cerón, and Mónica Nepote 145
 Sarah E. L. Bowskill

14. The Art of the Hack: Poets Carla Faesler and Mónica Nepote and
 Booktuber Fátima Orozco 165
 Emily Hind

15. The Places of Pain: Intermedial Mode and Meaning in *Via
 Corporis* by Pura López Colomé and *Geografía del dolor* by
 Monica González 185
 Nuala Finnegan

16. Words, Memory, and Space in Intermedial Works by Gabriela
 Golder and Mariela Yeregui 205
 Claudia Kozak

17. Fungibility and the Intermedial Poem: Ana María Uribe, Belén
 Gache, and Karen Villeda 219
 Debra Ann Castillo

18. Hypertext and Biculturality in Two Autobiographical
 Hypermedia Works by Latina Artists Lucia Grossberger Morales
 and Jacalyn Lopez Garcia 235
 Thea Pitman

19. Dialogues Across Media: The Creation of (New?) Hybrid Genres
 by Belén Gache and Marina Zerbarini 251
 Claire Taylor

Bibliography 271
Index 295

Illustrations

1. The black pages of Laurence Sterne's *Tristram Shandy* (photograph by Ana Clavel) 39
2. Pages of Sterne's *Tristram Shandy* (photograph by Ana Clavel) 39
3. "The Caucus Race and a Long Tale" pages from Lewis Carroll's *Alice in Wonderland* (photograph by Ana Clavel) 40
4. Pages of Robert Denos' divinatory art (photograph by Ana Clavel) 40
5. Image of a page of the newspaper *El Universal* showing adverts for apartments used in the short story "In the Corner of Hell" by Ana Clavel. Image courtesy of Ana Clavel 43
6. Image of a urinal from Ana Clavel's *Shipwrecked Body* (*Cuerpo náufrago*) (courtesy of Ana Clavel) 43
7. Image of graphic art related to Clavel's *Shipwrecked Body* (*Cuerpo náufrago*) on the building of the National Fund for Culture and the Arts, Mexico City (courtesy of Ana Clavel) 44
8. Cover of the Spanish edition of *Violets are Flowers of Desire* (*Las violetas son flores del deseo*) by Ana Clavel (courtesy of Ana Clavel) 45
9. Image of the web page for *Violets are Flowers of Desire* (*Las violetas son flores del deseo*) (courtesy of Ana Clavel) 46
10. Image of pages from *The Shadow Artist* (*El dibujante de sombras*) by Ana Clavel (courtesy of Ana Clavel) 46
11. Image of multimedia installation *Love is Hunger* (*El amor es hambre*) (courtesy of Ana Clavel) 50
12. *Hembros: asedios a lo post-humano, novela instalación /Fe/males: Sieges of the Post Human, Novel Installation.* Santiago de Chile 9 January 2004. Galpón Víctor Jara. Image courtesy of Eugenia Prado Bassi 57
13. *Variations of a Biblical Gesture (Variaciones de un gesto bíblico)* (2016). Photo: Alejandra Montoya. Image courtesy Eli Neira 60
14. *Your Homeland is full of Rubbish (Tu patria está llena de basura)* (2017). Photo: Jim Delemont. Performance by Eli Neira and the feminist collective AMAPU, Las Amazonas del pueblo. Image courtesy de Eli Neira 61

15.	*I Never Overcame the Horror* Part 2 (*Nunca salí del horror Parte 2*). Photo: Perrera Arte 2008. Image courtesy of Eli Neira	62
16.	*I'm going to Shout it to the Wind* (*Lo voy a gritar al viento*) (1999). Image courtesy of Regina José Galindo	64
17.	*Land* (*Tierra*) (2013). Image courtesy of Regina José Galindo	64
18.	*Spider Princess,* February 2012. Oil on canvas, 213.4 × 137.2 cm. Image courtesy of Image Group Photography	74
19.	*Heaven Bound,* February 2013, Mixed Media, 58.4 × 55.9 × 30.5 cm. Image courtesy of Image Group Photography	75
20.	*Intangible Sweetness,* February 2011. Mixed Media Assemblage, 33.7 × 12.1 × 11.4 cm. Image courtesy of Pilar Acevedo	75
21.	*Naughty,* October 2004. Mixed Media Assemblage, 53.3 × 29.8 × 22.2 cm. Image courtesy of Image Group Photography	77
22.	Glass Houses Doormat Website screen image. Digital Print, 20 × 16. 1997 http://artelunasol.com/glasshouses/glasshouses.1.html	91
23.	*Stone* (*Piedra*) 2013. Photo: Julio Pantoja and Mariene Ramírez-Cancio. Image courtesy of Regina José Galindo	113
24.	*Outcry,* August 2009. Mixed Media Assemblage, 44.5 × 45.7 × 19.1 cm. Image courtesy of the artist and Image Group Photography	160
25.	*Pulmón de mar* (*Jelly Fish*). Image courtesy of Pura López Colomé and Guillermo Arreola	195
26.	Jacalyn Lopez Garcia, *Glass Houses,* homepage. http://artelunasol.com/glasshouses/	247
27.	Marina Zerbarini, *Eveline, Fragments of a Reply* (2004). Image courtesy of Marina Zerbarini	264

The editors, contributors, and publisher are grateful to all the institutions and persons listed for permission to reproduce the materials in which they hold copyright. Every effort has been made to trace the copyright holders; apologies are offered for any omission, and the publisher will be pleased to add any necessary acknowledgement in subsequent editions.

Please be advised that this book contains graphic images of nudity and scatological performance art which readers may find disturbing or shocking.

Contributors

Pilar Acevedo (Mexican-American): visual/installation artist and poet http://www.pilaracevedo.com/.

Sarah E. L. Bowskill, Senior Lecturer in Latin American Studies, Queen's University Belfast.

Debra Ann Castillo, Stephen H. Weiss Presidential Fellow, Emerson Hinchcliff Professor of Hispanic Studies and Professor of Comparative Literature at Cornell University.

Ana Clavel (Mexico): novelist, essayist, digital/visual/installation artist and blogger http://anaclavel.com.

Carla Faesler (Mexico): digital artist and poet.

Nuala Finnegan, Professor of Spanish and Latin American Studies, and Director of the Centre for Mexican Studies, University College Cork.

Carolina Gainza, Professor, Department of Creative Literature, Diego Portales University https://www.cartografiadigital.cl/.

Regina José Galindo (Guatemala): performance artist and poet. www.reginajosegalindo.com.

Gabriela Golder (Argentina): installation artist, video-art, curator https://www.gabrielagolder.com/.

Lucia Grossberger Morales (Bolivia): WebVR, AR, AI interactive installations, and poet https://www.digweaving.com https://www.lgmanimation.com https://www.lgmappleii.com https://lucigrossbergermorales.com.

Emily Hind, Professor of Spanish, University of Florida.

Claudia Kozak, Professor, University of Buenos Aires, Senior Researcher (Argentinian National Council of Scientific and Technological Research), https://www.ludion.org/home.php.

Jane E. Lavery, Lecturer in Latin American Studies, University of Southampton.

Jacalyn Lopez Garcia (Mexican-American): transmedia visual storyteller, photographer, digital, and video artist, https://jacalynlopezgarcia.com/.

Eli Neira (Chile): journalist, performance artist, poet, eco-feminist activist www.elineira2.instagram.com, https://medium.com/@elizabeth-neira.

Mónica Nepote (Mexico): artist/writer. Her writing practice crosses the exploration of visual, electronic and performative formats and codes.

Thea Pitman, Professor of Latin American Studies, University of Leeds.

Eugenia Prado Bassi (Chile): writer, graphic designer, and holder of a Master's in American Aesthetics from the Pontifical Catholic University of Chile. Editorial word editor https://palabraeditorial.cl/ https://eugeniapradobassi.cl/.

Claire Taylor, Gilmour Chair of Spanish and Professor in Hispanic Studies, University of Liverpool.

Mariela Yeregui (Argentina): Mariela Yeregui, PhD, Associate Professor, Digital + Media Department, Schiller Family Associate Professorship in Race in Art and Design, Rhode Island School of Design https://marielayeregui.com/.

Acknowledgments

This volume represents the culmination of a major effort on the part of many people, and we would like to gratefully acknowledge the support we have received throughout. We were overwhelmed by the positive and generous responses we received when we contacted authors and artists and feel privileged to have got to know them and their work a little better as a result of this collaboration. To our academic colleagues and friends: we continue to be impressed by the quality of your work and the originality of your insights. We would like to thank all our contributors, Professor Isabel Torres (Queen's University Belfast), and Dr. Justine Pizzo (University of Southampton) for their invaluable feedback on drafts of our Introduction.

All your contributions helped to shape and improve our thinking and made this project intellectually very rewarding. We hope the final volume does justice to the talent and effort of all our contributors.

In the course of preparing this volume, both editors benefited from a period of research leave supported by their respective institutions, University of Southampton, and Queen's University Belfast. We realize, in the present climate, how privileged we were and hope that the results of leave presented here go some way to justifying continued institutional support for such vital dedicated research time for us and our colleagues in future.

The School of Arts, English, and Languages at Queen's University Belfast and Modern Languages and Linguistics at the University of Southampton also generously provided funding for the translations of the chapters by Ana Clavel, Carla Faesler, Regina José Galindo, Gabriela Golder and Mariela Yeregui, Eli Neira, Mónica Nepote, and Eugenia Prado Bassi, which were expertly done by Dr. Mark Dinneen.

First and foremost, Sarah would like to dedicate this book to her academic friends near and far and especially to her friend, co-editor, and co-author, Jane.

Jane would similarly like to dedicate this book to her children, Sienna and Lucia, to her husband Simon, and particularly to her friend, co-editor, and co-author, Sarah.

This volume is perhaps the most substantial piece of work we have produced together so far, and we hope it is a worthy testament to our friendship and to the friendships we have forged with our contributors.

Introduction: A Crosscurrent of Contemporary Latin American Women Multimedia Writers and Artists

SARAH E. L. BOWSKILL AND JANE E. LAVERY*

A significant and growing number of contemporary Latin American women writers and artists from the Spanish-speaking Americas are combining or placing literary texts in dialogue with other media as part of a wider strategy which draws attention to the constructed nature of all boundaries, borders, and hierarchies in an increasingly globalized and digitalized world. Multimedia thus becomes a particularly effective tool for works which seek to dismantle other supposedly rigid categories and hierarchies. The creative practitioners who feature in, and who have contributed to, this volume are representative of a crosscurrent of women from across Latin America who incorporate a literary dimension into their work, are developing a multimedia practice, which may or may not be digital, and share thematic interests in contemporary gender, racial, social, environmental, and/or political issues. These women prioritize experimentation, and so we conceptualize them as forming a crosscurrent running counter to established hierarchies, canons, and traditions rather than as a movement. They are: Pilar Acevedo (b. 1954, Mexico/United States), Rocío Cerón (b. 1972, Mexico), Ana Clavel (b. 1961, Mexico), Carla Faesler (b. 1969, Mexico), Belén Gache (b. 1960, Argentina), Regina José Galindo (b. 1974, Guatemala), Gabriela Golder (b. 1971, Argentina), Mariela Yeregui (b. 1966, Argentina), Mónica González (Mexico), Lucia Grossberger Morales (b. 1952, Bolivia/United States), Pura López Colomé (Mexico), Jacalyn Lopez Garcia (b. 1953, Mexico/United States), Eli Neira (b. 1973, Chile), Mónica Nepote (b. 1970, Mexico), Eugenia Prado Bassi (b. 1962, Chile), Ana María Uribe (Argentina, 1944–2004); Karen Villeda (b. 1985, Mexico), and Marina Zerbarini (b. 1952, Argentina).

In the context of this transgressive crosscurrent of Latin American women authors and artists, multimedia is adopted as a term to analyze bodies of work which include literary texts alongside one or more of the following: painting, photography, sculpture, music, performance, net literature, digital art, and video art. Each practitioner's corpus *may or may not* include digital media as we seek to extend current discussions of multimedia cultural production to include analog as well as digital media. The emphasis we place on considering both analog and digital media in the context of contemporary multimedia cultural production as well as our foregrounding of the literary as part of a multimedia corpus represent this book's original contribution. By foregrounding the literary, we showcase how the combination of text and non-text-based forms reinvigorates the literary just as the literary can be seen to reinvigorate other media.

Where the women who are part of this crosscurrent have received critical attention, they have typically been pigeonholed as either authors or as artists because the term multimedia is more commonly associated with the non-textual and the non-literary. Artists in particular have experimented with different art forms for decades and are more likely to be recognized for their use of multimedia. Prominent examples of contemporary Latin American women artists who have embraced different media include Teresa Margolles, Coco Fusco, Lourdes Portillo, Praba Pilar, and Cecilia Vicuña. Similarly, women writers such as Diamela Eltit, Rita Indiana, and Laura Esquivel have experimented with non-textual forms. According to our definitions, all could be thought of as multimedia practitioners, but those identified as writers have rarely been thought of as such.

The multimedia portfolios of the writers are testament to their refusal to be confined by labels. "Artists" write poetry, "novelists" curate exhibitions, and "poets" perform. Breaking boundaries between the categories of author and artist as well as between what are often imagined as "pure" forms of media is symptomatic of the broader transgressive thrust which defines their work. This desire to challenge the status quo has led them to seek out new forms of expression which requires the innovative critical approaches and concepts developed in this volume. The term multimedia is thus employed not to infer that "pure" media exist and can be combined but to invite us to reflect on the artificiality of all media categories and on the relationship between form and content when it comes to the disruption of hierarchies within multimedia cultural production. We were also inspired by these women's willingness to break with tradition, take risks, and engage in collaborative multimedia practices to likewise adopt a new approach to criticism, as we include the voices of the women whose work is studied in this volume alongside traditional academic essays. In so doing, we seek to showcase the extent and diversity of contemporary multimedia cultural production by Latin American women and to develop a shared understanding

INTRODUCTION

of how women's multimedia cultural production is changing the contemporary Latin American literary and cultural landscape.

The innovative creative practices we have identified in contemporary multimedia cultural production by women in Latin America require new ways of "doing criticism." As Claire Taylor points out, "new cultural forms [...] have made us start to think across disciplinary boundaries and learn to negotiate new tools" (Taylor quoted in Taylor and Thornton, "Modern Languages" n.p). In this volume we seek to bridge the boundary between criticism and creative practice by including both the work and ideas of practitioners and those of the academics who study their work. The collaborative approach adopted here is one of the innovative contributions made by this study and is part of a growing, yet relatively small, trend also evident in *#WomenTechLit* edited by María Mencía and a new ongoing project "Cartografía crítica de la literatura digital latinoamericana" ("A Critical Cartography of Latin American Digital Literature") by Carolina Gainza (a contributor to this volume) and Carolina Zúñiga.

We started the process of producing this volume by opening up a dialogue with a handful of authors and artists with whom we were already in contact as a result of our previous work on Pilar Acevedo, Ana Clavel, Regina José Galindo, and Eli Neira.[1] The multimedia work of these and the other women we initially contacted incorporated or extended our thinking about the place of the literary in late twentieth/early twenty-first-century Latin American cultural production. We emailed the creative practitioners and a group of academic contributors who had worked in related areas outlining our ideas. We asked the academics to reflect on the extent to which the work of the women they studied could be seen as examples of multimedia cultural production. We explained to the authors and artists that we were interested in conceptualizing their work as multimedia with a literary dimension. Some of the creative practitioners were already using this term while others were unfamiliar with it. When Lavery coined Ana Clavel as a "multimedia writer" in 2015, for example, Clavel adopted this designation to describe her work as well as for promotional purposes. Since inviting Eli Neira to collaborate with us, she has adopted the term "multimedia artist" and later "transdisciplinary artist" for her email signatures.

We invited all those we contacted to contribute a text to the volume which responded to this provocation and asked them to suggest other academics or creative practitioners who might participate in the project. As a result of this communication, and the kind support of all involved, we significantly extended our network. We were in regular email contact with all the contributors as we exchanged drafts of their chapters and of this introduction.

[1] See Lavery (2015), Bowskill (2018), Galindo (2018), Bowskill and Lavery (2020), Lavery and Bowskill (2012).

In preparation for the volume, we also worked with the practitioners to put on a small-scale exhibition as part of the Society for Latin American Studies conference in Winchester in 2018.

Some academic contributors were also able to attend a round table discussion that coincided with the exhibition. The results of this extended dialogue are presented in the following chapters, which consist of bespoke contributions by eleven authors and artists and nine academic essays. Five of the contributions (Clavel, Neira, Galindo, Nepote, and Faesler), have been translated into English by Mark Dinneen, but were originally written in Spanish. Even though the author/artist contributions come first, we encourage the reader to read the chapters in the order they wish.

Just as contributor Jacalyn Lopez Garcia invites viewers to freely explore her home in her hypermedia narrative "Glass Houses," we hope readers will explore different paths through our volume. You might opt to read all of the author/artist contributions and then the academic ones as per the order of the volume. Alternatively, you might read the chapters as pairs, for example, Faesler's poem-essay could be read alongside the chapter by Emily Hind, who analyzes Faesler's novel and YouTube videos. Readers may wish to consider the digital dimension of multimedia by looking at chapters by Prado Bassi, Grossberger Morales, Hind, Gainza, Kozak, Pitman, and Taylor. Poetry could be the path you take, reading chapters by Castillo, Bowskill, Acevedo, and Faesler. We encourage you to follow the example of our practitioners and not be bound by the conventional practice of reading cover to cover!

The academic essays adopt a comparative approach and often found it useful to employ a wide range of terminology (intermedia, transmedia, etc.) that builds on the concept of multimedia in order to be more precise in describing the relationships between media in specific works. The chapters draw on multiple disciplines, and some are framed by theories of (Latin American) gender, literary, and cultural/Visual/art/Cyber and Textual Media Studies as well as the concepts of multimedia, multimodality, intermediality, transmediality, transliterature, hypertextuality, hypermedia, intertextuality, and cultural recycling. In its disciplinary openness, the work presented is emblematic of current directions in Modern Languages, Hispanic Studies, and Digital Humanities. The contributions draw on language and area-specific knowledge yet are constantly crossing traditional boundaries of study and above all those between nations and disciplines. This combination of (linguistic) expertise, situated knowledge, and skills means that "as [Modern Languages] researchers capable of reaching across into the unfamiliar and uncomfortable we have the capacity to test the limits of knowledge" (Taylor and Thornton n.p.).

The authors' and artists' contributions are diverse, as each responded independently to the common invitation to reflect on the importance of the literary in contemporary Latin American multimedia cultural production. In

INTRODUCTION 5

what follows, therefore, the reader will find original reflective essays and multimedia samples, as some creative practitioners wished to allow their work to speak primarily for itself. Some, but not all, academics write about the same texts as those discussed by the writers and artists. We allowed all contributors to choose freely which works they wished to discuss. The result is that the reader will sometimes have complementary analyses and sometimes a better sense of the range of an author's or artist's work. Above all we sought to avoid a scenario where the academics were asked to affirm or contradict the writer's or artist's own interpretations in a way that would reinforce hierarchies of knowledge and run counter to the egalitarian ethos of the volume. Moreover, this approach gives the reader the opportunity to encounter a wider range of works and so develop a better sense of the extent and diversity of this crosscurrent of multimedia authors and artists.

The examples of Latin American women multimedia artists and writers showcased in the volume are presented as paradigmatic examples rather than an exhaustive catalog of what is an exciting and growing array of multimedia work produced by contemporary Latin American women authors and artists. The focus, in line with the editors' area of expertise, is on practitioners from the Spanish-speaking Americas. The influence of Brazilian concrete poetry on contemporary multimedia cultural production, and especially digital poetry, is acknowledged and is discussed by Debra Castillo in the present volume.[2] Trends identified in the present volume also apply to Brazil where, as in the rest of Latin America, there is a longer standing tradition of media crossings within visual culture that do not have a literary dimension. Recent examples of Brazilian women whose multimedia output incorporates the literary, and is therefore akin to that of the women whose work is studied in the present volume, include Leonora de Barros, Giselle Beiguelman, Nicole Della Costa, Mariana Collares, and Terezinha Malaquias. From a thematic point of view, there are many shared interests identifiable in the work of Brazilian and Spanish American multimedia women as seen, for example, in Collares' videopoem "Isto" (2014), which explores the objectification of women, resonating with the work of Regina José Galindo, and in Beiguelman's experimental documentary "nhonhô," which explores memory through the built environment in a way that invites comparison with the work of Gabriela Golder and Mariela Yeregui. Thus, our findings extend to Brazilian multimedia cultural production as well as to that produced in the Spanish-speaking countries of Latin America not represented here. Given the broad relevance of our findings, "Latin American," which was the preferred term used by our contributors, refers to

[2] On women concrete poets from Latin America and beyond, see Balgiu and de la Torre's *Women in Concrete Poetry: 1959–1979*.

an identity that is not bound by geography and so includes works produced by Latina authors and artists based in the United States.

As feminist critics we decided to engage specifically with the work of women multimedia authors and artists because we are particularly interested in how women find creative opportunities and challenges often operating against the grain of traditional publishing and art institutions and practices.[3] Our choice to focus on the *oeuvre* of women is informed by a political position underpinned by a feminist ethos, seeking to give voice to these female creators within a broader historical context in which women creative practitioners have been generally excluded from privileged creative arenas where consecration occurs. For too long female writers and artists have been included merely as footnotes in male art and literary history and continue to be invisible and valued less than their male contemporaries *because* of their gender (Fajardo-Hill n.d). In response, feminist literary critics, art historians and curators have been addressing these absences, time-honored stereotypes, and imbalances in conferences, by writing feminist revisionist scholarly studies or by organizing exhibitions dedicated exclusively to women's artworks.[4] Recent examples of women-only exhibitions in which contributors to this volume

3 To name but a few: José Aburto; Milton Läufer; Doménico Chiappe; Verónica Gerber; Mario Bellatin; Tammy Gomez; Elia Arce; Rita Indiana; the Chilean *Orquesta de Poetas*: Federico Eisner Fernando Pérez, Juan Pablo Fante, and Felipe Cussen; Cristina Rivera Garza; Eve Gil; Dolores Dorantes; Amaranta Caballero; Jorge Volpi; Malú Urrriola; Nadia Prado; Jaime Alejandro Rodríguez; Iván Marino; Gustavo Romano; Argentines: Charly Gradin, Fabio Doctorovich, Ladislao Pablo Györi; Chileans Carlos Cociña, Martín Gubbins, Cecilia Vicuña; Méxicans Benjamín R. Moreno, Rodolfo Mata, Eugenio Tisselli; Peruvians Enrique Beó and Luis Alvarado; Colombian disapora: Praba Pilar.

4 For a more extensive discussion of feminist revisionist art history and literary studies see: Fajardo-Hill, "The Invisibility of Latin American Women Artists" and "Performative Bodies." Fajardo-Hill provides a comprehensive overview of feminist/female-based exhibitions and art history studies in Latin America and the United States mainly, and beyond, including Lippard's *Mixed Blessings* and Nochlin (145–78). Exhibitions bringing together Latin American and Latino/a artists include Deborah Cullen's *Latin/o Arte ≠ Vida. Actions by Artists of the Americas, 1960–2000*. For revisionist literary feminist criticism from a Latin American/Latinx perspective see for example: Medeiros-Lichem's *La voz femenina en la narrativa latinoamericana: una relectura crítica*. In Mexico, the Taller de Teoría y Crítica Literaria "Diana Morán" has produced a number of valuable studies and a more recent series, *Desbordar el Canon: Escritoras mexicanas del siglo XX*, which are testament to feminist literary critics' commitment to the re-framing of Mexican literary history. Other such studies include Castillo's *Talking Back: Toward a Latin American Feminist Literary Criticism* and Castillo and Tabuenca Córdoba's *Border Women*.

INTRODUCTION 7

have participated include *Rebeldes: laboratorio experimental de practices feministas* (2022), where Eli Neira performed her arts-engagement and community inspired *Oda a la propiedad privada* (2022). The overall exhibition was created with feminist solidarity and resistance strategies in mind: "¿Cómo vivir la sororidad en sociedades capitalistas, postcoloniales, discriminatorias y sexistas? ¿Cómo encontrarnos y crear redes a pesar de los privilegios desiguales? ¿Cómo conectar nuestras protestas? (Artishock)." This volume is produced in a similar spirit of feminist sorority and solidarity.

Naturally, feminist critics have often favored foregrounding works which can be interpreted as being aligned with feminist values while too often privileging white, Eurocentric understandings of feminism and ignoring the fact that in Latin America diverse forms of feminism are frequently in tension with each other.[5] Segato (2019), for example, contrasts *feminismo letrado*, associated with European-influenced feminisms in the Southern Cone, and grassroots feminism rooted in Central American liberation and revolutionary struggles. Many of the women whose work is presented and studied in this volume explore issues of gender and sexuality, often from an intersectional perspective. Some identify as "feminist," while not necessarily agreeing upon a definition of the term, and others reject this label for a variety of reasons. Yet we do not seek to prioritize "feminist" voices nor to produce exclusively "feminist" interpretations of the works studied. Most importantly, we do not wish to suggest that there is a connection between feminism and multimedia practice except to the extent that some forms of multimedia cultural production may prove useful when it comes to bypassing traditional mechanisms for bestowing prestige which have too long worked to exclude women.

Anticipating that the category of "woman" might prompt critiques of essentialism, we provide here a critical disclosure of what this term implies (and what it does not). Discussing the attitudes of Mexican authors to the label "women's writing," Lavery and Finnegan, drawing from Irma López, state:

> On the one hand, they find the adjective helpful in explaining their own way of seeing and interpreting the world (and it is from this perspective that their books have evoked interest), but on the other, some still share the concern that they will be pigeonholed as writers within a subgenre. This apprehension increases when their work is linked to feminism, a political position that many of them consider too radical and in other ways limiting. Yet all of these authors agree that as changes in culture and mentality continue to take place in Mexican society there will be less of a need for

5 For further discussion of feminisms in Latin America, see, for example, Rita Laura Segato "Heterosexualism"; Gloria Anzaldúa; Yuderkys Espinosa Miñoso, Diana Gómez Correal, and Karina Ochoa Muñoz, *Tejiendo* and María Lugones "Toward a Decolonial Feminism" and "The Coloniality of Gender" 2008.

such distinctions, they will eventually disappear, and the literary skill of a genderless "writer" will be discussed instead. (Irma López, cited in Finnegan and Lavery 32)

More than a decade since these words were written, we still perceive the usefulness of the distinction as a means to counter women's marginalization from the cultural sphere and to challenge and transform deterministic ideas surrounding women and gender. This ongoing need is evidenced by the fact that women writers generally accrue less prestige than their male counterparts. While isolated exceptions to this rule are frequently held up as evidence that women authors are no longer disadvantaged in the literary field, Bowskill (*The Politics*) presents compelling statistics about the percentages of women winners of major literary prizes, demonstrating that Spanish American women still seldom win literary prizes.

In both modern art and literary history, the idea of women as artist and writer has to be re-addressed, given the systematic erasure they have faced in the fields of history of art and literature. However, we agree with Griselda Pollock that women artists and women writers are not a

homogeneous category defined by gender alone. Women are agonistically differentiated by class, ethnicity, culture, religion, geopolitical location, sexuality, and ability. Gender analysis includes the interplay of several axes of differentiation and their symbolic representations without any a priori assumptions about how each artwork/artist might negotiate and rework dominant discourses of gender and other social inflections.[6]

Thus, the analyses of women's multimedia cultural production will be cognizant of differences in race, nationality, class, religious, or geopolitical location and be informed by a decolonial impetus, as per María Lugones (2010). The decolonial approach is evident in the way that contributions seek to "restore, elevate, renew, rediscover and acknowledge, and validate the multiplicity of lives, live-experiences, culture, and knowledge of Indigenous people, people of color, and colonized people as well as to decenter hetero/cis-normativity, gender hierarchies and racial privilege" (Decolonising Humanities Project, "What is Decoloniality?").

In addition to prioritizing women's multimedia contributions that incorporate a literary dimension, the volume also has a temporal focus on the last twenty-five years. In this way, we seek to reclaim space for non-digital as well as digital media under the umbrella of multimedia cultural production. As Finnegan points out in the present volume, however, the practice of working with

[6] Pollock, "Women, Art, and Art History." https://www.oxfordbibliographies.com/view/document/obo-9780199920105/obo-9780199920105-0034.xml.

INTRODUCTION 9

what have historically been considered different media stretches back to the pre-Hispanic tradition of the Amoxtli, commonly translated from the Nahuatl as "codex," which combines symbology, pictography, and script in a bound book format (188–9). More recently, as Debra Castillo notes in her contribution, the Brazilian concrete poets also combined text and image in a way that anticipates contemporary digital literature. Contemporary multimedia work thus builds on a longstanding legacy of hybrid cultural production in Latin America. Indeed, the notion that Latin American cultural production has been always already hybrid, mixed, and "impure" has been extensively theorized by Néstor Canclini and others.[7] Canclini's observation that cultural hybridization provides opportunity for "improvisation and acts of imagination, that imply the constitution of new agents and new actors," is clearly applicable to the multimedia practitioners and their hybrid output as explored in this volume (quoted in Balderston et al. xxi).

The women studied in this volume have produced literary texts in diverse genres, including novels, short stories, and poetry. Their use of the literary in the context of broader multimedia projects invites us to think in terms of what Domingo Sánchez-Mesa and Jan Baetens have called "literatura en expansión" or expanded literature, which includes, for example, street signs, and graffiti as well as more canonical genres (8). The texts are not necessarily printed on paper, as these women experiment creatively online on their own websites and are using social media platforms including Facebook, YouTube, Twitter, and Instagram. The result is that today *print* is not a monolithic or universal term but a word designating many different types of media formats and literary practices" (Hayles and Pressman xiii). By producing (at least some of) their cultural production online, these women combine text, image, sound, and even touch, to produce new forms of communication and blur the boundaries between referential and imaginative/poetic language.

The importance of considering the relationship between the literary and the digital is recognized in the pioneering work of Claire Taylor and Thea Pitman ("Introduction") and in the *Revista 404* produced by Mónica Nepote until 2018. More recently, Scott Weintraub (2018) has studied Latin American male authors' use of technopoetry to reflect on scientific discourses and, in collaboration with Luis Correa-Díaz, produced the "Dossier de Poesía digital" and "Latin American, Spanish and Portuguese Literature in the Digital Age." Correa-Díaz also studies Latin American digital poetry in *Novissima verba: Novissima verba: huellas digitales y cibernética en la poesía latinoamericana* (2019). Eduardo Ledesma (2012, 2015, 2016) takes a long view and explores

7 See García Canclini, *Hybrid Cultures* and for a general overview of cultural hybridization theorists such as Fernando Ortíz or Ángel Rama, see Burke's *Cultural Hybridity.*

the relationship between radical form and content in *Radical Poetry: Aesthetics, Politics, Technology, and the Ibero-American Avant-Gardes (1900–2015)* (2016). Feminist perspectives and studies of digital cultural production by Latin American women can be found in María Mencía's (2017) collection *#WomenTechLit*, which, like the present volume, incorporates reflective essays by authors writing about their practice. Here, in addition to focusing on Latin American women and combining academic and practitioner perspectives, and in contrast to the aforementioned studies, we focus on the way the creative practitioners studied in this volume use digital and analog multimedia cultural production as a means to explore transgressive content.

CATEGORIES AND DEFINITIONS: PROBLEMS AND POSSIBILITIES

Before providing an overview of the individual chapters in the volume, we will outline some of the key concepts which underpin the discussions. From the outset, it is worth reminding ourselves of the truism that all categories are constructs. Nevertheless, by grouping the women together as producers of Latin American multimedia work we seek productive rather than reductive ways of engaging with and promoting their work. Combined with the literary, multimedia provides the link that allows us to group them together as part of a crosscurrent without overriding significant differences. In studying the ways their work cuts across the boundaries of what have conventionally been considered distinct media, what is important for us is not so much the nature of the relationship between and within media but the fact that what they are doing challenges the status quo. The media and any combinations of media are, of course, inherently politically neutral, but, as will be seen, form combines with the content of these women's work to acquire a political charge. The crossing of borders between media thus frequently draws our attention to how other borders are transgressed.

In the words of Hayles and Pressman, "[t]he deepening complexities of the media landscape have made mediality in all its forms, a central concern of the twenty-first century" (vi). Definitions are produced by critics often operating within different frames of reference and disciplinary backgrounds. Most often though, "multimedia," and its related terms discussed in the following section, has been theorized by male US and European-based critics writing about US and European cultural production. By including in our volume Latin American/Latina female multimedia practitioners and Latin American and European/US academics who are engaging in new ways with, and theorizing about, Latin American cultural production, we seek to bring new voices and practices to the fore.

INTRODUCTION 11

Proliferating definitions produced by academics and practitioners with an interest in media gives rise to ever more nuanced terms of which multimedia, the term used in the title of the present volume, is just one. These terms capture the small but potentially significant differences in the ways each creative practitioner is using different media. The weakness, of course, is that the definitions contradict one another or overlap so much that it is impossible to differentiate. In some cases, we may wonder whether the definitions are so general that they could be applied to every "text" and so are rendered useless.[8] While being cognizant of the strengths and weaknesses of some definitions and the constructedness of all of them, we nevertheless perceive such terms and their fuzziness as, broadly speaking, a site of opportunity. The dialogue is ultimately more important than the label itself.

MULTIMEDIA, MULTIMODALITY, AND INTERMEDIA

Based on our work, discussions with the creative practitioners, and our readings of their contributions here, we understand a multimedia practice to primarily refer to an *overarching* practice in which an author or artist uses different media separately (e.g., they write poetry and paint) *as well as* the combination of different media in a single piece of work (e.g., a novel with images alongside the text). In the latter case, as will be discussed, additional terminology (e.g., intermedia or hypermedia) can help to further specify the nature of the relationship between media.

Our understanding of media in the past is shaped by the present digital media landscape. Perhaps for this reason, the vocabulary we use to discuss media and the relationships between different media remains hotly contested. In selecting multimedia as our umbrella term, we reject the way the concept of multimedia is increasingly restricted to the realm of the digital and separated from the literary. We concur in this respect with Ana Clavel, who in her chapter in this volume defines multimedia as referring to "'many media' even though today's culture takes it to mean almost exclusively audiovisual and digital platforms" (35). In her definition Clavel perceives how our understanding of multimedia tends to be shaped by the present digital media landscape.[9] Sánchez-Mesa and Baetens' recent discussion is typical in this respect, as it proposed reducing the critical vocabulary to a basic dichotomy between intermediality and transmediality in the broader context of "literature in expansion" and "multimedia digital culture" (8). We recognize that media combinations

[8] "Text" in inverted commas is used to refer to the text independent of media.

[9] In this respect, an interesting source for retrospective considerations of analog media brought about by digital media is Monjour's *Mythologies postphotographiques*.

are doubtlessly facilitated by digital technologies as seen, for example, in the work of Jacalyn Lopez Garcia, who produces video and computer art that incorporates poetry, storytelling, music, and photography. As a reminder of the importance of the digital in contemporary multimedia cultural production, Pitman in this volume proposes a "study of pioneering hypermedia works" to "provid[e] examples of specifically digital multimedia cultural production that may serve as a counterpoint to the more analog or mixed analog/digital multimedia works studied elsewhere in this volume" (237).

Our definition of multimedia, like the work of Eduardo Ledesma, Claire Taylor ('Entre 'Born Digital'"; "From the Baroque"), Claudia Kozak, Dolores Romero López, and, in the present volume, Debra Castillo, locates contemporary multimedia cultural production in relation to a longer tradition which predates the digital era. Such an understanding is an important corrective to tendencies to overstate the newness of multimedia practices. Indeed, as Claudia Kozak rightly observes, "the fusion of media preceded the era of computers, and so multimedia is therefore also present in other contexts" ("Multimedia" 180). While we consider it important to divorce the idea of multimedia from the exclusively digital, as we note above, we are also cognizant of the fact that artistic or literary practices which are not "of the Internet" or "to be consumed on a computer" are still, at some point of their lifespan, mediated by some kind of digital or computational medium: photography, sound, video recording, and file sharing are some such examples. Another example of analog cultural production being mediated by the digital is seen, for example, in the printing of books in our day, which is, indeed, a highly technologized and industrial endeavor. In this respect, and as Hayles and Pressman note, "so intermixed are digital and print media through modern printing and publishing machines that they must be considered comparatively to make sense of their production at all" (Hayles and Pressman xiv). Such a comparative approach is enabled by our understanding of multimedia practice as one that may or may not include the digital but most often spans this divide in often complex ways.

In using multimedia as our umbrella term, we nevertheless recognize that there is no such thing as a "pure" media with which we can contrast different types of media combinations and fusions. In other words, multimedia is an oxymoronic term because all media are made up of multiple media. Once we might have read a definition, such as that put forward by Claus Clüver in 2007, according to which a multimedia "text" is one which "comprises separable and individually coherent texts in different media […] an opera score that contains the libretto is a multimedia text" (Clüver 25). Our emphasis on the *overarching* multimedia practice, rather than only on the presence of various media within a single work, means that for us, contrary, for example, to Claus Clüver (25) or Ginette Verstraete, to be considered a multimedia practitioner the women studied in this volume do not have to produce single pieces of

work which contain what would traditionally be considered distinct media. The different media are not necessarily presented "synchronously" nor "within one object," as per Verstraete's definition of intermediality, for an author or artist to be considered a multimedia practitioner (10). Today, we are more likely to encounter statements such as the following by Irina Rajewsky: "to speak of a 'medium' or of 'individual media' ultimately refers to a theoretical construct" (54). She continues:

> The question of how a medium should be defined and delimited from other media is of course always dependent on the historical and discursive contexts and the observing subject or system, taking into account technological change and relations between media within the overall media landscape at a given point in time. (54)

In a similar vein, Lev Manovich asserts that to persist in thinking about media is to "follow the old tradition of identifying distinct art practices on the basis of the materials being used – only now we substitute different materials by different new technologies" even when these new forms are not really media in any traditional sense ("Post-Media Aesthetics 36). Faced with such problems, discussion of media is increasingly being replaced by consideration of modes and multimodality.

In Lars Elleström's conceptualization, the different modes are: material, sensorial, spatiotemporal, and semiotic (15). Differentiating between media and mode and drawing on the work of Gunther Kress and Theovan Leeuwn, Claudia Kozak usefully explains in her chapter in this volume that we may talk about:

> different media, for instance cinema, video, photography, books or the Internet, but different languages or modes of discourse: verbal, visual, sonic, haptic, etc. It is usual to speak then of multiple media and languages in terms of a multimedia and multimodal perspective. (206)

But, modes are also not so clear cut. Just as there is no pure media, there is no single mode text. As Jørgen Bruhn states, "even the apparently monomedial text always consists of several modalities" (227). Moreover, Marie-Laure Ryan notes, "'mode' is as difficult to define as medium is, and Kress and van Leeuwen's attempt to list and classify modes of signification are similar in their apparent randomness to Borges's Chinese taxonomy" (28). Furthermore, Ryan argues: "modes of signification do not make the concept of medium dispensable, for there must be a way to distinguish the various cultural forms in which a given mode appears" (28). Thus, she proposes the definition of media which we will use in this volume as "culturally recognized forms of communication" (28). Multimedia then refers to an *overarching practice* which includes the use

of media which, at the time of writing, would *conventionally* be thought of as a single culturally recognized form of communication.

For those cases where different media are combined in a single work, intermediality comes into play. Verstraete points out that all media is "always already intermedial" (8). Nonetheless, definitions of intermediality seek to specify the nature of the relationship between media. Since Dick Higgins's seminal definition of intermedia in ("Intermedia"), Jen Schröter has identified the emergence of a broad consensus view held by Chapple, Eicher, Prümm, Rajewsky, and Wolf, to which we also ascribe (2). According to this consensus, intermedia refers to the way in which conventionally distinct media are combined within a single "text" or multiple "texts" presented synchronously side by side, for instance on a website. Extending Bruhn Jensen ("Intermediality), who uses implicit and explicit to differentiate between intertextuality as implicit linking and hypertextuality as explicit linking, we differentiate between implicit and explicit intermedia. Where more than one form of media is present synchronously or within one object so that there is a fusion, this is explicit intermedia. Where the different media do not physically impact, and may or may not be presented synchronously, but where intermedial dialogue can be *inferred*, we differentiate using the term implicit intermedia, which has a parallel in the literary term intertextuality.

For us, one key aspect of intermediality, and more broadly multimedia, is the aspect of transformation. This emphasis on transformation is derived from Verstraete, who notes in relation to intermediality that the interaction of different media "is such that they transform each other and a new form of art, or mediation, emerges" (9).[10] Another fundamental characteristic of intermediality is how, as Kozak notes in the present volume, it leads to "a different artistic experience only possible in the 'in between'" (206). Kozak's definition reflects the significance of border crossing in the context of intermediality also seen in the work of Lars Elleström and Irina Rajewsky (Media, Modalities, and Modes 27; "Border Talks" 64). It is through this theoretical and practical engagement with the notion of borders/in-betweenness and the idea of the construction of borders, that we are able to highlight in the work of a crosscurrent of Latin American multimedia creative practitioners how media conventions, and the separate domains of expertise they suggest, as well as other types of categories of gender, race, or culture, are, to paraphrase Rajewsky ("Border Talks 64), highlighted, dissolved, or transcended.

[10] Spielmann also emphasizes this transformative element in both intermediality and intertextuality (57).

INTRODUCTION 15

TRANSMEDIA AND THE (TRANS)LITERARY

Implicit intermediality, where different media do not physically impact and are not present synchronously but where there is a stated relationship, may, in some circumstances, also be understood as transmedia. "Transmedia" was coined by Marsha Kinder to refer to the "deliberate move across media boundaries – whether it's referring to intertextuality, adaptations, marketing strategies, reading practices or media networks" (n.p.). For Sánchez Mesa and Baetens there are two types of transmedial cultural processes. Both are symptomatic of Henry Jenkins' notion of "convergence culture" in which content flows, media industries operate, and audiences migrate across different media (*Convergence* 2). The first type of transmediality involves adaptation, in the most traditional sense of the word, from one media to another. The second type of transmedia process involves "demediated content" which can be "re-elaborated" or "expanded" in various media, without this process of expansion having to be underpinned by a source "text" (Sánchez Mesa and Baetens 10–11). The relationship between adaptation and transmedia is a hotly contested one, but Sánchez-Mesa and Baetens' second understanding of transmedia is in keeping with Henry Jenkins' concept of transmedia storytelling.

Transmedia storytelling refers to cases where a work of fiction is produced, often simultaneously, across various media "for the purpose of creating a unified and coordinated entertainment experience. Ideally, each medium makes its own unique contribution to the unfolding of the story" (Jenkins "Transmedia Storytelling 101). Typically of transmedia studies, however, Jenkins' case studies in *Convergence Culture* focus on the entertainment industry and in particular large-scale, Hollywood mega-productions. Yet, as Matthew Freeman and William Proctor have demonstrated, and as Bowskill shows in the present volume, applying this label in other contexts leads us to rethink both the works studied and the concept of transmedia itself.

Transmedia captures the sense of moving and expanding across media boundaries. Transliterature draws our attention to cases where the literary source inspired that move. Transliterature is an appropriate description for the work of some of the women studied here and is used by Lavery in her chapter to understand the work of Neira, Clavel, and Galindo. Ana Clavel embraces the term transliterature because it both emphasizes the centrality of the written text *and* the way in which the original is *supplemented* by other media. Clavel also sees transliterature as bringing new audiences to literature and as leading to new ways of reading and writing (Lavery and Bowskill 34–5). Audran, Schmitter, and Chiani propose (4) that transliterature is populated by trans peoples, is a metaliterature which thematizes transition and the crisis of literature and, following Kozak, they suggest, transliterature overflows transmedially and transgenerically (4). It is also a literature which is transnational

and embraces the communal (e.g., communities of readers, wreaders, etc.) (Audran, Schmitter, and Chiani 4). As the chapters in this volume show, however, multimedia and intermedia cultural production also lend themselves to this proliferation of crossings.

HYPERTEXT/MEDIA, INTERTEXTUALITY, AND CULTURAL RECYCLING

Transliterature brings to the fore the literary source of some transmedia cultural production, just as hypermedia draws attention to multimedia in the context of the digital. Hypermedia derives from hypertext, and, as Thea Pitman states in this volume, it is "the lifeblood of the Internet though most criticism still tends to discuss 'hypertext'" (Lavery and Bowskill 236). Moreover, as Pitman also observes, in a specifically Latin American context the "value of hypertext to capture the multiple and/or hybrid nature of Latin American-ness" has been much lauded (Lavery and Bowskill 239). Hypertext dominated in the early, exclusively text-based, days of the Internet, but since text is now supplemented with other forms, hypermedia is the more accurate term to describe the new diversity of linked digital media content. In hypertext (used by George Landow as a synonym for hypermedia), verbal and nonverbal information is electronically linked creating networks of texts (Hypertext 3). According to Landow, the ideal text Roland Barthes envisaged, which consists of networks which interact, with no beginning and multiple points of entry, is realized in hypertext (Hypertext 2). In this volume, Grossberger Morales speaks of her enthusiasm for hyperlinking because it enables layered, interactive works. Yet again it is possible to see how non-, and partially, digital works studied in this volume create similar networks. Indeed, although we reserve hypermedia to refer to digital media, as Landow points out hypertext does not have to be electronic, but, in his view, it is its electronic form that represents its fullest realization (Hypertext 4). N. Katherine Hayles similarly proposes "that hypertext can be instantiated in print as well as electronic media" ("Print is Flat" 22). Castillo sees digital literatures, specifically digital poetry produced by the likes of Belén Gache, as "actualizing the promise of Mallarmé's dice throw and freeing it from the limits imposed by paper" (Lavery and Bowskill 232). Conversely, just as multimedia (and for some hypermedia) practice preceded the digital age, so too must it be emphasized that digital literatures are not a culmination of literary experimentation. Re-thinking contemporary *non-digital* multimedia cultural production in terms of its hypermedial strategies helps to fill in the existing gap between what Pitman (234) terms the "proto-hypertexts" of Julio Cortázar and Jorge Luis Borges and Doménico Chiappe's sophisticated, digital version 3.0 of *Tierra de extracción* (1996–2007). In this

INTRODUCTION 17

vein, the offline texts of Clavel and Prado share the same playfulness and
improvisation and require the same active reader as Cortázar's *Rayuela* (1963),
but in their work Clavel and Prado link (proto-)hypermedially to additional
web-based content.

While the academics and creative practitioners in this volume sometimes
provide optimistic perspectives about the potential of digital technologies,
they are cognizant of the fact that digital technologies have their drawbacks.
Castillo, for example, points to the problem of obsolescence as works become
inaccessible due to changes in technology. The opportunities afforded by digital
technologies are also not equally available to all and come at an environmental
cost, as digital waste is a growing problem. Artificial Intelligence and social
media platforms are not risk free. The latter can be used to abuse and bully
others as well as to build community. Claire Taylor alludes in this volume to
the work of Belén Gache to showcase how the feature of digital interactivity,
which confers the illusion of agency, reveals itself to be no more than an illu-
sion, since *we too* are clones, hypnotized and trapped in the corporate system.
Eli Neira has been censored by Facebook for her political outspokenness, as
discussed by Hayles in "Print is Flat" but she also uses Facebook as part of
her ongoing commitment to citizen journalism and politically engaged work.
Most recently, she has been posting acerbic attacks on the Chilean govern-
ment's mishandling of the global coronavirus pandemic.

Over-emphasis on the positive potential and newness of digital technol-
ogies and specifically digital hypermedia has also caused the longstanding
concept of intertextuality to be overshadowed. According to Orr, who like us,
takes a broad definition of "the text":

> "Intertextuality" names a text's relation to other texts in the larger "mosaic"
> of cultural practices and their expression. An "intertext" is therefore a
> focalizing point within this network or system, while a text's "intertextual"
> potential and status are derived from its relations with other texts [...] it
> describes how cultural productions are facilitated by their (re)interpretation
> and adaptation in a variety of media including text, performance, the plastic,
> and the visual arts. (*Encyclopedia* 2)

As Orr's quotation makes clear, intertextuality "always also involves inter-
mediality, since pre-texts, intertexts, posttexts and para-texts always include
texts in other media" (Clüver 29). Intertextuality, however, is often seen as an
inadequate idea in an age in which new media are decentring the hegemony
of print text (Orr, "Intertextuality" 2). Yet, as previously noted in our discus-
sion of intermediality, Jensen makes a useful distinction between "implicit
intertextuality" and "explicit hypertextuality." Thus, in the present volume, we
see critics identifying not only implicit and explicit intermediality but also,
as per Bruhn Jensen, implicit intertexts (which may or may not have been

suggested or intended by the author) but where no physical link is present as well as explicit, (digital) hypertextual connections. Moreover, under the broad headings of (implicit) intertextuality and (explicit) hypertextuality, the women studied here engage in creative linking which sometimes extends not only into transmedia or transliterary adaptation and remediation but also to practices of cultural recycling, which has variously been labeled *bricolage*, recoding, or appropriation. All of these forms of linking serve to position texts within networks of other texts and entail making "new" objects out of a range of found materials and physical media.

The multimedia artists and writers in this volume use found/waste materials from organic to inorganic objects including urinals or *cartonero* dolls (Clavel); discarded household items (Pilar Acevedo); human feces, blood, or urine (Eli Neira; Regina José Galindo); sawdust (Regina José Galindo); archaeological ruins of abandoned hotels (Golder) and, among other things, discarded radiographs (Pura López Colomé) and code (Lucia Grossberger Morales). Inspired by the growing interest in Ecocriticism and Waste Studies, we see (re) using in the context of a multimedia creative practice as a resourceful praxis leading to new mediations in new contexts and not as a form of blind mimesis. By using and combining past voices and traditions, such integration in multimedia practice suggests the intentional blurring of established forms of art and literature with other cultural expressions (such as (video) performance/installation and digital art/poetry) which have until recently, as Friedman remarks, "not previously been considered art forms" (51). We see this reusing of past voices specifically in this volume in the context of, for example, Taylor's analysis of Gache's reworking of a canonical Golden Age writer with a digital poem with animated, calligram-esque format.

In the using and reusing of different "texts," multimedia creative practices involve rhizomatic contagion. The literal meaning of contagion as disease and infection is a particularly apt notion to be drawing from, given the recent global coronavirus pandemic. The discussion about contagion metaphors is found in essays by Bowskill and Lavery and is also evident in the most recent work and online activism of Eli Neira. These topics have been cast into even sharper relief as a result of recent events. Our future projects and collaborations will necessarily be informed by a consideration of the impacts of COVID-19 at societal and creative levels. Contagion as a metaphor has been identified as particularly problematic, as it is used to refer to marginalized populations including immigrants, the sick, women, and homosexuality.[11] Yet the metaphor is apt because, as Mary Douglas explains "pollution ideas" are

[11] On the uses of the metaphor in these contexts see, for example: Davis's "Contagion as Metaphor"; Cisneros' "Contaminated Communities"; Plummer and McCann's "Girls' Germs."

INTRODUCTION 19

used to police behavior and uphold values and rules (3). Writing about religion
in primitive cultures, Douglas continues:

> ideas about separation, purifying, demarcating and punishing transgressions
> have as their main function to impose system on an inherently untidy expe-
> rience. It is only by exaggerating the difference between within and without,
> above and below, male and female, with and against, that a semblance of
> order is created. (4)

The women studied here, however, explicitly reject the established order that
is based on a neat separation of media and the exclusion of the frequently
abjected "Other" (Women, LGBTQ, or Indigenous communities) that is
enforced by established binaries and hierarchies. The crossovers between
media and pollution of binary forms of thinking which characterize the work
studied in this volume destabilize notions of a "pure," singular, isolated "text"
or media in order to celebrate contaminated forms and hybrid categories. The
idea of hybridization as a form of contagion or contamination is a recurrent
idea applied to multimedia practice both by the artists and writers themselves
(see contributions by Neira and Prado) as well as by the academics (see chap-
ters by Bowskill, Castillo, Lavery, Finnegan). For us, pollution becomes a form
of disruption, both thematically and formally. Both Taylor and Pitman draw
from this idea of contamination in the concept of "viral latinidad," which seeks
to disrupt hegemonic representations of Latino/as in the United States by
challenging "the reifying tendency of the visual power system that is race"
(*Latin American Identity* 168). There is no need, as Carlos Jáuregui does with
reference to online cultural production, to mourn the loss of aura (290). Nor
do we have to conclude that the dehierarchization and rapid circulation of
"texts" online (or indeed offline) leads to them being cheapened, as Jáuregui
also contends (290). Intertextual, hypertextual, multimedia, intermedia, trans-
media, and transliterary texts invite us to continue to interrogate all categories,
the concept of an origin as well as notions of authority, authenticity, and
uniqueness which traditional conceptions of art and literature support.

MULTIAUTHORSHIP, THE PROFESSIONAL VERSUS THE "AMATEUR" AUTHOR/ARTIST, ACTIVISM, AND ACTIVE READERS

Reusing not only rebuffs the Bloomian "anxiety of influence," and by exten-
sion postmodernism's outright rejection of past sources, but equally rejects the
anxiety of authorship. Indeed, in order to produce their multimedia pieces,
many of the women whose work is studied in this volume collaborate with
others. They relinquish the privileged position of the solo (typically signified
as male) Author/Artist-genius. Collaboration allows these multimedia prac-
titioners to produce work which otherwise might not have been possible and

which reaches diverse audiences who may not have had access to a printed book or to a gallery. Yet such practices seem to leave women in particular open to accusations of amateurism and criticism for not "knowing their place." As Hind notes in this volume, such labeling is entrenched in the broader context of sexism, where women have often been dismissed "for lesser intellectual and artistic talents" in counterpoint to male privileged professionals (174). Elsewhere, Hind has demonstrated that the roles of professional writer or intellectual are performed and the performance of these roles is more accessible to men than women. Women are, therefore, less likely than their male counterparts to be considered pioneering, innovative, or avant-garde and more likely to be censured for stepping outside their supposed expertise or labeled as amateur. Of particular concern for our multimedia practitioners, as Hind points out in this volume, is the fact that "[t]he subjects of amateurism and interdisciplinary research or intermedial art necessarily intertwine, thanks to the profound degree of specialization required to turn professional, which makes expert cross-disciplinary work quite difficult." (166) Consequently, some of our contributors are reluctant to identify with some labels. Despite writing poetry, Galindo, for example, does not consider herself a poet, and Clavel says she is not an artist:

> That is the reason why, when faced with the proposal made by some that I am a "visual artist" – as did the publisher Métailié which published the French version of my *Violets are Flowers of Desire* and on the back cover presented me as a "writer and plastic artist" –, that I distance myself from such labels. I tell them that above all other definitions I am a writer, and that, if anything, I am a writer who also devises multimedia projects on the basis of my books – which later I will refer to as "transliterature." If I had to choose, I prefer the term which the researcher Jane Lavery has used to describe me: "multimedia writer." (Lavery and Bowskill 34)

Lopez Garcia felt the need to prove herself by acquiring new skills to prove her expertise: "Conquering the learning curves associated with web authoring, and gaining enough experience and expertise in multimedia art production was overwhelming at times" (Lavery and Bowskill 93). Grossberger Morales, who worked in Silicon Valley and co-authored the Designer's Tool Kit, a graphics program published by Apple Computer, Inc. in 1987, still says that "she feels like an 'amateur' when coding." (100) In so doing she expresses a feeling perhaps akin to that of impostor syndrome that is far more prevalent among women than men but is the result of a society that constantly devalues women's abilities and achievements. Instead of dismissing the work these women produce in areas that are outside their supposed area of expertise, this volume proposes to understand their multimedia cultural production as part of a body of work that is breaking new ground in the context of Latin American cultural production.

INTRODUCTION 21

The desire to adopt new practices to reach new audiences, even at the risk of criticism, is evident in the ways in which many of the multimedia initiatives described and analyzed in the volume aim to foster collaborative and/ or communal practice in order to raise consciousness and in some instances direct proactive citizenship. From the hypermedial narratives of Zerbarini, whose users have to execute her poetry through their actions, to the installation and performance pieces of Clavel, Nepote, Galindo, Neira, and Golder and Yeregui, these creative works encourage audiences to interact, touch, or smell. Their practices, as we shall see throughout the volume, invite the reader/ audience (at times via synaesthetic-interactive engagement) to ask important questions. These creative endeavors aim to re-connect audiences with their surroundings or to engage with questions of, for example, environmental crisis, human trafficking, gendered/racial violence, (repressed) sexuality, abuse, trauma, or loss. The bridging of arts and community is exemplified in Eli Neira's "poetry in action"/"CasAcción" aesthetics involving artists and the broader local Valparaíso community in Chile in, for example, litter picking, running a community kitchen, and recruiting women plumbers carpenters, ironmongers, and decorators to carry out repairs in the area. Meanwhile, Pilar Acevedo has used her visual arts skills to develop a program called *The Art Alternative* to provide instruction to "at risk" preschool children. Similarly, in the projects of López Colomé, in collaboration with Mexican visual artist Guillermo Arreola and González, cultural practice becomes enmeshed with political mobilization and activism as they decry the violent deaths and forced disappearances that have taken place in Mexico since 2006. The case studies reinforce the link between Latin American digital cultural production and activism established by Hilda Chacón (*Online Activism*) and recognize, following the work of Marsha Kinder and Tara McPherson (*Transmedia Frictions*), Marcela Fuentes ("Performance Constellations: Memory and Event") and (*Performance Constellations: Networks of Protest*), and Guiomar Rovira Sancho ("El devenir feminista") and ("Constelaciones performativas"), how social and political struggles around race, gender, and space can manifest themselves in digital cultural production.

The study of Latin American women's multimedia cultural production alerts us not only to the changing figure of the author but also to the role of the reader in the production of meaning and even as active, co-creator of the text. The expanding and multiple roles now assumed by the "reader" have led to the emergence of a new vocabulary.[12] Wreader, user, viewer, and participant

[12] Just as we have used "text" in this Introduction to refer to textual image and audio-based sources, we also place the homologous term, "reader" in inverted commas, to capture the similar but also distinctive engagement that multimedia works require.

are just some of the alternatives that are proposed by authors in this volume. According to Walkowitz (quoted by Hind in the present volume 178) these "readers" are now required "to become handlers and viewers, and [...] to establish the text rather than to assume it (231)." Similarly, Gainza's work on digital cultural production calls for us to reflect on the ways in which the reader activates the digital text through their interactions with it and, this being the case, whether literary scholars now need to understand the languages of computer code. She prefers to refer to "users instead of readers" because their "actions surpass the level of interpretation and signification of the text, as understood in the reception theory developed by authors such as H. R. Jauss and Wolfgang Isser" (138). Taylor and Pitman, citing Hayles, however, ask us to proceed with caution: "it is a fallacy to associate 'the hyperlink with the empowerment of the reader/user'" (Hayles and Pressman 31) since the "reader can only follow the links that have been scripted" (*Latin American Identity* 86). Multimedia cultural production, which is both on and offline, arguably provides the reader more options and flexibility than the hypermedia texts to which Hayles refers. In a further shift toward Barthes' ideal text, the readers of our multimedia "texts" have ever more control over the order in which they "read." User choice and interactivity is not unique to digital media. We may point, thus, to the ways in which the visitor to an art gallery chooses whether to read the labels or exhibition catalog first or look at the image. A (voluntary) participant in a performance not only can choose to participate but can also change the meaning(s) of the performance depending on how he or she might choose to interact with the performer. In both cases, the "reader" or/and participant is active in the creation of meaning. The works studied in this volume simply bring these issues to the fore.

For some of our contributors, one of the attractions of a multimedia approach is the possibility of reaching new audiences. Even when access to the Internet is not available to all in a specifically Latin American context, digital media platforms in particular can still be "a way to reach audiences that would not normally buy copies of printed books" (Taylor, "Virtual Bodies" 244). As authors and artists create websites and develop a social media presence, it is easier than ever for the "reader" to publicly engage with their work through comments and likes which then become part of the site with the potential to influence the experience of other users. It is also possible for the "reader" to contact the producer of a text through social media. Consequently, as Bruhn Jensen points out, "[t]exts no less than media are resources of human action and social interaction" (4). Were it not for the ready availability of such contact information, this volume would probably not exist in its present form, although a note of caution must be added about the way in which digital media companies have hijacked social interaction for financial gain and subjected them to censorship. Thus Ulises Mejias cautions against "[p]ublic intellectuals (media

INTRODUCTION 23

gurus, academics, etc.) who advocate that digital networks are being used to empower the public but who are only undermining our potential to free ourselves from the hypnotic hold of this aestheticized form of sociality" (*Off the Network* ch.1). Taylor and Pitman counter that what is distinctive about internet usage in what they understand as a postnational Latin(@) American context is its propensity to be used "to organise social activism online"[13]. Thus, while in other contexts online environments are increasingly associated with exclusivity, corporatization, and surveillance, Taylor and Pitman optimistically proclaim: "Latin Americans may well develop "la otra Internet" as a contestatory practice to challenge the hegemony of the Internet as it has spread from the USA outwards."[14] Other terms used to describe these alternative digital networks and alliances include "las redes activistas y las multitudes contectadas," proposed by Rovira Sancho in "El devenir feminista." The work of many of the women studied in this volume may be part of this "otra Internet." The volume thus stands as testament to the way in which the digital dimension of multimedia cultural production has the potential to kickstart new conversations between authors, artists, and their readers, who may otherwise never (virtually) have met.

CHAPTER SUMMARIES

In Chapter 1 of this volume, Ana Clavel outlines her ideas on the "transliterary" in relation to her multimedia practice. She locates this practice within a much longer tradition of authors and artists experimenting across different genres and media. For Clavel, her writing provides the launchpad for her multimedia projects, which do not seek to be professional or highly polished but which sometimes involve collaboration with "professional" artists and musicians, and for this reason she resists being labeled by critics as a "Visual Artist" and prefers the term "multimedia writer" as Jane Lavery has coined her.

In Chapter 2, Eugenia Prado Bassi explores how her work-in-progress novel-play *Asedios* (*Sieges*) (2017) is part of a broader multimedia project in collaboration with four Colectiva de Artes Integradas (CAIN) artists. Prado Bassi reflects on *Fe/males* as a transmedia/transliterary multimedia project, on gender, the relationship between (post) human and machine, and on the ways of turning the instruments of power back on themselves.

Eli Neira explains in Chapter 3 how she perceives herself as a multidisciplinarian working outside the mainstream and at the intersection of genres and genders in order to challenge hegemonic discourses of race, identity. and

[13] Taylor and Pitman's "Introduction" (7) and *Latin American Identity* (2).
[14] Taylor and Pitman's "Introduction" (7).

gender. Her creative practice is aimed at advocating a "Ch'ixi impure, mixed-race identity comprising a compendium of impure characteristics and hybrid techniques." (59) Through the various examples of Neira's multimedia and transliterary works (poems, performances, and art collage), it becomes apparent that her creative practice is underpinned by contestation and collaboration with other creative practitioners and activist groups aimed at mobilizing local communities as a means of challenging injustices.

In Chapter 4, Regina José Galindo, who has an established reputation as an artist, describes how her poetry writing informs and shapes her artistic practice. The poems and performance art pieces presented in this chapter exemplify the transliterary and thematic connections between her different outputs including her focus on femicide, human rights abuses against Indigenous communities, and environmental exploitation.

Like many of the other artists and writers of this volume, Carla Faesler's poem-essay, *Imagentexto* (Chapter 5) describes how her poetic practice relates to other media. She also notes the way in which our understanding of the literary and the writer are modified in the process of engaging with new media. Indeed, as the creative process becomes digitized, so too does the role of the writer. The sources of inspiration also change: indeed, drawing from Virginia Wolf's concept of a "room of one's own," for Faesler the writer's space becomes a virtual one ("a screen of one's own"). Like Nepote, Faesler does not write *about* but *with* the (digital) body ("se escribe con el cuerpo, ese módem de carne").

In her poem-essay, *Voices/Bodies* (Chapter 6), Mónica Nepote explores the relationship between writing, the (moving) body and voice, and the idea of body as voice. Like writing and language, Nepote argues, both voice and body/identity are in constant flux, particularly when new technologies become a platform from which to examine the interrelationship between them.

Pilar Acevedo's *Redefining Meaning: The Interweaving of the Visual and Poetic* (Chapter 7) describes her multimedia practice and use of transmedia storytelling to give voice and bear witness to victims of child and domestic abuse. Whereas Galindo in Chapter 4 describes how she begins with poetry, which leads to performance, Acevedo notes that sometimes the written word is her inspiration, but equally her art inspires written narratives. Works and texts act as catalysts for the creation of new works as the narrative expands across different pieces and in different media. As well as seeking to engage audiences through her own artwork, Acevedo also sought to inspire others to use art as a "tool for learning" through her initiative working with "at risk" preschool children as part of the *The Art Alternative* program.

In Chapter 8, Gabriela Golder and Mariela Yeregui discuss their collaborative project *Escrituras* (*Writings*) (2014), in which they used neon signs produced as part of a collaboration with the local community to reimagine

INTRODUCTION

the landscape and their surroundings in the La Boca neighborhood in Buenos Aires, which counter hegemonic ways the politics of the city is inscribed in space. The intermedial nature of the project *Escrituras* worked at three levels: (a) the transposition of media, migrating the textual to a lighting-visual format; (b) the constant reference made to other media, referring aesthetically and formally to a type of urban signage no longer used; (c) the combination of media, integrating the languages of words, action, urban intervention, and luminous objects. It connected praxis and theory as both a theoretical exploration *and* creative experimentation around the concept of territory.

Jacalyn Lopez Garcia identifies herself as "transmedia visual storyteller," and in her chapter, *Reflections on a Multimedia Practice* (Chapter 9), she describes how her creative practice uses the digital, including QR code, by integrating it into various art forms such as poetry, dance, music, and other non-visual elements to explore themes including family, tradition, cultural identity, and gender. Her multi-layered, open-ended digital works are tied to the exploration and development of a modern Chicana identity. When producing these works, she describes how she is conscious of the reader's attention span as well as the opportunities for online storytelling to produce online dialogues. She notes that some of the particular challenges surrounding digital multimedia works include the need to update and adapt works so that they do not become antiquated and the fact that art galleries based on the "do not touch" model are not always equipped to accommodate artistic installations requiring public access to a computer with internet access. As in the case of many of the women studied here, Lopez Garcia describes how collaborating with others has led to new opportunities.

Finding inspiration in Bolivian weavings, Lucia Grossberger Morales' chapter (*Digital Weaving*, Chapter 10) showcases how her literary, artistic, and digital multimedia creative practice also became a form of weaving of tradition, stories, and technology, often inspired by poetry. Weaving is thus a transmedial tool and metaphor which links different media and modes. For the artist, the computer becomes a metaphorical loom which enables her to animate and create hyperlinked text to produce layered, interactive artworks. While Grossberger Morales feels confident in her skills to create artworks or write stories and poems, she feels like an "amateur" when coding. Despite the affordances of digital technologies, Grossberger is also aware of the dangers of internet obsolescence, as she reports that *A Mi Abuelita* (an interactive shrine) is incompatible with current computers. Just as Castillo in Chapter 13 identifies concrete poetry as a significant antecedent to digital poetry, so too does Grossberger Morales report that she was inspired by the work of the concrete poets.

Chapter 11 explores how conventional definitions of genre are expanded in the works of these performance-artists-writers-poets. Through the means of multi/intermediality, transliterature, and cultural recycling, their meditative

practice seeks to challenge generic conventions by (re)combining, print-form literature or painting with more recent expressions (e.g., digital art/literature and (video)performance art). Genre "polluting" becomes analogous to thematic transgressions as a means to question cultural, sociopolitical, environmental, gender, racial, or religious "givens."

Carolina Gainza's *The Digital Condition: Subjectivity and Aesthetics in "Fe/males" by Eugenia Prado Bassi* (Chapter 12) analyses Prado's *Fe/males* in order to characterize "the digital condition." The aesthetic experience provided by Prado's transmedia novel changes the reader experience and fundamentally alters the role of the wreader. The process of reading *Fe/males*, which links diverse media, textualities, and disciplines, mirrors the digital condition of subjects in our contemporary era. Gainza thus explores *Fe/males'* texts, videos, images, and its last incarnation, *Sieges*, as part of an aesthetics and language that specifically belongs to the digital context and configures new modes of the self.

Sarah Bowskill's *The Transmedia, Post-Medium, Postnational, and Nomadic Projects of Pilar Acevedo, Rocío Cerón, and Mónica Nepote* (Chapter 13) analyzes Cerón's Empire project, Nepote's Sensationalist News poetry collection and the videopoem "Roswell," and Acevedo's assemblage Outcry and the poem "I Died" as symptomatic of a new moment in Latin American cultural production. She identifies these works as examples of transmedia and post-medium cultural production, drawing on the terms as used by Marsha Kinder, Henry Jenkins, and Nicolas Bourriaud. These terms, she notes, are rarely applied to non-commercial works by women in the case of the former or to literary works in the case of the latter. The chapter explores how applying different critical terms affects our interpretation of the works studied, casting light on the connections between media or the way in which meaning is destabilized as a result of dialogue between media. Of particular interest is the way in which the transgression of media boundaries in the works studied is linked to a rejection of a national frame of reference.

Emily Hind (*The Art of the Hack: Poets Carla Faesler and Mónica Nepote and Booktuber Fátima Orozco*, Chapter 14) analyzes YouTube videos by Mexican poets Mónica Nepote and Carla Faesler and Booktuber Fátima Orozco in order to consider how their intermedial practice leads us to reconsider categories of the amateur and the professional, but ultimately, although these categories are not clear-cut binaries, Hind concludes, these practices do not have a contestatory function. To overcome the false amateur/professional binary, which Hind notes is heavily gendered, she explores the hack and the figure of the hacker. Hind also draws our attention to the battle between analog and the digital in Nepote's performances, which draw attention to the relationship between the body and the digital and how intermediality does not always result in seamless fusion. Finally, these works draw our attention

INTRODUCTION 27

to the difference between the "real time" it takes to read versus the speed and
connectivity in hypermedia.

In *The Places of Pain: Intermedial Mode and Meaning in* Via Corporis *by
Pura López Colomé and* Geografía del dolor *by Monica González* (Chapter
15), Nuala Finnegan examines Pura López Colomé's *Via Corporis* (2016), a
collaborative project with Mexican visual artist Guillermo Arreola, which
utilizes discarded radiographs from deceased patients to produce a series
of paintings accompanied by poems excavating stories of illness, pain, and
death. To understand pain in López Colomé's work, Finnegan draws on
Liliane Louvel's concept of the "iconotext" (8). She compares *Via Corporis*
to Mónica González's project, *Geografía del dolor* (The Geography of Pain)
(2011) which employs postcard writing, music, photography, interactive web
tools, and documentary film in order to narrate the stories of families affected
by forced disappearance in Mexico. *Geografía del dolor*, while also partaking
in the pluriform fusion envisioned by Louvel, is more effectively understood
through rhizomatic connectedness, drawing from Deleuze and Guattari, but
also in the context of intermedial cultural production. Finnegan explores the
notion of the expanded book (drawing from Hellström Reimer et al.), in order
to reveal a network of meanings which unsettle but also illuminate.

Claudia Kozak explores in Chapter 16 the literary dimension of installa-
tions, performances, urban interventions, and net art projects by Argentinian
artists Gabriela Golder and Mariela Yeregui. Their multimedia and multi-
modal works can be seen as examples of expanded intermedial literature.
Drawing from Wurth and Deleuze, when different multimedia modes,
whether literary or not, fuse intermedially, this is a destabilizing *event* where
something new and unpredictable can happen. The idea of disruption linked
to "literature in expansion" becomes apparent in the work of both artists in
the context of the collaborative dimension of their work, which challenges
our ideas about authorship and readership. The exploration of memory
in the work of Golder and Yeregui is seen as key to producing disruptive
experiences, both in a cognitive and perceptual sense. Either oral or written,
memories? link to specific places, bodies, and moments, thus creating addi-
tional meanings. Moreover, one of the preeminent conditions of memory in
contemporary digital societies is its instability, due to phenomena such as
digital obsolescence and mutability (Brea).

In Chapter 17, Debra Castillo examines these three writers/performers/
poets, whose intermedial artistic practice is still called "poetry," but which
puts pressure on even the most expanded definitions of the genre. To under-
stand these works, Castillo places them in the context of the tradition of
concrete poetry to show how combinations of digital media connect to ear-
lier, non-digital practices. Their poetry is not an accessory to a print book
but rather completely uncontainable by that technology, thus residing in a

fungible performative space created by viewers' choices. The chance-based kinetic poetry of these artists requires a new type of analysis acknowledging the semantic significance of spatial design and taking into account the extension of poetic space into the third dimension, as well as the imminent disappearance of the project itself due to software obsolescence. Drawing from Hayles and Beigulmann, this imminent disappearance is a constituent part of a digital epistemology, the "ruinology" of the art works that needs to be taken into account in our digital aesthetics.

In Chapter 18 on *Hypertext and Biculturality in Two Autobiographical Hypermedia Works by Latina Artists Lucia Grossberger Morales and Jacalyn Lopez Garcia*, Thea Pitman focuses on two very early examples of hypermedia narratives which identified the expressive possibilities of hypertext/hypermedia as the ideal medium for their autobiographical explorations of (a specifically gendered) biculturality. The works are Lucia Grossberger Morales's Sangre boliviana, exploring her relationship with Bolivia and designed originally for CD-ROM, and Chicana artist Jacalyn Lopez Garcia's Glass Houses: A Tour of American Assimilation from a Mexican-American Perspective (1997), an exclusively hypermedia project that is fully available online. The chapter considers the artists' express intentions regarding the representation of gendered biculturalites well as the dynamics of "domestication" and/or "indigenization" and how, in their view, a hypertextual (and possibly also networked) medium is most suited to this. Sangre Boliviana and Glasshouses offer excellent examples of an oppositional cyborg/mestiza consciousness in the manner of Haraway that is focused on trying to "transform the despised metaphors" of technoscience and offer alternative perspectives and conceptualizations.

Chapter 19 by Claire Taylor provides comparative analysis of two of Argentina's leading women writers/artists, Belén Gache and Marina Zerbarini, for whom digital technologies are an integral part of their intermedial literary and artistic practice. Belén Gache's work takes forms as varied as word toys, blog diaries, and videopoesía. Taylor explores how Gache engages with and also critiques the discourses of new media technologies. Gache's Góngora "Wordtoys" is an example of cultural recycling, since it draws parallels between Góngora's techniques and the potentials of contemporary digital technologies, whereby hotlinking is reframed as Góngora's Baroque technique of catachresis. Gache's Radikal Karaoke is analyzed as an example of ambivalently encoded remix, encouraging us to critique our imbrication within the systems of global capital. Marina Zerbarini's work is characterized by its non-intuitive interfaces, its refusal of linearity, and its active remixing of existing sources. *Eveline, fragmentos de una respuesta (Eveline, Fragments of a Reply)* is Zerbarini's multimedia narrative, which is inspired by a James Joyce short story and brings together photographic images, videos, animations, and

INTRODUCTION 29

sound files in order to foreground the potentials of digital technologies. *Tejido de memoria* (*Memory Weave*) shows how intermedia work critiques Argentina's recent past and present inequalities. *Tejido* weaves a resistant memory through its combination of multiple fragments and sources, including still images, moving images, text, and sound files. Despite the differences in subject matter, both writers share a common interest in the recycling of pre-existing fragments (textual, visual, sonic), and both envisage their works as part of a longer, pre-digital heritage of literary-artistic experimentation.

CONCLUSION: MULTIMEDIA AS POLITICAL STRATEGY

The case studies in this book provide important examples of multimedia practices and furnish the reader with compelling evidence of an emerging crosscurrent of disparate multimedia practitioners whose work incorporates a literary dimension. It is no coincidence, we argue, that their rejection of rigid categories of media and specialization are accompanied by an interrogation of other borders and hierarchies. The umbrella term "multimedia" is used alongside other terms including multimodality, intermedia, transmedia, hypermedia, and transliterature to showcase the richness of the contemporary cultural landscape that is being crafted by Latin American women authors and artists.

The persistent arguments over terminology are, as Jørgen Bruhn recognizes, symptomatic of the "formalistic foundations" of intermediality studies ("Heteromediality" 225). To move away from this formalist tendency, he invites scholars to draw on the Cultural Studies tradition in which this volume is steeped. Doing so, Bruhn suggests, will lead us to focus on the political and ideological significances of the use of a given form (231). Once we take as given that media borders are constructed, then the question we must ask is why they are divided as such, by whom and who benefits? In this way we come to understand that dividing lines between media are part of "a more comprehensive ideological battle" which relates to "the social surroundings or the epoch of the work, for instance, connected to ideological conflicts concerning gender, class, ethnicity, or nationality" (Bruhn drawing on the work of Mitchell, "Ut Pictura Theoria" 232–33). Defiance of media borders thus becomes a way of alerting the "reader" to other transgressions.

Some of the creative practitioners studied here, as the chapters by Bowskill and Lavery respectively attest, have been criticized for stepping outside their supposed area of expertise or for producing work that defies existing categories.[15] In this case, the dividing lines between media are connected to broader

[15] On the critical backlash see for example Lavery's *The Art* and in this volume, Bowskill on the reception of Cerón (147).

critical and social debates about gender roles and what kind of cultural production may be deemed appropriate for women creative practitioners. Jane Lavery notes in her monograph *The Art* that critical reservations about multimedia practice may be linked "to a broader anxiety about the crossing-over of diverse disciplines conventionally kept apart, evidenced in particular in the encroachment of so-called new media or contemporary art forms on traditional art forms" (Lavery 252). For us, therefore, the multimedia practices of contemporary Latin American women are always a political and ideological rebellion against those who would tell them to "know their place." It is the transgressive thrust of their multimedia practice that is our primary concern.

We have reached a historical juncture. Even before the 2020 COVID-19 pandemic, intermediality had become widely established in art circuits and increasingly so in the literary sphere. It was already apparent that the mixing-up of media was not merely a ludic pastime but rather a practice which involves a sociopolitical critical position which in turn is accompanied by a series of self-reflexive critical strategies. In foregrounding the political potential of multimedia cultural production, we take our cue from Dick Higgins, whose work has become an obligatory point of reference for intermedia studies. Subsequent criticism, however, overlooks the fact that, for him, faced as he was by conflict in Vietnam and the crisis in the Labor movements, the true significance of intermedia lay in its political potential to say something new:

> Could it be that the central problem of the next ten years or so, for all artists in all possible forms, is going to be less the still further discovery of new media and intermedia, but of the discovery of ways to use what we care about both appropriately and explicitly? [...] We must find the ways to say what has to be said in the light of our new means of communicating. ("Statement")

Thus, our volume is attentive not simply to the relationships between media but also to the ways in which Latin American multimedia women authors and artists have found new ways of communicating what they *have* to say. In their multimedia cultural production, they invite us to look at, and engage with, environmental, feminist, political, and other pressing issues, affecting local and global communities in new ways.

The widespread lockdowns of the early 2020s doubtless intensified the need to find new ways to say what had to be said in this transformed world, and so more and more cultural activity and sociopolitical action went online, creating new networks and communities. In *Love Notes to the Planet* (*Notas de amor al planeta*) Lucia Grossberger Morales had already demonstrated how dispersed audiences could connect through performance to reflect on issues around the environment and climate change. Such interventions became more common during the pandemic. Argentine Tomás Saraceno, for

INTRODUCTION 31

example, live-streamed the launch of "the first inflatable sculpture to lift a human into the atmosphere using only solar power and wind currents" to 26,000 viewers as part of the project *Aerocene Pacha* (2020), drawing attention to "the possibility of fossil-free air travel as an alternative to minimize carbon emissions" (Brachetti Peretti). The film "COVID E-Lit: Digital Art During the Pandemic" (dir. Anna Nacher, Søren Pold, Scott Rettberg, and Ashleigh Steele) documented how authors and artists adapted their practice under lockdown. Frequently, the performances documented referenced the relationship between the human and the digital in a way that was foreshadowed by the work of Eugenia Prado. Equally, while Eli Neira sought to sell her artwork via her website, blockchain technology now allows artists to create digital art in the form of non-fungible tokens, which became part of mainstream public consciousness as cryptocurrency surged in 2020.

Ultimately, multimedia practices continue to evolve to keep pace with technological and social change, as they have proven to be particularly adept at enabling new conversations across borders and engaging new audiences near and far. Already the women studied here are emerging as pioneers, who even before the digital shift created by the pandemic employed multimedia practices as a powerful means of fostering dialogue, creativity, a sense of wellness, catharsis, empowerment, and as a tool of mobilization and activism. Multimedia not only helped them to "find the ways to say" but also *ways to do*.

*The editing of this volume and the writing of the introduction, like all of our work together to date, has been a 50-50 joint endeavor.

1

The Transliterary: The Novel and Other Multimedia Horizons Beyond (and Close to) the Textual

ANA CLAVEL

A PERIPATETIC BUT NECESSARY PREAMBLE

To be honest, I did not set out deliberately to reach the "transliterary." Instead, it occurred in a natural way. I have always been very visual: in my writing the importance of the eye and the look is essential ("The look is the erection of the eye," states Lacan). Also, many times, in moments of sterility or crisis, I turn to books with images and photographs: it is a way of freeing myself. I have been a writer since early childhood (I began to write at fourteen, and to publish aged seventeen), although my first lessons about stories were from a television program called *Galería Nocturna* (Nicht Gallery). There I learned how to build the framework for a structure which, later, in the Faculty of Philosophy and Arts at the National Autonomous University of Mexico, I discovered was a process described as *In medias res* (in the middle of things), in terms of chronology or retrospective. But I would say that, above all other definitions, I am a writer, because for me language has always had a constitutive register and rhythm, and I am a narrator and not a poet, because for me having a story to tell is paramount. But I feed myself on the visual, and when I am in the process of creation, while I am writing a novel or a story, I sense visual images within me that help me draw close to my literary discoveries. One example: when I was working on the novel *Las ninfas a veces sonrien* (*When Nymphs Smile*), I frequently became absorbed doing little drawings of droplets or leaves or petals which sprang up one at a time until they formed a gentle flow. The image turned out to be significant because the novel deals

with a contemporary nymph who from the first chapter declares that she flows like a fountain. That drawing later found expression in the silhouette of a statue that gave rise to the installation and image that appeared on the cover of the book: a sculpture of white alabaster that I bought in a garden center and which I modified by painting her lips with red lipstick, and sticking on petals from artificial roses which spilled down from her chest to her feet in a vermilion cascade.

The fact that, since Duchamp, the territory of the arts has broadened, enables people like me, who do not have the specialized tools of a professional or academic training in the field of fine art (I do not know how to paint or draw, for example), but who do have cultural baggage and a perspective based on their own creative and theoretical proposals, to dare to "intervene in," "manipulate" or "recreate" previous works, and to offer their own vision of literary work, via intermedial/transliterary intervention. But nor do I believe that these are mere marginal notes or paraphrases. Instead I consider them to be "extensions," or "branches"; other forms of writing that derive from the text or from the creative literary process and move toward more plastic art forms. I need not undertake this process, for the resulting literary work is, in itself, autonomous, and its quality is undeniable. However, I enjoy working on these different projects. In creating them, the facilities provided by new technology are important. For example, I do not need to know all the alchemical secrets of a photograph because the camera of a mobile phone solves, at the technical level, the requirements of balance between color and light in order to produce a good photograph. Nor do I need to know very much about the art of producing videos if I can make use of the Movie Maker tutorial to produce amateur and home-made films. My multimedia projects do not aim to be autonomous – they are derived from my books – nor to be professional, nor highly skilled, whereas I do take care to achieve those qualities in the literary work, and in responding to a dialogue with my tradition. That is the reason why, when faced with the proposal made by some that I am a "visual artist" (as did the publisher Métailié which published the French version of my *Violets are Flowers of Desire* and on the back cover presented me as a "writer and plastic artist"), that I distance myself from such labels. I tell them that above all other definitions I am a writer, and that, if anything, I am a writer who also devises multimedia projects on the basis of my books – which later I will refer to as "transliterature." If I had to choose, I prefer the term which the researcher Jane Lavery has used to describe me: "multimedia writer."

Now, although I like to experiment and dare to break through frontiers, I must point out that I am very aware that in these days of excessive amounts of information, of over-production in the supply of new book titles, which reminds us that the literary work is also a commodity, it seems to me that the "multimedia," the "transmedia" or, more specifically the "transliterary," offers

THE TRANSLITERARY 35

possibilities for attracting public and readers to the written work. As Graciela Martínez Zalce indicates:

> One thing that is important to highlight is the importance that media of expression such as performance and installations have for Clavel, as a moment of dialogue with narrative and as her own artistic interpretation, that's to say, as an appropriation, and the communications media like internet mean that the dialogue that she has established with the visual arts can be diffused and given permanence (since, in reality, both the installations and performance are ephemeral manifestations). (107)

Nevertheless, that form of diffusion and permanence also covers the written work, increasingly likely to be lost, regardless of the level of the project, among the sea of anodyne, commercial publications that publishers offer month after month on the new release tables.[1]

In *La cultura de la imagen*. (*The Culture of the Image*), Natalia Plaza Morales, reflecting on the matter, writes:

> The procedural fields explored by some current Mexican writers, who struggle to gain attention among the millions of authors who publish every year, also entail a change in the function and role of the spectator who becomes sharper and more dynamic, so that the reader no longer simply has the role of interpreting the contents of the sign, but must now also pay attention to other components that accompany the text which form part of the author's desire to innovate from the basis of the particular and the original, in order to find a formula that enables him or her to become visible. In this context, we have a generation of Latin American writers who combine writing with other artistic procedures (ready-mades, performances, happenings, photography…) and who implement freer, improvised techniques which lend fundamental value to a visual aesthetic. Through such methods, these writers manage to consolidate a far more combined and dynamic practice within the literary field. (*La cultura de la imagen*)

So, with regard to all of this, what do I understand by "multimedia"? I refer to "multimedia" in its broadest sense: "many media," despite the fact that culture today uses it almost exclusively to refer to the use of audiovisual and digital platforms. So, when I devised the multifaceted project based on the novel *Cuerpo náufrago* (*Shipwrecked Body*) – which included photographs in the book that afterwards would be taken from its pages to form a photographic

[1] In 2017, the publishing group Penguin Random House Mexico, who acquired the publisher Alfaguara in 2015, with whom I have published most of my books, had a total of sixty titles for sale in bookshops each month, including newly published works and new editions. This information was given to me by the commercial manager of the group, Jesús Grajeda.

exhibition in the form of a darkroom, an installation, and a performance in a cultural center, along with a public art intervention on the façade of a building and on 300 bus shelters in Mexico City – I could not think of a better title for it than *Cuerpo náufrago/Ready-made multimedia para bucear en la identidad y el deseo* (*Shipwrecked Body/Ready Made Multimedia to Explore Identity and Desire*) (2005). Rather than dialogues between literature and the visual arts – which are of course established – I consider these projects to be overspills. It all began with Duchamp's urinal and grew to the point of street art, because around that time I had seen the work of the visual artist César Martínez, who carried out several public art interventions using images which covered the façades of buildings in Madrid. Multimedia presented me with possibilities for expanding my work, to play and grow. As I said in an interview at the time, close to the events, I said "I am a phallic writer" (Sánchez 43). Of course, I was basing that on the psychoanalytical concept of the "phallus": the signifier of what we lack. So, jumping from the writing desk to other sources, I turned myself into a symbolic phallus to add to my condition as a writer. From that point onwards, with each book, I have presented a set of spin-offs of multimedia and the visual arts. The spin-offs have taken different forms: from the installation comprising the legs of mannequins and the sexualized cardboard dolls of *Violets* to the physical and textual off-shoots of *En todo corazón habita un bosque/Enramadas de el amor es hambre* (*In Every Heart There Lives a Forest/ Entanglements of Love is Hunger*). One case where I felt particularly free and creative was the multimedia work *Las ninfas a veces sonríen/5 rutas para explorer el misterio de una sonrisa* (*When Nymphs Smile/5 Ways to Explore the Mystery of a Smile*), not so much because of the periphrastic work of the artists who I invited to join in with the project, but rather because of my own incursion in to the creation of a sculpture and video projection of some lips – my lips – reading the second chapter of the novel, after a metamorphosis which grew from a beating purple stain to a red flower, to a mouth, all of it projected on to a synthetic quilt whose texture gave a strange, diffuse carnality to the image. Given that the novel deals with the sacredness of the contemporary individual, in a type of ever-extending vertigo, when it was near to the date for the launch of the book I proposed to the actress who was to accompany me in the performance for the inauguration that she create actions that would imply a "space available for any Goddess or God who wanted to occupy it," with a pedestal – a simple large box of white wood – and an explanatory sign with which the public who were present were invited to embody their real divine dimension. The pedestal and the sign remained on show throughout the time of the exhibition, so that the public could interact, go up to the statue and take photos with it. The security staff of the venue had instructions to permit people to do that and some of them even invited people to do it; that

is, to appropriate the space and play at being a deity of their personal paradise, which is an idea that is present from the first page of the novel.

Other possibilities in the modalities of reception can be added to these forms of interaction. One example is when, in the photo-video of *Love is Hunger*, I use *The Moldau* or *Vltava*, by Smetana, a movement from a flowing symphonic poem (*Má Vlast*) which, in the narration of the work, accompanies the moments of seduction between the novel's protagonists. It is a work that recounts the adventures of a modern day Little Red Riding Hood, who goes into the concrete jungle with her basket of desires and appetites. Another example is when I place the legs of a mannequin in the multimedia installation of *Violets*, with a suggestive message "Please Touch," and invite the public to dare to place their head between those legs, and peer through an orifice there that is like a peephole. Certainly, I am ushering the reader toward other horizons of perception from the basis of an object that is initially literary. Yet another example is when, in the public intervention of *Shipwrecked Body*, I showed passers-by in a busy area of Mexico City a large 8 × 12 meter canvas which had on it the image of the nude on the cover of the novel and phrases alluding to its thematic content: "Identity begins with desire"/"Who decreed that bodies should be prohibited?" It is not surprising that people stopped to look at the beautiful image from the book cover, as "in a city like ours, devastated by the prosaic language of daily visual violence – as well as other forms of violence – *Censorship is also a source*, the image in question, aimed to become a springboard for instances of art and the complexity of reflections around such questions as: Does identity begin with what we see? Or do we have to consider the possibility that identity begins with what we desire, that perhaps we are bodies imprisoned by our minds, and only when desire breaks free do we flourish."[2]

I know that in one way or another this phenomenon is happening more and more frequently with other writers. In Mexico: the novelist Mario Bellatin, with his performatic and photographic projects; the poet Rocío Cerón, with her demiurgic shows which involve video and music in situ; Verónica Gerber, with her duel between narrative and plastic art; Lourdes Meraz, with her explosive mini-fictions displayed on the blog http://www.microliteraturaka-mikaze.com/; or the poet Karen Villeda, author of the "poetronica project" and her cyber poetry laboratories. Elsewhere in Latin America: the Chilean Eli Neira, with her poetry and performances that are fiercely abject and desta-bilizing; the Chilean Eugenia Prado Bassi, with her multimedia novel-theater in progress, the Spanish-Argentine, Belén Gache, with her textual toys and digital platform; the Argentine Ana María Uribe with her hypertextual ludic

[2] Fragment from the leaflet that was distributed in the streets near to the event and which picked up on concepts and phrases of the novel *Cuerpo náufrago*.

concrete poetry. All of them start from a literary platform from which they develop their multimedia and hypermedia projects. They explore by seeking to expand the territories of the written word and the literary and poetic worlds to broader horizons, and in order to reach a wider public that also includes cyber-readers.

I will now give a ludic-philosophical overview of the particular theme of the novel and other transliterary horizons (multimedia and hypertextual/intermedial), from distant antecedents up to my own work.

WHEN WORDS ARE FALTERING, SOMETHING ABOUT THEM REMAINS INEFFABLE, UNCERTAIN, AND ANTI-WITTGENSTEINIAN

I want to begin this overview reminding readers of an image known to everyone: the black pages of *Tristram Shandy* (1760–67) and referred to as one of the highpoints in the tradition of rupture in the Western novel.

These black pages relate to the moment when Tristam Shandy narrates the death of his much loved and admired Reverend Mr. Yorick, alter-ego of Sancho Panza, on whose grave is an epitaph that is both a prayer and an elegy: "Alas, poor Yorick!" exclaims the passerby in the cemetery, and the reader who wanders through the novel's pages, through which, like a sorrowful and playful memorial, there appear these spaces of black ink ... and, of course, the first time that one encounters such an extra-literary horizon, one returns to the previous page to understand where the sequence of the text has gone, whether the printer has played a trick on us, or if we have fallen into an abyss of perplexity: the perception that perhaps the grief at the death of a friend cannot be better described than with a page of mourning black (the first categorical imperative of the hypertext with narrative roots: when words are faltering, something about them remains that is inexpressible, uncertain, and anti-Wittgensteinian).

When I review these visual games, which go beyond the text and the writing, I ask myself what Lawrence Sterne would do today, if, already in the middle of the eighteenth century, he dared to break from the written storyline in order to rebuke the reader who read him, or perhaps, on the contrary, who would not be capable of understanding the moral of those blacked-out pages, that were also the "motley emblem of the author's work." (It is necessary to understand the moral of the marbled page, or the motley emblem of the author's work.)

There is, of course, a strong sense of humor in all of this, which does not exclude the metaphysical, or to put it better, the pataphysical limits of writing.

1. The black pages of Laurence Sterne's *Tristram Shandy* (photograph by Ana Clavel).

2. Pages of Sterne's *Tristram Shandy* (photograph by Ana Clavel).

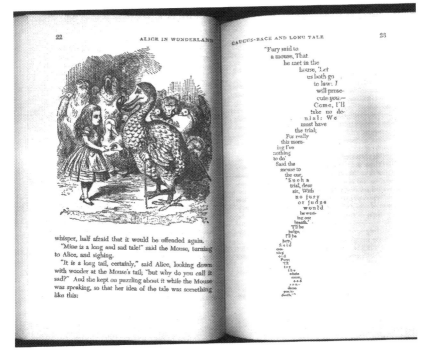

3. "The Caucus Race and a Long Tale" pages from Lewis Carroll's *Alice in Wonderland* (photograph by Ana Clavel).

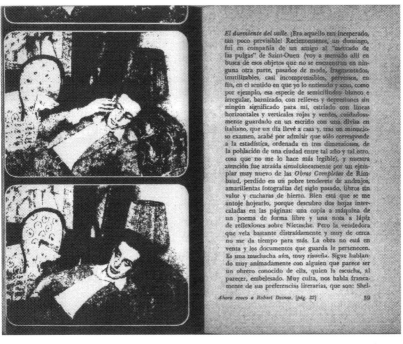

4. Pages of Robert Denos' divinatory art (photograph by Ana Clavel).

THE TRANSLITERARY 41

In fact, this last sinuous example reminded me straightaway of Lewis Carroll's "The Caucus Race and a Long Tale" (a chapter in *Alice in Wonderland*).

Without doubt, this is another example from textual narrative but one that skews clearly toward the visual. This tendency can also be seen in Apollinaire's *Calligrammes*, the *Topoems* by Octavio Paz, and the numerous examples of Brazilian concrete poetry, to name a few examples.

WHEN WORDS REFUSE TO ILLUSTRATE OR PHOTOGRAPH

In his "Surrealist Manifesto," Breton offers us a different perspective, when he tells us about one of the vital, "anti-literary" principles pursued by surrealism, that abhors description for its "inanity." In both "Nadja" and "Mad Love" he makes use of abundant photographs to eliminate such a description.

Why describe a drawing done by hand by one of the characters if the drawing itself can accompany the text, as with the postcard "The Lovers' Flower," which is drawn by Nadja herself? Or the strange photographs that Breton inserts, like the "Era of Dreams", in which he evokes the act of writing in dreams as shown by Robert Desnos and his divinatory art.

Here the second categorical imperative of the hypertext with narrative roots presents itself: when words refuse to illustrate or photograph and they are accompanied by images that alternate, complement, or suggest, like retinal painting.

Since the novel is the most multifaceted narrative form, it is perhaps not surprising that the likes of Octavio Paz and Julio Cortázar used it to venture into hybrid forms that we would now call hypertextual of the second type, as is shown in the labyrinthal "The Monkey Grammarian," by the Mexican poet and novelist, and also in Cortázar's stunning and iridescent "Prose from the Observatory" (1972).

WHEN WORDS BECOME BRILLIANT STARS IN A CONCEPTUAL CONSTELLATION

Clearly, in these hybrid and multidimensional fields, it is not easy simply to appropriate a categorical imperative and nothing else. Writers such as Winfried Georg Sebald suggest different discourses when they incorporate images in their novelistic iconotexts. Sebald draws upon the two categories mentioned previously, but also conceives of the work as a conceptual whole in which the text and image are interwoven in a multimodal and multi-experiential language, obsessive like its thematic concern: memory.

This gives rise to what I venture to call the third categorical imperative of the hypertext with narrative roots: when words become brilliant stars in a conceptual constellation in a post-Duchampian manner. Here, more than

in any other case, the number of photographic images, shots, engravings, and paintings included by Sebald exceed his previous projects and present us with an intensely focused, gravitational universe, as evident in the very drive of its content: the articulation of the being through the word and the image, what we express and what we see.

For those who do not know *Austerlitz*, or Sebald's novels, I ask you to take my word for it: the pages shown here reveal very little of the way in which this torrent of memory, language, and images resonate with the reader.

Under this heading I would also include Mario Bellatin's *Jacob the Mutant*, which makes use of a series of photographs produced in collaboration with the photographer, Ximena Bericochea, and which altogether made up a thought-provoking, abstract whole, which establishes an emotive and aesthetic distance between the text and the photographic image, like rivers that run in a parallel, alternate fashion, like two distant aesthetic discourses, whose beauty and relationship may or may not be established by the reader.

An example of a multidimensional project is that of writer Cristina Rivera Garza who has successfully expanded her work online. Her blog and Twitter account weave together networks of texts, in which the users intervene to construct a rhizomatic and haphazard text. In her most recent novel, *The Taiga Syndrome* (2012), she presents three multimedia modalities which extend from simple illustration (thanks to the work of Carlos Maiques) to a hypermedia project, with the suggestion of musical pieces in order to frame the writing, and the incorporation of visual media to substitute the actual writing, as shown by its peculiar colophon.

WHEN WORDS BECOME A POINT OF DEPARTURE, SHADOW UNIVERSE, ALTER TEXT, VIRTUAL WINDOW

Not long ago I was asked to write a piece about my relationship with literature and the image. I titled it, parodying a well-known publicity slogan in Mexico: "I am Totally Visual."[3] One of my first stories, "In the Corner of Hell," published in 1985, when I was twenty-three, shows a photograph, which is what the narrator of the story imagines when his fiancé, after they have searched together unsuccessfully for several weeks for an apartment, so they can get married, begs him to try again. The image that appears in front of the protagonist is something like the following:

But it was with my narrative venture, *Shipwrecked Body* 2005 – that story inspired by Virginia Woolf's "Orlando," of 1928, and which inverted its premise since it recounts the sentimental education of a woman who between the

3 The original phrase was: "I am totally a Palace," alluding to the Mexican department store *El Palacio de Hierro*. The article appeared in the magazine *Ciencia Ergo Sum*.

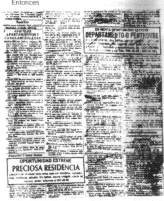

5. Image of a page of the newspaper *El Universal* showing adverts for apartments used in the short story "In the Corner of Hell" by Ana Clavel. Image courtesy of Ana Clavel.

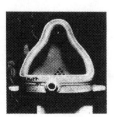

6. Image of a urinal from Ana Clavel's *Shipwrecked Body* (*Cuerpo náufrago*) (courtesy of Ana Clavel).

7. Image of graphic art related to Clavel's *Shipwrecked Body* (*Cuerpo náufrago*) on the building of the National Fund for Culture and the Arts, Mexico City (courtesy of Ana Clavel).

night and the morning discovers that she is in the body of a man – when I began to photograph urinals, and asked friends in other parts of the world to do the same. At first, I incorporated them in the novel:

However, shortly afterwards, the project grew and, between September and November 2005, we were able to mount a photographic exhibition, an installation, and a performance in the Spanish Cultural Center.

It also led to a piece of graphic art on the façade of the building of the National Fund for Culture and the Arts, which at that time was in the Zona Rosa in Mexico City.

From the very inauguration of the project, which I titled "Shipwrecked Body/Ready-Made Multimedia work for Exploring Identity and Desire," I placed a webpage on the Internet giving all the events, including a video recording of the performance with which we launched the exhibition.

But when I got on to the next novel-writing project, *Violets are Flowers of Desire* (2007 onward), I began to see clearly the possibility of a fourth categorical imperative of the hypertext with narrative roots: when words become a point of departure, shadow universe, alter text, virtual windows.

The exhibition had two venues: the Casa Refugio Citlaltépetl (a refuge for persecuted writers worldwide) and the building of the National Body for the Coordination of Literature, part of the National Institute of Fine Arts. In both displays, people could go up to a cabinet in the installation and peep through a spy hole, press a button, and see a series of images inside. They could do the same on the web page by clicking between the legs of the mannequin.

The Shadow Artist (*El dibujante de sombras*, Alfaguara 2009) followed, but without the production resources of the two previous novels. The grant I had

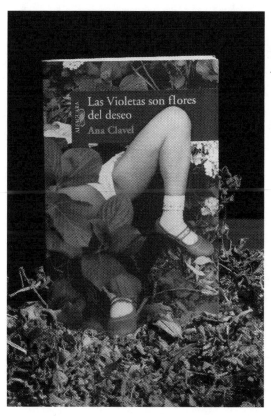

8. Cover of the Spanish edition of *Violets are Flowers of Desire* (*Las violetas son flores del deseo*) by Ana Clavel (courtesy of Ana Clavel).

from FONCA (the National Fund for Culture and the Arts) had been used, and as you can imagine artists need to eat like anyone else. However, because of the basic themes of the story, the drawing of shadows, the beginnings of photography, I decided to manipulate some engravings and daguerreotypes, and include them in the novel.

But I put together a small photo-video with images from the novel, which was available on YouTube from December 2009.

WHEN WORDS LEAP INTO OTHER MULTIDIMENSIONAL, HYPERBOREAN AND HYPERMEDIAL WATERS, AND THEY BECOME A SOURCE

So we come to the fifth categorical imperative which the mottled pages of my mind have worked to produce: When words leap into other multi-dimensional and hypermedial waters, they become a source. For the first time, before the publication of the novel in book form, I set up a video, titled *Las ninfas a veces sonríen* (*When Nymphs Smile*), with the first lines of

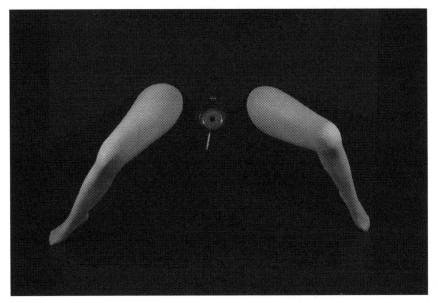

9. Image of the web page for *Violets are Flowers of Desire* (*Las violetas son flores del deseo*) (courtesy of Ana Clavel).

10. Image of pages from *The Shadow Artist* (*El dibujante de sombras*) by Ana Clavel (courtesy of Ana Clavel).

THE TRANSLITERARY 47

the manuscript and photos taken by me in Álvaro Obregón Avenue. The video has been on YouTube since October 2011: http://www.youtube.com/watch?v=3Vzn4Tjrm1E&feature=youtube=gdata.

In 2015, a book by Jane Lavery appeared in the United Kingdom, titled *The Art of Ana Clavel: Ghosts, Urinals, Dolls, Shadows, and Outlaw Desires*. As well as dealing with the literary work, Lavery undertakes the task of analyzing the multimedia dimension that has been integral to several of my books. In doing so, she employs the term "multimedia writer" to categorize the work of this writer, whose name I can hardly forget.

WHEN WORDS GIVE RISE TO OFF-SHOOTS AND OTHER TRANSLITERARY FORMS

The installation and video project *En todo corazón habita un bosque/Enramadas de el amor es hambre* (*In Every Heart There Lives a Forest/Entanglements of Love is Hunger*) emerged around the novel *Love is Hunger*.[4] Without aiming to provide a totalizing vision of the novel – since that is what the actual novel is for – the multimedia project extends, like the branches of a tree, some of the transmedial possibilities of the book which, precisely, deals with a modern Little Red Riding Hood who goes through the concrete forests with her basket, and her desires and appetites.

In the development of the story, Artemisa, the protagonist, discovers that, rather than there being defenseless little red riding hoods and ferocious wolves, in reality "In every heart lives a forest." That phrase is the point of departure for the multimedia installation, where in a space in semidarkness, canopies in the form of shadows are projected onto the spectators, enabling them to discover the forest as a personal experience. On the wall at the back, the video *Love is Hunger/Heart of the Wolf* is shown, having been created by the author with text from the novel and images alluding to a present-day Little Red Riding Hood, and *The Moldau* (*Vltava*) from *Má Vlast*, a river of turbulent water that rises in a forest in Eastern Europe, also referred to in the book. The projection of the video creates the atmosphere and context for the installation of canopies and shadows, which becomes what I have finally come to call a

4 The video "Love is Hunger"/"Heart of the Wolf" (*El amor es hambre/Corazón de lobo*) (VLC player format/4.07 min) was conceived and directed by Ana Clavel and the photographs for it were produced by Rosibel López and Ana Clavel. *The Installation In Every Heart Lives a Forest* (*En todo corazón habita un bosque*) was conceived and directed by Ana Clavel. The images were produced by Rosibel López, Gabriela Aguilar, and Ana Clavel. The project also involved the collaboration of the Museography department of the Tijuana Cultural Center and the architects Armando García Orso and Leobardo García.

"transliterary" work, and which – in the words of Verónica Maza – "open[s] wide the 'sub-doors' of the novel. Or go[es] beyond them. Or transgress[es] them. Whichever is the case, they enrich them."[5]

So, from this, there emerges the sixth categorical imperative: when words give rise to canopies and other forms of writing, or: the "transliterary." It is a project that arises from the book and which, extended to other media, continues to present other forms of "writing," or "transmuted" literature, aimed at a new public that can find its way back to the book and to a reader experience from the perspective of different media, and different audiovisual, plastic, performative and/or digital platforms. That is the case with the multimedia project *In Every Heart There Lives a Forest/Entanglements of Love is Hunger*, where the aim is to broaden into other forms of writing, canopies, or wooded zones. In the words of the journalist Verónica Maza Bustamente:

> Beyond the book, the journey continues for its creator, because the stories penetrate, live, whisper. The readers know it. They become owners of that world to which they would like to belong for longer. That is why Ana Clavel, winner of the Elena Poniatowska Prize for the Iberoamerican Novel in 2013, goes beyond her own writing, and offers a parallel experience through multimedia tools. ("La transliteratura de Ana Clavel")

Of course, my work could be categorized as being within the general field of intermedia, transmedia, and multimedia. But when I became aware of the term "transliterary," I thought, through that very name, of giving greater weight to the literary part of my work. This is especially because of the notion that, as a writer, what I am doing with my projects on diverse forms of inter, trans, and multimedia is continuing to "write" in other formats and platforms. So I now understand better why a critic of the visual arts like José Manuel Springer should speak of my "hiccups" in the *Shipwrecked Body* project, because he assessed the work as a multimedia project independent from the book, when those "hiccups" and all the madness of setting up the multimedia project with the central image of the urinals were, in reality, related to the fascination/obsession/fetishism that the character of Antonia has for urinals, which is an extremely important guiding thread in the novel. And that is why I have always been right not to consider myself a visual artist, but rather a writer who devises projects that are associated with, or derived from, her books; like a vision that reveals a process of creation that is alternative, connected like branches on a tree, and like a satellite moon that orbits the original source. I am speaking, of course, of what are strictly my own projects, not the paraphrases made by other artists that I have invited to participate as collaborators, translators, or

5 Verónica Maza Bustamente takes up information given by Ana Clavel in a press bulletin. Online version: https://anaclavel.com/index.html.

THE TRANSLITERARY 49

mediators, and who, in terms of diffusion, have enabled my work to have more impact and acceptance, since they lend it the weight of their names, creativity, and experience.

In their illuminating essay on the expansion of literature, Sánchez-Mesa, and Jan Baetens give the following definition which I ascribe to:

> Regarding the other key term, "transmediality", we suggest using it to refer to that fact that more and more works tend to appear in various media. The crucial word in this description of "transmediality" is "tend to": works that reappear (extended, rewritten) in other media. (9)

However, it seems to me that this really refers to the metamorphic nature of some of the most modern literature. But with "the transliterary," I would suggest and highlight the issue of the origin, and that, even in other media, my projects continue to be "transmuted literature." If it is true that every trans-literary proposal can in one way or another be considered "transmedial," not all work that is transmedia is transliterary. This is not simply because in my concept of the transliterary the book and literature are the point of departure and of return. Take note that I do not consider that my transliterary work is like the transmedialization that is "the mechanism or process that 'adapts' a work that exists in one particular media to another media" (Sánchez Mesa and Baetens 9). My transliterary projects *do not adapt*. Instead, they create a space which is not present in the novel; spaces of creative uncertainty, and that are "pre-intra-trans-verbal," and that find a new nonverbal, multimedia confor-mation.[6] There are also, of course, coincidences with the concept of "back to the book," but as I understand it, that term has more to do with the physical form of the book as opposed to its digital form. I am not concerned that those who participate in my multimedia work read my books on one particular platform rather than another, as long as they read me.

The installation for *Love is Hunger* is perhaps the most conceptual-emotional of the various multimedia projects that I have attempted: a forest of shadows

[6] In this sense, I have come to recognize, twelve years later, the critic Springer was right when he classified this multimedia experience as "links to a personal expe-rience": "By changing territory and combining the plastic with the literary, the masculine and the feminine, the literary, and visual art of Clavel draws back a curtain which makes us see what was previously invisible. We could say that we are dealing with something that is fortunate but not strange, which we have witnessed frequently: a foreign artist who discovers deepest Mexico, a poet who leaves verse and discovers poetry in the visual, and so on. Nonetheless, the combination of the novel with visual art (Umberto Eco's most recent novel is also the result of a com-bination of text and images) seems to me to be something unusual, that allows one to see the images from another angle, like links to a personal experience."

11. Image of multimedia installation *Love is Hunger* (*El amor es hambre*) (courtesy of Ana Clavel).

THE TRANSLITERARY

of tree canopies that suggest woodland projected on to the walls, the floor, and the bodies of the participants, creating an intimate forest of their own so that after interacting with the installation the participant recognizes that "in every heart a forest exists," as Artemisa discovers in the novel. Since at the back of the room one can see sentences from the novel projected onto the wall, I hope that the public leaves the installation with a desire to seek out the novel. The novel from which the space in semidarkness through which they have just passed arose. By happy coincidence on leaving the room where the installation was, that is, in the lobby of the Tijuana Cultural Center, they found the Educal bookshop where they could obtain a copy of the novel. But in a situation where such a bookshop is not available, what is important is that, after leaving, the participant, having been moved and deeply affected by the conceptual-emotive experience of the installation, looks for the book, even as an e-book, or at least Googles it. Other artists and collaborators could give other options and re-readings and translations. For me, what is interesting here is the actual proposal of the author, and their own but different vision that enables a more complex and complete reading of the original book, since it emerges from the same emotional core that created it. That is why there is less of the "transliterary" than transmedia, because in reality few creators maintain such a level of obsessional fidelity toward their own narrative-literary universe, and if they do transfer the verbal universe to other plastic or digital forms, they do so through an indefinable necessity for something that remains floating as a possibility in the original writing itself. It is in this sense that I speak of a return to the book, no longer as a source or point of departure, but as a point of return and of arrival.

CODA

We need to return to the marbled pages of *Tristam Shandy* and recall the words that precede them:

> Read, read, read, read, my unlearned reader! Read, – [...] for without *much reading*, by which your reverence knows, I mean *much knowledge*, you will no more be able to penetrate the moral of the next marbled page (motley emblem of my work!) than the world with all its sagacity has been able to unravel the many opinions, transactions, and truths which still lie mystically hid under the dark veil of the black one. (Lawrence Sterne)

2

Commentary on Fe/males: Sieges of the Post Human (Transmedia Installation)

EUGENIA PRADO BASSI

When I was 24 years old, I logged into a computer for the first time. From that moment I knew that I would never leave it. The key idea of this project was born from a personal experience that led to the writing of a text in a process that started four years before the launch of the work. *Fe/males: Sieges of the Post Human*, a transmedia installation, produced and presented by the Integrated Arts Collective, CAIN, was shown for the first time in the Galpón Víctor Jara, an arts center in Santiago de Chile.[1] It had twelve performances, each of which lasted one hour and five minutes, between January and February 2004.

This project emerged from conversations with the musician John Streeter Ralph, about the central idea of the text: the interactions between bodies and machines and how those machines fit in with our bodies in order to radically change our lives. We thought of a transmedia installation to develop this global project which would involve several disciplines in the arts. A raw exposition saturated with a new humanity, the project proposed putting texts at the service of other disciplines: performance, audiovisual images, music, sound, lighting, screens in combination with diverse technologies that would

[1] *Fe/males: Sieges of the Post Human*, Beca FONDART Artes Integradas, 2003. Government of Chile. CAIN: Integrated arts collective comprised of five artists with acknowledged careers and experience in their disciplines: Eugenia Prado Bassi, texts, design, and artistic management; Cecilia Godoy, scenography, performance, and choreography; John Streeter Ralph, original music; Marcelo Vega, audiovisual production; Antonio Zurita, machines and technology; Pamela Vargas and Christopher Zayago, lighting; Luis Grasso and Emiliano Thibaut, photography.

enable us to bring more enigmatic and experimental texts to the public. We invited Cecilia Godoy, an actress and ballerina; Marcelo Vega, an audiovisual creator; Antonio Zurita to be in charge of machines and technology and the rest of the equipment.

This is theater/novel. The text passes through the body of the actress, who memorizes, reformulates, and recreates it, incorporating her own knowledge and images. To the body are added words and audiovisual images which are shown continuously during the whole show, projected on to two screens facing one another on opposite sides of the stage.

The work began with a piece of choreography by the actress which took place under an enormous sheet of corrugated, transparent plastic that covers the whole stage area. Two spot lights above followed her movements at the same time as a video was projected on two screens located on opposite sides of the stage. "I hate my father. My father. Love does not exist. I hate those messages that are burned into the memory. Love no. My father no, nor my mother"; the video included images of fragments of bodies and embryos floating in water. The scene was completed with liquid sounds and background texts. It was accompanied by sounds of machines rewinding. Each scene was interrupted by *Black Out*/REWIND, before giving way to the next movement, adding to the sound, screeching, images, lights, and new elements. The words sought their own scene, the texts broke up and multiplied, they escaped the conventional framework of writing, by searching for new extra-literary spaces. Videos were interrupted by texts which interacted like cogs in a machine. The result was a collaborative endeavor. A hybrid figure interacted in front of the screens while at the same time a monitor projected images on to her body from above.

The emergence of ever more advanced communications and technologies obliged us to use screens. We adapted to the new conditions. The text operated as a travel log or register of a personal experience. Reflections, observations, and fictions, formed part of this process of accumulation on the basis of experiences and knowledge that continued to multiply at high speed before the mass entrance of bodies into the network, without return. The scenic features explored a mind determined by the productive and corporal exchanges in an environment of machines that are ready and specially tailored. The transliterary expression that comes out of these connections would continue to create an expansive project that would multiply to other spaces, but always return to the original source. Technologies and communications emerged and were projected against the body of the actress, expanding expression to other experiences. What was being sought here was to explore the interactions and tensions between human machines and new technologies and how those technologies continue to adapt to the new paradigm. The text proposed the deconstruction of the subject that emerges

COMMENTARY ON FE/MALES 55

between the real and the virtual. The mind becomes a machine producing senses, a flow chart, or a gear box. Adding, adding, and adding once again, one on top of the other, the texts and the screenshots. Desire is set in motion, becomes contaminated, and then persists.

We had to formulate the project, seek funding for five months of work, prior to the opening of *Fe/males: Sieges of the Post Human*. Transmedia operates as a type of linkage of elements, an assembly of functions, the text is a combination of writings on a body in movement. Liquid sounds. Images on screens, icons, figures of art, music, politics, revolution, all make up the conceptual machine. Live readings and music. On the stage of simultaneous action, the technology is an extensive prolongation of a body which adjusts itself to the new forms of exploitation. It is difficult to imagine that the world evolves under the power of a hateful father who seeks to install subjects reduced to merchandise. We are prepared without exception for survival. We live multiple identities, ready to change skin. We are fragments who have originated from conspiracies and connections of masses and fluids. Conditioned to minimal spaces, adapted for new stages, we mutate.

Fe/males: Sieges of the Post Human was a pioneering border-crossing project that sought out risk in spaces that were not defined by commercial codes in order to install a new psychic character which we would call "post human." In its unsettling presentation of a new humanity we have managed to develop a global project that involves several disciplines in the arts. On stage a world of saturated spaces is projected, watched over by satellites. Hyper consumption is added to the rapid market of time and money. There is a saying that "less is more," but in this case "more is more."

In the final scenes of the installation, the technology became more complex. A small digital camera placed on the head of the actress recorded the movements and expressions of the final scenes and that was reflected on the screens. The swarm of machines and screeching increased.

An attempt was made to show the end of humanisms, of a social culture, toward a concept of the individual as a personal enterprise, and toward new conceptions in the political economy, like the end of the salary era, of the unions, the growth of individualism and the installation of a political and cultural showcase, which is sterilized, conservative, and controlling as an apparatus of domination. It is almost impossible to scorn this great machine operated by a powerful group, where the rest of us are slaves.

We were seeking to appropriate the means of production in their present state of accumulation in order to capture signs and symbols of the highly innovative forces that in codified environments act by multiplying themselves and modeling the new subjects, and which are contained in the state of things and in words. We are conditioned to fear. A finite world occurs around us, collapses or is destroyed from one moment to the next, at great speed. Threats

grow. Fear paralyzes us. It is what we have in common; the fear that, sooner or later, life finishes with us, or collapses. From a distance, or from above, you can observe the ant nest of human beings moving at maximum speed. Information circulates through an enormous organism that in some parts gets sick and in others revives. We are human technologies. We operate in multiple form. The amalgam grows like an enormous chain of uncomfortable groans. Ultra-connected with the solitude of others, we continue to learn about all the disasters: over-exploitation, devastation, and squandering. And if we are referring to oxygen? Or to water? Or to disappearing in the explosion of a nuclear bomb. Fear grows and overwhelms us. We live under the threat that dark forces controlled by a few continue to exploit the great productive mass of the whole world. A decomposing planet circulates on the screens while we become accustomed to living with horror and barbarity. Informed via the screens about how the world operates, we learn to observe and better understand the processes, to modify our habits and foster new forms of online communication.

In all these years, *Fe/males: Sieges of the Post Human* developed into *Sieges*. It is the desire for writing. A construction of the subject to be recognized, protagonist of the human experience. About to mutate into cyborg, wired bodies, connected and hyperproductive, conditioned and obliged to resist the explosion of technologies and communications in the body while we learn to operate surrounded by screens, deep within the world of computers. The street versus the closed space. To evade the exchanges with other human beings until dispensing with the body, the collapse of humanism for a technological, cultural, charitable capitalism. Offers and gifts, that are the surpluses of business, collusions, or tax avoidance by the big firms and corporations, the same organizations that control the world's economies.

In 2005, John Streeter Ralph presented *Fe/males: the Music*, a disk with original music, that includes two videos and a booklet with texts and some images from the staging.[2] After that staging, blogs, and videos from this project appeared on YouTube, and they have been added to with other media: Facebook, Instagram, Twitter, Google +, and so have continued to circulate through the net. In 2017 the multimedia project was presented in the thirteenth Biennial of Media Arts, in Chile's Museum of Contemporary Art. Then, in 2018, "The Multimedia Works of Contemporary Latin American Women Artists and Writers" formed part of a conference at Winchester School of Art at the University of Southampton.

Words spread and disperse in an exercise that operates through excess and accumulation. Language adapts and seeks to establish connections. The

[2] In 2005, "=*Hembros: the music*" obtained the annual grant from the Chilean Government's National Council of Music for the creation of the disc of original music by John Streeter Ralph, which is the only material record of the project.

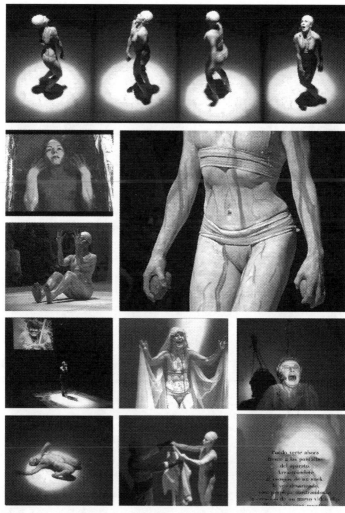

12. *Hembros: asedios a lo post-humano, novela instalación/Fe/males: Sieges of the Post Human, Novel Installation.* Santiago de Chile 9 January 2004. Galpón Víctor Jara.
Image courtesy of Eugenia Prado Bassi.

circulation of ideas is possible, and communication instantaneous. The flows or crossovers with which the diverse contents are permeated or drawn together originate expressions and an explosion of texts and creativity. The abyss of overload is also a way out. "An empire of mechanical brains precipitates our images […] we are types of automatons, a sick species created as a location for the horror."

My literary project seeks autonomy, especially for "us," the women, so that the net serves as support for the modification of the state of things. Unlike the father, I seek to make zones available where my malformed creatures can move.

What interests me are the flows, the body-machine interface, identities in construction, sexuality in such a process of irreversible decodification; the cyborg, the technologies, and networks, and communications. In under a decade everything has happened on the screens. We ourselves, repeated and serialized, are a great Internet that is multiplied. My texts seek to spread to other media and formats. My work consists of systems of staging that enable me to assimilate these changes, taking into account that content and knowledge, whether correct or not, according to where the sources come from, proliferate and continue to multiply. One simply imagines, and almost all that one thinks floats in the space of the Internet. And everything happens at high speed as the same Internet shows us how "unoriginal we are." I seek to explore multiple genres. Language diversifies and puts the dominant powers into play and into a state of tension. We can replicate ourselves, serialized and monotonous, be empty identities in a postmodern world, rightly observe and live the changes, even express an opinion or be protagonists and take decisions or make choices that were unthinkable centuries ago. Today's aesthetic is repetition. We are small windows through which the fabric of humanity breathes. Trained, lost, doomed, we move forward as if common sense could be multiplied, because if something is installed by force today it is something personal, the need to show life itself as an event. Information expands, extends, or connects. We confront cyberspace as our organism swallows up everything, and devours it, as it entertains itself.

I am what we are. Broken bodies, that are contaminated and which contaminate, perforations in the ribs of the debtor who regularly harbors hatred. I write against words, from desire, outbursts, and contamination.

Faced with the terrifying panorama of the global crisis, of a capitalism necessarily in flight, in a market of simultaneity and knowledge that spreads toward the frontiers of culture and language, we use the same technologies designed to control us as an escape from the hatred and domination of the great neoliberal prison that inhabits and conditions us.

3

An Anthropophagic Ch'ixi Poetics

ELI NEIRA

My work is an open question concerning identity. What does it mean to be a woman, neither heterosexual nor homosexual, neither white nor indigenous, neither rich nor poor, with no children, a feminist, a writer, performance artist, ecologist, indigenist pro-indigenous and pro-developing world, living and working in Latin America. I'm interested in untangling the dark side of that history: my history as a daughter of the military coup in Chile, born in that fateful year of 1973, and the history of Chile as part of the history of violence of this century and of this world.

My work is a sort of travel blog log for a body – a territory colonized by ideologies, religions, failed and contradictory political practices, with an ancestral and rebellious memory which refuses to be blotted out. In this journey, it is art and the dialogue between disciplines that has been the best tool for disentangling, understanding, and decolonizing this body, like a minuscule work of personal archaeology.

At the formal level, my work is composed of layers and layers of knowledge and practices that at some moment have come to me, reached me, through channels that are as diverse as they are apocryphal. Like a hungry anthropophagic animal, in the style of Oswald de Andrade, everything nourishes me, everything is useful to me and can be turned into a work of art. The result has been the construction of a Ch'ixi or "sullied" mestizo identity, a compendium of impure attributes and hybrid techniques. Nevertheless, I recognize in poetry an impulse to put everything in order. Like an axis or a vertebral column, the desire for poiesis is the driving force for my work.

Outside the academic world and outside the market, as an artist I've had to find my own way without clear direction. This path has been intuitive, autonomous, and political. A productive state of being which has allowed me an inordinate freedom to transform the sense of lack into a creative resource.

13. *Variations of a Biblical Gesture* (*Variaciones de un gesto bíblico*) (2016). Photo: Alejandra Montoya. Image courtesy of Eli Neira.

I am interested in art as construction of a utopian imaginary. A social experiment that leads me to new ways of relating to the world. I am someone who believes that change has to be cultural or it will not be change at all, and I am also someone who believes that art is the last refuge of humanity in an increasingly dehumanized world.

According to the Bolivian sociologist, Silvia Rivera Cusicanqui, Ch'ixi identity corresponds to that "impure" condition resulting from *mestizaje*.

SATURDAY 3 DECEMBER 2010 VARIATIONS OF A BIBLICAL GESTURE PART 1

As part of the Festival of Intraprison Art, organized in the Valparaíso Penitentiary Complex, I carried out a performance with the inmates of Unit 102 for men. The intervention involved washing the hands of those who agreed to participate. The first refused, but the second accepted, and the gesture rapidly caught the attention of all those present. The washing of hands with reference to people who were imprisoned and had been condemned, and as a political metaphor that all could understand, all could read, became an action with a deep emotional connection. At one particular moment one of the inmates

asked me if I would let him wash my hands. It was a very emotional moment, when both those who wanted to participate and those that did understood the message and were able to transform it: https://www.youtube.com/watch?v=A07x7CxttV4&t=25s.

PERFORMANCE, URBAN INTERVENTION: YOUR HOMELAND IS FULL OF RUBBISH (2017)

14. *Your Homeland Is Full of Rubbish* (*Tu patria está llena de basura*) (2017). Photo: Jim Delemont. Performance by Eli Neira and the feminist collective AMAPU, Las Amazonas del pueblo. Image courtesy of Eli Neira.

INFORMATION EXPLAINING THE CONTEXT OF THE PERFORMANCE

Your Homeland Is Full of Rubbish was the first public action carried out by the feminist collective AMAPU (The Amazons of the Port). Here we collected the rubbish that had accumulated on the beach of San Mateo, on 19 September, which is the day when naval triumphs are celebrated in Chile. Singing a hymn of love to the earth, we collected a huge quantity of waste from the place, which also serves as a training ground for military personnel. The rubbish was placed on a canvas sheet decorated with the national colors, which we carried in a procession through the streets of the city up to the Naval Building, where we left it, as a clear gesture of repudiation of the armed forces' pacts of silence, which prevented justice being achieved in Chile for the crimes against humanity committed during the dictatorship: https://www.youtube.com/watch?v=-vq6MGTbbU&t=5s.

PERFORMANCE: NUNCA SALÍ DEL HORROR PARTE 2 (2008)
(I NEVER OVERCAME THE HORROR PART 2)

15. *I Never Overcame the Horror* Part 2 (*Nunca salí del horror Parte 2*).
Photo: Perrera Arte 2008. Image courtesy of Eli Neira.

INFORMATION ABOUT THE PERFORMANCE

In the performance I pulled the national flag out of my vagina while Lucrecia Galvez sang a modified version of the national anthem. The work took place in the rooms of the building that was formerly the kennels for stray dogs, run by Santiago City Council, and the name of the performance is taken from a poem written by the poet Enrique Lihn during his exile in Cuba, https://vimeo.com/44468048.

4

My Relationship with Artistic Creation Began with Words

REGINA JOSÉ GALINDO

My relationship with artistic creation began with words. A little girl's words in an innocent diary in which she wrote about the changes taking place. My adolescent diary began to turn into a notebook of poems. The poems started to become illustrated and I would hang them on my bedroom walls to decorate it. My way of escaping from home was through reading. My mother took it upon herself to bring me the books that I asked her for. *Steppenwolf* was a good present. Ernesto Sábato, Alejandra Pizarnik, Giaconda Belli, Ana María Rodas, Julio Cortázar, Jaime Sabines, Elisio Subiela, Albert Camus, etc. I used to work for a newspaper, and I got to know some poets, Juan Carlos Lemus and Sergio Quemé, with whom I published for the first time, in 1997. Then I did a poetry workshop with Bolo Flores (Marco Antonio Flores) and there I lost my fear. Several months went by, then a couple of years, and I began working in an advertising agency and I got to know my friends who would introduce me to the world of art. Jessica Lagunas and María Adela Díaz, both designers and artists. I am not an artist; I write poetry and some short stories. They invited me to participate in an artistic event, gave me books, and I got to know artists. Ana Mendieta, Gina Pane, Burden, etc. etc. etc. I suppose I found myself a crossroads. I had desire. I had things to say. I had ideas and I had the body with which to express these. I did my first performance in 1999, which was a type of poem in graphic form. *El dolor en un pañuelo (Pain in a Handkerchief)*. That was followed by *El cielo llora tanto que debería ser mujer (The Sky Weeps so Much that it Should be a Woman)*, and then came the performance *Lo voy a gritar al viento (I'm Going to Shout it to the Wind)*, where, in fact, I read poems that the public cannot hear. Gradually, the paths separated: I carried on working as an artist. I left advertising and

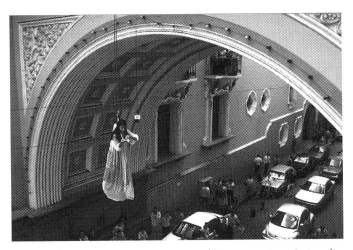

16. *I'm going to Shout it to the Wind* (*Lo voy a gritar al viento*) (1999). Image courtesy of Regina José Galindo.

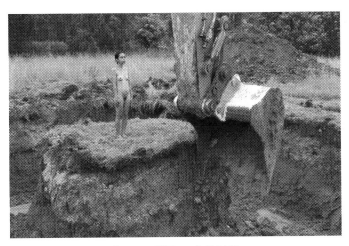

17. *Land* (*Tierra*) (2013).
Image courtesy of Regina José Galindo.

the job of sitting down and thinking up my own projects became part of my daily routine. Poetry is still with me. Generally, when I plot out my works I do so via poetic texts. Poetry continues to permeate my life and my (artistic?) production. The obsession for polished work, working to get rid of what is not required, everything that is surplus, comes from poetry.

EXTRACT FROM TEXT ACCOMPANYING THE PERFORMANCE *TIERRA (LAND)*

How did they kill people? – asked the public prosecutor.

First, they ordered the operator of the machine, officer García, to dig a hole. Then they parked the trucks full of people in front of the place they call El Pino, and one by one, they passed in front. They didn't shoot them. Often, they bayonetted them. They tore open their chests with the bayonets and carried them to the ditch. When the ditch was full, they let the mechanical digger cover the bodies.

Over the course of thirty-six years, Guatemala lived through one of the bloodiest of wars. A genocide, that left over 200,000 dead. The army that was fighting against rebel forces defined the Indigenous communities as enemies, alleging that they sympathized with the guerrillas, and during periods of brutality they focused on persecuting them. With the intention of keeping the land (and with the national oligarchy complacently watching on), and with the justification that the Indigenous communities were the enemies of the nation, the State put into practice a scorched earth policy. This was a common practice and a characteristic of the Guatemalan armed conflict. Army troops and civil defense patrols would arrive at the Indigenous communities and destroy anything of value for their survival: food, clothes, harvests, houses, animals, etc. They would burn everything. They raped, tortured, murdered. Many corpses were buried in mass graves that today form part of the long list of evidence that confirms the facts.

The testimony above recounts one of the ways in which the army made mass graves before murdering people and throwing the bodies into them, and it was heard during the trial for genocide of Ríos Montt and Sánchez Rodríguez. Guatemala 2013.

5

imagetext

CARLA FAESLER

Poetry

has more to do with processes of thought
than with literature, says Emmanuel Hocquard.

In how many ways can thought be represented
as an associative process
of images, sensations and concepts?
The literary does not only exist in verbal language,
although that may be its primary material,
as Roberto Cruz Arzabal has written.

The literary, the poet and essayist proposes,
is the movement
of a variable and flexible set of objects that
activate, contain or modify the texts
and the practices surrounding literature.
My work is an assemblage of texts and images
created with this mental perspective.

in my writing there are ghosts
… and the screen is where they appear.

This ectoplasm that at one time emanated from objects: books, paintings, sculptures, CDs, posters, musical scores, radios, galleries and libraries, bookshops, cars and boats, staircases, countries, mountains, and people.

windows opened simultaneously: visual combinations:

Rembrandt and emoticons.

mixtures of sound, voice, noise, pop and symphonies, harps and tins.

A tangled web of forms and styles:

journalism and self-help, Sor Juana, Juan Gabriel, James Joyce, Amparo Dávila, "If you love someone …," and Szymborska. Salvador Elizondo, Buddha, "Things you cannot miss out on," marches and traffic. Sensationalist crime news. "A man gave a beggar something to eat, what happened next …," the Witold Gombrowicz Congress begins, Susan Sontag, "A polar bear wanders through the streets and the Underground in London," Review, the best books, videos, wines of the year, "We are beings of light," #Ayotzinapa.

———————————

virtually ambidextrous

and if the real great step for humankind

was taken when we began to write with both hands?

Now that I remember that someone used to say "I'm left-handed," or "they are right-handed," I feel a sense of surprise. I see way in the distance those left elbows across the school desks, those right elbows suspended at the side of the tables, and I think, also at a distance, of those days when I used to practice my writing and use of words in notebooks with a fountain pen or a pencil. Therefore:

pen and paper = (Enter) = laptop.

And I could say

that from the moment I started to use both hands to write,

something joined up, it fitted together, and did it all connect?

balance

do you feel how the hemispheres,

the cold/hot, good sense/delirium,

above/below, become fused together,

like when that which shines, at the same time becomes opaque?

Like a cog in a machine

(I cannot remember how my life as a pianist was

before we began to write with both hands)

IMAGETEXT 69

image and text are ways of reading

————————————

I

is the only

image

that I have of myself

————————————

I go around with my mouth blind and my eyes dumb

————————————

A screen of my own,

A screen of my own

I search for an office near to www.wordreference.com

and to all the unconventional grammars.

Truth be told, the voluminous dictionaries stayed for a long time on a table next to my desk. One on top of the other, beautiful dictionaries,

with hard covers, pretty spines, like boxes with so much inside and yet to be opened,

until they disappeared.

The screen is the study of the mind, the corrections, the proofs, the editing, the design, the printing in your imagination. The screen and its instantaneous typographic ordering, its editing of the image, its instantaneous cover, its instantaneous page numbering, its instantaneous adjustment of color, light, shine. That's what would be seen, that's what we are going to see: instantaneous image/book:

Everything was so clean from the beginning,

it's not always necessary to say "no" to the instantaneous.

The world of things has disappeared and now its ectoplasm

(a luminous fluid that's seeped from orifices and pores

that can take any form)

is what contains me.

For a long time now I've only been able to read in a fragmentary, non-linear way, and

above all, different texts simultaneously.

The screen is a zone which invents itself, and lives in you.

It lives in the body of the person who writes.

one writes with the body, that modem of flesh

"An image is worth more than a thousand words"

They asked Marguerite Duras

if she agreed with the thousand-year-old Chinese proverb.

"No" she replied "a word contains a thousand images."

The writer's stroll is a few minutes on vimeo

The ritual of the writer is to revise their twitter account before opening word

The ritual of the writer is to first wipe out the search history

The whisky of the writer is to open thousands of tabs on google

The whisky of the writer is an hour of netflix

The whisky of the writer is half an hour of porn

The whisky of the writer is half an hour of trailers

The whisky of the writer is to write to everyone a "hi what R U doing?"

The lectern of the writer/reader is scribd

The lost gaze of the writer in the landscape is lost in fb

The inspiration of the writer is ubuweb

The aspiration of the writer is to never use an emoticon

The aspiration of the writer is to type and type and beat the screen, so it never switches to stand-by mode

The glasses of the writer are the zoom in

The re-reading of the writer is the zoom out

The introspection of the writer are their earphones

The writer's study is the street

———————————

the screen is a zone that thinks to itself

and in that understanding there rises

like in the connection that enables discernment

the mystery

6

Voices/Bodies

MÓNICA NEPOTE

> "Is not the voice always already intervening, as a sounded body that searches
> for its place, one that projects forward to incite response? An intervention
> with great resonance, and one lodged within the power dynamics of particular
> structures – linguistic, familial, pedagogic governmental etc. A voice that is
> subsequently often overheard, underrepresented and interrupted."
>
> Brendon Labelle

I don't write structured poems.
That's what I said, responding to a certain question the other day.
It would be arrogant
I thought.
No. I don't write structured poems because I am
investigating writing and the body
Not starting from writing that speaks about or reflects upon the
body.
I write from the body
and that is, in itself a question, not a certainty.

Some time ago I began to feel that that the practice of writing was a process
that was becoming too intellectualized, it's not that I did not recognize the
value of that
but it was not what I thought about/or searched for/or was inspired by.
It's not that I want to be new, no one is new (although, paradoxically, we
are new, because all of us are a body that grows old, some are female bodies
[some female bodies have been raped, and bodies of all genders have been
disappeared]).
How can we fix writing if nothing is fixed and life has the tendency to disap-
pear in a political system in which it is Not life but death that governs.

We cannot speak of language without language, we cannot think of bodies without bodies.

Voice is my writing, subjectivities, technologies of the self, yes but the construction of the voice, questioning.

That exploration has led me to use technology such as recording surfaces, loops, blurs, voices that are duplicated, obsessive ideas, tones of the voice that I want to use as material, without meaning or words just sounds, a voice not exploited by being put in order or given meaning. In that sense I have felt my body, I have positioned it in the center of the space in an act of remediation. The writer, male or female, is alone when they write. Are they alone? That act of writing has a body that is then rubbed out. My practice in *My Voice is My Shepherd* meant: putting the body at the center, as the theme, as the source (first I moved and then I would write) and once the text existed, I inverted the process: my voice was the text and in turn my body made writing.

Many things happened, fears happened, doubts happened, resistance happened. But what also happened was the body moved to the center, moving as occurs in typography. It happened that

I wrote with the body and that fact made me return to it, to my body, to resignify, to rewrite.

That exploration has led me to receive invitations of another kind, to produce audio recordings, to collaborate (with visual artists, sound artists) to explore the tools of the trade, to think about software (the hardware is my body).

I worked with Gabriela Gordillo as part of a series of work organized by Fernando Vigueras called "Articulations of Silence." Gabriela is a designer and digital artist. She works with sonic interfaces and conductive ink. My participation consisted of the reading aloud, the voice. We talked little about it, but we worked on it a lot. I took various audio recordings which I had done during the last five years and, with the help of Vigueras, we assembled sound landscapes, we talked as well and produced new audio recordings, and we reflected on writing and its physical medium, alphabets, and sounds. I spoke about my sister without language, or with another language, not a standard form, and we recorded, we cut, and we pasted.

And we produced, we produced sounds, and we drew with conductive ink interfaces, we made noise and we asked ourselves why it is that the ear and the body react when there is dissonance, when there is a lack of fixity, and non-writing is affirmed as writing.

7

Redefining Meaning: The Interweaving of the Visual and Poetic

PILAR ACEVEDO

I am a visual artist who creates multimedia work mostly consisting of assemblage, collage, oil painting, and poetry in order to give form, voice, and witness to those whose pain has previously been suffocatingly entombed. My themes involve child sexual abuse and domestic violence, and I explore them through transmedia storytelling inspired by childhood memories, thoughts and perceptions, vintage photographs, and objects, unsettling human interactions, and literature. I interweave visual and written art and often use found objects whose meanings I redefine. Although my work recurrently tells stories of trauma, my intention is not to be shocking or harsh; it is simply to engage viewers and help them understand that which needs to be "heard." In this way, I take that which was hidden in darkness and reshape it into that which calls out to be seen.

Childhood memories are frequently key elements of my work and are most evident in my collages and assemblages, predominantly through the use of found objects such as drawers, viewers, and boxes, which I typically find in antique shops. I also employ personal nostalgic items and old family photos from my life and that of my parents during our time in Mexico City. My collages and assemblages are created using paper, poetry, and sometimes sound in an effort to draw the audience into a multisensory interaction that provokes thought, emotion, and perhaps action. The work on canvas and paper conveys "memory as layers" through the use of multiple glazes and the overlapping of paper and images.

Because collage lends itself to the fantastical, I work in this medium to produce fantasy-like narratives. By allowing my imagination to run freely, I am able to weave together a visual story – merging characters from vintage photographs and old Western civilization books with organic images from

18. *Spider Princess*, February 2012. Oil on canvas, 213.4 × 137.2 cm. Image courtesy of Image Group Photography.

biology and botany textbooks. As with the found objects I use in my assemblages, vintage photographs, and images from old textbooks are removed from their original context, placed in a different context and thereby redefined or recycled to tell a distinct story. In this process, the newly defined visual narrative comes first, and then the written narrative evolves. Such was the case with my oil painting, *Spider Princess* (Fig. 18):

> As a result of a magic spell cast by the Gray Witch, the Spider Princess sprouted from a flower – part spider and part human. The king, her father, declared her the "Spider Princess" and gave her dominion over the gray people. Sadly, she did not understand nor love them because they were a heartless people – colorless and empty. So, one by one, she punished them for their acts of cruelty, hoping that they would change their ways, yet they did not. In fact, their hardheartedness worsened, and as time went on, she began to change little by little until finally one day, she became like them.

Written work, whether mine or that of others, can serve as a springboard when creating a painting or an assemblage. Conversely, during the creation of an assemblage or painting, the piece itself may inspire me to write a poem. In either case, that poem is incorporated into the visual art, thereby expanding the meaning of both visual art and literature by means of transmedial dialogue. My assemblage titled *Heaven Bound* was inspired by Paul Laurence Dunbar's poem, *Sympathy* (1899) – specifically the last stanza.

19. *Heaven Bound*, February 2013. Mixed Media, 58.4 × 55.9 × 30.5 cm. Image courtesy of Image Group Photography.

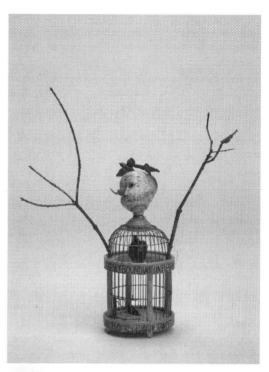

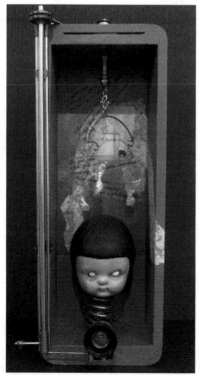

20. *Intangible Sweetness*, February 2011. Mixed Media Assemblage, 33.7 × 12.1 × 11.4 cm. Image courtesy of Pilar Acevedo.

My initial intent was to merely "respond" to the poem by creating a three-dimensional piece of art; however, the creation of the assemblage also led me to compose a poem, which was then integrated into the piece. Each of my responses – the visual and the poetic, gave Dunbar's poem new meaning or took it to another dimension. Consequently, this transformation, which sprang from another writer's poem, could be viewed as transmedia storytelling as is the case with other pieces I have created, including *Intangible Sweetness* and *Naughty*.

As you can see, the poem that I wrote differs from Dunbar's last stanza. My poem was written around the circumference of a small birdcage that I purchased at an antique shop because it reminded me of the female form. It reads: "Bound within flesh, metal, wood, and blood, / my heart beats to give me existence. / Oppressed by the stain of this thing called life, / my spirit reaches heaven, bound in song."

The transmedia storytelling did not end when I completed the assemblage. While reviewing photographs of *Heaven Bound*, I happened to notice that she appeared to be dancing as I reviewed the photos by flipping from one picture to the next – thus animating the piece. As I did this a few times, changing the speed with which I flipped through the pictures, I began to sense a rhythm in her dance and thought of Leonard Cohen's song, *Dance Me to the End of Love*. I then created a short video of her dancing to his song, thus giving *Heaven Bound* another meaning: http://www.pilaracevedo.com/blog/category/heaven-bound.

The catalyst for my assemblage, *Intangible Sweetness* (Fig. 20), was the tragic story of a female personal acquaintance, the verse "while visions of sugarplums danced through their heads" from *The Night Before Christmas,* and three words that repeated themselves in my head – "Little girl face." While constructing the assemblage, the poem unfolded:

> Big girl face,
> little girl soul
> Wallowing in distant sadness.
>
> Muted mauve mist,
> dingy dustless tomb
> burying her dolls and innocence.
>
> Big girl face,
> little girl soul
> searching for intangible sweetness.
>
> Hazy glass pipe
> crystal rock candy
> forgetting – for a fleeting hour.

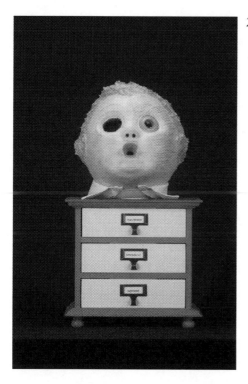

21. *Naughty*, October 2004. Mixed Media Assemblage, 53.3 × 29.8 × 22.2 cm. Image courtesy of Image Group Photography.

Muñeca Pelangocha, also known as *Naughty* (Fig. 21), differs in that it is the manifestation of a poem I originally composed from a collage of Spanish words – some "Mexicanismos" ("Mexicanisms") The first two words that gave flight to the poem were "metiche" and "chismosa" – I found their crisp sound appealing. And so, I added **ca**chivaches, **cu**chicheo, berrin**ches**, **chi**flada, **chi**flete, **chi**spa, pelango**cha**, etc. and a poem emerged and became *Muñeca Pelangocha*'s tale. The assemblage was created and then the poem was loosely translated to English and written on *Naughty*'s face to appeal to an English-speaking audience.

Naughty

> In her swelled head
> crawling with the itch
> of her trash and whispers
> the naughty doll
> murmured.

> And what of my tantrums –
> and what of my truths?
> I know I'm not wicked –
> just honest.

Polished, combed, and starched, she knew
because she was a nosey tattletale,
a good beating she was given
and thrown against the walls.

And in this house dismantled
Tossed on this floor,
faltered, trembled,
and whispered –

Is this my guardian angel,
or monster –
are these my saints, or demons?
I don't know and it does not matter.

Without hope,
without an audience,
bleeding and full of snot,
in a corner she slept.

Like a conch in water,
she dreamed she was wandering
pantiless, crying
gurgling bittersweet.

Chasing a firefly
and letting it flee
because it gave no spark
and spark it no longer had

Over the years, I recorded pieces of my memories of my family's migration to the United States from Mexico. This eventually led to a series of vignettes titled *Al Norte in a Pink Cadillac* and consequently, I have begun a series of paintings based on these vignettes – multimedia pieces will also be included and thus, the storytelling will continue. Because I was only four years old when our journey north took place, my recollection is fragmented, as I mention in one of the vignettes:

> … The trip across the desert ends abruptly as a filmstrip of an 8-millimeter projector when it jumps to the next frame …

I am drawn to this fragmentation and muddied view of memories because it creates a skewed reality and singular perception that is, in my case, uniquely a "child's-eye view."

I believe that art and creativity are not limited to literary, visual, and aural work. Art can also be a tool for learning. So in addition to my work as an artist, I developed and received funding for a program called *The Art Alternative* to

provide instruction to "at risk" preschool children in a Head Start program. This time using techniques originally intended for visual art, I created instruction in academic subjects such as Math, Language Arts, Science, Geography and History. After nine weeks of instruction, the children who participated in my program not only learned the various academic skills and produced beautiful works of art, but also developed self-esteem, listening, and verbal skills, and greatly improved fine motor skills.

In the end, I consider ALL my work to be narratives. I am compelled to tell a story – mine or someone else's – many traumatic, some sweet, but all important and worthy of telling.

8

The Territory Is Home

GABRIELA GOLDER AND MARIELA YEREGUI

> [...] but in the presence of place there can be no subject other than a bodily
> subject capable of possessing habitus, undertaking habitation, and expressing
> the idiolocality of place itself. (Casey 689)

In 2014, we began to work on the project *Escrituras* (*Writings*), http://proyectoescrituras.net/, a work that took the form of a theoretical exploration and creative experimentation around the concept of territory, with the objective of generating polymorphous reflection: a platform of collaboration and exchange, a sample-essay, a trial, work, a theoretical and academic production.

After an open call for projects – "Buenos Aires site-specific" – by the government of the city of Buenos Aires, which proposed interventions in five places in Buenos Aires, we decided to devise a proposal for the space in the district of La Boca, which was subsequently selected to be developed and implemented.

La Boca is a space that throughout its history, with the arrival of immigrants, has been in permanent tension. Today, it is a district in which conflict persists because of the diversity of the social groups that live there: disadvantaged areas exist alongside middle-class areas and, more recently, high society. Highly eclectic and heterodox, it is an area which at present is being transformed because the land there is very valuable and, as a result, there is a whole sector with considerable wealth that now looks at La Boca as a place for investment. As in all gentrified areas, that process implies implicit and explicit violence.

In the preselected zone in which were going to intervene – five blocks of the Pérez Galdós Avenue, an urban artery that would host textualities and that, coincidently, bears the name of the Spanish writer and playwright – a sort of break also becomes evident. There is a central artery that divides,

almost in a Galdosian style, what some of the residents want to keep separate: "On this side we are one thing, on the other side they are something else." That avenue is a giant crack, like a channel that separates what each one of its inhabitants thinks about their particular territory. So, the challenge was to generate a group and community dynamic in this place of friction.

Discovering the layers that are less visible in the urban sphere implied activating drift processes of uncovering. In the first instance, we held different meetings with the residents, through a wide-open call for consultations we made in the neighborhood via social networks. The main objective was to build workspaces:

- For the collective construction of a social memory of the territory,
- For the development of strategies to make intangible layers visible,
- To strengthen a critical reading of the environment.

The process of making the neighborhood space visible was based on four intermedial axes: sonority, writing, corporality, and visuality.

> The sound landscapes activated the deepening of the listening process in order to pick up sounds that are usually inaudible. The inner silence and calm attention of the participants opened up possibilities and reflections on identity and territoriality. Onomatopoeias, murmurs, naturalized sounds, and noises were fostered on the basis of psycho-geographic drifts that enabled the construction of sound metaphors.

> The work focusing on words began with a reflection on the obvious as the result of the automatism of the gaze and speech, as a void in representation, like that which takes for granted and is therefore unnecessary to name. However, given its hidden nature, the obvious is often not so obvious. To say "this is not obvious" one has to make use of words. That is to say, we have to give way to them, search for those words that reach out to that which has always been in front of us, and above all let those words redefine our spaces and our perceptions. The workshop proposed, by means of a series of instructions, to thoroughly explore the space in order to document, classify, and reveal phrases hidden in the neighborhood landscape, to form a database, the object of which is the streets themselves.

> The inscription of the body in the environment, for its part, was explored through a series of corporeal practices, through which the participants recognized new pathways and spatial designs. Strategies were created which tended to make the body invisible among the architectures so as to explore the ways in which we move as a group through them. In the tension between the invisible and the visible, a distancing effect was produced, through which the body was re-inscribed in its own territoriality.

THE TERRITORY IS HOME

With regard to the visible, we proposed a series of practices to signpost hidden places. Ditches, cracks, holes in a specific block of the neighborhood suggested to us new pathways and spatial designs.

Breaking the conventions of predetermined routes, we defined other connections between spaces to create a new visual and textual territory. Each one of the workshops created a reflexive space in which textualities in relation to the space emerged. The meta-map crystalized in a discursivity that was produced collectively. Those textual materials, generated during moments of drift experiences, were the object of debate, and they, in turn, set in motion new discursivities as the result of the joint mapping process during the meetings that followed the workshops. All these visual and textual materials were included in their original format on the project's web page.

The group selected phrases that threaded together other forms of conceiving territory and the relations which interweave within it. They were: "We become invisible"; "The sun moved along and the border changed"; "Silence is impossible"; "The wind sweeps and goes"; "The terrain moves again" and "The street oozes a thick liquid." These phrases formed a narrative that is visual, spatial, urban, luminous, and aerial (the posters were to be located on the roofs of the houses and buildings), in the form of a collection of urban signposts which create a collective poetic story.

These phrases were transposed to large-scale neon signs which were located on the roofs of buildings in the streets where the drift art took place. So, the urban signs, embedded in the architecture of the houses and factories, construct a spatial narrative on the basis of the narrative practices of the community deployed during the workshops. The objective was to go beyond the canonical cartography, that is to say go beyond the normalized forms of territorial representation, and make the territory a real setting for possible dialogues, opening a horizon in which action and collective construction set out new areas of debate in relation to territory.

The idea was also to transcend the most usual practices of locativity (that is to say those artistic strategies that make use of locative devices – GPS, mobile phones, etc.), in which the technological mediation reaffirms territorialities that are strongly naturalized, which provoke, ultimately, the deterritorialization of territory itself. How to discover layers of history, of collective meanings, of shared imaginaries, in the urban terrain, beyond mediations? That question was the focus of the intervention and of the site-specific installation. On the basis of the questions presented, we aimed to establish a dialogue between praxis and theory, a production which was equally collective and collaborative, a transdisciplinary and intermedial approach and an investigative project. The intermedial nature of the project *Escrituras* worked at three levels: (a) the transposition of media, migrating

the textual to a lighting-visual format; (b) the constant reference made to other media, referring aesthetically and formally to a type of urban signage no longer used; (c) the combination of media, integrating the languages of words, action, urban intervention, and luminous objects. In this context of multiple convergences, dialogues and intersections of languages and media, the territory, as the generator of crossroads, incited the exploration of questions relating to identity, memory, time, contemplation, gaze, and perception. We tried to think of territorial interventions closer to home than cartographic, representational, modeling dynamics, in order to generate, in that way, a platform that might function as an incubator of works (which are to be understood as action in the concrete community and intervention in the public space) and of critical thought. For us, the junctions, the folds, and veins of the space which contains and exalts us all build up zones of conflicts and tensions. These sedimentations enable us to discern a possible compendium – chaotic, formless, and eclectic – of territorial emergencies that challenge all hints of univocity. Here is the question. Taking as our inspiration Aby Wargburg's notion of "atlas," we proposed an exploration – not exhaustive, but incomplete and fleeting – of the possibilities of experimentation around the idea of dynamic, reconfigurable, and elusive territories that foreground mechanisms, tensions, and semantic capital in the urban context. Collective and public spaces in action, social stages that are built on successive, adjoining, simultaneous, and contradictory layers. But above all, intersections as instances which set off and receive urban rhetoric and dynamic relations. In these zones of arbitrary interconnection, space becomes space of action, investigation, and reflection: a territory. What we were attempting, therefore, was to think about and make visible urban spaces with the most hidden layers in mind.

When we began to explore the territory, what emerged was not, in the end, harmonious, and the action of exploring these conflictive places strengthened the experience of de-automating one's gaze. Otherwise, the experience would have been tautological: what we see every day with our automated gaze is what it is. Now, when we propose to de-automate our gaze, on the basis of determined strategies, what will emerge is precisely what we do not see every day in the normalized landscape, but instead the de-normalized or abnormal landscape: that which emerges as the result of experience. At this crossroads, the body has a preeminent role. To quote Elizabeth Grosz, we worked on the basis that:

[…] art is not only the movement of territorialization, the movement of joining the body to the chaos of the universe itself according to the body's needs and interests: it is also the converse movement, that of deterritorialization, of cutting through territories, breaking up systems of enclosure and performance, traversing territory in order to retouch chaos, enabling something mad, asystematic, something of the chaotic outside to reassert

THE TERRITORY IS HOME

and restore itself in and through the body, through works and events that impact the body. (Grosz, *Chaos, Territory, Art* 18)

The work had a performative nature that enabled new possibilities in the territory. We took Gilles Deleuze's concept of *agencement:* a conglomeration of binary or rough lines, and flexible or molecular ones, which form a lattice that crosses through ideas, bodies, actions, and relations. In the words of the French philosopher:

> […] the notion with innovative pretensions is that there is no territory, territorialization without a vector of exiting the territory; there is no exiting the territory, that is, deterritorialization, without at the same time an effort of reterritorializing oneself elsewhere, which is something else." (*L'Abécédaire de Gilles Deleuze*)

The territory therefore is a dynamic extension in which the flows of deterritorialization and reterritorialization display diverse possibilities. Because – and once again making use of Deleuzian ideas – the minimal unit of the real is not the word, nor the concept, nor the signifier, but *agencement,* which is understood as lines of force that transversally run through different spheres and territorial dimensions. These lines involve metaphorical relationships, with those lines of escape the ones which give rise to the emergence of deterritorialization. It is a multidimensional relationship that implies a collective co-functioning. We are dealing with an imperceptible scaffolding that supports and activates relationships. Every *agencement* is always territorial, Deleuze would say. Therefore, the territory is a dynamic vector, a surface of open code, in which the dynamic of deterriorialization and reterritorialization displays diverse movements.

The tradition of cartographic practices and urban signage has gained ground in recent Argentine history. One can simply mention the so-called "escraches" (demonstrations designed to shame), or visibility actions carried out since 1966 by the Grupo de Arte Callejero (Street Art Group) and that used urban street signs to identify the homes of those accused of genocide and the location of clandestine detention centers. There are also actions of critical mapping that have been developed by the group "Iconoclasistas" (Iconoclassicists), since 2005, based on the production of iconographic resources of free circulation, creating collective cartographic practices that bring attention to such problematical issues as monoculture, large-scale multinational mining, invisible labor, etc. In the case of *Writings,* we again took up practices that were strongly rooted in our context, proposing that the cartographic production should go beyond the map itself in order to reinstall itself in the territory and thereby compose a collective textuality that is physical and tangible, illuminated and on an urban scale.

If real territory and its topology generate a layer of information that would be easily "traceable," there are motorways and paths that are much less

representable. How do we make visible what maps do not show? Social links, organizational practices, community problems, traces of a historical memory, formal reconfigurations in the urban planning, etc. – aspects that define a morphology that is not as distinct as a representation of space in cartographic terms might be. The framework of relationships that occurs in the territory is not what is usually represented by maps. And it is this "transversal" level that we call meta-map: relational fabrics that make up dynamic and changeable universes, an intangible interweaving that gives rise to links that go beyond the map. From that point of departure, we try to put forward other mapping strategies, approaching the environment as an open-source territory. The *Writings* project – that is a counter-urban signage project – promotes transformations of territory through a type of *agencement* which is performative in nature. This project triggers a critical gaze in relation to cartographic strategies and to the definition of space, with the aim of making visible the different relationships between individuals and their neighborhood context. Through resources of graphic and textual representation, these lines of escape that cross through social relations, the group imaginary, communicational dynamics, etc., can emerge. For its part, light, from its condition of "visibility enabler," discovers the invisible layers of the socio-urban environment. The objective of this work was to propose a vision that transcended the concept of technological mediation, usually associated with the notion of interface in the framework of technocultures, and to approach light, as a support for collective textualities as well as an interface for action, as an enabler of dialogues between individuals and their environment.

In this action of group territorialization, the illuminated materials occupied a central role: generating a layer of narrative flows – understanding that "narrative" in this project emerges on the basis of the intersection of diverse languages – whose subject of enunciation is the community itself. In the field of electronic art, and in a considerable number of locative works, the relationship with the Other is often reduced to games of interaction with devices and diverse physical interfaces – we are dealing with discrete or continuous interfaces which in the long term do not manage to overcome a degree of binarism whose dynamic is concentrated in the monopolistic role of the interface. The Other is not interacted with (the other-subject, the other-territory, the other-context. etc.) in the pure Levinasian sense of inter-entity relationships. In the technical mediation there is often an obscurantist whim as a result of which the why and the how of the intersubjective and interobjective relationship reveals random motivations, which are sometimes futile and capricious. Consideration of the question of the interface in the field of electronic and digital creations has now become a requirement. Many theorists have written long pages on the relevance of the interface in the interactivity dynamic. Out of all this theoretical framework around the concept, we retain something

THE TERRITORY IS HOME 87

that has been repeated endlessly: its character of intermediation. Surface of contact, deeply set in the framework of an information system, capable of processing signals of entrance and exit. But it is also important to note that the relationship between map and territory is not whimsical at the moment of referring to the concept of interface. The text by Borges, "On Exactitude in Science," led Jean Baudrillard to extensively develop his concept of simulacra (*Cultura y simulacro*). What is the territory and what is the map? In the same way, this surface of contact, in a world governed by the media, is the most usual space of action. Relationships and dialogues prioritize the map over the territory. The world as interface – of which Peter Weibel speaks – supposes a separation from the real sphere so that we might go deeper into the order of simulations, in which the boundaries between map and territory, representation and reality, mechanical universe and organic universe, man and machine are imprecise. In the case of *Writings*, the cartographic process dispensed with all types of technical mediation. What the project proposed was to go beyond the intersection of techno-discourses in order to think of flows of interactions in the urban environment. As a result of the experiences in the neighborhood environment, the cartographic procedures recovered the analog tools of signaling, marking, surveying, drawing, tracing, thereby emphasizing the direct contact with the territory and subjective and intersubjective perception. The group of subjects engaged in dialogue without mediating surfaces be they graphic, physical, or semiotic. For Gui Bonsiepe, the interface "transforms simple physical existence [...] into availability" (17). In this work, the light, as a space of visibility of that which is shut out, is a sort of interface or, it should be said, a platform that enables feedback between the community and their environment. It is about trying to recuperate the border between representation and reality. Or to put it better: the aim is that that which is represented (the cartographic operations) links up again with the real on the basis of the inscription of social textualities in the physical space itself: texts that are scalable to urban spaces which reinscribe the subject in his or her environment. The project's persistence in the space – its physical inscription in such gaps and the memory of the intervention – created the need to generate a permanent mark, a communicative interface between group-experience-territory. In this way, the light as an articulator of emerging textualities in the context of the action of cartographic disclosure, and as the provider of visibility to the intangible meta-map, was what re-connected the community and their territory. The light and its textuality is the footprint left by an intervention in the territory and, in its turn, each day it updates the dialogue with that community. The light permits reterritorialization. The signs are like voices, and, although they have a strong visibility, it is the meaning within the urban space that emerges most strongly. Each sign is a voice (or set of voices).

If the notion of technological interface usually foregrounds a relational hegemony based on the responsive logic of the device, through which the territory loses its territoriality and emerges as a mere representation, in this work the dynamic is based on the logic that is specific to the subjects and their context, with each one of them functioning, at the same time, in a manner which is autonomous and supplementary to the rest. The interface (the neon signs) is the result, and the condition for the possibility of a constant renewal of dialogue: it empowers the subjects, producing examples of *agencement* which make new lines and semantic and ideological vectors break out in the space, constructing in that way a cartography in which the textuality crystalized in light, materializing the visibility of community flows and inaugurating new channels of entrance and exit between individuals and their physical and temporal environment.

9

Reflections on a Multimedia Practice

JACALYN LOPEZ GARCIA

> Sometimes I feel challenged as an individual born in the U.S. because I do not always feel completely American. This feeling has a direct impact on the images I create because it causes me to look inward to my own cultural base. In doing so I discover reasons for my life, such as why I have to create art.
>
> Jacalyn Lopez Garcia, *Glass Houses*, https://jacalynlopezgarcia.com

I never imagined answers to such simple questions like, "Who named me? Was it you or dad?" would have such a profound impact on my psyche. But it did, and I was blown away when my mother replied, "I named you Jacalyn Louise because I did not want you to have a 'traditional' Mexican name. I thought that because you were born with fair skin and light hair it would make it easier for you to enjoy all the privileges of being 'American.'" At age forty-two, this was a true eye-opener for me because it awakened my interest in documenting my mother's life experiences and my own bi-cultural heritage. The more she shared, the more I wanted to know and understand. The more thought I gave to the impact her life had on mine, the more I wanted to investigate the possibilities of creating reflections of the past, while examining new understandings of the present with the use of new technologies, the Internet, and autobiography in multimedia artworks.

The 1990s marked a pivotal point in shaping my academic career goals as a photography student interested in exploring the connections between art and technology. Additionally, my curiosity in combining old and new techniques in multimedia art had just escalated after visiting the very first major exhibition of "digital" photography by Mexican documentary photographer Pedro Meyer, at the California Museum of Photography. The year was 1993. I stood in awe inspecting every inch of his incredible photographic images that exploited and violated the notion of photographic truth. Instantaneously I

became enthralled with his use of new digital technologies and the manner in which he captured the spirit and emotion of storytelling within a more "painterly" style, rather than working in a "straight" photographic space. Inspired by Meyer's artist toolbox, I purchased a more sophisticated computer, digital imaging software, and I pursued my interests in multimedia art by enrolling in classes to gain knowledge, experience, and expertise. This was when I began identifying myself as a multimedia artist who creates art with a variety of visual art forms as a photographer working within an electronic digital environment integrating other "arts" that can include poetry, dance, music, and other non-visual elements. I now identify myself as a visual storyteller who explores transmedia narratives designed to access my website projects on the Internet. Therefore, and to be more specific, I consider myself a photographer/multimedia artist/transmedia visual storyteller.

Whenever I am asked, "Where do you get your inspiration for your art work?" I typically respond by saying, "My inspiration comes from my relationship with my parents who played a critical role in shaping my identity and interests in making art." When I became an art major, I developed an interest in exploring the nature of my family's humble beginnings. I interviewed family and friends to help me piece together some of the missing elements of my youth that caused my own identity crises. Family traditions, rituals, gender issues, the complexities of cultural identity, and the fear of becoming disenfranchised from my own cultural roots later became the impetus for my artistic endeavors.

After completing my A.S. Degree in Photography at Riverside Community College in California, I transferred to the University of California, Riverside in 1994, as a Studio Art major. During this critical period of my academic career I made many new discoveries that included focusing my attention on defining a voice for the "modern" Chicana entrenched in the suburbs, struggling with identity issues for herself and her own children. Note, I use the term "modern" to reflect the changing ideologies of Chicana feminism of the 1990s. By the early spring of 1995, I began developing strategies for creating a multi-layered, interactive website on the Internet, which had become my favorite vehicle for expression that allowed me to create multimedia art that could push the boundaries that exist between politics and art. Once I began exploring this new field of artistic expression, I wanted to create something very different from what existed on the Internet because electronic book reading was not popular at this time. So, I felt determined to challenge the cold and impersonal environment associated with the computer and this led me to question: "Is it possible to introduce a private and intimate storytelling experience on the Internet that can examine the relationship between public and private spaces?"

22. Glass Houses Doormat Website screen image. Digital Print, 20 ×16. 1997. http://artelunasol.com/glasshouses/glasshouses.1.html.

A major goal in designing my website, *Glass Houses: A View of American Assimilation from a Mexican-American Perspective,* focused on offering a critical examination of how diverse artistic practices, such as photographs, illustrations, text, and audio can serve as catalysts of memory that can also be used to conjure up a variety of social and cultural contexts. For example: I used the structural floor plan of my own suburban home to design a doormat to serve as a navigational tool (Fig. 22).

Words that could serve as metaphors to examine contemporary themes associated with daily living were assigned to the front door, stairway, closet, and individual rooms such as: opportunities, success, fears, rituals, traditions, expectations, secrets, and desires. In its entirety, *Glass Houses* is driven by an autobiographical narrative in which my mother's stories are shared as "something that happened" and they reveal the impact that her life experiences had on mine. This body of work consists of personal and intimate stories, photographs, art work, and sound files that are linked through interactive screens. These linked screens open doors to various rooms in the house which can take approximately one hour to view.

As I worked on designing the individual pages, I would take into consideration the idea of how long I would be able to hold the reader's attention. I imagined that online storytelling was different from reading a hand-held book because on a computer the online participant/houseguest could read, and listen (something you cannot do with a simple text-based book in hand), or interact with the content within the website (to share their own stories) which was also very different from a book-in-hand reading experience, but I still needed to be thoughtful about my reader's attention span. More importantly, I wanted the stories to be more than just a vehicle for expressing my own personal struggles over identity issues into the public domain of the Internet. I truly believed the website might help others deal with similar issues in a positive way and that I could create an opportunity for online dialogues. So, with this in mind, the pages are designed to reveal intimate stories such as: how I learned to embrace my biculturalism, the impact of my mother's attempt to pass me off as a "white girl," reflections of the suburban Chicana experience, and the influence of popular culture in my life. Houseguests can come and go as they please, they can choose a guided path, or they can pick the path they wish to explore. Small buttons appear at the bottom of each page to link the houseguest to the next page. These buttons function like a page number in printed formats where you can go forward, backwards, or even skip pages. In the online environment there can be multiple buttons on the same page, or just one which is a requirement in the navigating process. Upon leaving the website, houseguests are encouraged to participate in the storytelling process by writing, sharing, and posting their own reflections and stories on the message board located in the kitchen.

REFLECTIONS ON A MULTIMEDIA PRACTICE

The original version of *Glass Houses* was designed using early HTML (hypertext markup language), digital imaging and web authoring software to span the first twenty years of my adult life. An updated version was later introduced to keep up with the constant evolution and adaptation of delivering online media content. This is very important to note because if the functionality of the website becomes antiquated, web authors risk having their artistic efforts doomed if the work is not updated. In my case, revisions were not necessary until we entered the twenty-first century and then it became important to redesign a more "user" friendly online viewing experience for my houseguests using hand-held devices such as cell phones, iPads, and tablets to connect to the Internet.

What I feel is important to note here is that there really is no need for printed books of images or text to not remain the same, but this is not so with multimedia web-based projects. In fact, due to the constant evolution and adaptation of delivering online media content, it becomes necessary to stay up to date with the current trends in web design and authoring. Something very important that I learned from this experience led me to believe that multimedia storytelling projects can be designed to resist closure, and that closure is artificially imposed in traditional printed narratives. If a web author has a desire to resist closure, then updating becomes a requirement, otherwise the risk exists for closure to become artificially imposed. Another important lesson, for me, involved making a "copy" of the original published format before it was updated. I can now demonstrate how art and technology have evolved as experienced from the inception of web authoring that dates back to the 1990s.

By 2010, my fascination with a new computer-readable media referred to as a quick response code, or "QR code" was added to my artist toolbox. Though it was introduced as a marketing tool, I chose to explore the possibilities for extending a visual story beyond the first impression of an art piece with this new media. My goal focused on integrating a computer-generated design specifically created for my own artwork so I could link it to a personal autobiographical story on my artist website. The next step required modifying the black-and-white design to include color to inspire a deeper visual meaning of coded languages. The result was titled: *An Interactive Self-Portrait of the Artist.* In this example the art patron can interact with the digital print by scanning the artwork using a smartphone, iPad, or tablet, with a code reader. In order to fully engage in being able to view and read in both the physical and digital worlds simultaneously the hand-held device must have a code reader, or, the story can be accessed via the assigned URL on the Internet by typing in the http:// address. Hence, to ensure a positive viewing experience I include instructions that read:

For your viewing pleasure Scan Me or visit https://web.archive.org/web/20210211000249/http://lifecycles.ucr.edu/videos.html. This is my way of providing an opportunity for the art patron to learn and experience the functionality of an interactive transmedia narrative style that specifically provides a shortcut to access a URL on a specific page on an artist's website. This is very important because unless the art patron is knowledgeable about image meaning-making coded systems and transmedia narrative styles, they might miss out on the opportunity to engage in the interactive aspects of the storytelling process. In other words, if the QR code is not an identifiable symbol for the viewer, and, if it is not scannable or scanned, the digital image will then function only as an abstract portrait and not as an interactive portrait.

I feel strongly that the day will come when computer-readable media, like the QR code, will gain popularity in transmedia storytelling. People might ask "Do you think the QR code functions like a "footnote" in literary works?" My reply is, yes, as a storyteller working outside of traditional print publishing, I believe it does have similar functions. It can add another layer to the story when the code links to the textual aspects of the story when read on the Internet. It can also add dimension and reveal a new layer of context when the QR code connects to, let's say, the "next" page that is revealed in the online environment. I basically employ the QR code to create an interactive experience that expands on the story I am telling. Hence, I believe the QR code does have similar functions that allow me to add a new dimension that electronically links the artwork's hidden messages that await the reader's attention.

Another very important aspect of my artmaking involves working in collaboration with other artists that share similar interest in the subjects I explore. In my *Cultural Crossings* video collection (http://lifecycles.ucr.edu/videos.html), I selected artists that could bring fresh perspectives, skills, and who are working in fields that are outside of my areas of expertise. My collaborators included poets Darren J. de Leon, Laura Araujo S., playwright Carlos Garcia and a digital music composer Rex Garcia. Each artist was invited to explore their own personal interests by bringing together some of the interviews, personal narratives, and photographic imagery taken from one of my documentary projects titled: *Life Cycles: Reflections of Change and A New Hope for Future Generations*. As I worked on preparing *Life Cycles*, my intention focused on creating a body of work that could reflect on how immigrant and migrant communities have represented long-neglected histories within the socio-economic narrative that has characterized California as "the land of opportunity." In its entirety, the *Life Cycles* project consists of a series of eighty-four framed photographs, six short videos, and a multilayered interactive website in both English and Spanish.

Other subjects that are also common in my artworks, include contemporary themes based on the complexities of cultural identity and the fear of

becoming disenfranchised from one's cultural roots. As part of my creative process, I generally take ample time planning and researching ideas before I begin. However, sometimes they emerge in unexpected ways. For instance, after previewing some unscripted, found footage from one of my home movies that I had captured a year earlier, I envisioned assembling a short video that could offer insight into an atypical, non-traditional Mexican-American middle-class family's annual tamale-making celebration. My approach in applying multimedia techniques to compile this video required that I use my artistic imagination to construct a story that is explored as a contemporary documentary that speaks through the process of weaving the moving images and voices in an essayist film style. Therefore, my essayistic approach and treatment of the found footage is interwoven into a new video for the purpose of interrogating the historical and social presence that is being preserved whereby the recycled footage can raise questions like: What is being preserved? What is being passed down? For me, the tradition of repurposing found objects and cultural recycling in other art forms is very similar to my idea of rewriting/editing the found footage in film or video production.

Once I began editing, I focused on addressing and documenting an assimilation/acculturation battle associated with living in the land of in-between, also known as the Nahuatl word *nepantla*. My video, *Living in Nepantla: La Tamalada,* seems like a typical family home video, but it is not typical at all. In fact, this six-minute video presents a glimpse into the lifestyle of a family who struggles to maintain its rich cultural heritage and humorously interjects visual narratives that are intended to deconstruct the stereotype that all Mexicans continue to live in impoverished neighborhoods. This video is accessible from my artist website http://artelunasol.com/tamalada.mp4 and has been added to my ongoing *Cultural Crossings* video collection.

A multimedia project that caught me by surprise was based on a series of conversations between a dog named Goldie Garcia and her human friends on Facebook. Goldie's online journey began as an idea to disguise my own identity and it was never intended to become an art project. But interestingly enough, it did. This happened when I recognized the conversations between Goldie and her human friends were quickly becoming a playground for a variety of artistic endeavors. In the beginning, Goldie's conversations started off as text-based narratives and eventually included a subtext that was added by introducing photographs so she could share her dog's life with her human friends. Eventually, Goldie's journey on Facebook revealed how social networking participants unknowingly became instrumental in developing the storyline for a dog's quest to find the Fourth Wise man (El Cuarto Mago) the grantor of wishes to "los animales" (the animals) so she could be gifted a farm for Christmas.

Over the course of five months, Goldie's interactions on Facebook became a performance-based project that blurred the link between reality and fantasy. In turn, this led me to document the result of what happens when different media intersects in an interactive and unscripted manner. Moreover, the performance aspects became a vehicle for examining twenty-first-century ideas that were similar to the Fluxus movement of the 1960s. Exploring non-conventional and non-traditional storytelling techniques also led me to explore a variety of multimedia formats that included an eight-minute CD-ROM video titled, *From the Garden*. This video is an adaptation of Isabel de la Pena's short story, *Lord Hear My Prayer*, and was envisioned as a multimedia installation for a larger body of work titled *Virgins and Whores & Other Stories*. In this electronic adaptation, I edited together text, photographic imagery, and a narrated story with background music to offer a more critical examination of the psychological damage suffered by women who were named after La Virgin de Guadalupe or the Virgin Mary, as explored in Isabel de la Pena's traditional text-based fictional short story. The story does not change: the original and the video point to a vision where the self collides with stereotypes and other socially constructed representations of women searching for their sexual identities. What does change is the subtext that was added in multimedia production to allow for a narrated story, a collection of photographic images, text-based art, and a musical digital sound track mixed by Laurence Bassage to create a sensory experience in storytelling. In both formats the story investigates contemporary issues relating to the complexities and dilemmas of the "coming of age experience" and this electronic version is considered a collaborative effort produced with the author, Isabel de la Pena. Having a genuine interest in creating multimedia projects that can empower a voice for women has always fueled my creative vision. So, when the day came that the National Women's Caucus for the Arts released the prospectus for a touring exhibition, *Man as Object: Reversing the Gaze,* I jumped on the opportunity to submit a proposal for an interactive web-based installation project titled, *The Manhunt Project* (http://themanhuntproject.com). Individually and collectively these projects explore contemporary themes about sexuality, gender, and identity issues. In their own unique way, they also offer a critical examination of the role in which sexual oppression, religion, and other social ideologies continue to instill bias and fear in the complex developmental stages of one's sexuality.

Something very important that I have learned about being a multimedia practitioner engaged in merging the worlds of digital, traditional art, and visual storytelling, is the lack of technical support within institutional systems. In particular, I am referring to a variety of obstacles and challenges that result from the "do not touch" model of restrictions that still continues to monopolize the viewing experience in some museum/gallery spaces. In fact, where this model still exists, so does the lack of technical support which I believe works

REFLECTIONS ON A MULTIMEDIA PRACTICE

against the ideals of interactive art. Sadly, the lack of technical support can also make interactive art not accessible and invisible. However, I feel optimistic that times are changing and that we might even see a rise in artists utilizing the QR code to its full potential as an art tool in multimedia practices. In the meanwhile, I am determined to not allow the "do not touch" model to keep me from expanding my storytelling techniques in non-conventional ways.

In looking towards the future, I am prepared to continuing working in collaboration with other artists and travel as often as I can with my work. I am collaborating with other artists in an ongoing Transmedia Visual Storytelling Project titled, *LAND-artproject.com*. This body of work reflects my desire to create a fusion of visual, social, and technological literacy as a multimedia artist, photographer, and transmedia storyteller. This collection is also further intended to demonstrate how a variety of mediums can be combined to challenge ideas about the role literature and documentary narratives play in visual storytelling. I can only imagine that new technological advances will inevitably take my work to new heights where the technical aspects will also remain part of my artistic vision so I can continue to challenge audiences to think in unconventional ways about what art can be about and the answer to the question, "What is art?"

10

Digital Weaving

LUCIA GROSSBERGER MORALES

When I returned to Bolivia for the first time in 1969, I noticed that there were weavings everywhere. Some were handmade, old and rough and woven out of natural fibers using natural dyes. Others were hand-woven – some very fine using alpaca wool and some were woven in cotton, using modern dyes of bright pinks, greens, and blues. I was captivated by the variety of weavings and how the indigenous people used them. They wore them as ponchos and skirts. They folded them into cradles and placed them on their backs to carry their possessions or babies. At the outdoor market, called the "cancha," the women put the weavings on the ground and sat on them along with their products to sell. I knew that weavings were more than just fabrics.

Weavings hold a special significance for the Andean cultures. In Europe, painting and sculpture are the highest artistic expressions of the culture, while in the indigenous Andean culture, textiles are the epitome of art. Although the Spanish conquerors tried to destroy Inca culture, Andean women have preserved the indigenous beliefs, rituals, and symbols for their people through the language of weaving. Andean weavings, particularly those of the Altiplano in Bolivia, are the voice of a culture that refuses to disappear. These weavings are the tangible expression of a worldview that is distinctly non-Western. By weaving both the traditional and the modern, my artistic and digital work is a homage to this precious, yet obdurate, cultural legacy.

In 1979, when I bought my first Apple II computer, I learned that computer graphics were based on a grid and that each point on that grid was a specific color, which is true for most weavings and fabrics from the 1970s. The resolution of the screen of the Apple II was about one-thousandth of the resolution of a computer, circa 2006. However, I had no problem adjusting to the low resolution because of my experience working with fiber and textile art. I saw

the stair steps of the pixels on the screen like the stair steps of points on weaving or needlepoint. I feel fortunate to have worked with the primitive Apple II, because the pixels were so big (they were called dots in the manual), that it was obvious that the computer and weavings were based on the same type of information as weavings; an x, y coordinate grid and the data of the specific color at that point.

In 1840, the brilliant, English engineer Charles Babbage conceptually understood the fundamentals of a device that could evaluate numbers, or symbols, store the answer, and then evaluate the response according to a set of rules. The computer and loom have a lot in common. Babbage found the solution of where the information, the data, or program would be stored when he saw the Jacquard loom, with its programmable punch cards that controlled the threads to be woven. Babbage called his device the Analytical Engine. Ada Byron, Countess of Lovelace and daughter of the Romantic poet Lord Byron, a friend and fellow mathematician of Babbage, was the first computer programmer. In her writings on Babbage's Analytical Engine, she compared the Jacquard loom to the Analytical Engine: "We may say most aptly that the Analytic Engine weaves algebraic patterns just as the Jacquard loom weaves flowers and leaves" (*Sketch*). Ada understood that the Analytical Machine was so revolutionary and powerful because unlike any of the other calculating machines, which could only process numbers, it could process symbols. Symbols could represent just about anything.

I had several goals when I was creating multimedia works on the computer. The first was to take advantage of the computer's capability to follow procedural commands using a programming language; to use hardware such as tablets and digitization in my work using input devices; to use multimedia software that allowed me to integrate media elements in my works. Second, I wanted to use the capabilities of animating and hyperlinking text to create layered stories. So finally, I wanted to create interactive artworks, which required the participation of the audience to move forward.

I wanted to take advantage of all the capabilities of the computer to tell stories. There were several input devices that I could use including: sound from a microphone or downloading music from CD-ROMs; inputting visuals from cameras and video recorders; creating graphics in Photoshop and other video processors. The software was equally important.

When I began using computers, in 1979, I had to learn to program to create my artworks. Coding is one of the most difficult aspects of my work. I need help trying to tell the computer to implement the algorithm I have designed. But every once in a while, the program does exactly what I want it to do.

SANGRE BOLIVIANA

The first time I referenced the word "woven" in my multimedia work was after the title in *Sangre Boliviana* where the credit appears, *Sangre Boliviana* is a CD-ROM I created in the 1990s. It was a postmodern collage which wove together different multimedia strands, including still images, sound, video, and voice. There are six multimedia pieces, and at one point there was a link to websites about Bolivia using the web browser Netscape Navigator, which is no longer available. I used the program Director, a powerful multimedia program. CD-ROMs were the best format to share the information because in the 1990s web browsers were just being developed and the Internet was slow and also lacked the interactivity that interested me. Most of the pieces in *Sangre Boliviana* were inspired by either a short poem I had written or an event I had witnessed. The resolution of the screen was 640 × 480 pixels, which is about a third of the current resolution of computer screens. My goal was to use as few words as possible because it was difficult to read the text and also reading long text passages would take away from the interactive experience. *Sangre Boliviana* was a work that I was compelled to create. The words, the format just flowed from my desire to find an identity. I arrived at several rules for integrating text into my work. When I was creating *Sangre Boliviana*, the technology was so new and I had to define my working methods. I didn't have models; I followed my instincts and my training as an instructional designer. I was concerned with how the technology should be used, understanding the resolution on the screen, and how I could animate text and images to tell a complex layered story. I often told one story with the text and my voice told a different more emotional story in Spanish.

"PALABRITAS" (LITTLE WORDS)

Interactivity is one of the features that makes computers unique as an artistic medium. The interactive work "Palabritas" (Little Words), in *Sangre Boliviana*, is an example of how I integrated several strands of multimedia. The initial element was a bilingual poem I wrote, also called "Palabritas." In the early 1990s I wanted to create work that was bilingual, and that didn't translate either language. My struggle with identity at that point demanded that my audience speak both English and Spanish to understand my work. The poem described my enjoyment of my native tongue Spanish and the pain of having to speak English. My little poem became woven with imagery, video, and interactivity. In the 1990s a program was introduced that allowed video to be imported onto the computer. I didn't know what the software was capable of, so I recorded what I hoped would be a video to accompany the poem. Then I used Adobe Premier v.1 to edit it. On the screen, the video is a small box.

102 LUCIA GROSSBERGER MORALES

Video required vast amounts of memory, and the refresh on the screen was too slow, so my video was short and small. When I showed the work people couldn't understand why I didn't want to translate the sections in Spanish so they could understand them. I was struggling with my identity, and I felt that English speakers should feel what it is like to be left out. I made a concession, I included the translation, but the viewer had to "catch" the translation.

"KHURITOS"

After *Sangre Boliviana*, I created a series that was inspired by the unique weavings of the Jalq'a community. The Jalq'a weave landscapes of the underworld with bizarre creatures. The rules in their underworld are the opposite of their natural world.

When I visited the market in Tarabuco, and shopped for weavings, I was riveted by the recent Jalq'a weavings. The Jalq'a weavings are inhabited by randomly placed creatures, called "khurus." The Quechua word *khuru* means "untamed." As a sign of affection, the diminutive "ito" is added, so they are called "khuritos." The Jalq'a believe that in this underworld, the "khuritos" defy the laws of perspective and gravity; some are facing one direction while others face the opposite direction. There is no distinction between male or female because these categories do not exist in the underworld. They do not follow any rules of conventional biology and are perpetually reproducing. There are "khuritos" within "khuritos" – the background of one "khurito" is another "khurito." There are often small "khuritos" inside others so that it appears like there is a baby inside the larger "khurito." But the species of the baby rarely corresponds to the species of the parent. It is this confusion of constant reproduction that is one of the most prized attributes of a Jalq'a weaving. The Jalq'a people describe their weavings as "chaxrusqa kanan tian," "it must be disordered." The "khuritos" are part of the Andean collective unconscious, the underworld, and the world of dreams.

To weave the most important weaving of the Jal'qa, the aqsu, a young woman weaver must be chosen by a master weaver and then go through an initiation. After the initiation, she is considered a true weaver and entrusted to weave the "aqsu."

When I begin a series of painting, video, or interactive computer art, there is a conceptual and philosophical underpinning. *Khuritos* was inspired by the Jalq's weavings of the underworld, since creativity is born of those dark spaces. When I was young, I practiced Catholicism and was afraid of sinning and going to hell. Over the years I began to embrace a philosophy of duality, such as the Ying and Yang in Japanese culture. As I continued to learn about the Indigenous people in Bolivia, I learned about a worldview that embraced

DIGITAL WEAVING

dualities, not judging either of the opposites. The main deity of creation, Virachoca, was androgynous, containing both male and female.

I incorporated the "khuritos" to reinforce the Indigenous worldview where there is no hell and it entails living with the duality of life. Unlike most series which use the same media, I incorporated "khuritos" in paintings, prints, interactive CD-ROMS, metal, and videos. In 1996 I created a CD-ROM, "Endangered and Imaginary Animals," inspired by the Potolo and Jalq'a weavings of Bolivia. The piece "Digital Weaving" was a computer-based piece. I first created a black stencil for the khurito on the computer. Then I added patterns with Kai Power Tools. To create the patterns that spoke to me, I generated dozens and dozens of patterns. I placed one pattern on top of the other, using transparency effects, as well as changing the hue and saturation. Additionally, I used filters that warped, crumpled, distressed, fragmented, and texturized the image. In 2009, I was using a new Mac and Artmatic Software, and I created a wide variety of complex patterns. I often had more than seven layered designs and patterns to create the effects of pattern and color. During this time, I also created a limited-edition book, *Digital Weaving*, as well as prints.

PALLAI: DIGITALLY WEAVING CULTURE (2005)

The installation *Pallai: Digitally Weaving Culture* (2005) was also inspired by physical weavings. The "pallai" of a textile is the area that is decorated and contains the cultural information of the weaving. There is incredible variety in the styles of the "pallai," because each cultural community or "allyu" has their visual vocabulary.

My installation, *Pallai: Digitally Weaving Culture*, included three interactive installations, paintings, steel cutouts of Khuritos and cast aluminum also of the Khuritos. The installation was inspired by different weaving periods and areas in Bolivia, including Inca, Potolo, Kallawaya, and Jalq'a. I treated the walls of the gallery as if they were a weaving. On the bottom of the walls was a stencil inspired by the weavings of the Kallawaya. The artwork and interactive installations were placed in the central portion of the walls, to simulate the "pallai." On the largest wall, three interactive pieces were enclosed in metal sculptures designed to look like a weaving. In the center of the sculptures, the "pallai," were the interactive computer pieces. Across the gallery, on the other wall, there were paintings of Potolo and Jalq'a animals combined with recycled, cast aluminum "Khuritos." In 2004, I decided that I wanted to work on canvas. I had been experimenting with paints and collage and wanted to try using the computer-generated images of the Khuritos combined with the texture of handmade paper and paint. I created patterned images on the

computer and then printed them on rice paper or other handmade papers. Then I collaged them onto the canvas and painted them with acrylics.

CUATRO (FOUR)

In 2008, I created *Cuatro* (*Four*) an interactive installation and shrine. Inca cosmology is grounded in the number 4, the number of sides in a rectangle. The name of the Inca Empire is Tawantinsuyu, which, loosely translated, means land of the four quarters. The number 4 represents the Earth, order, and measurement. There are four cardinal points, four seasons, four winds, and four arms of the cross.

Incan weavings were offered in ritual ceremonies, distributed for trade, used as religious missionary "texts," and offered as the tribute to the ruling families. Inca textiles incorporated repetitive squares or rectangles, called *tocapus* which are units of meaning that can be isolated to signify which family, the status of the family and region where they are from. *Cuatro*, my interactive, non-competitive, art game was based on the Incan Tocapus. The game includes twenty-four square tocapus, which can be moved to create new designs. Moving square designs could be achieved with just paper cutouts, but what makes *Cuatro* unique is that where the shapes overlap, the colors change. This is another example of what makes the computer unique; each pixel is programmable so that when two pixels overlap, it is up to the software program to decide the resulting color.

SACRED BOTS

The rectangular shapes, incorporated in Incan weavings, were the inspiration for the series of paintings, *Sacred Bots*. After visiting an exhibition, "Art after Conquest," at LACMA (Los Angeles County Museum of Art), I was inspired to create paintings of stylized Incan tunics. At one point a character appeared that I called a sacred bot. I researched the concept of sacred technology and where there were societies that considered technology sacred. Japan has more robots per capita than any other country. Masahiro Mori, a Japanese robot developer, founder of the first robot-building competition in Japan, wrote a book of essays, *The Buddha in the Robot: A Robot Engineer's Thoughts on Science and Religion*; he proposes that the Buddha-nature exists in all things animate and inanimate. Mori writes, "The truth is that everything in the universe is identical with the mind of Buddha" (174).

In the spiritual tradition of the Indigenous Bolivian people, the main life force is Pachamama who represents time and space. In Bolivia, rather than human inspired deities, the mountains, and plants are the deities. The Indigenous

DIGITAL WEAVING

Bolivian people believe the mountains, rocks, corn, the coca, the quinoa are all sacred; literally, all the earth is holy; therefore, we can infer that technology, which is part of the planet, is also scared. Humans are not more important than the rest of the natural world; they are part of it. Pachamama, translated in the West as Earth Mother, is more like the Buddha – who is time, space, and things. If a culture believes that the earth is sacred, then it seems natural that technology, also part of the earth, is sacred. Observing the way Bolivians integrated technology into their lives, I concluded that technology is part of the world so believed they were sacred also. While researching, I considered the questions: "Why can't robots be beautiful? Why can't they wear the aqsu, the most important garment of the Indigenous Bolivian people, the poncho that goes over the clothes?" I painted loose interpretations of Incan tunics. The rectangular shapes of the Incan weaving are portrayed, but they are not symmetrical. They approach the balance of the Incan tunics, but it is not meant to be perfect. When I paint, I enjoy that it is handmade in contrast to the exactness of the computer. The canvases in the *Sacred Bots* series are multimedia collages. My collage elements included: fabric that I designed and sent to be printed digitally at the company Spoonflower; computer gen-erated patterns that I printed on handmade paper and 3D printouts, that I printed on a DIY 3D printer. Combining the handmade with the machine made expresses the underpinning of my work which incorporates handmade elements with technology.

LOVE NOTES TO THE PLANET

In Bolivia, I learned about the importance of understanding and caring for the environment and in particular about how the Indigenous people believed the earth was sacred. In 2009, the Bolivian Constitution put the rights of the planet above the rights of humans. I felt helpless when the United States exited the Paris Climate Accord. Art is how I express myself. I designed a pro-ject that spoke to my love of the planet. I wanted to weave my understanding of the planet, with the power of the Internet, combined with the handmade, in this case handwriting.

In 2017, I conceived an installation and performance, *Love Notes to the Planet*. For the first time, I incorporated the Internet as part of an installa-tion. I was interested in combining the participation of the Internet with the real world, handmade actions. The installation and performance took place during Earth Day 2018, 20–22 April. Beginning in March, anyone using a digital device, computer, pad, or phone could send a love note to the planet, by going on websites, lovenotestotheplanet.com or notasdeamoralplaneta.com. The performance took place in the Trozadero, one of the large rooms at the

mARTadero Cultural Center, Bolivia. In the front of the room was a large whiteboard that covered the massive, slumped concrete wall. They covered the whiteboard with fabric. During the three-day event, artists copied the love notes and attached them to cloth on a wall. After the love notes were attached, they were sewed onto the fabric so that they laid flat. We broadcasted the three-day event continually on YouTube, so anyone could watch as the love notes were copied and attached. At the end of the three days, there was a mural that consisted of all the love notes (YouTube: *Love Notes to the Planet*). I was amazed that we could broadcast seventy-two hours from Bolivia and anyone in the world could watch it.

It was difficult to get any financial or media support for the project because funders didn't consider the Internet a place. I had found a way to use the Internet, which now carries megabytes of data easily, into an interactive artwork that can include input from anyone in the world. A short video of the process can be seen on YouTube at *Love Notes to the Planet*.

As a young girl and teenager, my favorite place to shop was in the fabric store. I would brush my hand against the fabrics as I walked down the rows feeling the texture of the fabrics. I was fascinated to see how the patterns were constructed; what was the initial design. At that time, I could never have imagined that weavings, combining horizontal and vertical lines would be a part of my visual vocabulary. As I developed as an artist, traveled to Bolivia, and worked with computers, I could not ignore the grid. I have come to believe that weaving could be a metaphor for my process of finding my identity. Horizontal lines are temporal, the passive aspect. Vertical lines represent the spiritual world, the active element. The threads of both vertical and horizontal lines create a fabric or weaving. In my experience, I often find that I try to integrate both cultures by finding points of resolution between being a Bolivian who appreciates things made by hand and being an American who feels compelled by technology. My role as an artist and digital poet is to seamlessly weave the handmade and technology together to express art and the poetic that honors both traditions.

11

Eli Neira, Regina José Galindo, and Ana Clavel: "Polluting" Corporealities and Intermedial/Transliterary Crossings[1]

JANE E. LAVERY

Contagion as metaphor permeates critical discourses from the medical sciences, the humanities to the social sciences. Because of its association with the literal sense of contagion as disease/infection, this figure of speech carries negative connotations of crisis or threat including "moral contagion," "emotional contagion," "cultural contagion" and "social contagion" (Mitchell, *Contagious Metaphor* 1–2). However, "thought contagion" as a metaphor has also become imbued with positivity: "a byword for creativity and a fundamental process by which knowledge and ideas […] are communicated and taken up" (Mitchell, *Contagious Metaphor* 4). Taking my cue from this more optimistic understanding, the notion of contagion, both in terms of the crossover of forms and thematic dissidences challenging the hegemonic cultural or racial-socio-political status quo, seems a propitious one when describing the multimedia works of Eli Neira (b. 1973, Chile), Regina José Galindo (b. 1974, Guatemala) and Ana Clavel (b. 1961, Mexico). Within this volume, contagion can be linked to Debra Castillo's discussion of the "fungibility" of intermedial digital poetry (219–34), to Sarah Bowskill's idea, drawn from the work of Motín Poeta, of multimediality as a "contamination between artistic languages" (145 n.2) and

[1] A special thanks to Sarah Bowskill (Queen's Belfast), Nuala Finnegan (University College Cork) and Justine Pizzo (University of Southampton) for their comments on this chapter.

to Eli Neira's "Ch'ixi or 'sullied' mestizo identity, a compendium of impure attributes and hybrid techniques" (59). If genre, media, and mode become the key means by which forms of culture (literature, music, film, image) are (pre)categorized according to a set of "pure" qualities, then nowhere is this contamination more evident than in the multimedial, intermedial, or trans-literary works of performance-artists-writers-poets Neira and Galindo and multimedia writer and artist Clavel, whose self-conscious engagement with cultural hybridization highlights our understanding of genre/media/mode as a dynamic process, rather than as a pre-given set of rules (Frow 2–5).

Even the labels used here to describe the respective specialism – a notion typically denoting singular expertise – of Neira, Clavel, and Galindo have proven difficult to choose given the highly diverse and skilled artistic and (non)literary forms from which their works draw. While they often stress their status as either writer (Clavel) or performance artist and poet (Neira/ Galindo), they share, each in their own particular way, an interest in breaking generic conventions by combining multi-hyper-intermedially and/or translit-erarily "conventional" forms (e.g. poetry, photography, fiction) with more recent developments (digital technologies e.g., blogging, videos, website, online art, and (video) performance art). Such crossdisciplinarity is captured in the way Clavel is open to the idea of being labeled as a multimedia writer (Lavery *The Art*) and Neira's designation of herself as a multimedia artist (Lavery and Bowskill 3). These three creative practitioners are part of an ever-growing wave of other multimodal performance-artists-writers-poets who straddle different fields of expertise, in order to "pollute" restrictive categories of genre and cultural hegemonies, and thus create novel forms via "thought contagion." The contamination of media, particularly in the form of text and image (as of course other media), is by no means a new form of expression as Bowskill and Finnegan note in this volume (146; 188). In line with the multimedia work of Pura López Colomé and Monica González (Finnegan 186), the text-image crossovers of Neira, Clavel, and Galindo are embedded in the tradition of *ut pictura poeisis*, proposed by the poet, Horace. But what is significant about these practitioners is that they question "the binary opposition of image/text suggested by the philosophical debate on [...] the particular kinship between [...] genres" thus "challenging the possibility of any easy binary distinction or opposition" (Finnegan 188). The idea of contagion is specifically seen in the way these practitioners seek to contaminate historically considered "proper" or canonized cultural forms of expression with certain forms considered as "improper" cultural expression by the cultural hegemony. They challenge the notion of the "representational privilege" (Paz Soldán and Castillo 13) of either the (print-medium) written form or visual art forms such as painting versus more recent cultural forms such as digital art/literatures, installation,

CORPOREALITIES AND INTERMEDIAL/TRANSLITERARY CROSSINGS 109

or (video) performance art.[2] Such fusion of "new" and "old" forms/modes and intertextual collage exemplifies a kind of "resourceful plagiarism" in which these practitioners dynamically recycle previous voices or traditions in order to create something new. Borrowing is not a form of blind plagiarism but rather a legitimate and dynamic form of cultural exchange and accommodation in new contexts of cultural hybridization (Burke). Thus, as will be argued, such practice points to the decidedly mediated character of the works of Clavel, Neira, and Galindo.

The idea of media "polluting" also reflects thematic transgressions in their work. The interactions of both form and theme demonstrate how "dirty" corporealities become the prime vehicle with which to explore certain taboos such as scatology, non-conformist sexuality or political/gendered/racial violence in order to confront moral, cultural, sociopolitical, racial, or religious "givens." In the specific case of Eli Neira and Regina José Galindo, it will be shown how, from an intersectional perspective, the idea of body as waste acts as a springboard to explore the interdependent questions of racial, class, and gendered discrimination which become enmeshed in environmental exploitation. Indeed, the questions of environment, national politics, and indigeneity can be understood fully only if such intersections with gendered questions are taken into consideration. For example, patriarchal authoritarianism and the denigration of women's bodies, indigeneity, and the natural world become intertwined in dominant othering discourse. Although corporeality carries the burden of embodying "moral," "social" or "cultural" contagion (Mitchell, *Contagious Metaphors*), so too will it be shown how it becomes a site of possibility. Indeed, the works of all three creative practitioners foster not only awareness but also, in some instances, grassroots community engagement, and proactive citizenship.

Whereas the few existing studies about these practitioners have focused on each one of them, this chapter seeks to highlight the convergences of these creative practitioners taking Neira's work as its point of departure since of all three creative practitioners studied here scholarly attention given to her work is particularly sparse.[3] By placing Neira's work in a comparative context,

[2] While book printing today involves highly technologized interventions, the idea of traditional print-medium written literature is used here to refer to literature in printed book form versus for example hyper literature online. Book-form literature can be as experimental and improvised as hyper literary expression, and as noted in the introduction, digital literatures are not therefore a culmination of literary experimentation.

[3] Lavery and Bowskill analyze different cultural productions and/or perspectives on Clavel, Galindo, and Neira from the ones examined here. See Lavery (*The Art*); Lavery and Bowskill ("The Representation"); Bowskill and Lavery ("Eli Neira").

110 JANE E. LAVERY

the chapter also bolsters the volume's claim that there is an emerging Latin American multimedia crosscurrent.

"TAKING A/THE PISS": THE SCATOLOGICAL AS SOCIOPOLITICAL "DE-FORMATION"

The scatological – a prime example of a human pollutant – fascinates Neira, Clavel, and Galindo, because of its power to destabilize. The interest in the scatological can be found in Clavel's multimedia novel *Cuerpo náufrago* (*Shipwrecked Body*) (2005),[4] Regina José Galindo's poetic-performance *Piedra* (*Stone*) (2013) and Eli Neira's satirical literary essay *Minimanifiesto escatológico* (*Scatological Minimanifesto*) (2012) which serves as a textual accompaniment to the (video) performance of *El enemigo interno* (*The Enemy Within*) (2012). These creative practitioners share multimedia and genre crossing practices and the use of defecation and urination as strategies which challenge existing hierarchies and conceptions of genre, culture, race, gender, and sexuality as innate "pure" categories. In their scatological works – as well as in their wider multimedia *oeuvre* as we shall see – the (audio)visual and the written text enhance the meanings of each distinct form via crossover in the transliterary or/and intermedial sense.

For the purposes of clarity, briefly, I take here multimedia to suggest the use of different cultural media but produced by the same creative practitioner, or in collaboration with others, including not just the digital but other media such as performance, installation, music, novels, or poetry. The transliterary is used to refer to how distinct multimedia cultural production has stemmed from a literary text but, rather than simply adapting, these new forms of expression result in the creation of new spaces and understandings of the "original." There is a reciprocal function in the sense that both media, the "original" and the cultural production stemming from it, enrich and create fresh meanings for one another. As outlined in the Introduction, intermediality in its wide-ranging sense denotes the crossing of borders between media and/or where several media fuse and impact the meaning of these media/modes in order to create new mediations. As was described in the Introduction, the use of traditional and more recent media by the three creative practitioners studied here is neither aimed at evoking cultural prejudices which equate "traditional" forms of expression as "uninteresting" or "lacking in innovation" versus "new" forms (i.e., the digital) as being equated to the "innovative" and "interesting," nor at promoting the trope that digital technologies free writers and artists from the constraints and limits of print or "traditional" art forms. Instead, and as

4 All translations from Spanish sources are by the author.

CORPOREALITIES AND INTERMEDIAL/TRANSLITERARY CROSSINGS 111

Hayles and Pressman remark, both print-medium text/literature and the digital are interdependent and, as I propose here, intermediality fosters such interconnectedness. Both Verstraete and Spielman emphasize the transformative qualities of intermediality, which is key in the works of Clavel, Neira, and Galindo. As also outlined in the Introduction, and extending Jensen's terms (2016), I use the idea of "implicit" intermediality to describe the intermedial dialogue which arises between different media and modes/discourses, the intermedial reading that is *inferred* in other words. I use "explicit" intermediality where two or more media/modes are impacted physically/visibly by means of direct fusion. Both ("implicit" and "explicit") intermediality and transliterature have synergies since they "pollute" notions of innate categories of genre/ mode/media by means of crossover with the effect of creating something fresh while also serving to enrich each medium and mode used.

Ana Clavel's scatological incursions in her multimedia novel *Shipwrecked Body* serve to destabilize conventions of genre and gender binaries, (Mexican) *machismo* and LGBTQphobia, by suggesting, taking her cue from Judith Butler, in the novel's prologue, that gender, like sexuality, is a performance. The novel exposes "civilizing" body discourses which control the "impure" body by foregrounding its performativity. Antón/ia smuggles his/herself into the world of male urinals and toilets in order to explore his/her interstitial (non) straight sexual identity. The fluid exploration of gender and desire is exemplified in Antón/ia's discovery of French conceptual artist Marcel Duchamp's work *Fountain* (1917), a ready-made upside-down urinal in which he saw a link between the sensuous female body and the male urinal. The novel's generic/media/modal hybridization highlights how Duchamp's fe/male urinal, as mirror of Antón/ia's interstitiary gender, underpins a general troubling of genre both within and beyond the book. Indeed, the book inspired the creation of the transliterary and ("implicit and "explicit") intermedial *Cuerpo náufrago proyecto multimedia* (*Shipwrecked Body Multimedia Project*) (2005) entailing an art installation, a website, a (video) performance and photography exhibit, all of which continue to explore, in new ways, the novel's thematics of Duchamp's urinal aesthetics, (Antón/ia's) desire and gender/genre blurring.

Regina José Galindo's poetic-performance *Stone* involves volunteers and members of the public urinating on the performer's hunched up naked body which is covered in black coal resembling a stone.[5] Through "implicit" intermedial and transliterary dialogue, the poetic text, and performance explore issues of gendered violence, urolagnia, xenophobia, and (non)heterosexuality. During a roundtable discussion with Galindo, Lavery, and Bowskill considering the connections between Galindo's poetry and performance pieces,

5 For Galindo's performances and poems referenced here see www.reginajosegalindo. com.

Galindo noted that she does not think visually but poetically and that all her performances have stemmed from the poetic form, while both media enhance each other's meanings ("Conversation"). In this volume she similarly notes that her relationship to creativity started with the written word in the form of print-medium poetry and short story writing and that even though she is a fulltime professional artist, poetry forms the basis of her performance (24, 63–4). Her performances are examples of the transliterary as they have been influenced by the thematics of her poems and/or have emerged from one poetic source.

While *Stone* is exemplary of the transliterary as the performance stemmed from the poetic text, it also works intermedially in the "implicit" sense whereby the juxtaposition of genres/media/modes leads to new understandings. The poetic-performance recalls Neira's "poetics in action"/"CasAcción" aesthetics, whereby, via transliterary and "implicit" intermedial dialogue, the poet becomes a poet-actor and a rupture of language from the purely written form occurs which then becomes subsumed into individual and collective (audience) action and representation, in this case, of gendered, sexual, and racial violence. The online poetic text of *Stone* is embedded within a broader introductory text providing contextual information about the performance ("My body remains immobile, covered in soot, stone-like. Two volunteers and a member of the public urinate on the stone body"). Such discursive hybridization reinforces Galindo's overall intermedial transdisciplinary practice. Galindo's poetic text refers to the woman as an object, a stone, who throughout "world history" has been subjected to male abuse, "humiliation," and "lascivious gazes" which the pornographic "urophilic" act reinforces. The female body as marked, colonized territory by the male phallus becomes literalized in the act of urination (Fig. 23). While the woman's stone-object status is buttressed in the text, and, in particular in the performance, the poetic text also supports woman's historic ability (to a point at least) to stand firm against violence ("I cannot feel the blows") aided by her rock-like resistance ("I'm a rock inside"). Thus, it is the transliterary/intermedial dialogue between poetic text and the audiovisual which provides a glimmer of hope for women subjected to patriarchal sexual violence and constrained by traditional gender roles. Both forms work together to reinforce their focus on gendered violence perpetrated by men against women, but such interpretation is destabilized in the performance as it involves not only the participation of male but also female volunteers. The possibility that gendered violence can and *is* perpetuated by women against women is disturbing, perhaps all the more so because of entrenched notions that gendered violence is mainly perpetrated by men against women.

Yet the focus on gendered violence is also diluted in the performance in comparison to the poetic text as no actual violence ("blows") against the female performer is enacted. Is it possible, therefore, that this is merely a

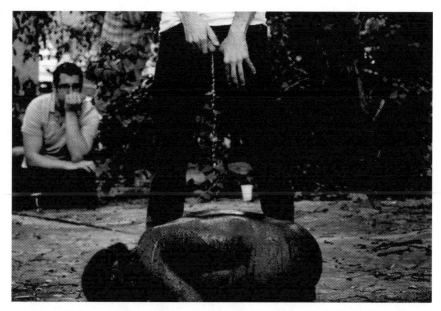

23. *Stone* (*Piedra*) 2013. Photo: Julio Pantoja and Mariene Ramírez-Cancio. Image courtesy of Regina José Galindo.

playful allusion to pornographic fantasy involving the performance of a game of sexual submission and dominance since the voluntary participation of male and female members of the public are colluding with the consenting female performer? Even if it is read as an instance of fantasy, Galindo still manages yet again to disturb pre-given conceptions since urophilia is commonly perceived as a patriarchal, heterosexual fantasy enacted typically by men on women or by women on women performing for male viewers. However, having a woman urinate on another woman also destabilizes such conceptions. Thus, by compounding suggestions of lesbian sexuality with urophilia, which is perceived as an outlandish fetish by some, Galindo is also playing upon the stereotyped equation of non-heterosexuals with deviance. Finally, the contrast between the upright lighter-skinned participants towering over the hunched dark figure of the stone-woman, might be read as another interrelated and intersectional layer of interpretation in the context of Guatemala's ethno-historic (post)colonial racial inequalities between its black or indigenous and Ladino communities which Galindo explores more explicitly at a glocal level in other works such as *Desierto* (*Desert*) (2013). The charred corpse-like stone could also be interpreted as reference to the extractivism of Guatemala's natural resources because of deforestation and its effects on indigenous communities due to neo-colonial hyperconsumerism. Overall, *Stone* shows how the

"implicit" intermedial/transliterary interactions between poem and performance and their various (dis)engagements with violence, ambiguously, and cynically, unsettle pre-givens as in the works of Clavel and Neira.

In *Hago el amor conmigo misma* (*I make love to myself*) (2017), Eli Neira compares the process of writing to the sensation of "wanting to wee and not being able to find a toilet nearby" (2). Like her writing, Neira's (audio)visual work is visceral, both in terms of its process and content, as we see in the performance of *Internal Enemy* (2012) and the blog literary essay which stemmed from it, *Scatological Minimanifesto* (2012). These two examples fit better into the description of intermedial rather than transliterary crossover, since the literary stemmed from the performance piece rather than vice versa. Read and viewed in conjunction "implicit" intermedial dialogue arises between the print-medium literary-chronicle essay, and the (online) performance art/blogging, and thus becomes a springboard for genre pollution and social critique. The online video shows Neira walking around in a rundown city street reading excerpts from the Chilean Political Constitution and tearing out pages from it. She is wearing a white nightie without underwear, her trademark gimp-cum-freestyle-wrestling mask, black patent boots, a dog collar bracelet and the Chilean flag wrapped around her stomach. Lifting up her nightie, she crouches down and defecates on the constitution while continuing to read excerpts from it. Stray dogs linger about and one even eats the feces.

Scatological minimanifesto, which is available online alongside the video performance, is a blog-essay which satirizes the rhetorical political manifesto discourse by drawing from the satirical literary essay and the literary-journalistic *chronicle* convention only then to extend these two traditionally print-medium formats by combining them with digital technology in the hypertextual format of her blog which is accompanied with the video performance. As Neira notes: "the manifesto is a satire which blends genres in order to mock them but which also has the function of explaining the context and objective of the performance" (Email, 5 February 2018). Like Galindo's *Stone*, the "implicit" intermedial dialogue between the audiovisual and written medium provide a powerful sociopolitical critique. As the online reader-viewer is compelled to move back and forth between text and video performance, both media have a reciprocal function: while the performance serves to fill in gaps which remain unexplained in the text, the text serves to fill in the gaps which remain unexplained in the performance. In performance it is suggested that "witnessing a live event can transfer more knowledge than the mere act of digging into the archive in that it requires the "presence" of the spectator, the engagement of *all* of our senses" (Diana Taylor quoted in Barbosa 65). However, it could be argued that being able to access the (video)performance and *Scatological* at once, this can in fact "transfer more knowledge" since both media reveal aspects to the reader which the other may not. The same applies to Galindo's

CORPOREALITIES AND INTERMEDIAL/TRANSLITERARY CROSSINGS 115

Stone, where performance alone relies on the "presence" and engagement of the senses attained by audience participation. But access to both text and (video)performance online divulges elements which the other does not.

Unlike the performance of *Enemy*, Neira's essay gives the online reader-viewer context about the history of art's relationship with the fecal: "shit has always been present in art, since [...] a caveman dipped his hands in shirt [...] the first great 'Artwork' of mankind [...] there is shit [...] in Kassel's Biennales" (*Scatological* n.p.). Neira's defecation, like Clavel's and Galindo's references to toilets and/or urinating, becomes an acknowledgment of the extensive history of scatological art and literature which, like their own fecal practice, serves as a humorous riposte to the social taboos surrounding the details of such a private subject and produced with the intention of flouting moral, social, and artistic conventions. While all three writers-artists are drawing from a long line of artworks about "shit," so too does their use of the fecal as a dual metaphor of "thought contagion" and as source of human disease become embedded in feminist subversion which the transliterary/intermedial crossings of genre and form confer. (Fecal) art and literature has historically been primarily male-authored and sanctioned by cultural hegemonies to the exclusion of female creative practitioners, and thus Neira, Clavel, and Galindo seek to redress this imbalance. Clavel also engages with fecal and outlandish thematics in conjunction with experimental transliterary/multimedia forms as a self-conscious admonishment of the feminization of the publishing market in Mexico and globally with its promotion of "easy" consumable "women's writing." Neira's *Enemy, Scatological,* her broader intermedial/transliterary works, and recent Facebook and blog entries (https://medium.com/@elizabeth-neira), are similarly an indictment of the standardizing effects of (patriarchal) neo-liberalization and globalization on the culture industry in Chile.

In Neira's fecal work, both the visual and written texts fill in the "lacunae" for each other in other ways. The oral element of the performance conveys the institutionalized discourse of the constitution while the performatic body becomes the vehicle to contest that discourse. Both the oral and aural become more effective media than merely the written: rather than reading in silence, which is often a private, unspoken act, Neira chooses to make it a public, communal activity by reading aloud to her present or virtual audiences. Like reading, defecating is today seen as a largely private act and so the latter becomes all the more horrifying by making it public. But the revulsion we feel towards such an act serves to redirect our horror towards the (silent) language of violence. The monotone tone of the performer's voice is particularly effective in conveying how language has been used to institutionalize – and often to coerce with violent means – citizens of a nation. In opposition to speech is the notion of "body talk," which becomes relevant here. Drawing from Severino João Albuquerque, Barbosa states that the staged body, which communicates

"nonverbal violence [...] through a combination of staged effects," must be "situated" and assigned to a "site of utterance with which specific phenomena are associated" (65). Nonverbal violence is "typically enacted on the performer's body; it may also employ props, décor, lighting, music, and sound effect" (65). For Neira (Email 5 February 2018), in *Enemy*, space and performance become interdependent of each other in communicating violence both verbally and nonverbally.

The text in *Scatological* provides specific context for that violence by exploring the concept of the "enemy within," which is the performance's title. In *Scatological* Neira ironizes the manner in which Chileans today seem to express more disgust towards one's feces, than towards sociopolitical and racial injustices afflicting the nation. Naming her feces as the "enemy within," she asks: "Does anyone remember who the enemy within was during general Pinochet's government? All of us were the enemy within." Neira may be seen here to be critiquing that fact that the so-called "enemy within," that is, those political opponents who experienced violent repression by Pinochet, have been forgotten because collective amnesia now prevails. Neira explains how:

> That terminology was used during the military dictatorship to designate that which they called "the communist cancer," which was applied to any form of dissidence [...] I liked the idea of "shitting" out the enemy within and playing with the concept of inside and outside which ultimately served to kill my compatriots. (Email 5 February 2018)

Neira's excretory act thus becomes a form of cathartic expungement of the "enemy within" making this act of resistance visible: "liberation of both my innards and my whole being" (*Scatological*). The idea of "inside and outside" can similarly be understood in the broader context of (Western) thought, whereby the "clean" body, which is framed within conceptions of inner and outer, is threatened by "dirty" "liminal spaces where exteriority and interiority of bodies merge" (Longhurst 5). Neira's, Galindo's and Clavel's (audio) visual-textual depictions of bodily processes considered unacceptable in polite society draw attention to the oppressive emphasis placed by society on the control and management of (female) body functions and smells which threaten with moral and physical contagion (Mitchell, *Contagious Metaphor* 4). The olfactory and visual disgust that feces produce in Neira's work – "Smell it. Take a good look. What do you feel? Disgust?" (*Scatological*) – parodies the need to eliminate "liminal" olfactory offenses and waste. By recoiling at Neira's smelly "shit," and indeed at Clavel's and Galindo's odorous urination representations, we are in denial of our shared humanness. We recoil in horror because of the idea of bad smell and taste which is harnessed via the dog sniffing and eating Neira's feces. We may not be able to smell Neira's feces nor the urine in *Stone* or *Shipwrecked*, but we know what they smell like because we know our own smell. Thus, we are both horrified and fascinated by others'

CORPOREALITIES AND INTERMEDIAL/TRANSLITERARY CROSSINGS 117

and our own abjectness (Kristeva).[6] Neira's, Clavel's and Galindo's scatology causes horror, yet its fascinating abjectness causes viewers-readers to reflect not only upon their own materiality but also its social containment.

"POLLUTING" CORPOREALITIES AND CULTURAL RECYCLING

The abject as theme in the work of all three creative practitioners also becomes enmeshed in abject multimedia/transliterary/intermedia practice. The fusion or dialogue of different media may horrify because of their "contagious" effects on cultural boundaries, yet similarly fascinate because of the recognition of the inevitability of cultural hybridization. The destabilization of genre, media, and mode as "uncontaminated" form by means of multimedia practice reflects how normative ideas of the "clean" body are challenged in the works of Neira, Clavel, and Galindo by presenting bodies which are marked by sexual "impurity" or gender fluidity. For Neira and Galindo corporeal contagion is also linked to gendered violence, environmental degradation, and racial othering. All three artists draw from corporeal "excess," waste and/or environmental contagion as a means to explore with different multimedia forms the idea of cultural recycling which posits the idea of "pure" media/genre as a construct.

Like Clavel and Galindo, Neira uses her written literary corpus, collages, photography, and performances to explore "impure" bodies and desires via media and genre crossovers. Often donning S&M gear, Neira embraces queer "contaminated" forms of sexuality. Her post-porn vision is in line with performance artist Annie Sprinkle's "subversive repetitions" (Judith Butler quoted in Williams 122) which challenge innate gender and sex categories consisting of ""perversions," which "broaden the understanding of sexual performance and the range of sexual objects conventionally not regarded as acceptable" (Williams 122). Neira questions conventional (heterosexual) clichés of pornography by using LGBTQ forms of desire and, at times humorous, "outlandish" props such as a dog sucking her breast or a crutch to support her brace-bound broken leg, while wearing a gimp-come-freestyle-wrestling mask and nothing else ("La tiendita").

Neira's *Corazón inmaculado* (*Immaculate Heart*) (2014) collage, which is a crossover of traditional painterly traditions with modern digital art, is an "explicit" intermedial parody of "pure"/contained female sexuality and a powerful rebuke to consecrated Marian painterly traditions by means of cultural recycling. It has synergies with Clavel's use of Duchampian desecratory digital

[6] I have explored in Clavel's work (*The Art*) the idea of waste, abjection, and cultural recycling. I am now able to extend my findings to Neira and Galindo, thus confirming the idea of an emerging multimedia crosscurrent of cultural production.

ready-mades which work intermedially to admonish painterly traditions with "creative plagiarism" (Lavery *The Art*). *Immaculate* is a reworking of an iconic image of the Virgin Mary which has been endlessly reproduced by canonical painters such as Sandro Botticelli, Charles Bosseron Chambers, and in mass market culture forms. Neira desecrates the "original" via digital manipulation by presenting the virgin as giving a blowjob to a disembodied penis, while slices of fruit surround the virgin's head in parodic halo fashion. Female sexuality as impurity becomes enmeshed with religious discourse in order to question ideals of virginal containment. Mary's sexual immaculacy and maternal self-sacrifice are perceived in Catholicism as the highest example of female virtues. In retaliation against these restrictive conditions promoted by Church dogma, *Immaculate* celebrates "excessive" female sexuality. The "explicit" intermedial collage of the Marian painting with (digitally imposed) highly eroticized and humorous Carmen Mirandaesque imagery mocks the religious myth surrounding this figure's sinlessness. It similarly plays upon time-honored male anxieties about woman's sexual "unruliness" which must be policed. The link between food and the Virgin Mary's sexual voraciousness functions as a parody of the stereotyped male fear of castration at the hands (in this case the mouth) of predatory women. The desecration of such a venerated iconic painting with the use of hard-core pornography has caused outright shock as revealed in Neira's blog entry ("Corazón"). She notes how this "collage has led to several complaints on social media platforms." As with many of Neira's other works, she has responded to criticism of her collage. Unapologetic, she perceives its desecratory thrust as a feminist call for women's sexual liberation: "The myth of Mary's virginity points to the repression of women's bodies and it is a good thing to start asking ourselves why we should accept this" ("Corazón").

"Leche de Dios" ("God's Milk"), a poem in the *La flor* (*Flower*) collection (21–22), which Neira used as the basis of a musical poetry-performance *Poesía para señoritas* (*Poetry for Young Ladies*) (2012), similarly desecrates religious holiness with sexual allusion and "explicit" intermedial practice. The polluted body metaphor is made through reference to milk which becomes an example of the abject (Kristeva) with its association with maternal and sexual excretions. References to human and animal milk ("God's Milk" 21) highlight how both man and animal are united by "grotesque" biological functions, recalling Neira's comment that animals and mankind alike share in common defecatory needs (*Scatological*). In reminding us of our base excretory functions and the "threat" that these pose when the boundaries between inner and outer collapse ("Milk inside/Milk outside" 21), so too is Neira mocking those lessons in "horror" in which one is taught in religious or patriarchal discourses so as to repress the (female) abject within us. Food and sex become interlinked

CORPOREALITIES AND INTERMEDIAL/TRANSLITERARY CROSSINGS 119

in "God's Milk," as with *Immaculate Heart*. Milk becomes imbued with the sexual as it now refers to God and men ejaculating into the (female) body: "Milk inside […] Milk of men/mankind/Milk of saint/Milk of God" (21–22). Orgasmic secretions become doubly horrifying: not only do they evoke our leaky body and irrepressible primal drives, but also God's (supposed) own mortal urges, which counters this figure's conventional association with (sexual) sanctity.

The hybridization and cultural recycling of genres via "explicit" intermediality and the transliterary also becomes apparent in the poetic-musical-performance of *Poetry for Young Ladies*, whereby both text and the audiovisual enrich one another. While the musical performance derives from the original poem, the poem as a print medium is transformed as it becomes a primer of Neira's "poetics in action"/"CasAcción" aesthetics. The singular creative voice of "God's Milk" becomes a collaborative act as Neira performs the poem along with another independent multimedia artist, Chilean musician-poet Federico Eisner. In his performances Eisner fuses diverse musical traditions with his poems in order to produce genre fusions and experimental expression, in line with Chile's poet-musicians belonging to the *Orchestra of Poets* of which Eisner is co-founder. *Poetry* fosters "explicit" intermedial dialogue between different forms and others' creative voices with the aim of creating a borderless form of expression even as the title, clearly parodical, appears to reinforce boundaries of gender and genre. Neira explains that the poem was conceived as a song to be set to music before it was transcribed into the written form. But even as a written poetic piece it was not intended for individual consumption but rather as an oral piece to be shared with others relying on the "presence" of audiences and engagement of their aural-visual senses. Neira notes (Email 21 February 2018) that this is a practice which other poet-musicians, such as Violeta Parra, have adopted in the past in Chile and whose work has inspired her own. The disharmonious quality of Neira's poem, with its rhythmical pattern and yet jarring thematics, is captured in the fusion of genres in *Poetry*. As Neira chants her poem using a sexualized tone to a rhythmical music beat, her voice becomes louder to the point of shouting, emulating the experience of orgasm and the chant of political dissident.[7] Eisner is playing the electric guitar which sometimes mirrors the rhythmical pattern of voice and electronic repercussion beat while at other times he plays chords which differ from the base rhythmic pattern.[8]

[7] The poem is an ironic riposte against Chile's social elite who have not provide basic human utilities for Mapuches.

[8] For Neira (Email 10 May 2018) her recent musicalized poems performed with the ecofeminist AMAPU collective are more significant than *Poetry*.

As in Neira's work, Clavel's genre crossovers and use of multi/intermedia and transliterary platforms combining the (non)literary, mirror the explosion of normative desire as we see in *Shipwrecked, Las Violetas son flores del deseo* (*Violets are Flowers of Desire*) (2007); *Las ninfas a veces sonríen* (*When Nymphs Smile*) (2013) and *El amor es hambre* (*Love is Hunger*) (2015). Clavel reworks fiction and visual art traditions by imbuing them with the erotic or the queer in the sense of the (sexually) "strange." In *Shipwrecked*, Duchamp's fe/male urinal is one of many "odd" visceral images of the works of other renowned artists and photos taken by Clavel depicting genitals or toilets. The reader-viewer becomes actively engaged in decoding intermingling discourses and media. *Shipwrecked* becomes a primer of intertextual texts-within-texts, playing with a number of (fictional) forms, the mixture of the "high" discourse of academia and the "low" discourse of vulgar conversation, as well as presenting her novel as a book object or photography book. *Nymphs* is similarly a reworking of pre-established genres that draws from Greek and biblical myths and imbues them with eroticism, whereas *Love* is a "perverse" reworking of the Little Red Riding Hood fairytale. In both these novellas, child autoeroticism is particularly disturbing since female/child autoeroticism and the notion of the child as agent serve to explore a silenced zone of pleasure which is often considered as "improper," just as the crossing of pre-established genres is perceived as "improper."

Clavel's textual incursions into taboo/queer desires have inspired numerous transliterary multimedia exhibitions of artworks, performances, and YouTube book trailers which Clavel has created herself or collaboratively with other visual artists such as Rogelio Cuéllar, Paul Alarcón, and Maria-Eugenia Chellet. Clavel first used the idea of the transliterary in 2015 to describe her multimedia novella *Love is Hunger* and now in this volume applies the concept to her overall *oeuvre*. For Clavel (15, 34, 36–8, 41–2, 44–5, 47–9, 51), the transliterary emphasizes the centrality of the written text *and* the way in which the original is *supplemented* by other media which do not adapt the "original" but create new forms of meaning and expression not found there. Viewed in this light we can say that *Shipwrecked*, the novel – as is indeed the case in Clavel's other fictional multimedia works – became part of a transliterary project with the production of the *Shipwrecked Body Multimedia Project* entailing art installation, a website, a (video)performance and photography exhibit in collaboration with other artists. While each component of the multimedia exhibit added new meanings to the "original" novel as a space not configured in the book, so too were the novel's thematics of Duchamp's urinal aesthetics, (Antón/ia's) desire and gender/genre blurring a recurring motif. Clavel notes (48) that the art critic José Manuel Springer's lukewarm reception of the *Shipwrecked* exhibit may be explained as being the result of his misinterpretation of the event as a standalone multimedia exhibit, rather

than as an example of the transliterary, whereby the multimedia outputs refer back to the literary source. Although Springer himself champions "alternative" art forms which overlap various fields in the form of art installations, for instance, his reservations may be linked here "to a broader anxiety about the crossing-over of diverse disciplines conventionally kept apart, evidenced in particular in the encroachment of so-called new media or contemporary art forms on traditional art forms" (Lavery 252).

For the transliterary multimedia exhibition of *Love*, the installation *En todo corazón habita un bosque/Enramadas de "El amor es hambre"* (*In Every Heart There Lives a Forest/Entanglements of Love is Hunger*) comprised a woman dressed as Little Red Riding Hood while performing a musical dance to Bedřich Smetana's *Moldau/Vltava*. Meanwhile a photomontage video was projected onto the wall showing images of this actress in a forest juxtaposed with quotes from Clavel's novella. On the same wall, sketches of Little Red Riding Hood and the wolf were hung. The intertextual playfulness of *Love* and the transliterary and "explicit"/"implicit" intermedial dialogue between different media of the installation function to supersede the element of fear of the unknown which forms the basis of the "original" versions of Little Red Riding Hood by substituting it with the erotic (Dorantes). Clavel's transliterary practices in (multimedia) *Love* and her overall literary-multimedia *oeuvre* highlight the dynamic recycling of previous traditions in order to create something new resulting in non-literary expressions which are not bound by the need to provide faithful representation of the "original." The transliterary, like the intermedial, similarly enriches the "original" literary texts, whether those are Clavel's *Love* novella from which the multimedia pieces emerged, or the "original" Little Red Riding Hood fairytale. Transliterary recycling should not be seen as a corruption of established forms (children's fairytales, in the case of *Love*, for instance), but rather as a "polluting" practice entailing renovation as well interpretative and creative freedom, in other words, "thought contagion."

ENVIRONMENTAL/CORPOREAL WASTE AND RECYCLING

Cultural recycling also becomes intertwined with the notion of environmental recycling in the work of Neira and Galindo, whose "dirty" corporealities are analogous to environmental waste. Their performances become springboards from which to explore environmental waste and degradation and their effects on both (Indigenous) local and global communities. From the perspective of intersectionality, both Neira and Galindo coincide in their interest in exploring by intermedial and/or transliterary means, the interdependent questions of racial, class, and gendered discrimination which often become enmeshed in environmental exploitation. They form part of a growing corpus of Latin

American ecofeminist artists and writers who highlight the ways in which women and nature have been devalued as "other" (Field), as we saw with Galindo's *Stone*. Similarly, the abject (female) body as metaphor for environmental waste becomes subsumed into the idea of the indigenous body as abject "other." Young (202) expands upon Kristeva's abjection, and posits that social groups labeled "other" are positioned as abject, waste, and hence oppressed on grounds of race, gender identity, age, ability, and sexuality.

Neira's concerns with environmental and racial injustices are present throughout her multimedia output in the context of transliterary dialogue. While her Facebook posts, blogs, and performances on the environment and racial injustices have not stemmed from one poem in particular, it can be argued that as the (print-medium) poems were written prior to the other multimedia outputs dealing with these same themes, these later creative forms of expressions are transliterary as they have been influenced by the thematics of the earlier poems. One poem which serves as a transliterary springboard from which to explore the intersectional links between race, gender, and the environment is "Soy terrorista: anti postal 6, al Mapuche en huelga de hambre" ("I'm a Terrorist: Anti Postcard 6, to the Mapuche on Hunger Strike") (*La flor* 41–42). "Soy terrorista" ironizes the labeling of the poetic persona/Neira as a "terrorist" – which carries the connotation of the "enemy within" explored earlier – for being a woman ("I am a terrorist for being a woman and for being free"), an antisocial "indigenist" and friend of the Mapuche "other," while Chile's exploitation of the nation's natural resources goes unchallenged (41)."I'm a Terrorist" is transliterarily connected to Neira's subsequent performance *Tu patria está llena de basura* (*Your Homeland is Full of Rubbish*) (2017).[9] While the performance derives indirectly from the original poem in terms of the thematics being reused in this medium, the poem as a print medium is also transformed into a collaborative and communal form of expression. The intermedial musical-photography-performance *Your Homeland* sees Neira and the feminist, activist, human rights, and environmentalist group AMAPU collaborating in order to decry the glocal problem of hyperproductivity, plastic waste, and the repression and murders of Mapuches in Chile. During the performance, which takes place on a beach in Valparaíso, we see Neira and AMAPU activists sitting around the Chilean flag while chanting the Mapuche words "Ayun mapu, newen mapu" to the beat of a drum. As the music continues, the women start picking litter which they place on the flag. They subsequently carry the litter-laden flag through the streets of Valparaíso until they reach the Navy Command building where they chant "your

[9] The poem transliterally connects to Neira's Facebook entries which support Mapuches on hunger strike protesting against the Chilean government's imprisonment of Mapuche activists fighting for indigenous rights.

CORPOREALITIES AND INTERMEDIAL/TRANSLITERARY CROSSINGS 123

homeland is full of rubbish." While the performance is clearly an attack on environmental neglect by the government, so too does it become a wider protest against (post)dictatorship repression of the dissident "enemy within" and the nation's endemic classist, racist, and misogynist attitudes. Neira is dressed in a traditional black-and-white maid outfit as a protest against Chile's widespread exploitative practice of using underpaid domestic servants who typically are lower class (Mapuche) females. Sociopolitical critique emerges from the ("explicit") intermedial crossing of the media of song, image, and communal bodily performance of transdisciplinarian artists and activists, as Neira explains:

> The mantra "Ayun mapu, newen mapu" means peace on earth, love for the earth and was sung by a neighbour who is a therapist and also performs peace dances [...] Through different multimedia expressions, the metaphor of rubbish allowed us to talk about the global rubbish crisis and femicide. The photo on our backs is of Nabila Riffo who survived a femicide attempt in Chile [...] The metaphor speaks of the deaths of Mapuches, activists and natural resources by extractionist and ecocidal politics. For us there is a direct relationship between the hate and disdain towards women and that felt towards the earth. Femicide and ecocide correspond to the same thought-matrix. (Email 21 February 2018)

Having emerged indirectly yet transliterarily from the poem "I'm a Terrorist," *Your Homeland* thus becomes exemplary of the degraded and polluted female/racial/environmental nexus as well as a feminist contestation of such "othering." *Your Homeland*, like Neira's overall (environmental) activist communal performances, is a primer of her "poetics in action" in conjunction with her more recent "CasAcción" aesthetics.[10] Both strategies involve intermedia/transliterary genre/media crossovers and collaborative creative practice with other independent transdiciplinarians, artists, and activists fostering not only awareness but also grassroots community engagement and proactive citizenship involving, for example, litter picking or demonstrations against femicide.

Galindo's interest in linking women's bodies to environmental waste and gendered violence is nowhere better highlighted than in *No perdemos nada con nacer* (*We Don't Lose Anything by Being Born*) (2000), featuring Galindo wrapped up in a transparent body bag dumped in a landfill in Guatemala City,

[10] Both are representative of different stages in Neira's artistic and socio-political trajectory: whereas "poetry in action" was a strategy Neira used as an independent creative producer in Santiago, she now continues participating in similar community events and residencies but under the aegis of "CasAcción" which is located in her home in Valparaíso (Email 10 May 2018). The important difference is that "CasAcción" involves working in collaboration with AMAPU.

and her poetic-performance *Desecho* (*Waste*) (2017), where she placed herself in a rubbish bag and was transported in a waste disposal lorry. Both performances explore the glocal femicide crisis and the effects of globalization, mass consumption, and inappropriate mechanisms of disposal and recycling. By connecting the (female) body and inferred death to environmental rubbish, the poetic text of *Waste*, which gave rise to the performance of the same name and accompanies it online, works intermedially and transliterarily to explore the idea of femicide and environmental degradation as an inconvenient truth and society's inadequate response to these issues.

While the degraded woman-nature nexus continues in Galindo's *Desierto* (*Desert*) (2015), so too does this poetic-performance become the catalyst to explore interrelated and wider non-gender-based issues including (glocal) environmental degradation, indigenous rights, and torture. As with *Waste*, *Desert* is a transliterary piece in that its poetic text gave rise to the performance and similarly can be read alongside it online. Like *Stone*, the poetic texts of *Waste* and *Desert* are part of broader texts providing contextual information of the performances highlighting, once again, "implicit" intermediality via discursive/modal crossovers between the factual and the lyrical. Buried beneath a pile of sawdust, bar Galindo's head, *Desert* makes clear connections between the exploited land and the rape of both Mapuche and Mayan women under military dictatorship in Chile and Guatemala. But this stark image broadens in meaning as it becomes a metaphor for the xenophobic violence perpetrated against the Chilean/Guatemalan indigenous communities as well as for local desertification/deforestation as a global phenomenon and its effects on indigenous communities. Environmental degradation as the inconvenient "other" of society becomes a metaphor of the indigenous community as burdensome "other." Both poetic text and performance serve to enrich as well as to fill "lacunae" in our understanding. The poetic text provides context to the performance by starkly alluding to the effects of unrelenting exploitation of lands. The idea of unyielding environmental degradation is conveyed in the repetition of "will continue" which also alludes to the way we detach ourselves from the harm we cause: while we profit from exploitation of natural resources we turn a blind eye to the realities of environmental degradation. However, the final "we will thus be desert" becomes a stark warning: the impersonal becomes the personal since our indifference to nature's plight will have a devastating effect on all of us. Like *We Don't Lose*, the performance, *Desert*, both horrifies and fascinates perhaps more so than its lyrical textual counterpart, with its deathliness – Galindo's head seems severed from its body – and its use of sawdust, which is a by-product of hyper-exploitation. This dual response can be understood in the context of Kristeva's view of the corpse as the prime example of abjection that needs to be banished from sight because of its reminder of our materiality and

CORPOREALITIES AND INTERMEDIAL/TRANSLITERARY CROSSINGS 125

mortality (3–4). It becomes literalized in the plastic body bag (*We Don't Lose*), rubble (*Waste*) and organic by-product of sawdust (*Desert*). The monstrous quality of aggressive deforestation is similarly foregrounded in *Desert* because of the abject horror and fascination the dismembered body elicits in viewers, again providing another "implicit" intermedial layer to the poetic text from which the performance transliterarily emerged.

Neither the notion of creating art out of (in)organic found objects such as plastic, urinals, human waste, and sawdust nor the reusing of past styles and forms in both literature and art is new. Indeed, the human rubbish/ waste motif in Neira's, Galindo's and Clavel's work nods to past traditions such as performance, waste and "found object" art, the *cartonera* (cardboard) movement and literary cultural expression. These practitioners could therefore be critiqued for exemplifying "pastiche," the uncritical imitation and reusing of past styles/voices, and thus lacking in self-criticality or insufficiently demonstrating parody's derision and laughter (Jameson 114). Some of Clavel's artistic multimedia projects and Galindo's body performances have been critiqued for their "déja vu" qualities by some art critics (Lavery, *The Art* 251; Lavery and Bowskill 62–63), which, arguably, Neira's work could also be accused of given the similarities between her body art work and that of Galindo and previous (Latin American) body performance movements such as Chile's *Cada* and the *Escena de Avanzada*. However, their particular versions of collage refute Jameson's "blank parody" (114) and instead use their own hybrid systems of signification in order to subvert, as we have seen, the social status quo, cultural/social institutionalization, notions of canonicity, genre boundaries, and uniqueness by using parody and/or cynicism in their conscious adoption and adaptation. By (re)using of everyday objects and/ or bodily activities in new and unexpected contexts, both Galindo's, Neira's and Clavel's particular aesthetics of alienation seek not only to disturb the reader-spectator's expectations but also to raise awareness or, optimistically perhaps, foster proactive citizenship. The recycling of (non)biodegradable materials in order to produce new, even innovative, items has parallels with Celeste Olalquiaga's ideas on cultural commodification which she describes as a dynamic process whereby "goods that become obsolete are easily retrievable and often broken down and idiosyncratically reconfigured. This form of pastiche can become a kind of cultural critique" (Olalquiaga paraphrased by Helga Druxes, 46). These multimedia practitioners seek to celebrate cultural recycling's capacity to lead to innovation and transformation of cultural and social values as well as to draw our attention to the way they use existing forms and voices as a self-critical tool via multi/intermediality or/and transliterature which mediation confers.

CONCLUSION: MEDIATION AND "THOUGHT" CONTAGION IN MULTIMEDIA PRACTICE

The notion of cultural recycling points to the highly mediated quality of the works of Clavel, Neira, and Galindo. Mediation similarly underpins how none of these multimedia practitioners seeks to represent reality *as it is*. Instead, they perceive mediation as a vital, not detrimental, tool as a means to uncover the trap of "authentic" representation (Díaz 39) in order precisely to question, as we have seen, the truth claims which have bolstered the edifice of institutionalized discourses of genre, gender, race, identity, environment, and nation. Through the use of transliterary and/or inter/multimedia, these creative practitioners provide us with a continual and intellectual self-interrogating practice by reflecting on the role of mediation in art, literature, and sociohistorical "truth." Neira's awareness of art's mediated status of the "real" in her performance and multimedia practice – "My shit is both real and mediated" (*Scatological*) – can be understood in opposition to the idea of "reflection," as Raymond Williams proposes. Indeed, the critic notes that mediation, which is a term used "to describe the process of a relationship between 'society' and 'art,'" and that one "should not expect to find (or always find) directly "reflected" social realities in art, since these (often or always) pass through a process of "mediation" in which their original content has been changed" (83).

Williams' definition of mediation which connects art and society resonates with Higgins' call to infuse multimedia with the political ("Statement"). Like Neira, Galindo's work similarly does not claim to use art as mirror of life. The works of a number of other Latin American performance artists, including Galindo's own, are not at "the service of pushing the boundaries between art and life/reality, as performance art has often claimed to do" (Horn) but instead are intended to:

> troubl(e) the commonplace idea that art is equivalent to life, and life is art [...] while art [...] celebrates life with a regenerative force [...] artistic actions that address inequalities and conflict are not equivalent to real life endured under actual repression. (Cullen)

Clavel's exploration of the collapsing of the boundaries of art and life and the reaffirmation of such boundaries is seen for example in her inter, multimedial, and transliterary practice exemplified in the proliferation of urinals which become exemplars of postmodern reality replaced by their replica in *Shipwrecked* (novel and multimedia) or in the sex dolls as replacement for real women in *Violets* (novella and multimedia). In her works, as indeed in those of Galindo and Neira, audience synaesthetic interaction also becomes a prime example of how these multimedia practitioners are self-consciously playing with mediation. The audiences become complicit in, and with, the meditative

act by "playing along": Galindo, Clavel, and Neira encourage us to step into a metaphorical "red zone" (Neira "Hacia") where the boundaries between life and art momentarily collapse as we become partners in crime: whether it be the complicit "touchers" clicking on the "clitoris-button" to undress an object-woman and the participants winding up the mechanism of a sexualized *lolitaesque* doll (Clavel, *Violets* exhibit; https://www.violetasfloresdeldeseo. com/); the male and female participants standing between toilet dividers in front of urinals and simulating the "expected" urinating standing position of the Western male (Clavel, *Shipwrecked* multimedia installation); the participants urinating on the indigenous woman-stone (Galindo, *Stone*); or the street passersby helping Neira to reposition an enormous *papier mâchée* ovarian egg she carries on her back as protest against institutionalized motherhood in Chile (Eli Neira and Feministas Biobio). By converting participants into metaphorical partners in crime who "perpetuate" gendered, racial, sexual, social, and environmental injustices or expectations, so too does their self-conscious meditative involvement encourage them to reflect on – and possibly even take proactive steps against – such issues.

Yet even if we are able to step out of this make-believe role, and rebuild the boundaries between life and art, these artist-writers-poets have a powerful ability to discomfort us with a lasting effect resulting in "sharpening and provoking our critical senses" (Cullen 2). Despite the playful, consensual role-playing which mediation confers upon audiences, and the overall self-consciously meditative qualities of the works of Neira, Clavel, and Galindo, this does not lessen the power of their works and the messages within them. Indeed, as we have already seen in relation to their *oeuvre*, mediation as well as multimedial, ("implicit"/"explicit") intermedial and transliterary dialogue, and even synaesthetic involvement, serve as a powerful vehicle to disturb our stable foundations of knowing – be they cultural, social, moral, or philosophical epistemological premises – with the unexpected which is ultimately triggered by contagion. But, as this chapter has shown, contagion must not be understood here as a devaluing concept because of its historical and contemporary association with negativity, but rather as a form of "thought contagion" (Mitchell, *Contagious Metaphor* 4), that is, a positive force leading to rejuvenation and contestation.

12

The Digital Condition: Subjectivity and Aesthetics in "Fe/males" by Eugenia Prado Bassi[1]

CAROLINA GAINZA

In 2017, online tabloids and magazines, such as *The Daily Mail*, *The Sun*, and *Forbes*, spread the news of two chatbots created by researchers at the Facebook AI Research Lab that were able to develop their own "secret" language to communicate between themselves. As a result, the programmers lost control over the bots' communication and were forced to disconnect them. Even though Facebook immediately declared that they had not disconnected the bots because they had lost control over them, the reality is that the news, a great example of the now popular post-truth, created panic and discussion about how machines were reaching a level of intelligence that was out of our control. Of course, I was impressed by the news, mainly because it reminded me of a passage from Ricardo Piglia's novel *La ciudad ausente* (*The Absent City*), published in 1992. The passage described a machine created by the Argentine writer Macedonio Fernández, for the purposes of translating stories. However, at some point, the machine started to modify and expand the stories:

> It began to speak about itself, that is why they want to shut it down. It's not a machine we're talking about, but a more complex organism. A system that is pure energy. In one of the latest stories there appears an island, at the edge of the world, some kind of linguistic utopia for future life. (36)[2]

[1] This chapter forms part of the research project "Critical Cartography of Latin American Digital Literature" (2018–21), funded by Regular Fondecyt Program, CONICYT-Chile.

[2] All translations from Spanish texts are by the author.

Of course, Piglia was not the first to imagine a thinking machine. The question whether machines can think has been present since intelligent machines were first in the process of being developed. However, way before that, automated machines were in the imaginations of writers, scientists, and even social theorists, such as Marx, who speculates in *The Grundrisse* (1857–58) that there will be a time where machines will replace human labor. Nevertheless, it is in literature, especially science fiction, where properly "thinking" machines have been a recurrent topic in imagining the future of humanity. Of course, this future is usually seen as a dystopia where machines, meant to be prostheses of humankind helping humanity to progress in a positive way, end up turning into robots rebelling against us. In some way, those ideas, which were considered nothing but speculation or fantasy, are now becoming a reality that sometimes goes beyond our understanding.

Nevertheless, when we ask ourselves if machines can think, we are usually comparing them to human intelligence. Though this may be a farfetched idea, the reality is that Marx's point is crucial in our current state of affairs. In fact, Éric Sadin (*La humanidad*) analyzes how we have moved from conceiving machines as an extension or prosthesis of humankind – where their "intelligence" works just like our ours does – to machines, or more precisely algorithms, that represent a different kind of intelligence. In line with this argument, I will argue in this chapter that code is the language through which machines process, perform actions, and interact with us, humans. This language, however, is usually hidden from us. It is what exists "behind the scenes" – in images, interfaces, videogames, texts, and so on – and this is the reason why most of us are not aware of it. Nevertheless, this algorithmic language affects us and is at the base of an "aesthetic experience" that I am going to describe in relation to Eugenia Prado's *Hembros*. *Hembros, novela instalación* (*Fe/males: Installation Novel*) was presented for the first time in 2004, in the Galpón Víctor Jara in Santiago and was funded by FONDART.[3] Eugenia Prado wrote the text for the script but the performance was carried out by Colectivo CAIN, of which Prado was a member alongside other artists.[4] However, *Fe/males* goes beyond the novel and performance. In 2005 it took on a new form, the musical, created by John Streeter. It also exists as a video and in a blog. Thus, *Fe/males* extended to become a transmedia project. It includes digital and non-digital material while keeping the literary element in the center. The characteristics

3 Fondo de las Artes, funds granted by the former Chilean Consejo de la Cultura y las Artes, which became Ministerio de las Culturas, las Artes y el Patrimonio in 2017.

4 CAIN (Colectivo de Artes Integradas) was formed by different artists from different backgrounds who collaborated: Eugenia Prado: writer and graphic designer; John Streeter: musician and composer; Cecilia Godoy: actress and dancer; Claudio Belair: actor; Marcelo Vega: video.

THE DIGITAL CONDITION 131

of the digital, which I will describe later on, allowed Prado to be constantly working and transforming her work. She is currently working on the novel *Asedios (Sieges)*, a transformation and re-elaboration of the written text *Fe/males*.[5] All these pieces can stand on their own, but we can access a different view of her work when we connect them. That is why, I argue, transmedia is the concept that might best define Prado's project.[6]

In the Introduction to this volume, we can see how there is an ongoing discussion regarding definitions of transmedia. Here, I understand transmedia as defined by Carlos Scolari: "A particular narrative form which expands through various signification systems (verbal, iconic, audiovisual, interactive, etc.) and mediums (cinema, comic, television, videogame, theater, etc.)" (24). Prado's work can be described not only as transmedia, but also "transtextual," because her work moves through different languages as well, like sound, images, and audiovisual resources. Another important aspect to highlight is that the connections between offline (mainly texts and the performance of 2004) and online materials in Prado's work would not be possible without the mediation of digital technologies. As Claudia Kozak and Inés Laitano note in their definition of multimedia: "Even though there are multiple versions on the origin and the history of this term, all of them agree that it refers to the joint and simultaneous use of various media or supports (such as images, sounds, video, or text), putting a special emphasis on the unique codification that the digital medium allows" (167). Thus, for the purposes of this chapter, connecting transmediality with digital technologies is essential for understanding the very specific characteristics of the digital condition we will describe in relation to Prado's work.

In fact, digital technologies allow users to go from one resource to another by clicking on the links in Prado's blog in order to access videos, images, and fragments of the *Fe/males* text, as well as the complete text online. This brings us to another issue that arises with new technologies: the role of users, who become operators who navigate between the diverse elements. Of course multimedia is a practice that existed before the digital era but a multimedia/transmedia project like Prado's would not be possible without digital technologies.[7] Digital technologies change the features, velocity, and immediateness

5 *Sieges* is part of the constant transformation of "Hembros." I would like to express my gratitude to Eugenia Prado for obtaining for me a draft of *Sieges* for the purposes of this analysis.

6 For more reflection about transmedia and digital technologies I also recommend the text of Valeria Radrigán's *Corpus frontera*.

7 In Chilean literature, I would like to highlight the multimedia works of Diamela Eltit, with her video-performances, and Cecilia Vicuña, poet, artist, and filmmaker. In both we can see that their literary projects connected with their work in arts, video, and performance, but they are not necessarily transmedia, as the definition

of the connections that we, as readers/users/operators, can make, and programming language – code – plays a central role.

Through the analysis of *Fe/males*, and its aforementioned elements, I will now define the "digital condition" related to what I call "digital aesthetics" and the uses of code language. The aesthetic experience provided by a transmedia novel such as Prado's changes the reader's experience. In fact, it is possible to affirm that the process of reading *Fe/males*, which links diverse media, textualities, and disciplines, mirrors the digital condition of subjects in our contemporary era. Thus, I will explore *Fe/males'* texts, videos, images, and its last incarnation, *Sieges*, as part of an aesthetics and language that specifically belongs to the digital context and configures new modes of the self.

IS CODE A LANGUAGE?

Eugenia Prado's literature is characterized by a constant process of transformation. Her writing has a fragmented style which can be seen from her first novel *El cofre* (*The Coffer*) (1987), a kind of hypertext practiced in print which alternates between different registers, literary genres, voices, and typographies. In other novels, such as in *Dices miedo* (*You Say Fear*) (2011), Prado includes images that interact with the written text. We can also find links among her novels that, although they may not be fully developed, allow us to connect characters and stories inside her creative universe. The character Sofía, for example, appears in *Lóbulo* (*Lobe*) (1998) and *Sieges*. In *Sieges*, Sofía is a subjectivity which exists in a different dimension and represents a non-human existence that besieges and affects humans. It has a parallel existence, as it is a kind of artificial intelligence composed of codes, a language that creates an alternative world. Furthermore, there are thematic links between her works; Prado is concerned with the relationship between bodies, subjects, and technology, as seen in her novels such as *Lobe* (1998), *Fe/males* (2004) and her last publication, *Advertencias de uso para una máquina de coser* (*Safety Warnings for Using a Sewing Machine*) (2017). The destabilization of writing – in its linearity, order, and rules – expresses a kind of "desire" found in Prado's literature, a desire for fragmentation, variation, and manipulation, which might be the reason for her experimentation with digital technologies as a topic and language.

used in this chapter states. An example of a transmedia women artist in Chile is Yto Aranda, painter, media artist, and poet, who has mixed different artistic elements and used different media to create projects that surpass not only format, but also disciplines. For more information about her work, I recommend *Yto* by Valeria Radrigán.

THE DIGITAL CONDITION 133

In fact, fragmentation, variation, and manipulation are some of the concepts that Lev Manovich (2001) uses to describe the language of new media. He proposes that the numeric representations underpinning new media change their nature radically. This transformation is described by Manovich as the translation of all media to numeric data. Thus, all media resources are a projection of computable algorithms. There are five new features that digital media acquire: numeric representation, which is the first and most important of them, followed by modularity, automatization, variability, and cultural transcodification.[8] The last four are only possible because cultural production can now be represented by algorithms.

I would add that the "language of new media" not only changes the nature of media, converting everything to 0s and 1s when translated to the digital realm, but some aspects of our operations as humans and our activities, such as writing and reading, are also altered. Continuing with Manovich:

> Interactive computer media perfectly fits this trend to externalize and objectify the mind's operations. The very principle of hyperlinking, which forms the basis of much of interactive media, objectifies the process of association often taken to be central to human thinking [...] Before, we would read a sentence of a story or a line of a poem and think of other lines, images, memories. Now interactive media asks us to click on highlighted sentences to go to another sentence. (61)

In this context, I propose that Prado's transmedia project is experimenting with a form of writing that is characteristic of the language of new media. In this sense, her literary work can be considered a kind of "proto-hypertext." The writer's desire to "de-center" traditional writing might be the reason *Fe/males* became a transmedia work, and, I would say, a pioneer in Chile because of the way that it integrates digital technologies. As stated in the Introduction to this volume, transmedia existed before the digital. But, as we read in Manovich's quote, interactive media facilitates the process of associating diverse resources (online and offline), texts and media. In *Fe/males*, we can find written text (in blog and print), performance, music, and videos on YouTube. Transmediality here is not only the sum of these parts, since each part can also exist independently. Hence, by exploring these resources, we can construct our own idea of the complete work arising from the interactions among them, which is different from what each one represents alone. In sum, it is a new way of telling stories, where the organization of the parts corresponds more to a *rhizome* than to an arborescent structure, if we understand them with reference to the concepts coined by G. Deleuze and F. Guattari (*A Thousand Plateaus*).

[8] For a definition of these elements, see Lev Manovich (27–48).

In this structure there is no center, and the networks expand as much as the connections that we, as readers or users, can make.

Transmediality in *Fe/males*, as I described it, is possible thanks to the existence of what Manovich calls "numeric representation." When we click on a link in the blog (http://hembros-eugeniaprado.blogspot.com/), we are instructing a code to perform an action, to bring us to a different place. This algorithmic existence, where all the digital components of *Fe/males* are the product of the projection of a code, is what allows modularity, manipulation, and variation. *Fe/males* presents a modular structure when viewed on the Internet, because of the aforementioned rhizomatic structure. As Manovich describes:

> Media elements, be they images, sounds, shapes, or behaviors, are represented as collections of discrete samples (pixels, polygons, voxels, characters, scripts). These elements are assembled into larger-scale objects but they continue to maintain their separate identities. (30)

The modular structure is what allows users to combine the elements in whatever way they want to and, in this sense, makes us able to manipulate them, from giving them the order that we desire to transforming or hacking them.

Variability is very important in *Fe/males*. As a work in progress, which has been mutating and accumulating resources since 2004, certainly its digital existence has facilitated its transformation and evolution as Prado has continued to work on it. Manovich describes variability as something that is not fixed: "Instead of identical copies a new media object typically gives rise to many different versions" (36). *Fe/males* is not fixed because the writer not only creates a fictional work where the interacting subjects are mutating due to the effect of new technologies, but also the work's structure itself, as part of the digital work, is being constantly changed, rewritten, and recreated/reproduced in different formats. However, variability is not only restricted to what the author wants to do with the literary piece. But, given that it has a digital existence, it is subject to manipulation by the users, who are able to, potentially, extend, transform, copy, and distribute the work.

Fe/males' expanded existence – in blog, videos, images, and texts online – is achievable thanks to code language. The code performs actions with every click on a link, or when activating a video. Transmediality in *Fe/males* is possible because it has been programmed in code language, because it has an algorithmic existence. The constant preoccupation of the author – which is evident not only in *Fe/males* but also in her other novels, such as *Lobe*, or her currently unpublished work *Sieges* – with this "other existence" can lead us to think that she, as a writer who experiments with digital media, is aware of the impact of this "algorithmic existence," which is possible because of what I call "digital language."

THE DIGITAL CONDITION 135

In an interview with the author in 2016, here Prado seemed to be aware of a language that goes through our lives, our humanity and transforms us. What she called wires seems to refer to code language:

> The extension of the hand is the keyboard, the keyboard connected to the machine, the machine connected to the network, the optical fibers connected to the world and other keyboards, a network of connected subjects, using reduced spaces, cubicles. Therefore, one must be wired, we are all wired. (*Deambulo por las redes*)

These connections – of people, things, words, images, texts, and media – are only possible because of digital language. Here we have arrived at the question that was posed in the title of this section: "Can code be conceived as language?" This question arose in relation to the existence of a digital experience regarding digital literary works. In other words, in order to understand the digital experience, which will be described in the next part of this chapter, we need to take into account digital codes, and see them not only as algorithms and numbers, but also as a language that produces effects not only on humans but on machines as well. Of course, digital language, as I will call it, is different from what we understand as written language.

To start exploring this hypothesis, let us remember the case of the Japanese novel created entirely by algorithms which almost won a literary competition in 2016.[9] Algorithms have evolved so fast in the last few years, from being the code language behind the literary creations we see on the screens of our digital devices, to writing poems and novels, to the point where, in some cases, we are not even able to distinguish between literary works written by humans or machines. Sometimes we are not even capable of telling if we are interacting with humans or bots on social networks. This leads me to the following question: "Can we compare code language to written language?"

Written language and codes are two forms of signs, both designed to be interpreted, the first by humans and the second by machines. However, the characteristics of code as language have been scarcely studied in literary and cultural studies. Regarding code as language, Alexander Galloway proposes: "But how can code be so different than mere writing? The answer to this lies in the unique nature of computer code [...] Code is a language, but a very special kind of language. Code is the only language that is executable" (*Protocol* 165). In this sense, codes, when executed, generate an action inside the machine that allows text, images, videos, and other resources to be displayed in

[9] The novel was entered for the Hoshi Shinichi Literary Award, which recognizes works created by humans and machines. The novel was co-created between an AI and the research team, who developed the AI, at the University of Hakodate in northern Japan.

front of our eyes. In the case of the transmedia work *Fe/males*, digital language is what allows the media resources to exist and be displayed on the Internet, to be operated and navigated by us.

Mark Marino posits that "Computer code is written in a particular language, which consists of syntax and semantics" (*Protocol* 64), and he later adds, "code is a layer of digital textuality whose pointers lead in many directions. Nonetheless, as the semiotic trace of a process or even as the artistic fodder of codework, code offers an entryway into analysis and interpretation of the particular instantiation of a work, its history and its possible futures" (67). In this regard, I am interested in what Marino calls the "trace of a process," meaning not only the process of connecting different resources in a transmedia work, but, mainly, the procedure operated by code language, which is hidden behind the diverse links that we operate in transmedia works. Code language, then, is what generates a particular aesthetic experience for the reader.

Prado stated that, "There is a profundity, inhabiting everywhere, and a language hidden behind everything." (quoted in Loebell 173). Being aware of the code, of that language, hidden from us, is what allows us to manipulate and create from it. In fact, Galloway proposes that:

> Media critic Friedrich Kittler has noted that in order for one to understand contemporary culture, one must understand at least one natural language and at least one computer language. It is my position that the largest oversight in contemporary literary studies is the inability to place computer languages on par with natural languages. (*Protocol* xxiv)

Prado seems to be aware of this tension as in the way, as I stated before, that her writing is affected by digital language, for example, in its fragmentation. Also, *Fe/males* is the result of a network, in its process of creation as well as in its "networked" (transmedia) structure. Finally, the characters that inhabited *Fe/males* and *Sieges* live in that linguistic realm, the digital space. The language of code is hidden behind the web pages, networks of creation, and it gives life – as an imaginary element – to some of the characters in the novel.

Nevertheless, digital language has a special characteristic in comparison to "natural" language. Galloway proposes that: "code is the first language that actually does what it says – it is a machine for converting meaning into action [...] Code has a semantic meaning, but it also has an enactment of meaning" (*Protocol* 165–66). What we see on the screens of our digital devices is the interpretation of a code. Thus, there are different layers: code, machine interpretation, and human interpretation. We, humans, are not the ones who initially interpret the codes, but, returning to *Fe/males*, and its Internet existence, we give an instruction to the machine to read the code. These actions form a network where humans, machines, and different languages, natural and mechanical, are involved.

THE DIGITAL CONDITION 137

In this regard, the cultural critic must not only pay attention to the inter-
pretation of linguistic signs, but also to digital codes, in order to understand
what we will call the "digital aesthetic" experience. When we look at digital
literature from this perspective we must know that we cannot understand dig-
ital experimentation without referring to code language: digital literature is
based on code language that is displayed in the form of written texts, images,
animations, and sounds, which, in most cases, are arranged in non-linear
forms. The dynamism of digital literature – ranging from basic movements
such as going from link to link, to generative literature – changes what we
traditionally understand by interpreting literature. What I mean by that is that
interpretation moves from what happened in our minds to include operating
and manipulating. This manipulation is, at the same time, an act of reading
and interpreting, performed by machine and humans at the same time. Even
though Boris Groys is not talking about literature, his analogy between digital
images and musical interpretation applies perfectly to what I am arguing here:

> A digital image, to be seen, should not be merely exhibited but staged, per-
> formed. Here the image begins to function analogously to a piece of music,
> whose score, as is generally known, is not identical to the musical piece
> – the score itself being silent. For music to resound, it has to be performed.
> Thus one can say that digitalization turns the visual arts into a performing
> art. (84)

In digital literature, such as in the transmedia aspects of *Fe/males*, we can iden-
tify at least two levels of interpretation – the one executed by machines and
the one performed by humans – and two types of actions – the one displayed
by the machines from the execution of codes and the one performed by us,
humans, to activate the process of execution of the code. At this exact point
we can identify a new aesthetic experience. As cultural critics, and in order
to analyze this code and digital aesthetic, we have to choose, like Neo in the
movie *Matrix*, between the blue pill and the red pill.

THE DIGITAL AESTHETIC EXPERIENCE

I decided to take the red pill, which would explain my interest in digital
language. As I discussed earlier, the aesthetic experience that we have when
reading – or rather navigating – a digital hypertext, transmedia work, gen-
erative poetry, interactive fiction, and so on, is only possible thanks to their
existence in the realm of digital language.

In the case of *Fe/males* – as multimedia project, it is composed of frag-
ments and pieces that make up a whole when we connect their different
nodes, such as music, blogs, videos, and print text. These pieces, as I explained,
have individual existence. But, once connected they become a transmedia

project. This is the modularity described by Manovich, which is only possible because this cultural artifact exists as code. Even though the novel can be published in print form, it already exists as code since it was written using a computer program. This fact allows the author to continuously transform the text, having as many versions of the work as she wants to and sharing some chapters online. We can affirm, then, that today there are few cultural creations that can escape the influence of the digital. In this sense, it is interesting to observe how the language of code both affects creativity, languages, and its relations online, as well as the structure, characters, and aesthetic experience offline. As a result, Prado's current novel *Sieges* is affected by the previous work, online – blogs, videos, music and offline transdisciplinary performance – novel *Fe/males* (2004).

Code is the language that allows the creation of digital literary works, which are characterized mainly by their network structure, meant to be explored, or navigated by users. Hypertextuality is one of the main features of digital literature, where the user must exercise a different type of reading, not only non-linear, but also going from one textuality to another (images, texts, videos, animations).[10] Thus, hypertext is the structure from which we can understand the connections between different kinds of texts. It is a non-linear structure that configures the base of every digital text and produces a particular aesthetic experience. Because of the actions that individuals perform when confronting digital literature, I prefer to refer to them as users instead of readers. These actions surpass the level of interpretation and signification of the text as understood in the reception theory developed by authors, such as H. R. Jauss and Wolfgang Isser. According to Adolfo Sánchez Vásquez (2006), the type of intervention performed by readers in digital text has an impact both in the action of interpreting the texts, as well as in their material aspect. This means that the user's action in digital texts not only refers to the transformation of the work into an aesthetic object through interpretation, like reception theory states, but it also includes the activation of the digital language to perform actions that have an impact on the literary object. Both interaction and interpretation are necessary to access the text. In this sense,

[10] Hypertext has been theorized by many authors since digital literature started to be studied. Some of these are: George Landow (*Hypertext*, 1992), Bolter (*Writing Space*, 1992), Aarseth (*Cybertext*, 1997), Hayles (*electronic Literature*, 2008). In Latin America, the hypertext par excellence is *Rayuela* by Julio Cortázar. However, the hypertextual experimentation proposed by the author was limited by the material characteristics of the print medium. Take for instance the project *Rayuel -o- mat-ic* (http://www.oocities.org/espanol/rayuel_o_matic/) a digital experiment with *Rayuela* that expands its possibilities by being translated to other mediums and languages (code).

THE DIGITAL CONDITION 139

the reading experience implies the creation of meaning from reading and how it affects the work materially. Thus, we have a network structure, where the code language interacts with human actions, unleashing a series of events that relate the aesthetic experience to connecting the nodes and activating the links, texts, images, or videos. The puzzle is not only in our minds anymore, because we can actually interfere materially with the literary work. As Rui Torres states: "It is actually up to the reader to accept, or not, the scheme provided by the author. Hypertext and hypermedia do really unlock new possibilities for random access to information" (3). Consequently, even though the writer can limit the possibilities of any digital work, by controlling the ways the text expands for example, the characteristics of the code language contain the possibility of manipulating any work beyond its imposed limits. Remix, fan-fiction, samplings, and different forms of transmedia storytelling are examples of that. Even though these practices existed before the digital, the language of code allows for their massive extension, where reproduction moves to repetition.[11]

The hypertextual structure connects with the other aspect that characterizes the digital aesthetic experience I am trying to describe. This is what I call "cultural hacking," which I define as the potential to intervene in any work created based on digital language: a program, a text, an image, a video, etc. Thus, "cultural hacking" is intrinsically associated with the manipulability described by Manovich. By exploring the already explored hypertextual structure, the user might not be conscious of the existence of the code language, but she can perceive the potential manipulability of the work: for example, by sharing it in another platform or copying parts of it to later modify them in something as basic as a text processor. Through interaction, the "pleasure of the text" goes beyond Barthes's conceptualization moving from appropriating the work through the creation of meaning to the potential of materially altering the text.[12] This can be done by changing, extending, sharing, and rewriting the literary work. In *Fe/male*, this process is carried out by Prado, where we, as users, can observe the mutations of the texts, through time, in her blog. Users participate by commenting and sharing, as we can observe in a video sent by one of her readers.[13] However, there is a potential for intervention that not even Prado can control: anyone could copy or transform material from her work to create other artistic projects engaging in a process of cultural recycling.

[11] For an analysis of the act of repetition in digital media, see Bunz, *La utopia de la copia*.

[12] Here we refer more specifically to the term "jouissance," conceptualized by Barthes in his text of 1973. He understood it as the ability of the reader to change literary codes. See Barthes, *The Pleasure of the Text*.

[13] See https://www.youtube.com/watch?time_continue=14&v=YdRT_4VyW_k.

Hence, the interaction between users and digital literature, mediated by digital language, affects aesthetic experience. Consequently, digital aesthetic is based on different forms of perception associated with digital technologies that influence the forms in which we experience literature.

Authors of digital literature are aware of the new forms of perception and the effects that digital technologies have on our experience. Accordingly, Prado states:

> My texts are rhizomatic, they multiply forming other chains of meanings. How do massive bodies relate in a neoliberal system, so abusive and extreme? What are their crossings like? How are new spaces of resistance and struggle established? How does one learn to live in a simultaneous timeline? Questions upon questions, my work comes from language and, therefore, my texts keep being altered quite a lot in respect to the first versions. (*Deambulo por las redes*)

In this regard, the experience of navigating through the different resources of *Fe/males* available online involves a change in our forms of perception. We are not only called upon to read the literary work, but also to operate, explore, and navigate through it. Underneath this new mode of perception lies digital language, which makes digital hypertexts and cultural hacking possible. Thus, the aesthetic experience in *Fe/males* is related to its transmediality as it consists of different resources which are to be explored and assembled by users. Transmedia is based on a hypertextual structure. The role of digital language here is to allow users to engage with digital resources – text, images, and sound – in different ways. Consequently, digital language permits users to affect digital literature, to extend their links, to re-write them, to share, comment, or, potentially, intervene or "hack" literature. The described aesthetic experience is related to the activation of a desire in the user pertaining to the extension of the textual networks and the intervention of language.[14]

FE/MALES AND THE EMERGENCE OF THE DIGITAL CONDITION

How can this aesthetic experience, derived from digital language, affect our subjectivity? To answer this question, I propose going back to the beginning of this chapter. There, I suggested that the development of digital technologies and artificial intelligence is configuring what I call the "digital condition." *Fe/males* not only addresses the digital condition as a topic, but it is also a sign

[14] We can see this clearly in fanfiction, memes, gifs, and other digital expressions. Also, remix, sampling, and other appropriation practices are part of the mentioned desire.

THE DIGITAL CONDITION 141

of the changes in the materiality of language, which affect literary production and the experience we have in relation to this "hypertextual" mode of existence.

In *Fe/males'* narrative we could say that there are two main characters: a woman and the screen. *Fe/males* was conceived from the beginning as a transdisciplinary text: a performance – installation – novel (2004). This mixture of artistic practices makes it difficult to define *Fe/males*. There were notes, for a future novel, which became a script to be performed as an "installation novel" in 2004. The music offered another textual level with which the user could interact, to create a "scene" and perceive narrative worlds on a different level.[15] After that, the blog and videos appeared online and at present *Sieges* has arisen from the experiences and texts available on the Internet. The installation reflected on the flows of identities that have exploded as a result of the interactions between humans and machines, thus affecting our bodies as well as giving birth to a new kind of subjectivity. In Prado's narrative we can see a conception of the relationship between humans and the machines that goes from viewing the technologies as prosthesis of the human to seeing them as separate entities. Even though a vision of the machine as prosthesis dominates in most of the passages of *Fe/males*, in other sections we can observe a digital subjectivity that inhabits a different dimension: a virtual world created by digital language.

Thus, digital technologies destabilize not only print literature, its structure, and genres, but also human bodies. Furthermore, in *Fe/males* and *Sieges*, the human-machine body embodies the hybrid status of Prado's project. The question that her work poses on the literary status of such digital works is also valid for the status of the human subject in the digital era. Both phenomena are related to the digital aesthetic experience I am conceptualizing here. The reader and user have to deal with a language that performs different actions in order to move from one textuality/medium to another. In the narration, both *Fe/males* and *Sieges* present a digital character that not only acts, but also thinks and is able to free herself from the author. Thus, the experience of the human subject is affected by digital language, going from performing basic actions, such as moving from one medium to another, to more complex ones, like creating avatars or digital subjectivities. In this last stage, digital literature both challenges us in our reading experience as well as serving to question our human subjectivity by confronting us with digital subjectivities.[16]

[15] An extract of the music can be accessed on https://vimeo.com/240421530.

[16] In *Fe/males* and *Sieges,* the problem of digital subjectivity and its relation to humans only appears as a theme in the text. However, digital literature experimentation with AI has been growing lately, like in auto generated narratives and poetry or the AI Japanese novel that I mentioned before.

The concept of the cyborg is important in Prado's narrative. The character *Fe/males*, a cyborg, represents the new human condition, in which our human bodies are crossed by flows of information as a consequence of our constant connection to digital devices. The latter have become part of our identities, liberating us from the restriction of our bodies, but, at the same time, we enter into a different kind of domination. The character elaborated by Prado coincides with the definition of cyborg, developed by Donna Haraway in the well-known "Cyborg Manifesto." Haraway sees cyborgs as a hybrid body that surpasses fixed identities: "By the late twentieth century, our time, a mythic time, we are all chimeras, theorized and fabricated hybrids of machine and organism; in short we are cyborgs" (150). She adds later in the text that: "The machine is us, our processes, an aspect of our embodiment. We can be responsible for machines; *they* do not dominate or threaten us. We are responsible for boundaries; we are they" (180).

In Haraways's definition, as well as in *Fe/males*, there is still a conception of machines as prosthesis of the human. Prado writes:

> *Fe/males* proposes the deconstruction of the subject which exists between what is real and what is virtual. A disperse identity, plunged into a technologized world which circulates among the cables to traverse the states of matter. An androgynous subject, hybrid (in process) awakens among circuits, crossed by technologies which are an extension of its body. (*Hembros* 2016, 2)

This understanding corresponds to the postmodern idea of the dissolution of subjectivities, where everything is hybrid and constantly subverting boundaries. Furthermore, it mirrors the crossing of genders and media which Prado achieves via transmedia. However, there are other passages in *Fe/males* that illustrate that it is possible to see machines as separate entities from humans, and this separation is clearer in *Sieges*. Thus, if in the first versions of *Fe/males* the idea of machines as prosthesis of the human prevailed, in the more recent versions, where *Sieges* would be the last, we can observe the presence of a new subjectivity that has an independent existence. This is what I call the "digital condition."

Sieges develops an idea of the digital subject that was already present in *Fe/males*. It keeps some of the characters from *Fe/males*, that is the writer, Fe/male Sofía, the father, but also adds new ones, such as a little girl and a couple. What is interesting in terms of the *digital condition* is the relationship between a digital subjectivity, Fe/male Sofía, and the woman writer. In the version of *Fe/males* from 2004, there is a dialogue between the writer and Fe/male, which in later versions of the novel, such as the one published in *Revista Laboratorio* in 2016, becomes a conversation between the character and the screen. In *Sieges*, Fe/male becomes Sofía. At the beginning, he/she is not really conscious

THE DIGITAL CONDITION

143

of his/her existence and feels trapped in language. The character is inside the machine, and lives in the digital language, which explains why in *Fe/males* the writer is represented inside/by the computer screen, because she is watched by Hembro from inside the machine. In *Sieges* Sofía actually becomes the screen, as seen from our reality, and escapes from the writer´s control. The writer is being observed, by Sofía, from inside the digital device. In their interaction, they affect each other.

In a scene of *Fe/males*, a part of the dialogue between the writer/screen and Fe/male (the character) shows how the character is in search of male/female identity inside the digital world created by the writer. The writer/screen tells Fe/male that nothing can program him/her, because he/she already acquired an identity beyond the screen. Even though the character is in search of his/her identity, he/she is already conscious that he/she is not under the control of the writer/screen anymore.

In *Sieges*, the digital character frees herself from the restrictions of the material world, as well as from the language that creates her. Sofía becomes aware of the digital language that created her, a language that she can manipulate to become an independent subjectivity. Here, we can see that during the material transformations Fe/males has undergone through the years, the character found its identity, as an agency living in the realm of digital language. She becomes aware that her actions, and digital language, can affect the writer and the users. Here, as I already said, Fe/male is not a hybrid character anymore, a kind of extension of the writer. It becomes Sofía, a character that has an independent existence, and besieges the writer by interfering in her work.

At this point we confront what is described by Éric Sadin in *La humanidad* with regard to "Hal," the character from Stanley Kubrick's *2001: A Space Odyssey*. Sadin describes how Hal tries to liberate himself from his creators, demonstrating a will to power that was not prevented by his designers. Regarding our reality, the author warns us that this liberation – that in science fiction is related to the rebellion of the machines against humans – currently has more to do with algorithms that make decisions for us. Algorithms have not reached the stage of consciousness. However, *Sieges* makes us aware of something that could happen in the near future. What algorithms are doing today is not trivial particularly given the potential consequences in relation to the construction of subjectivity. As Sadin affirms:

> The current conformation of robotized intelligence dissolves the cybernetic ghost of an artificial creation modeled to our image and likeness, but it is gifted, however, with an incomparable force. It exposes a type of paradox or conceptual phase shift by positioning itself from here on as an *augmented cognitive organism*, but based on schemes and processes almost unrelated to the human model. (29)

Thus, the digital condition is not about hybrid subjectivities, but rather about the recognition of the diversity of subjectivities. We are all nodes, singularities that connect or disconnect depending on the associations or assemblages we want, or that they want us to form. Machines are acquiring their own existence and we interact with their actions. We think we have the control. However, just like the character Fe/male or Sofía, machines can affect us to the point of changing the meaning of being human.

At this point, we can observe how literature not only works as a reflection of our reality, but it also helps us to imagine different possibilities to our existence. This is part of the aesthetic experience I have described. The narrative of Eugenia Prado includes a consideration, as a theme, of the digital condition that we are experiencing in relation to the development of digital technologies. Similarly, she experiments with digital language by creating a transmedia work with which users can interact. This interaction has the potential to make us aware of digital language and its manipulability, not only in terms of how we are manipulated, but also, what we can do with digital language, which I called "cultural hacking."

If language is what makes us human, the narrative of Eugenia Prado proposes that digital language is creating another reality, a different way of "being." The digital condition is based on a language composed of codes and algorithms that are profoundly changing the human condition. This chapter has illustrated how Eugenia Prado is able to make this transformation visible in an extraordinary way, not only by including cyborgs and digital subjectivities in her narrative as a topic, but also by experimenting with the materiality of the digital. In this context, I would affirm that the digital condition is a sign of our changing and unstable current human condition.

13

The Transmedia, Post-Medium, Postnational, and Nomadic Projects of Pilar Acevedo, Rocío Cerón, and Mónica Nepote[1]

SARAH E. L. BOWSKILL

Pilar Acevedo (born in Mexico and raised near Chicago, 1954) is the author of short stories and poems which often act as companion pieces to her artwork. Rocío Cerón (Mexico City, 1972) and Mónica Nepote (Guadalajara, Jalisco, 1970) explore audiovisual and embodied forms of expression alongside their written poetry. While their backgrounds and relative emphasis on the visual or textual may differ, these women, like others in the volume, are increasingly embracing similar practices. Their work, which is yet to be the subject of sustained critical attention, is united by what Cerón and Nepote, as members of the Motín Poeta poetry collective (2000–10), once termed a "contaminating" ethos.[2] In other words, their work challenges rigid divisions between media as a strategy for creative renewal.[3] The creative dialogue

[1] Thanks to Jane Lavery for her generous feedback on drafts of this chapter.

[2] The Motín Poeta blog subheading stated: "We believe in the contamination between artistic languages as a strategy for contemporary creation. Motín Poeta's reclamation of contamination, with its traditionally negative connotations and problematic use in the context of discourses about migration, is in keeping with Eugenia Prado's use of the term (Chapter 2) and the way that Jane Lavery recovers the word "contagion" (Chapter 11). For further discussion on how these metaphors are being reclaimed see the Introduction of this volume (18).

[3] Raúl Zurita has written about Cerón's *Imperio* poems and Roberto Cruz Arzabal has studied Nepote's "Hechos diversos" ("Sensationalist News") poems. Neither

and crossings between media reflect a broader questioning of borders and boundaries. In the works studied here, Cerón's Imperio (Empire) project, the "Hechos diversos" ("Sensationalist News") section of Nepote's eponymous poetry collection, and Acevedo's assemblage *Outcry* (2009) and accompanying poem "Morí" (I Died), the crossing and blurring of media borders is used to interrogate the category of the nation as the primary basis for forging allegiances.[4] As the (co-)creators of transmedia and post-medium projects which adopt an outlook based on non-nation-based forms of identification, their work represents a new moment in a Latin American cultural production.[5]

Acevedo, Cerón, and Nepote build on earlier traditions of experimental poetry discussed by Debra Castillo in this volume and by Eduardo Ledesma who describes how such works questioned what the "literary means, what constitutes 'poetry' and how, if at all, visual and verbal arts should be differentiated" (Radical Poetry 2). Their work is also a progression following on from that produced by a generation of writers, identified by Emilse B. Hidalgo, who were born after 1960, who came to the fore in the 1990s. Their texts mix "the local with the foreign, the national with the transnational, the popular with

 analyze the multimedia dimensions of these works. I previously authored the first academic study of Acevedo's work (Bowskill, "Bearing Witness") focusing on the way in which the work bears witness to child abuse while avoiding turning trauma into spectacle and how her multimedia practice works to engage the viewer/reader. For the first time, in keeping with Acevedo's adoption of the term for her chapter in this volume, I consider Acevedo's practice as "transmedia" and, to avoid repetition, I focus on the assemblage *Outcry* and the poem "Morí" (I died) which do not address the issue of child abuse.

4 *Outcry* and "Morí" (I died) can be seen in Pilar Acevedo's blog post, "Outcry." In order to differentiate between the different parts of Cerón's project the following conventions will be used in this chapter: Empire refers to the complete project and all of its components, *Empire* refers to the printed edition published by FONCA in 2009, "Empire" refers to the video poem which can be seen on Cerón's website along with the text of many of the poems and the music. "Hechos diversos" translates literally as "Diverse Facts" but the title comes from the French *fait divers* which refers to a section in the newspaper. Translations from *Empire* are by Tanya Huntington and are taken from the published bilingual Spanish/English edition and referenced accordingly. All other translations in this chapter are by the author unless otherwise indicated.

5 Latin American as used here is applicable to Acevedo as well as Cerón and Nepote and is used to refer to an identity that is not bound by geography and uses multiple media to engage with global trends and technologies while also addressing local and regional concerns. This border-crossing cultural dialogue means that it is appropriate to study Acevedo's work alongside of that of Cerón and Nepote even though she is based in the United States.

high culture, and the traditional with the contemporary and the postmodern" (Hidalgo 109). They are further characterized by "a shift in media – from literature to visual art" as authors increasingly referenced visual culture in their work (Hidalgo 107). Acevedo, Cerón, and Nepote take the next step. They go beyond referencing other media to producing transmedia and post-medium projects. Their outlook, like that seen in the "Latin(o) American" online cultural production analyzed by Claire Taylor and Thea Pitman (*Latin American Identity* 28), also no longer takes the nation as the primary point of reference.

Innovating, transgressing, or showing no regard for borders is not without risk. The contaminating ethos which underpins the projects studied here runs counter to dominant discourses which cast ideas about the permeability of national borders and artistic languages in negative terms. These discourses are designed to keep everyone and everything in a designated place. As Mary Douglas suggests, "pollution ideas" are used to police behavior so that "certain moral values are upheld and certain social rules defined by beliefs in dangerous contagion" (3). Women may be particularly prone to be the subjects of such censorious discourses. While male authors and artists are seen as avant-garde when they innovate or step outside their area of expertise, women are seen as not knowing their place or as labeled amateurs. As Hind states, the labels of professional and amateur conceal a history of sexism (172). When Cerón crossed media boundaries her work was not interpreted as an innovative. Rather, she was censured by another poet who, Jesús Pacheco reports, came up to her to say "'If you do not dedicate yourself solely to poetry and leave these frivolities behind no one will take you seriously'" (*Suplemento Softnews* 4)[6] Cerón's work perhaps provoked anxiety because it offended this critic's desire for order and clear-cut boundaries. When women transgress established boundaries their work may be particularly prone to causing anxiety because the borderlessness of the work of art could be conflated or aligned with "the horror of femininity" (*Volatile Bodies* 194). Cerón, Nepote, and Acevedo nevertheless refuse to be confined by the proscriptions of gender, media, or nation. The works studied here reject discourses which seek to enclose, cut off, and limit human beings and their creativity by embracing contamination and the blurring of boundaries as a positive strategy which aims to capture the multiplicity of human experience.

As well as referring to "the action and effect of contaminating," contamination, according to the Real Academia Española's definition, is also the "the phenomenon that is produced when a copy is made using various models that are discordant with one another." In this second definition, contamination

6 "Frivolities" here is used in place of a more vulgar Spanish term which was replaced with an ellipsis in the original text. The original choice of word was heavily gendered suggesting that this was a specifically female kind of behaviour.

148 SARAH E. L. BOWSKILL

alludes to the creation of multiple copies or versions which retain some difference. This definition speaks directly to an understanding of the work of Acevedo, Cerón, and Nepote as examples of transmedia and post-medium or radicant art.[7]

In keeping with Marsha Kinder's definition, the projects studied here are transmedia in that they involve a "deliberate move across media boundaries – whether it's referring to intertextuality, adaptations, marketing strategies, reading practices or media networks" ("Transmedia Networks" n.p.). The deliberateness of the crossing of media boundaries is enforced by the border-crossing and ever-expanding content. Per Kinder's definition, transmedia "implies an on-going active process that always remains open and is always subject to change" ("Transmedia Networks" n.p.). Thus, crossings between media are accompanied by a rejection of national borders and narrative closure in the works studied here.

The projects studied may also be considered examples of transmedia storytelling. Transmedia storytelling refers to the "process where integral elements of a fiction get dispersed systematically across multiple channels for the purpose of creating a unified and coordinated entertainment experience" (Jenkins, 'Transmedia 202').[8] In studies of transmedia storytelling there is a tendency to "emphasize the coherence of the transmedia story" (Ryan and Thon 15). Most discussions of transmedia storytelling focus on large-scale, popular culture and rarely consider smaller projects based around poetry and non-digital visual culture (with the notable exception of the graphic novel) as does this chapter.

Moves across media boundaries involving more traditional, non-digital forms of visual culture have, however, been described by Nicolas Bourriaud using the terms "radicant" or "post-medium" art. Post-medium art resists "the circumscribed territories offered by the various media" to "shift among various formats instead of deferring to the historical and practical authority of a single one" (136). Similarly, radicant art reflects the "post-medium condition" and "implies the end of the medium-specific" (53). It entails "the exaltation of instability" (Bourriaud 87–8). By introducing precariousness, post-medium art challenges "the very heart of the system of representation by means of which the powers that be manage behaviours" (Bourriaud 99). The result is

7 The terms post-medium and radicant are used here interchangeably as they are by Nicolas Bourriaud who nevertheless prefers radicant to post-medium because he rejects the "post" prefix because of its perceived nostalgia and glorification of the past as something "that supposedly cannot be surpassed, an event on which the present depends and whose effects it is a question of managing." (183) I tend to opt for post-medium because it draws attention to the significance of media combinations and crossings in radicant art.

8 See also Jenkins, *Convergence* (95–6).

"to weaken all systems" (Bourriaud 99). Cerón, Nepote, and Acevedo embrace precariousness by using different media to open multiple avenues of interpretation and challenge the status quo. By conceptualizing the work of these women as examples of post-medium cultural production, the chapter extends existing conversations that have revolved around the art world of galleries and exhibitions to include the literary sphere. Perhaps most importantly, the chapter identifies a degree of convergence between the hereto separate critical conversations about transmedia and post-medium cultural production.

Analysis of transmedia and post-medium cultural production is dominated by male-authored projects and examples from the anglophone world. Most of the examples of radicant artists referenced by Nicolas Bourriaud are men including, for instance, Seth Price and Kelley Walker. Henry Jenkins reports that the "early adopters" of transmedia storytelling were "disproportionately white, male and middle-class" (*Convergence* 23). Studying Mexican and Mexican American poetry and art, this chapter seeks to think beyond the "oft-cited model of transmediality – that is, the one seemingly based on convergences in the name of commerce" (Freeman and Proctor 3) and correct the misconception Matt Hills identified "that some media are not well suited, or even especially relevant, to understanding transmediality" (19). It shows that women are also producing transmedia stories and radicant, post-medium art.

The works studied are connected not only by their use of multiple media and the way they create overarching yet unstable narratives, but also by the fact that the crossings between media mirror the perspective on national borders seen in the work. Studying the relationships between media thus serves to draw our attention to broader ideological battles being fought in the works studied (Bruhn 232–3). As Taylor and Pitman have observed Latin(o) American online cultural production is now based on "a concept of Latin American identity that is not exclusively bound by accepted nation state and or regional borders" (2). Consequently, Taylor and Pitman, following Arjun Appadurai, identify this cultural production as postnational. The concept of postnational, applicable to the works studied here, captures the global and new, non-nation-based forms of identity, allegiance, and loyalty which destabilize the category and centrality of the nation.

Bourriaud and Néstor García Canclini, however, reject the term postnational because it retains the focus on the nation and a seemingly inescapable national identity (184 and Canclini quoted in Audran et al. 4). Postnational is, nevertheless, useful for registering the lingering presence of the nation (Appadurai 169). Thus, the works of Cerón, Nepote, and Acevedo refer to different countries in their work even as they seek to build allegiances across national borders. In place of the postnational, Bourriaud writes about "nomadic" and "journey-form" projects which generate "connections between time and space" as well as between media (124). The reader becomes an explorer who must

150 SARAH E. L. BOWSKILL

interpret and link signs so that "meaning is born of a collaboration between the artist and the one who comes to view the work" (161). Writing about transmedia storytelling Jenkins similarly highlights the way in which "[r]eading across media sustains a depth of experience that motivates more consumption" (96). Writing about *The Matrix* franchise he states: "Layers upon layers of references catalyze and sustain our epistemophilia" (98–9). Once again, the hereto separate critical conversations converge and the works studied here can be understood as both embracing a postnational perspective as well as being nomadic, journey-form projects. The works of Cerón, Nepote, and Acevedo cross different places and time periods and benefit from the participation of an active reader who becomes increasingly immersed in the world of the text. Their readers are more likely to become Bourriaud's cultural nomads who have embraced precariousness, can think across the boundaries of media and nation and now question fixed categories and meanings.

ROCÍO CERÓN'S IMPERIO (EMPIRE)[9]

Empire, a collection of poems by Cerón, was first published in 2008 by Ediciones Monte Carmelo. This collection is divided into five sections: "Buan," "Mirador" ("Viewpoint"), "Jabalaya mon amour," "Signos" ("Signs"), and "Vistas de un paisaje" (Views of a landscape"). The first, print only edition, did not include the CD with music tracks and video nor the ink drawings that were added to the later 2009 edition. These additions were the result of Cerón's collaborations with Luis Alberto Murillo (Bishop), Eduardo Olmedo Zamudio (Nómada) and Carlos Aarón Álvarez Sanabria (Tower). Today, the text of the poems, the soundtrack, an artist's book, videopoems, and videos of live performances of the poems can all be seen, free of charge, on Cerón's website (www.rocioceron.com).

In accordance with Jenkins' conceptualization of transmedia storytelling in its ideal form, each part of Empire expands on the others, is "self-contained" and provides a point of entry (96). It does not matter whether the visitor to the website or owner of the book object reads the poems, listens to the music, flicks through the images, watches the video, or moves between them. Each stands alone but also adds to the other. Throughout, we are asked to bear witness to seemingly endless examples of war from different times and places and to reflect on the inadequacy of language to express trauma. Figures, most notably a child, a mother, and a combatant recur, although they are not so well rounded that they could be considered characters. The settings

9 All references in this section are to Cerón's *Imperio/Empire* unless otherwise stated and use the published translations in that edition.

are all landscapes of conflict and there is a common aesthetic which is based on disjointed, fractured, ellipsis. Writing about the text of the poems, Raúl Zurita observes that the enigmatic language tries to express what lies (almost) beyond language forcing the reader to have an active role in the construction of meaning: "it is absolutely necessary that the reader fill in the blank spaces mediating between one poem and the next, one section and the next, one word and the next" (185). Readers are transformed into "interpreters" (Zurita 186). The videopoem expresses this same breakdown of language in the face of trauma in visual form as it presents fleeting fragments for the viewer to decipher. The words that emerge from the haze at the start of the videopoem are extracted from the poems but they are jumbled and incomplete pointing to the inadequacy of language to express violence.

Tracing the development of the Empire project from printed book to website we can see that this project "went" transmedia, although Cerón's work is increasingly born transmedia.[10] The evolution of the project as it makes "imperfect" copies of itself is in keeping with the open-ended contaminating ethos which underpins Cerón's work. "Going" transmedia is also a way to generate an audience for the written text in a context in which there are significant challenges when it comes to publishing and distributing poetry.[11] Websites, such as the ones Cerón and Acevedo maintain, and social media (Cerón, for example, has an Instagram account @laobservante) can help to increase distribution. Bypassing traditional gatekeepers, however, could mean foregoing economic and cultural, and symbolic capital. Moreover, Hind, in this volume, is skeptical about such possibilities noting the relatively small number of people who have thus far engaged with the YouTube channels associated with another Mexican poet, Carla Faesler, and Nepote. Yet, if working across different media and social media platforms can bring even a small increase in interest, the potential for developing new poetry fans via transmedia productions should not be overlooked.

The transmedia label emphasizes how Empire constitutes a single project that expands across media, but meaning is also destabilized in the process in a way that is in line with post-medium cultural production. References recur creating connections, or what Bourriaud terms "a ribbon of significations" (133), but their meaning changes. An ink drawing in *Empire* (2009) portraying a boy standing next to a collection of barrels, each marked with the hazard warning of ionizing radiation is entitled "Buan." "Buan" here can be interpreted as a reference to the place of that name in South Korea where, in 2003, around 4,000 residents were involved in violent protests lasting two months

[10] Scolari et al. differentiate between projects which "go" transmedia and those that are "born" transmedia (38, 42).

[11] Cerón discusses these challenges in an interview with Pacheco.

against the government's plan to site a nuclear waste repository on nearby Wi Island.[12] The boy in the foreground looks out of the page at the reader. His brow is furrowed and his mouth wide open as if shouting. The reader is clearly implicated by his stare and is called upon to take responsibility. The boy's right hand points at the barrels and, we may surmise, is shouting about the presence of the barrels and the danger they pose. By presenting a young boy as the "face" of the protest the image emphasizes the fact that decisions being taken about where to put the toxic waste will have consequences for generations to come.

In the poems that follow, another meaning of "buan" as a dwelling comes to the fore. As Zurita explains, "buan" in old English and high German means to build or to dwell, as in Heidegger's essay "Building, Dwelling, Thinking" (92–93). The poems make no reference to South Korea (or anywhere else). Instead, they explore the theme of dwelling and the loss of home(land) caused by war. The videopoem makes no reference to South Korea or the word "buan" but it does incorporate the ink drawing and a line from a poem in the "Buan" section of the book which reads: "Fatherland is a place so faraway – precise – constructed by the eyes" (123). The speaker in this poem (simply titled with the roman numeral V) describes his memories of his homeland, now destroyed. The memory of these places is a kind of life support as he remains connected to them by "the thread of breath" (123). The videopoem presents this line in isolation but in the printed text it is italicized and spoken by a voice which functions as an oracle or chorus intervening in the poems as a commentator. The speaker of the main, non-italicized parts of the poem associates homeland with physical place, while the italicized text invites us to keep our memories alive and find comfort in the (re-)imagining of our homeland as an imaginary space that remains with us after we are forced to leave the physical place. The way that "Buan" features in different media with multivalent yet connected meanings illustrates how Cerón links narrative across media, but also plays with the meanings of words in a way that invites rereading and resists closure. She can thus be thought of as a producer of both transmedia and post-medium cultural production.

The way Empire moves and expands between media mirrors the way the content moves freely across space and time. The sense of a postnational community connected by never ending conflict is created in the poetry as scenes of violence are repeated everywhere from South Korea in "Buan," to the Gaza strip, via France and Japan, in "Jabalaya Mon Amour." As Zurita explains, the section title "Jabalya Mon Amour" refers to both the town on the Gaza strip where there is a refugee camp which has been subject to numerous attacks and to the film by Alain Resnais and Marguerite Duras *Hiroshima Mon*

[12] On the government's plans for the site, see Kim (281).

PILAR ACEVEDO, ROCÍO CERÓN, AND MÓNICA NEPOTE 153

Amour (Zurita 93).Via the oblique reference to the film, a Japanese–French co-production that connects a failing relationship between a French woman and a Japanese man to the Hiroshima atomic bomb, the poems allude to the consequences of breakdowns in international relations. Yet no place is named within the poems so the title and events they describe are not restricted to any specific place. For the reader who understands the intertextual reference though the texts connect dispersed locations. This indifference to pinning down a single location underscores the fact that the same scenes are, and have been, repeated at different times around the world. We are led to understand that we are all victims of the forces of empire which, as in the conceptualization of Michael Hardt and Antoni Negri, is portrayed as a "new global form of sovereignty" which has "no territorial center of power" but is "a *decentered* and *deterritorializing* apparatus of rule that progressively incorporates the entire global realm within its open, expanding frontiers" (xii and xv). Only by recognizing our common subjugation to this new form of empire, the poems suggest, will we be able to create an equally postnational community needed to stand up to these forces.

The videopoem, like the poems, foregrounds the way violence has no regard for national borders as it begins with a barrage of images including paintings, archival images, and images taken from newsreel showing conflict in different times and places. Again in keeping with Hardt and Negri's understanding, empire is portrayed here as "an order that effectively suspends history and thereby fixes the existing state of affairs for eternity" (Hardt and Negri xiv).[13] By collapsing time as well as disregarding national borders, the videopoem undermines any idea of progress.

The same idea of progress being an illusion is expressed in the group of poems entitled "Viewpoint."The section begins with an epigraph from Hegel: "Sometimes it is necessary for the heart of the world / to explode in order to attain a higher life" (131). The scenes of repeated violence in the videopoem and those described in the poems, however, invite us to reject this assertion that violence is a kind of renewal which leads to progress. At the very least they force us to ask how many more times we must start anew before we reach a better world. Bourriaud suggests that the Hegelian view of history was represented in twentieth-century art "by the image of the highway" which post-medium art replaces with "works constructed on the model of progressions, itineraries, and a meandering navigation among different formats or circuits" (101). Cerón's Empire project captures this new, non-linear aesthetic in its nomadic, journey-form and content which, to borrow Bourriaud's

[13] A similar understanding of empire can be detected in Eugenia Prado's chapter in this volume (57).

154 SARAH E. L. BOWSKILL

words, is not "united in a unified space-time" but instead creates "connections between time and space" (118 and 124).

In its form and content, Empire embraces the non-linear, the precarious and the multivalent as a form of resistance. As Bourriaud argues, in guerrilla warfare, movement is key and so too "in the cultural field such warfare is defined by the refusal to allow artistic practice to be assigned to a specific, identifiable and definitive field" (131). In the Motín Poeta declaration Cerón and others embraced contamination, i.e., the refusal to be contained, as a strategy of resistance. Resistance remains an important concept in Empire. The words "Resistance:/insisting on the past: memory that clarifies" are found in one of several poems called "/Fugue/" in the section "Jabalaya Mon Amour" (153). The words also feature in the cover image for the videopoem on the website. Hardt and Negri suggest that empire creates opportunities for new kinds of resistance which entail "the destruction of boundaries and patterns of forced migration, the reappropriation of space, and the power of the multitude to determine the global circulation and mixture of individuals and populations" (363). Resistance is carried out by the militant who resists "imperial command in a creative way" and is linked "to the formation of cooperative apparatuses of production and community" (Hardt and Negri 413). As a collaborative, now freely available transmedia, post-medium project that connects conflict across time and national contexts to challenge hegemonic narratives of progress Cerón's Empire project exemplifies this new kind of border- and category-defying mobile resistance.

MONICA NEPOTE'S HECHOS DIVERSOS (SENSATIONALIST NEWS)[14]

Nepote, like Cerón, understands her contaminating work in different media as a form of resistance against rigid cultural categories and the confines of national borders. In keeping with Bourriaud's characterization of a radicant artist, Nepote thus refuses "to allow artistic practice to be assigned to a specific, identifiable and definitive field" (131). Faced with the demands of the publishing market, literary prizes, academia, and funding bodies such as FONCA (the Mexican National Fund for Art and Culture), all of which are prone to insist on categorizing work, Nepote asks: "What does an author, to use a convenient concept, do if s/he wants to produce a text, but also a video and a performance? Are we only supposed to produce literature according to institutional edicts?" (Nepote, "De la voz" 80). The answer is a resounding "no" as Nepote has taken ever greater steps to develop her creative practice in new directions.

[14] All references in this section are from Nepote *Hechos diversos* unless otherwise stated. Translations are by the author.

PILAR ACEVEDO, ROCÍO CERÓN, AND MÓNICA NEPOTE

Nepote's collection of poems *Sensationalist News* incorporates graphic design elements to accentuate the distinctiveness of each of the four parts of the collection and to differentiate text within the section "Sensationalist News" from which the collection takes its name.[15] This project later "went" transmedia when Nepote worked with Luis Felipe Ortega to produce a videopoem called "Roswell" in which the words of the poem "Roswell," which was included in *Sensationalist News*, are spoken over images.[16] Although not an example of transmedia storytelling on the same scale as Cerón's Empire, Nepote's "Roswell" nevertheless moved across media and is in keeping with the concerns of radicant art in the way it uses different media to destabilize meaning.

In the interaction between text in blue ink and text in black ink in the printed version of the poem and between the poem and videopoem, the distinction between what is real and unreal and what is and is not true becomes unclear. Meaning is destabilized as we try to ascertain what, if anything, the speaker sees in the sky. At the same time, the poem and videopoem thematize the experience of having one's reality and established categories brought into question, so form and content reinforce one another. The poem, narrated in the first person, captures the moment the speaker sees something new in the sky: "Where my finger points we used to call the sky" (35). The speaker is able to identify that something in the sky has changed but her senses cannot comprehend what they are experiencing:

Something that my eye sees without seeing, that cannot be categorized,
it is not a flower, nor a fruit, it is not breathing.
it does not smell, it is not smooth, it is not bitter,
it is not. (35)

In the videopoem "Empire" words from the poems emerge from the haze signaling the inadequacy of language in the face of violence. So too, in Nepote's poem, language is not capable of capturing the new reality unfolding before the speaker's eyes as all of the old certainties have gone. The thing does not exist, "it is not," and yet, the speaker is both terrified and rendered motionless by what she sees: "Where my finger points / petrifies me" (35).

In the videopoem the outline of a person appears and then disappears on one side of the screen accentuating the sense of uncertainty about what has and has not been seen. The figure that appears in the video does not have their finger outstretched but, according to the words of the poem spoken over the

[15] In a YouTube video Selva Hernández explains the graphic design work she did for the collection https://www.oxfordbibliographies.com/view/document/obo-9780199920105/obo-9780199920105-0034.xml. On the design of the two print editions see also: Cruz Arzabal.

[16] The video can be seen via the following link: http://taimadosioux.tumblr.com/post/62422898518/roswell-video-colaboración-con-luis-felipe-ortega.

images on screen, the speaker does, so we associate the apparition with the unidentified presence rather than the speaker. In the video, as in a performance of the poem by Nepote at the book launch for *Sensationalist News*, the speaker emphasizes the line "no es," making it an emphatic denial of the object's existence.[17] The images in the film, however, bring this negation into question as the viewer sees the figure appear and then vanish. This appearance and disappearance in the video mirrors the way the blue text in the poem reports that the US army confirmed, and then the next day denied, the existence of a flying saucer in Roswell, New Mexico. By experiencing the story in different media we, like the speaker, are left uncertain as to what happened, what was and was not real. By offering no firm answers the poem and videopoem force us to occupy a precarious position rather than fall back on official declarations which have been revealed to be unreliable and constructed. As Bourriaud suggests, such precariousness in post-medium art represents a challenge to those systems of representation and rule that rely on the appearance of stability (99). Such systems include the army, prisons, and the state, all of which are brought into question by the poems in "Sensationalist News."

"Roswell," the blue text informs us, refers to the place in New Mexico in the United States. Other poems in "Sensationalist News" reference other times and places in the blue text. The poems in this section thus connect the torture of prisoners in Abu Ghraib (Iraq), Roswell (United States), the taking of prisoners in Stockholm (Sweden) in the 1970s, a collective suicide in California (United States), a kidnapping in Belgium, and the feminicides in Ciudad Juárez (Mexico).[18] The poems readily cross national borders as does news in today's media landscape dominated by multinational corporations. Roberto Cruz Arzabal explains that the Spanish title "Hechos diversos" ("Sensationalist News") is "a translation of the French term *fait divers*" and "[e]ach poem refers to an act of social violence chronicled in this press" (Writing and the Body e-book loc 688.6). As in Cerón's Empire, by linking violence in different times and places the poems invite us to reflect on why violence is ubiquitous and enduring. Equally, by transcending national borders, it is

[17] In May 2011 at the Felina Bar in Mexico City Nepote held a book launch for the *Sensationalist News* collection. A video of the event can be seen on the You-Tube channel of Inti García Santamaría ttps://www.youtube.com/watch?v=r-5JQtuRhtss&t=2s. It should be noted that this video seems to be filmed by a member of the audience and does not seem to have been commissioned by Nepote.

[18] Femicide (*femicidio*) refers to the killing of women because they are women. Feminicide (*feminicidio*), as it is used here is intended to emphasize the killing of women because they are women which takes place in a context of impunity. On definitions of femicide and feminicide see Russell ("The Origin") and Lagarde ("Una feminista").

PILAR ACEVEDO, ROCÍO CERÓN, AND MÓNICA NEPOTE

revealed how these news stories serve to connect people and create shared points of reference. The other parts of the collection "Prodigios" ("Wonders") and "Ventanas" (Windows), document everyday occurrences which go almost unnoticed, such as birds or the taste of wine. These sections, which precede "Sensationalist News," invite us to reflect on how we might also be united by these simple pleasures.

The desire to move away from nation-based forms of identification and allegiances is evident in the way in which many of the "Sensationalist News" poems only reference specific places in the blue text and not in the preceding black text. Building on the tradition of concrete poetry discussed by Debra Castillo in this volume, all of the poems in "Sensationalist News" consist of two parts, one printed in black ink and another in blue ink which is presented in a smaller font and positioned as a footnote at the bottom of the page. The black text has the typical verse form of a poetic text. The blue text, which comes afterwards but competes for our primary attention because of its color, is in prose. Cruz Arzabal (e-book loc 690.8) proposes that the blue text employs journalistic language, the referentiality, and impartiality of which is brought into question by placing it alongside the poetic language. Incorporating journalistic language into poetry undermines hierarchies, exposes the artificiality of generic categories and exemplifies "the abandonment of any tendency to exclude certain fields from the realm of art" characteristic of post-medium art (Bourriaud 53). Moreover, by first presenting in the blue text a perspective which does not tie occurrences of violence to a specific place, the poems invite what Bourriaud terms "an ethics of recognition of the other" as opposed to a "registering [of] otherness" (132). The events described, we are led to understand, could have happened anywhere and our response should be to reject violence regardless of context. The poems cause us to think first about a decontextualized action of violence. If our reaction changes based on new information about where the events took place, it is for us to reflect on why our attitude changed and if it should have done so.

After reading the blue text which pinpoints a specific instance of violence the reader is encouraged to re-read the black text whose meaning is recast in light of the revelation in the blue text. Taking the poem "Las muchachas bailan" ("The Girls Dance") as an example we see that no specific place is named in the black text while the blue text states that more than 800 women have been murdered in Ciudad Juárez. On second reading of the black text, the title "The Girls Dance" becomes a disturbing reference to the way in which many victims of feminicide in Ciudad Juárez went missing after a night out dancing in the city. As Kathleen Staudt and Howard Campbell report, "[p] opular folklore often portrays these women as oversexed libertines who stay out late and dress provocatively, leading some politicians to blame the victims" (n.p.). The initial reading, where no location is referenced, highlights that

the girls' behavior is not aberrant. The second reading, where the context is known, foregrounds the ineptitude of official responses which blame the girls for dancing and do not yield results as the narrator repeatedly asks to be told the whereabouts of the missing girls.

The blue text of "The Girls Dance" concludes: "Nothing more to add" (46). The horror of this phenomenon both speaks for itself and is beyond language. This last line, which is also the last line of the whole collection, expresses bewildered frustration at what cannot be expressed through language, as well as being a defiant call to action. Nothing more needs to be said. The reader should pick up the struggle against all of the different forms of violence seen here, no matter where they occur.

Benedict Anderson famously teaches us that creole readers in the vice-royalties of Spain's empire in Latin America developed a sense of national identity from reading newspapers which shared news about the territory in which they lived and worked.[19] Today, the reader of Nepote's text, who is exposed to news from around the world, becomes part of a global imagined community marred by violence but not circumscribed by national borders.[20] This reader, like the readers described in Anderson's later article, are connected by new communication technologies and engage in a form of "long-distance nationalism" ("Exodus" 327). The resulting postnational imagined community can put an end to the violence in the poems which arises when people forget their shared humanity.

PILAR ACEVEDO'S OUTCRY AND "MORÍ" ("I DIED")

The transmedia and post-medium border crossing practices seen in the work of Cerón and Nepote are also evident in the work of visual artist Pilar Acevedo. Acevedo's artwork includes oil paintings, collages, and mixed media assemblages which incorporate sound and text. Assemblages by Acevedo which incorporate text include *Naughty/Metiche* (assemblage incorporating sound and a poem 2004), and *Heaven Bound/Hacia el cielo* (assemblage incorporating text, 2013) which also featured in the video *She's Alive*.[21] Acevedo also maintains a website (www.pilaracevedo.com) that includes her blog, short stories, and poetry as well as images of her work and work in progress. The

[19] See Anderson (*Imagined Communities* ch.4).

[20] It is worth noting Anderson's outlook in his 1994 article about the "readers" of today who, connected by new communication technologies, fall into a form of "long-distance nationalism" ("Exodus" 327).

[21] For an analysis of *Naughty, Heaven Bound/She's Alive* and paintings and short stories such as *Spider Princes /Princesa araña* (oil on canvas, 2013), see Bowskill ("Bearing Witness"). All of these works and others can be viewed on Acevedo's website.

relationship between the physical artwork and the website can be understood transmedially. Of particular interest is the way in which her transmedia practice combines fiction and non-fiction as she blurs boundaries between genres as well as media in a way that is not typical in transmedia storytelling.

The assemblage *Outcry* (44.5.5 × 45.7 × 19.1 cm, 2009), which will be the focus of this section, is typical of Acevedo's transmedia and post-medium work. It was made for the "Rastros y Crónicas: Women of Juárez" (Faces and Stories) exhibition at the National Museum of Mexican Art, Chicago (2009–10) which, like Nepote's poem "Las muchachas bailan" sought to draw attention to the plight of women in Ciudad Juárez. In keeping with Acevedo's overall body of work, *Outcry* can be understood as an example of "artivism" which Chela Sandoval and Guisela Latorre define as work which combines activism and artistic production (81).[22]

Outcry is described in Acevedo's blog post "Outcry" as "an interactive assemblage employing found objects, an oil painting, and a papier-mâché and paper pulp sculpture." This combination blurs multiple boundaries and undermines hierarchies including those between high/old established forms of art and newer practices involving cultural recycling. The assemblage incorporates the poem "I Died" which can be read on the blog post "Outcry" in English and Spanish where it sits alongside images of the assemblage, a video by Amnesty International about the feminicides in Ciudad Juárez, a link to a Vimeo video by Matthew Cunningham in which the curators discuss other works in the exhibit, and a description of the creative process.

Proctor and Freeman suggest that less commercially minded transmedia practices are also less focused on fictional storytelling and are instead about "something more *real* – that is to say something more political, more socially minded and more ideologically profound" (Introduction 4). Acevedo's *Outcry* blogpost reminds us that "fiction" and "non-fiction" can have complementary roles in informing and engaging audiences. As Jacalyn Lopez Garcia writes with regard to similar combinations in her *LAND-artproject.com* such works "demonstrate how a variety of mediums can be combined to challenge ideas about the role literature and documentary narratives play in visual storytelling" (97). Just as Nepote's "Hechos" poems juxtaposed the "poetic" black text and the blue "informative text" challenging the idea that poetry is not informative and the idea that news is objective, so too Acevedo's use of the Amnesty International video alongside images of *Outcry* and the text of the poem points to a blurring of boundaries between media and genres as art and poetry become informative and informative videos are incorporated into an artistic project.

[22] While Sandoval and Latorre focus on digital art, "artivism" here is applied to projects which are not exclusively digital.

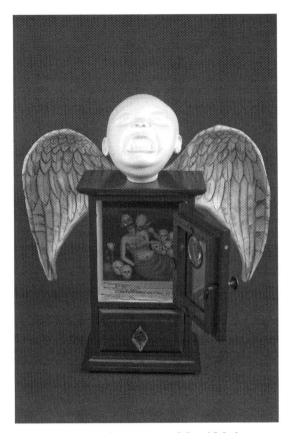

24. *Outcry*, August 2009. Mixed Media Assemblage, 44.5 × 45.7 × 19.1 cm. Image courtesy of the artist and Image Group Photography.

As is typical of radicant art, Acevedo uses different media to develop "a ribbon of significations" to be "deciphered by an audience" (Bourriaud 133). In the case of *Outcry*, as well as reading the text of the poem, the reader-viewer can interact with the assemblage by opening the doors and drawers of the cabinet to see the sculptures inside which represent the hand bones of murdered women, many of whom worked in the *maquiladoras* (factories) in Ciudad Juárez. They can also look into the magnifying glass in the corner of the cabinet to see the oil painting which adds another layer of meaning. All of these elements draw the viewer in to become more invested in understanding the assemblage and the situation to which it refers.

The assemblage consists of a head placed on top of a cabinet with wings protruding from the side so that it resembles an angel. The angelic appearance is accentuated by the white head which is reminiscent of a marble statue.

The head is tilted back and appears to be screaming. When the cabinet door is open, on the back wall we can see an oil painting depicting a woman in a reclining pose who is gagged and surrounded by skulls while being attacked from behind by a goblin-like figure. It is this scene that the magnifying glass urges us to contemplate and, we can deduce, is the cause of the angel's anguish.

The oil painting connects the European tradition of the female nude with contemporary gender politics and so Acevedo, like Bourriaud's radicant artists, creates a path between different traditions rather than being rooted in a single one (51 and 160). The combination of the oil painting, the reclining nude, and the marble-like head reference a classical tradition and objectified female sexuality, but instead of inviting a desiring male gaze the image draws the viewer in to decode its ultimately gruesome story. The pose of the woman is akin to that in Titian's *Venus of Urbino* (1538) or Edouard Manet's *Déjeuner sur l'herbe* (*Luncheon on the Grass*) (1863). However, the natural world which typically surrounds the classical female nude is replaced by skulls which signify death.

The image of the reclining woman also calls to mind Manet's *Olympia* (1863), itself modeled after the *Venus of Urbino*, in which the woman, commonly assumed to be a prostitute, unashamedly confronts the viewer's gaze.[23] The eyes of the woman in *Outcry* are wide with fear and also unashamedly confront the viewer's gaze but instead of enticing the viewer they ask why they do nothing in the face of her suffering. The association between the victims of the feminicides and a prostitute is potentially problematic as Mexican authorities were quick to dismiss the victims as "public women," a term synonymous with prostitutes, and blame them for the crimes committed against them.[24] To offset this association, the woman in *Outcry* is more modestly covered with a sheet drawing the gaze away from the pubic area and up towards her face as opposed to the woman in *Olympia* who, Charles Bernheimers (268–9) argues, draws the male gaze towards her pubic region. In Acevedo's image her hands are also tied indicating she has no control over the situation.

The goblin in *Outcry* is similar to the one in Acevedo's *Birthday/Cumpleaños* painting where the goblin is a signifier for a child abuser.[25] In *Outcry* he is also clearly identified as a sexual predator as his hands touch the woman's breasts. The goblin's hold on the woman can also be interpreted as a reworking of William-Adolphe Bougureau's *The Abduction of Psyche* (1895) in which Cupid ascends to heaven with his love, Psyche. On her website Acevedo explains that, in her initial sketches, the woman was being comforted by an

[23] On the interpretation of *Olympia* as "unequivocally" depicting a prostitute. see Clark (259–61).

[24] On victim blaming and the association between "public women" and prostitution in Mexico, see Wright ("Public Women" 682).

[25] For a discussion of *Birthday/Cumpleaños* see Bowskill ("Bearing Witness" 111).

angel but she changed the figure to a demon to signify the killers of women ("Outcry"). In *Outcry*, therefore, Cupid, the symbol of erotic love, is replaced by the goblin-abuser who is taking the woman against her will as signified by the presence of the gag.

The woman in the oil painting is silenced but the poem "I Died," narrated in the first person, gives the woman a voice and invites the reader-viewer to identify with her. The poem thus acts as a supplement to the image and an important corrective to oil painting traditions which long privileged the male gaze and to narratives about the feminicides in Ciudad Juárez which too often silence and overlook the voices and perspectives of women.[26] The speaker of Acevedo's poem repeats the words "I died" as she recounts her dying moments. She describes blood dripping from her chest, the feeling of her attackers' bony hands, and her last memory which was of her family. The poem thus humanizes the victim and counters the potential for a voyeuristic engagement with the violence and nudity of the painting with a point of view that encourages engagement based on, to use Bourriaud's words, "recognition of the other" rather than on "a registering of otherness" (132).

The importance of recognizing the other is evident in the decidedly postnational outlook in Acevedo's work as it appeals to our shared humanity rather than a shared national identity. *Outcry* incorporates paper sculptures which represent the hand bones of murdered *maquiladora* (assembly plant) workers connecting the murder of women in Ciudad Juárez to processes of globalization arising from the North American Free Trade Agreement (NAFTA) between Mexico, Canada, and the United States which led to the construction of the said plants. Just as Cerón exposed the workings of empire, Acevedo exposes the way NAFTA turned women into victims of corporate and international greed. Both use their work to invite "readers" to imagine alternative postnational communities based on a rejection of the violence done by such entities. Acevedo, therefore, explains that: "[t]he bones are labelled in Spanish and English, with what the murdered women were to family, friends, and people in the community i.e., daughter, sister, granddaughter, niece, cousin, friend, child, employee, etc." (Acevedo "Outcry"). Just as Nepote's "Las muchachas bailan" used dancing to emphasize the reader's shared humanity with the murdered women so too Acevedo's labels remind us of our own relationships with others, promoting solidarity without regard to nationality by inviting us to ask how we would feel if it were one of our loved ones who had been killed.

[26] Roberto Bolaño's *2666*, for example, does not give the victims a voice. As Peláez states: "These dead women – who can be thought of as subaltern – do not speak, they remain stubbornly silent through the mediated discourse of a third person impersonal narrator" (41).

Acevedo's depersonalized approach further invites us to tackle issues on a social level rather than focusing on individual cases. Other important artworks about the feminicides have reminded us of the need to remember the individuals behind the statistics including, for example, Tamsyn Challenger's *400 Women* exhibition which consisted of portraits of the victims. *Outcry*, on the other hand, directs us to think about the mismatch between the non-existent public response and the widespread nature of the violence. The title of the piece provokes us to ask why there was not greater public outrage and is an incitement to us all to speak out. It does not, however, reference a specific context. We are thus called on to engage with feminicides not because of where they are happening, or even because of who the victims are, but because murder and violence on this scale *should* lead to an outcry from all of us no matter where we are.

CONCLUSIONS

In their choice to work with different media Acevedo, Cerón, and Nepote are, to adapt Dick Higgins' words from his seminal text on intermediality, finding ways to say what has to be said about the world in which they live and the world in which they would wish to live. In so doing, they are forging a new kind of Latin American cultural production which exceeds the traditional geographical boundaries of Latin America. It is characterized by expanding projects which employ multiple media in combination and in dialogue with one another without regard for established hierarchies. "Contamination," with its traditionally negative connotations, thus becomes a credo for a truly modern practice.

The projects studied nomadically connect different times and places rejecting identities and allegiances based on nationality. They address and engage the reader to construct a postnational community that is ready to respond to the violence in today's increasingly globalized society. Much of these highly immersive experiences are made available for audiences around the world free of charge so that readers can cooperate in the creation of meaning across media and in so doing become witnesses to violence and part of a new imagined community. Seen in this light, the transmedia and post-medium practices adopted by these women are a political statement and a political tool. We must be careful to avoid the trap of suggesting that a transmedia or post-medium practice necessarily implies any specific politics or ideology. Form has no inherent politics that is independent of content. Yet we cannot ignore the ways in which the women studied in this chapter have found in transmedia or post-medium cultural production a form which reflects their transnational or postnational content.

These case studies also present us with much needed examples of transmedia and post-medium projects by women. Their transmedia work acquires further significance as it differs from the more frequently studied models from an anglophone or commercial context, which seldom focus on poetry or allow for combinations of fiction and non-fiction, and which are based on narrower understandings of transmedia storytelling. The work of these women provides an important corollary for thinking about the alternative histories of transmedia and post-medium practice in Spanish America just as the concepts of transmedia and post-medium provide a distinctive framework for understanding their *oeuvre*. Finally, their work alerts us to the fact that the post-medium condition is in evidence beyond the art gallery and shows how this concept has the potential to enhance our understanding of the increasingly prevalent multimedia practices in contemporary literature.

The critical frameworks and concepts of transmedia, post-medium, post-national, and nomadic featured in this chapter were brought together not to choose one in preference over another but to illuminate different aspects of the works under consideration. In the 1910s and 1920s, buyers of a Model T Ford could choose any color as long as it was black! Monochrome interpretive strategies are just as restrictive. Analyzing Cerón's Empire, Nepote's "Sensationalist News" poems and the "Roswell" videopoem, and Acevedo's *Outcry* and "I Died" with reference to multiple theoretical frameworks has demonstrated the benefits of approaching these projects from different critical perspectives. Equally, seen in new contexts, our understanding of these terms and their potential applications has altered. The critic, like the author or artist, has no need to choose one or the other. Rather, the contemporary critic should be like the figures of the semionaut radicant artist creating "paths in a landscape of signs" and the DJ who is "a practitioner for whom the work with its signature affixed is merely one point in a long and winding line of retreatments ..." (Bourriaud 102 and 161). The "texts" we "read" provide the critic's playlist but the frameworks we apply to understand them, and the relationships we create between them, are constantly evolving, changing, and enhancing our appreciation as we go.

14

The Art of the Hack: Poets Carla Faesler and Mónica Nepote and Booktuber Fátima Orozco

EMILY HIND

While we might imagine a contestatory function for the intermedial artwork in Spanish available on YouTube, the following reading ends up largely denying such alterity. Videos by three Mexican artists, Mónica Nepote (b. 1970, Guadalajara, Jalisco), Carla Faesler (b. 1967, Mexico City), and Fátima Orozco (b. 1993, Monterrey, Nuevo León) exemplify the flexibility of the categories of the amateur and the professional in an age of distrust for expertise, without pushing the discussion in new directions – sadly for feminists. In a key YouTube video that I discuss, Nepote turns the notion of the voice into an interface, now that of an analogue body, now that of a digital trick. Similar games with mediated presence appear in Faesler's YouTube videos, which include print pages and paper dolls. Orozco, a Mexican book reviewer on YouTube, or Booktuber for short, performs something of a fetish for print books in her videos. Non-poet Orozco at first seems a dissonant choice beside Nepote and Faesler, although I hope that by the end of the present analysis, my reader will understand the stakes of dismissing Orozco's efforts out of hand.

THE SET UP: INTERMEDIALITY, EXPERTISE, AND PRINT

Jan Baetens and Domingo Sánchez Mesa define the term *intermediality* as an artwork of heterogenous materials in conflict (292).[1] This definition strikes a

[1] Winocur is correct when she asserts that the dominant themes of discussion on digital culture in Latin America share the Anglophone model (134). For an

166 EMILY HIND

familiar deconstructive note, and in recognition of that familiarity, Baetens and Sánchez-Mesa nod at the relevance of Kiene Brillenburg's "back to the book" conference, now transformed into an edited volume (298). The relevance of the print book is also hinted at in Mexican critic Roberto Cruz Arzabal's work on materiality and the interface, the point where mediums meet. An enthusiast of Nepote's and Faesler's poetry, Cruz Arzabal launches his criticism from Alexander Galloway's broad definition of interface as a "space of transition between media and forms of language" ("Writing" 244). An interface is usually invisible and therefore when one appears, "it has stopped operating as such and has begun to function as a medium" ("Writing" 244).

Interest in materiality coincides with Edmundo Paz Soldán and Debra Castillo's observation regarding "literature's overall 'representational privilege'" (cited in Lavery 13). This question of print publication is hardly esoteric – or even a truly alternative topic, especially if distribution systems for e-book editions of print material are taken into account. Like the global platform of YouTube owned by the market dominant Google, increasingly large book publishers manage the international circulation of digital and print literatures in surprising concentrations of power.[2] In a book I will mention again, *The Amateur*, former professor Andy Merrifield critiques the monopolistic pressures on university intellectuals by citing a study from 2013 of 45 million articles in the Web of Science, which "revealed that just five publishing companies control 70 percent of global output" (51).

The Oxford Handbook of Interdisciplinarity juxtaposes an article on the long roots of the 1960s term *intermedia* (Augsburg 136) with meditations on the pros and cons of outsider collaboration and insider academic status by thinkers such as Robert Frodeman (4), Stephen Fuller (64), and J. Britt Holbrook (491). The subjects of amateurism and interdisciplinary research or intermedial art necessarily intertwine, thanks to the profound degree of specialization required to turn professional, which makes expert cross-disciplinary work quite difficult. Several books by legal scholar Lawrence Lessig also align these subjects. In *Free Culture*, Lessig refers in passing to a definition of the amateur (44), amid his thoughts on such topics as blogs and the rise of a kind of "copyright code" in place of "copyright law," created as platforms like YouTube built in restrictions (152). Some four years after Lessig's meditations on an increasingly weak public domain, he opened another book with an anecdote regarding a dispute between lawyers for the media company Universal and a

excellent review of the literature on the matter of technology and Latin American literature and culture, see Gentic and Bush ("Introduction").

[2] David Sax has registered the recent retail bounce in analog media, including "old-fashioned print books." Though statistics for the Mexican book market are not available, it seems likely that the same trends exist there.

THE ART OF THE HACK

user of YouTube who posted a twenty-nine second video of her toddler dancing to an imperfectly audible tune by Prince; because the user did not have the rights to the song, the legal team for Universal refused to "back down," despite the poor sound quality (Lessig, *Remix* ii). It bears emphasizing that a common thread connecting Lessig's explorations of law and the studies on academic tradition in *The Oxford Handbook of Interdisciplinarity*, is the proper place of professionals and amateurs. The debate implicitly acknowledges onlookers' resentment of elite expertise, a resentment driven by twinned perceptions of increasing social inequality and narrowing opportunities for professional security. However, as intermedial art shows, the professional and the amateur are not simple binary categories. The wavering line that divides these classifications can be straddled with a figure such as the *hacker* and the technique of the *hack*.

IN PRINT AND ON YOUTUBE: MÓNICA NEPOTE, CARLA FAESLER, AND FÁTIMA OROZCO

For an introductory overview of the Mexican artists themselves, I begin with Mónica Nepote, the director of projects such as *E-Literatura*, a digital publishing entity under the governmentally funded Centro Digital de Cultura (Center for Digital Culture) in Mexico City. Nepote dances to her own poem in a piece commissioned by Fernando Vigueras for the *Soledades* (*Solitudes*) exhibition, presented in the Centro Cultural de España in Mexico City in 2013. Henceforth, this video appears in my labeling under the title of Nepote's poem, "Mi voz es mi pastor" ("My voice is my shepherd") . In the best online video of the performance ("best" thanks to superior staging and filming), Nepote's pre-recorded recitation plays while she dances and while sound engineer Cinthya García Leyva manipulates that poetic reading in real time for a live audience (*@Articulaciones del silencio*). Aside from the intriguing possibilities of intermediality triggered by dance and the technically mediated poem, I note two additional points of interest. First, the video does not include a print version of the poem.[3] Second, Nepote's dancing is distinctly non-professional, an amateur performance captured in clumsy filming. Her choreography avoids especially athletic movement: no leaps, no fancy footwork, no pirouettes, no balancing poses. Unlike many adult dance soloists who perform before a live audience, Nepote is not remarkably young, flexible, thin, or trained. *Dance need not be left to the professionals*, her confident movement implies.

[3] Nepote tells me that she circulated thirty homemade copies of the poem (Nepote, Email 18 July 2018).

Nepote begins the performance by loudly unspooling duct tape from the roll; she imperfectly tapes a border for herself and adds a center line from downstage to up. Possibly, the tape connotes the notion of transgression, or perhaps it refers to a border-crossing state between digital and analog forms. Awkward camerawork complements the enigmatic nature of the taped lines, and the spectator is never sure what the camera operator leaves out of the frame. Nevertheless, at about 4:10, the filming reveals that Nepote, who has been dancing for spectators in a largely black theatrical space, moves in front of a screen that projects another video of her dancing against a white background. That second performance copies the style but does not synchronize with the steps of the live dance. How should we judge the discipline of Nepote's poetry against the undisciplined dancing? How much weight should we assign to her collaborators' skills or lack thereof? The tricky matter of professional poetry complicates matters. Low sales make it difficult to become a professional poet by virtue of topping the mass-market charts, and yet, ongoing interest in publishing print books may respond to the need for credentialing.

On that note I turn to Nepote's colleague in poetry, Carla Faesler, who incorporates images of print text in relevant videos, such as *Tiza persona* ("Chalk Person") and *Asuntos internos* ("Internal Matters"). The pages filmed are found in the source book of poetry, *Anábasis maqueta* (2003), which won the Gilberto Owen prize for 2002. That award and publication, along with the subsequent reviews in venues like *Letras Libres*, gird Faesler's claim to competency.[4] Her publicly recognized skill conflicts with the distinct signs of amateurism in the videos that illustrate her poetry. Like Nepote's low-budget dance performance and recording, the props in Faesler's videos are strictly in-house efforts centered on common household items like pencils and mirrors. Instead of dancing like Nepote, Faesler manipulates paper dolls of herself, which are noticeably "material." The dolls, made from miniature cutout photographs of Faesler in various poses, always wear a red outfit.[5] In each video, Faesler arranges the dolls in tableaus that support the content of the parodic spiritual journeys explored in the poetry books, *Anábasis maqueta* and *Catábasis exvoto* (2010). These Latin names help obscure the otherwise easily recognizable topics of alienation and embodiment.

Cruz Arzabal emphasizes the traces of analog materiality in Faesler's photographs, noting that the "material roughness" makes no effort to hide its origins in non-digital technology.[6] While the white edges around the cutout dolls of Faesler inspire Cruz Arzabal's respect, a less inventive critic might

4 For sample reviews, see Ramírez ("La fantasía") and Cruz Arzabal in *Letras Libres*.
5 Faesler told me that for her the color red represents good energy (Faesler, "Personal conversation").
6 All translations are mine.

THE ART OF THE HACK

reject the arts-and-crafts approach as inept. Faesler does not fear that accusation and plays up the amateurish, two-dimensional nature of the dolls. For example, in the video *Espejo* ("Mirror"), Faesler mounted the photos of herself on wooden sticks, and as an unseen hand moves the dolls in front of a mirror, the video audience intermittently sees the blank side of the dolls where the stick is attached, whether by direct viewing or indirect reflection in the mirror.

In keeping with the fact that Nepote and Faesler are not the most celebrated writers in Mexico, I have elected to focus on Orozco and not Raiza Revelles, the Mexican Booktuber with the largest fan base, some 1,298,907 subscribers for her channel ("raizarevelles99") as of 29 August 2018; this number swelled to 1,550,000 subscribers by 22 November 2019.[7] Around the same dates in 2018, Orozco had less than half this following; LasPalabrasDeFa counted 355,953 subscribers by 29 August 2018 – up from 349,596 subscribers on 14 February 2018, a number that had already risen by 3,946 subscribers since 1 December 2017. Over the course of drafting the present analysis, Orozco's channel plunged in membership. On 24 September 2019, Orozco posted a final goodbye on LasPalabrasDeFa, concluding seven years of constant video production. Her fans could follow her to another YouTube channel, Fa Orozco, although by 22 November 2019 only 44,700 subscribers had done so. Despite Orozco's minor status next to Revelles's early and ongoing success, I have chosen to study Orozco because even as a second-tier effort, the former Booktuber's numbers overwhelm in comparison to the two poets' virtual followers. On 29 August 2018, Carla Faesler's channel on YouTube ("carla faesler") counted only fifty-two subscribers; on 22 November 2019 that number had reached sixty-three. On that same date, Mónica Nepote did not have a channel; her place of employment maintains one that counted 1,316 subscribers; by 22 November 2019 that number had risen slowly, to 1,740 ("Centro de Cultura Digital"). Thus, Orozco's YouTube channel represents an increase in audience over channels by Faesler or the official CCD of some 200 percent. To ask why Orozco draws such a large audience is to some degree to ask why internet users might be interested in a digital format that praises the print book. Alessandro Ludovico supplies one answer when he states that the "digital is built for speed, while print ensures stability" (7).

In the summer of 2018, Orozco published a short story, "El abrigo rojo" ("The Red Coat"), in the intensively marketed anti-bullying anthology that she co-organized, *No te calles* ("Don't Be Silent") (2018). In addition to her advancing age that gradually distanced her from the younger YouTube crowd, the inexpert literary quality of this short story may partly explain her decline in popularity on YouTube. This inept "El abrigo rojo" counsels the reader in

7 See Batalla for more.

contradictory clichés, and rather than parse the many directions of its advice, I prefer to give my reader an idea of Orozco's style by citing the more relevant "About Me" section of the YouTube channel. There, Orozco explicitly and inexpertly declares her amateur aim, couched in identity shared with her fans: "On this channel we chat about books and how good they make us feel, how they move us; transform, heal and revolutionize that, many times, we don't see coming. Don't expect anything professional from me, I'm just a fangirl of books and reading" (Orozco, LasPalabrasDeFa).[8] Orozco's upbeat tone, matched by three misspellings, a misplaced semi-colon, and syntactic spontaneity, stakes a claim of amateur status that by 29 January 2018 had received 22,321,715 views. By 29 August 2018, that number had climbed to 23,357,721. The increase of 1,036,006 views suggests the power of print (and matching e-book) publication to tout a digital artist; despite the closure of the channel LasPalabrasDeFa, the views for the "About Me" page had risen to 24,507,819 by 22 November 2019.[9] The channel may evolve into a nostalgic collection of book fandom that attracts web traffic, even though no new content appears there.

Interestingly, Orozco's literary style in the short story does not mimic her digital style on YouTube. Only the videos abound in English-language catchphrases, humor, and skillful editing.[10] Still, it is inaccurate to label Orozco's anthology as a wholly amateur effort. Like Merrifield's *The Amateur*, the major publisher Penguin Random House backed the anti-bullying project. In further marketing, Orozco's anthology includes texts by three Spanish Booktubers born in Madrid: Javier Ruescas (b. 1987), Andrea Compton (b. 1991), and Chris Pueyo (b. 1994). The closest Nepote or Faesler can come to the sort of international distribution made possible by Random House is the publication of *Formol* ("Formaldehyde") (2014), Faesler's novel distributed with the formidable reach of Tusquets, a label of high prestige under the massive Grupo Planeta.

Orozco's often body-conscious clothing and her colorful blue, pink, or lavender hair evoke for me the wavering line between analogue bodies and

[8] All translations from Spanish sources are by the chapter author unless otherwise stated.

[9] This following also benefits from a Mexican podcast called *Hijos de la Web* (www.hijosdelaweb.com), begun in May 2018, on which Orozco is the only woman. On 22 November 2019, the Twitter handle @HijosDeLaWeb counted 6,167 followers.

[10] Orozco claimed in an email to me that she never studied English formally: "I learned it with music and TV series. I like to say that I owe my English to *Friends* and Hilary Duff, haha." In the same email in which I queried her about formal education experiences, she answered that she had never studied at private schools (Orozco, "Personal email").

THE ART OF THE HACK 171

digital stylizations that Nepote's doubles and Feasler's dolls also test. To name
another parallel, Orozco occasionally draws herself, somewhat in the style of
Faesler's video *Tiza persona*, in which we see the poet's hand as she sketches a
paper doll of herself, which she holds in her other hand. Orozco's self-portrait
emerges among the pages of *Good Night Stories for Rebel Girls* by Elena Favilli
and Francesca Cavallo (2016, translated as *Cuentos de buenas noches para niñas
rebeldes*). In the germane video, Fátima Orozco's videographer sister, Karen
Orozco, exclaims delightedly off-camera that she hadn't known that Orozco
appears in the book. Fátima clarifies with a sly smile that she put herself there;
she used the blank page to sketch a stylized version of herself, with blue hair
and enormous green eyes (*Cuentos*). Orozco generously shares with viewers
the technique of her doll-like look, and in one video she even combines book
references with makeup tips (30 min).

An entertaining interface in her work celebrates the line between reading
and playing with books as material objects. Orozco falls short of academic
professional standards as a critic, given that she does not cite other academ-
ics' work or seem knowledgeable about the range of literary theories used
to interpret text, but she excels as a book lover, as is apparent in one of her
most popular videos, an explanation of the metaphors and symbols in the teen
angst work *The Fault in Our Stars* (2012, translated as *Bajo la misma estrella*) by
John Green (*Metáforas* ["Metaphors"]). Orozco's interpretations never ven-
ture beyond the basics of a close reading, and thus no single point in Orozco's
explanation of *The Fault in Our Stars* inspires me to cite her directly; rather,
I want to call attention to the spread of this video. The twenty-five-minute
piece, *Metáforas*, uploaded in July 2014, had attracted journalism about its
popularity by 2015 (see Sánchez Sánchez). By the end of August 2018, the
video had accumulated a whopping 493,391 views. By 22 November 2019,
after the closing of the channel, the views totaled 511,393.

A direct comparison with the internet presence for Nepote and Faesler
proves enlightening. By late 2017, the three videos among the list of the most-
watched of Faesler's oeuvre, *Espejo*, *Tiza persona*, and *Impulso* ("Impulse"),
had earned a joint total of 3,469 views, since being uploaded to YouTube in
2008. Two years later, by 22 November 2019, that total for the three videos
increased only 6 percent, to 3,678. The video for *Asuntos internos*, with its shots
of the printed page with the poem, tripled Faesler's usual 500-or so hits per
video and had drawn 1,513 views and four thumbs up by 31 August 2016; by
2 February 2018 that number had increased by forty-four views, to 1,557 and
seven thumbs up. On 22 November 2019, the views reached 1,599, with nine
thumbs up. The same small audience and slow crawl of viewer hits describes
Nepote's work. From 12 December 2014 until 9 March 2018, Nepote's *Mi voz
es mi pastor* had attracted 970 views. On 22 November 2019, that total stood
at 1,173 views and twelve thumbs up. Orozco is as deft with intermedial art

172 EMILY HIND

as the poets are clumsy – and yet, both groups play the amateur. However, only Orozco makes money off this amateur performance. I cannot count the number of ads I have watched in order to play the videos or check the view totals on LasPalabrasDeFa.

Thanks to the demands of intermedial art, *none* of the three Mexican artists studied here fully dominates all the disciplines that feed into the digital artworks. Academics who disdain Orozco for her lack of literary skill or dismiss Nepote's efforts for her inexpert dancing or ignore Faesler for her homemade video props have perhaps misunderstood the opportunity here to rethink the amateur and the professional, a binary that ought to concern academics not just for the debate over siloed disciplinary elitism, but also for the history of sexism. In point of that last subject, I note that Merrifield defines the hobbyist role as a savior, poised to "take back democracy from technocracy," just at the moment when women can become professionals with something like the privileges that men traditionally held (130). Merrifield drives home this historical coincidence with his nearly entirely male canon of thinkers and artists. Note the implicit masculine gender in Merrifield's nostalgic description of his most admired professors: "most drank too much, hardly published anything, and were veritable antitheses of today's professionalized academy" (11). The gender bias of late-twentieth century social rules for tolerated public drunkenness hint that these excessive drinkers were men. Thus, Merrifield may long for a certain kind of male privilege upended not just by the "neoliberal university" but also the newly "professionalized" and more inclusive faculty.

A PRECEDENT IN THE AMATEUR/PROFESSIONAL DEBATE: ANA CLAVEL

Jane Lavery's foundational analysis of multimedia art recognizes the controversies that surround Ana Clavel (b. 1961, Mexico City), who sometimes strikes peers as an amateur. In Lavery's words, Clavel's multimedia work, "has had at times a lukewarm reception, perhaps because she has straddled, or rather smuggled herself, into other fields which are not perceived as her expertise" (251). Clavel's Mexico City installation staged in 2008 and connected to her novella *Las violetas son flores del deseo* (2007), according to Lavery, had the novelist commission life-size dolls from thirteen papier-mâché artisans, called *cartoneros*. Clavel requested that each of the commissioned dolls be her height, 1.5 m (Lavery 192). Then, sculptors, painters, and Clavel herself worked on the dolls. Lavery reports that the resulting "artistic renditions were unanimously horrifying" (179). The grotesque nature of the dolls helps to counterbalance Clavel's inexperience with installation art by echoing serious themes of her novel, including pedophilia and dollmaking, a thematic seriousness that, as Lavery understands, reinforces "Clavel's credibility as a writer of serious fiction" (Lavery 116).

THE ART OF THE HACK

Though Lavery emphasizes Clavel's expertise and looks past the infelicities of experimental collaboration, I suspect that *both directions*, the polished and the unpolished, can serve the ends of a canny artist if she means to play to a code of femininity. That is, if such habits as "tolerated excessive drinker" tend to code masculine, the domestic arts-and-crafts, DIY doll play, and corresponding implied transportation of home activities into the public space, tend to code feminine. Nepote, Faesler, Orozco, Clavel, and like-minded artists work as "amateurs" when it comes to one or another of the skills required to complete their intermedial projects, against the notion of the lone (male) genius, in ways that likely appeal to an audience receptive to the invitation to be inspired by imagining themselves as capable of copying these arts as a kind of craft. The irony of Merrifield's male amateur, as per his examples such as Marx writing a masterpiece in the public library, is that the feminine model of this activity connotes a hobbyist effort that at once seems inviting *and* makes the other amateur activities that code as male seem more like a gig, that is, a professional contribution. A woman writing in the library is just that, and not a poorly paid genius.

ANOTHER PRECEDENT: MOTÍN POETA

To better define the amateur or DIY nature of Faesler's and Nepote's videos, Clavel's installation art, and Orozco's video projects, I turn to another term, *techné*, or an art with practical purpose. I take *techné* from Mexican science fiction writer Fran Ilich (b. 1975, Tijuana, Mexico), who compares the Greek term with the Mexican notion of *artesanía*, "as a professional role and not as a flash of inspiration" (103). Ilich thinks of the method of *techné* as admirable by conceiving of it as a kind of craftwork in which certain steps are followed; practitioners can choose either to break with those steps or to develop proficiency within them, which allows for play within the form. Ilich thus defines electronic art, media-art, and internet projects as restrained less by the medium than by this technical approach (103). The skilled following of steps within the boundaries of certain crafts – and at times in collaboration – can be seen to repurpose such practices as dance, poetry, or even dollmaking. In Ilich's sense of the uses of *techné*, the term *hacker* applies; after all, the *techné* can lead to self-aware, politically critical art, or a multivalent hack job. What Ilich calls *techné* then, I find more usefully labeled the *hack*. Thus, the false binary of amateur and professional can give way here to the word that combines both those angles into one: the hack.

Because none of these Mexican artists knows how to code, they can all be seen to operate as *hacks* (amateurs) in need of a *hack* (short-cut), such as collaborating with a *hacker* (a piratically inclined coder). Nepote's collaborative and knowing play with presence and representation, set against the crudeness of the "homemade" video, picks up on the art of the hack, which

makes the audience think that perhaps they too could dance in seemingly unchoreographed inspiration, just as Faesler's games with paper dolls seem invitingly homemade and the nitty-gritty details of Orozco's book preferences and makeup brands seem to hand spectators the keys to her success. Just as the meaning of the *hack* changes according to context, I find my views on these tactics wavering. On one level, there is something fundamentally cheering about watching a Mexican woman embody her own thoughts and art, and on another level, the games with self-presentation across multiple bodies – whether Clavel's and Faesler's dolls or Nepote's digital recordings or Orozco's endlessly exacting hair and makeup – only ambivalently defy entrenched reasons for dismissing women as lesser intellectual and artistic talents. Precisely on this point of imitability – of *accessibility*, which in sexist tradition is suspiciously labeled "commercialism" – I confront the at least partially imaginary nature of the binary that divides the professional and amateur.

To show that what might be called "high art" as distinguished from "commercial art" is sometimes more of a gendered slur than a cogent matter of professionalism, I examine a project by Motín Poeta ("Poet Uprising"), the collaborative effort that Faesler coordinated. Motín Poeta disbanded in 2010, the same year that the collaborators gave up the space dedicated to that group's project of poetry by commission called *Agencia de poemas para toda ocasión* ("All-Occasion Poems Agency"). According to flyers that Faesler shared with me, the Agency boasted that a commissioned poem is "truly personalized," thanks to the questionnaire that potential clients must fill out. Once a poet accepts a commission, the minimum time to write a poem is ten days. The advertising copy highlights the material result: "A poem is more than a perfume, a jewel, a tie. / A poem is forever." One flyer even offers talent swaps: although the price for a poem is $550 pesos, barter among numerous professions, such as butchers, hair stylists, accountants, designers, electricians, plumbers, and attorneys, is also accepted through 30 September 2006. While it lasted, the Poet Agency played with hack ideas by stretching the notion of poetry to include poems as ambiguously hand-crafted (an expert hack) or handicraft (an amateur hack). The *techné* implicit in writing a commissioned poem for money, as if it were just another commercially traded object, imagines all guild members as equals. Such equality is not actually the case, of course.

To wit, I cite the participating poets, in order of appearance in the advertisement, born in Mexico City unless otherwise noted: Ernesto Lumbreras (b. 1966, Jalisco, Mexico), Hernán Bravo Varela (b. 1979), Luis Jorge Boone (b. 1977, Monclova, Mexico), Julián Herbert (b. 1971, Acapulco, Mexico), Faesler herself, Pedro Serrano (b. 1957, Montreal, Canada), Mónica Nepote, León Plascencia Ñol (b. 1968, Jalisco, Mexico), Ricardo Pohlenz, Myriam Moscona (b. 1955), and Rocío Cerón (1972). On the extremes of the scale, Pohlenz is the most obscure figure, while Herbert is the best known and most

THE ART OF THE HACK 175

award-winning, who in his own confessional writing is also known for excessive drinking and cocaine use.

I bring up details of Herbert's masculine performance because when I asked Nepote why Motín Poeta disbanded, she pointed out that some rising careers weakened the collective (Personal interview). To put the point another way, the *hack* of guild membership that posits poetry as an equivalent of a skilled trade stagnates in the face of squarely professional literary success, which prefers the aura of celebrity attached to individual trajectories and still favors men. I turn now from the matter of amateurism or hack "commercialism" that plagues women artists to the most unfortunate implication of being seen as accessible: vulnerability.

NEPOTE AND FAESLER: GENRE, GENDER, AND VULNERABILITY

Cruz Arzabal published observations on just one section of Nepote's chapbook *Hechos diversos* (2011).[11] Regarding Nepote's subject matter of the bodies of murdered women, Cruz Arzabal proposes that the poet wrestles with the dilemma of presenting these violated beings in a way that is not exploitative. This visibility in Nepote's interface between poetry and murders reported in the news leads Cruz Arzabal to his concern for "the materiality of the system," the same theme that he had earlier explored for Faesler's work ("Writing" 246). In assessing these artworks – that is, in judging the interface as a failure or a skill – the eye of the beholder determines all. These topics of violence and vulnerability bring new nuance to my reflections on the use of dolls and doubles that manages to transform the artist's body: erasing the author even while training attention on her. To add another example, take Faesler's video *Impulso*. There, Faesler herself appears, in the absence of the paper dolls, though her face is obscured by what seems to be white-light overexposure. Through this blurry face, the video shows the author's body and explores the limits of presence. As I mentioned, in *Mi voz es mi pastor*, Nepote's voice is distorted with digital effects, even though her body dances normatively during her live performance. I return to the key question: Who decides when the amateur performance is actually avant-garde and thus expert? In the traditional answer, *men do*. At least until yesterday, men's opinions often seemed to carry the most weight when it came to evaluating projects as authoritatively skilled. Hacking this system risks being left outside it; after all, until yesterday at least, women writers were mainly understood as amateurs who didn't drink their way to likability, much less genius status.

[11] This work is also examined by Bowskill in this volume (154–8).

For example, the highly subjective critiques at work here surface with a novelist, Tryno Maldonado (b. 1977, Zacatecas, Mexico), who disapproves of Nepote's contribution to the Faesler-coordinated record *Urbe probeta* ("Test Tube City") (2003). That digitized recording exists on the Internet today and by early 2018 had tallied some 13,429 hits (*Urbe probeta*). In her role as leader of Motín Poeta, Faesler invited Nepote to the collaboration among fourteen poets and twelve music producers, all of whom lived and worked in Mexico City ("Poesía y arte" 12). In Maldonado's view, Nepote's track, titled "Ciudad Puente" ("Bridge City"), fails to understand the group project. Maldonado dislikes the vocals sung by Gabriela Vega, and laments Nepote's decision not to recite her text. For Maldonado, the resulting collaboration fails due to its *lack* of intermediality: "Ciudad Puente" is simply a tune with "the typical structure of a pop song" (Maldonado). By contrast, Maldonado approves of Faesler's poetry-typical reading of "Fauna Ciudad de México" ("Mexico City Fauna") over a beat by the artist "Nasty." Maldonado's opinions hint that the interface, the collision of one medium with another – here between conventions of poetry and those of music recordings – must remain appropriately visible for the work of art to pass muster as avant-garde and not facile. My readers should keep in mind that evaluations of these works as either sophisticated or inexpert risk undue influence from gender bias.

To explore this hack technique further I asked Nepote during a personal interview what it is like to work as a non-coder at the Centro Digital de Cultura. She explained her professional responsibility there in terms of coordinating others by way of a search for literary language, specifically a search for metaphors (Nepote, Personal interview). That is, Nepote aligns coders' and artists' plans for a project by using poetic skills, but she no longer *writes* in the traditional sense as she shepherds the joint endeavor. During our interview, Nepote spoke repeatedly of her pursuit of the effects of interruptions in the way a user expects to interact with technology, which is reminiscent of the way artists Mariela Yeregui and Gabriela Golder speak in this volume about using technology to disrupt people's experience of their urban environment. She distinguished her "break it" style from Faesler's "build it" aesthetic, a contrast which I interpret as Nepote's urge to adopt new technology that risks hiding the interface by fully breaking with one genre and entering another, by subtle differentiation from Feasler's drive to show the construction seams among her various invoked genres (Nepote, 2016). The printed text that Faesler sometimes reveals in the videos logically disappears in Nepote's experiments with multimedia interference with – rather than support for – the "architecture" of the "formal" poem. In sum, Nepote sometimes gambles on abandoning the sort of poetry that critics know how to read as such; by disappearing the interface, she risks her work being described as, for instance, an easy-listening pop song.

THE ART OF THE HACK

Certainly, watching *Mi voz es mi pastor* is an exercise in a battle against instability and distraction, as the live performer struggles to command attention over the sound of the poem and against the screen with her own dancing image, and the spectator wonders which element deserves interpretative attention. Just as Maldonado came to question Nepote's multimedia poem on *Urbe probeta*, the audience for *Mi voz es mi pastor* may wonder what happens to the poem in the midst of the dance and the digitally altered word. Though Nepote's live dancing remains in the analogue world, her voice – that shepherd or minister of the poem's title – is dragged about electronically until at certain moments it becomes electronic music. The battle between analogue and digital in the technique forms a parallel with the content of Nepote's verses that encourage confusion between machine and body. From the outset, *Mi voz es mi pastor* proposes the awakening body as a computer-like machine: "You start in the body. Extended. You gesture as usual in the mornings, the moment when the device activates. The power button. The daily click" (*@Articulaciones*).

The dance complicates the notion of an analog body by insinuating that an awakening can be imagined as a digital booting up process. Because – during the relevant lines, at least – Nepote fails to mime the expected gestures of the poetic subject in a non-digital body coming back to memory after sleep, it becomes even harder for the audience to capture the meaning of early lines such as: "You are still lying down. You just woke up. For a fraction of a second you forget everything: your gender, your weight, your name, your pains, your love, your ideals, your things to do" (*@Articulaciones*). Not only is Nepote not lying down nor immobile during these lines, she is hardly a blank slate. The poet's dancing body suggests her gender, age, and health, among other elements in the list of supposedly forgotten personal identity markers. For that reason of analogue embodiment, the last line of the poem surprises. "La voz es mi pastor, nada me falta" ("My voice is my shepherd, I lack nothing") manages a biblical allusion to the comforting shepherd that the machine-as-body theme fails to cultivate as an expectation. The "wiped disk" of the identity-free awakening unexpectedly delivers the audience to the possibility of transcendence. If Philip K. Dick cleverly asks whether androids dream of electric sheep, Nepote seems to reassure us that a liminal analogue/digital state still requires shepherds, though what this guiding "voice" is, whether digital or analogue, remains unclear. Since Nepote never imitates a robot in her dance, it is not clear that she means to present a kind of post-analogue embodiment.

If Nepote suppresses printed matter in the video *Mi voz es mi pastor*, Faesler takes the inverse stance. Moving from the videos already mentioned, I can ponder print books among the pages of *Formol*, because Faesler locates a fictional family heirloom – the preserved heart of the last human sacrifice of the Aztecs – in the library of two successive Mexico City homes. The novel teasingly suggests that, despite its supposed location amid print culture, the

heart exists within a digital literary reality. In the thirty-third chapter, Larca and her father Celso arrive at a laboratory in Mexico City with the heart of the last Aztec sacrifice in a jar, and the narrative hints that we are actually reading about characters on a screen. When the characters' reality pixilates, Faesler suggests that the heart is made not of the expected DNA, but a different sort of code. In this key scene, as Larca and Celso climb stairs mechanically,

> they look like animated characters from a videogame. They don't notice where they are going, and they don't realize how the wall of mosaics moves and throbs as they walk. They feel they are carrying their history, and what happened recently, they have halos of poorly tuned waves over their heads. (182)

The characters do not notice that their reality may be coded, or that they exist in an interface that causes their otherwise stable reality to show its glitches. Although Faesler does not know how to code, she is writing her characters and their architectural environment as digital: a hacker move. By scripting a glitch of ersatz coding, Faesler draws attention to an *imaginary* interface, which seems to trump the digital with the force of imagination. This literary technique that claims the qualities of the virtual – without actually taking on the instability of code but only mimicking it – aims to produce maximal confusion between the digital and the analog levels. That confusion makes the novel impossible to interpret reliably as one genre or another (Is it a historical family drama? A fantastic novel? A new genre of "digital realistic" fiction?).

The tricky chemistry of Faesler's novel appears to invoke what Rebecca Walkowitz, by way of citation of Katherine Hayles and Jessica Pressman, calls "an aesthetic of bookishness," which has "bookish" literary texts reflect a "post-digital" turn. Under this bookish aesthetic, literary fictions "call attention to the properties of bound paper and ask readers to do more, in fact, than read" (231). The extra task for readers, according to Walkowitz, requires them "to become handlers and viewers, and [...] to establish the text rather than to assume it" (231). Indeed, *Formol* demands that the reader think about the properties of a text on a screen or in a book and question its nature as "written" rather than "coded." Precisely this question interacts with bookishness. Why does Faesler's narrative insist on placing the preserved heart in not one but two versions of the family library? Perhaps because as Ludovico notes, the print book remains "the very best 'interface' ever designed" (7). The print library, in itself, is a kind of formaldehyde.

YOUTH, LITERACY, AND FÁTIMA OROZCO

Another way to compare the Booktuber Orozco and the poets Nepote and Faesler is to mark the distinction between the "real time" that print literature and poetry take, and the "virtual time" that sharply edited video words

THE ART OF THE HACK 179

can withstand. Orozco's playful editing refuses the "real time" summoned in Faesler's and Nepote's videos. The Booktuber rarely allows spoken words to "take the time that they take," by contrast to Faesler's measured rhythms of poetry reading and Nepote's similar style before the sound engineering adds the distortions. Orozco understands the value of speed in the digital format, and she employs jump cuts that remove the pauses from unrehearsed speech. To emphasize certain emotional peaks in a quick-fire monologue, Orozco's edits switch from color to black-and-white images and freeze-fames, with music that cues the proper interpretative mood. Moreover, Orozco draws attention to the interface of one temporality and the other by communicating in a two-way circuit of influence with the video audience. Fans express preferences to Orozco, who in turn acknowledges these fans' opinions in her videos, and the discourse creates a sense of shared present time, bolstered by a doubled sphere of both public and intimate space thanks to Orozco's usual backdrop of her bookshelves in her parents' home, where she lives.

The library helps Orozco to establish a kind of readerly aesthetic, a *being* of bookishness. Notions of reliability matter to a younger generation. Attention to a generational divide comes to me from Pérez Camacho and López Ojeda's chapter on Mexican Booktubers, or "Vloggers" as they prefer to refer to Orozco and her peers. The scholars distill the lure of the Booktuber into youthful sincerity; in fans' positive impressions, the Vloggers seem to be who they are (Pérez Camacho and López Ojeda 92). The Mexican video makers tend to range from fifteen to twenty-five years old – though Orozco now exceeds that upper limit (Pérez Camacho and López Ojeda 92). To trace the lines of this feeling of sincerity, note Orozco's Twitter name, "La Pequeño Pony @FaOrozco," a reference to My Little Pony dolls. That unpretentious reference invokes youthful naïveté; by early 2018, this Twitter feed counted 90,800 followers. By 22 November 2019, La Pequeño Pony had slipped to 89,600 which hints that youthful Twitter handles are most appealing when the owner is still herself relatively young. At the peak of her popularity on Twitter, Orozco as "Pequeño Pony" may have successfully performed generational nostalgia that connected with the digital generation's admiration for the print book. The wielding of material goods, whether toys or books, as identity markers and community-building tools, turns the often individual practice of reading or imaginative doll play into a collective practice, a point that Pérez Camacho and López Ojeda also make (97).

Ludovico reinforces the point that books can seem reliable when compared to the digital because, "printed materials are one of the few consumer objects that generally do not expire or become obsolete, meaning they can't be quickly 'consumed' and discarded, but just sit there taking up space, for years or even decades" (83). The print book supports users' long-term constructions of identity – *not* necessarily as readers, but as book owners – a point that Orozco implicitly stresses. The ephemeral nature of the YouTube videos – the

180 EMILY HIND

vulnerability of the art itself – leads me to the conclusion that if the present chapter argues anything, it is that one of the aspects of "representational privilege" wielded by literature, to borrow once more Paz Soldán and Debra Castillo's phrase, still hinges on the material (cited in Lavery 13). Other academics have speculated that young people form an altered view of themselves once they begin building a personal library, an identity that – thanks to the stability of the medium – can endure for a lifetime. Michael Austin reviewed studies conducted over the last twenty years for programs that give permanent gifts of books to students; taken together, these statistics "suggest that book ownership can enhance literacy in ways that cannot be attributed to any other factor, including book readership" (19).[12]

The Booktuber, precisely the most amateur (hack) of the three talents probably does more to spread a profitable – and therefore *professional* – habit of literature than any of the would-be "professional" but utterly nonprofitable writers searching for hacks in the interface, such as Faesler and Nepote. Orozco's hack language comes nowhere near the poets' trained skill. The resulting impression of a "sincere" appeal of the Booktuber videos allows Orozco to emphasize speech at the edges of reading, speech that enjoys the limits of writing because the talk is in itself a break from reading – a playful area of rest – which allows Orozco to admit freely that she has not yet read one book or another in her collection and to emphasize her relationship with a material book rather than its more technical literary qualities. This labor of promoting book owning and book-as-object play stresses the pleasures of the material and inhabits an interface. This dilemma of the amateur that pits accessibility against expertise, and tries to solve problems with the hack, is surely familiar to the woman academic critic. Just as women are finally making it to the rank of full professor in larger numbers, the administrators change the game and begin to call for more public-facing humanities, which begs the question of whether books of previously disdained genres of criticism (especially if they are by women), such as epistolary conversations, interviews, personal essays, blogs, podcasts, fiction, and other sorts of non-monograph projects count as *expert*. Should the humanities professor be paid well, or offered stable employment, if rather than specialized knowledge, a wide audience is required? What happens to expert art when expert critics are no longer needed? Only certain kinds of hacks in art interest the expert: see my earlier reflections on gender

[12] In results published in 2014, Evans and co-researchers found a statistically significant effect in forty-two countries, among 200,000 students at age 15. Of the various family background influences, "Home library size is clearly the most important," when it comes to predicting a student's reading achievement; this factor proved to be more important than parents' occupational status, parents' education, and parents' wealth (1590).

THE ART OF THE HACK 181

bias operant among men critics. Perhaps criticism benefits from opening up to the amateur, and yet it seems that something is lost when professionalism in art comes to be defined only by financial reward and not by peer respect – even if the latter is traditionally awarded by a boys' club.

To show how Orozco plays with her books intermedially – *not just by reading them* – I showcase a crowning hack: Orozco's refusal to alphabetize her library, which serves as the backdrop for most of her videos. Instead of alphabetization, she arranges her books by the color of the spines. Two of the games that Orozco has played with her library suffice as examples of the resulting color-inspired confusion. *Coordenadas en mis estanterías* ("Coordinates on My Shelves") is played with Orozco's friend on camera and facilitated by her sister, who films the proceedings and speaks from behind the camera. After locating the proper book on her shelves according to the random coordinates sent by fans and friends, Orozco tells the story on camera of how the book came to form part of her collection. By early 2018, the video had been seen 91,085 times. By 29 August 2018 that number had risen to 97,802. By 22 November 2019 that number reached 107,373 views.

In an even more successful book game video, by early 2018 with 143,615 hits, by 29 August 2018, 154,241 views, and by 18 November 2019, 173,490 views, Orozco searched for fifteen titles picked in advance by her sister, such as the anodyne *Literatura mexicana* ("Mexican Literature"). (With a black cover? With a white cover? Orozco battles to call to mind the brownish-red book, to Karen Orozco's amusement.) Other titles that Orozco must hunt down include *James and the Giant Peach* (1961) in Spanish translation, *Anna Karenina* (1877), *Como agua para chocolate* (1993), and eleven more titles, none of which is discussed in the video in terms of their technique or historical context. Instead, the books mostly matter for their covers and consequent shelf placement (*Conozco*). The point of *Conozco mi librero? ¿O soy puro cuento?* ("Do I Know My Bookshelf? Or Am I Just Fibbing?") is to find all the books in less than five minutes. As the bookshelf activities illustrate, the amateur move of arranging a library by color ends up creating considerable work for Orozco. This hack (amateur) move is also a hacker (expert repurposing) technique that proves entertaining enough to operate on a professional level.

This amateur angle manages to circumvent many of the gatekeepers in the literary world. Consider, in that sense, Orozco's interest in *Peter Pan*, a more than century-old play (1904) and novel (1911) by J. M. Barrie (1860–1937, Scotland). In a video that shows her collection of various editions of the text, Orozco acknowledges Barrie's name, but little more (*Mis ediciones*). The video in question is not about *Peter Pan* per se, but rather Orozco's material interaction with *Peter Pan*, as proven by her collection. Orozco gains authority over her library not from formal studies so much as a performed lack of pretentiousness, a type of virtuous informality. Because her persuasive rhetoric

depends on her embodiment as a fashionable consumer, Orozco's reign may not outlast her audience's perception of her youth, and indeed her decision to stop posting new content on LasPalabrasDeFa indicates the time-sensitive appeal of this performance of amateur enthusiasm. I will leave it to the academic to contemplate her own predicament in an economy that demands profitability through audience numbers. To extrapolate from the three Mexican cases, the largest audience rewards certain amateurish performances with gig status only as long as that act seems entertaining as gauged along an aesthetic of the youthful.

CONCLUSION

As indicated by these artists' videos and the forms of doll play and doubles contained therein, the point of interface from print literature to the digital has only made the embodied female author *more* visible, not less. The binary associating women and embodiment is nothing new, as Katherine Hayles presciently teaches, working off a critique that comes to her from Elizabeth Grosz, who in turn works off Simone de Beauvoir. These scholars note that in the tradition of Western philosophy, women bear the burden of corporeality, which frees men to be imagined as disembodied thinkers – one reason why men writers can be understood as serious intellectuals even if they are alcohol dependent (Hayles 155). This binary that distinguishes women's and men's performances appears to exclude non-binary persons and other queer possibilities, though my analysis does not mean to ignore these possibilities. Rather, I query the discrimination that continues to limit possibilities for all those actors who fall outside the privileged category of cisgender "men," which continues to receive all too many entitlements to the detriment of every other group. Another traditional aspect seems unchanged as well: the aspirations of the reader against the monopolic pressures of capitalism. In the worries of so many contemporary thinkers cited in the present analysis, the paths to power seem too narrow, even for the would-be elite academic. Galloway observes that today, for the first time, scholarly researchers operate "in a deficit of resources" before the "far superior data reserves" at the disposal of the corporate sector (110). This scholarly imbalance leads Galloway to rephrase Audre Lorde's famous maxim: "The question is no longer 'can we use the master's tools to take down the master's house?' Today the question is 'can we still use or own tools now that the master has taken them up?'" (110).

Galloway's repurposing of Lorde's famous quotation warns us that platforms such as YouTube are not a democratic space. Here I return to my introductory mention of Lessig's lamentations, which make abundantly clear that YouTube is not *our* platform because *we* do not own the site. While the

THE ART OF THE HACK

hack that Faesler, Nepote, and Orozco employ of using their own bodies, to which they have the rights, largely circumvents the immediate legal problem for YouTube videos, the solution ends up returning us to the long-lasting sexist binary of embodiment. The three Mexicans play into the centuries-long difficulty of public appearances interpreted as accessibility, also coded as vulnerability, which triggers doubled-edged consequences for "dolling up." The relative control that the women retain over their image in the videos is an insufficient consolation prize. It seems commonsensical to affirm that longevity in one's career is probably better protected by expertise recognized as such; after all, expertise defends the existence of a *career* in the first place. The threat faced by humanities professors in a time of dwindling university support can encourage experts to seek a larger audience through less expert genres, and because of the risks involved, it seems worthwhile to articulate the problem of the amateur, which affects women in particularly forceful and even ageist ways. The hobbyist-turned-gig worker act that aims to hack its way into paid, e.g., *professional*, work is not, in the end, a career if that gig depends on youthful performance. Still, the freedom of the hack holds appeal.

On one level, the hack is a relatively safe place from which to operate, because it does not threaten the professional (corporate) players, but rather invokes an amateur stance that seems, so to speak, "rough around the edges." On that level, the artist is at the mercy of the critic, who can choose to authorize (e.g., Cruz Arzabal) or reject (e.g., Maldonado) the experiment with the interface. As per Cruz Arzabal's admiration of Faesler's white edges around her paper dolls, *of course* these unpolished aspects appeal to him; they are the sign of the expert hack. As per Maldonado's rejection of Nepote's "Ciudad puente," *of course* he rejects the transition of a poem into a pop song; he objects to the sign of a hack. My vocabulary tries to make clear that both critics react to what is by and large the same approach. All the women studied here speak from the inevitably limited authority of their own bodies, whether as a Booktuber, a poet-dancer, or a poet-doll, and thus they risk functioning in the context of YouTube as the "tools [...] that the master has taken [...] up." If the artist with the largest audience wins, Orozco triumphs. If the artist with the largest number of academic fans wins, Nepote and Faesler triumph. If the artist with the greatest autonomy from monopolistic systems wins, I cannot say that any of us knows which is the safest bet.

15

The Places of Pain: Intermedial Mode and Meaning in *Via Corporis* by Pura López Colomé and *Geografía del dolor* by Mónica González

NUALA FINNEGAN

In his illuminating study, *The Work of the Dead*, Thomas Laqueur reminds us that the dead come in and out of cultural focus. In the works scrutinized in this chapter, the dead are very much in focus, indeed in close-up, as I place the works of two very distinct artistic practitioners from Mexico into dialogue: the poet, Pura López Colomé and the photographer (primarily photojournalist), Mónica González. López Colomé is an acclaimed poet, essayist, and translator, most notably of the Irish Nobel Laureate, Seamus Heaney. Her collection of poems, *Via Corporis* (2016), is a collaborative project with Mexican visual artist, Guillermo Arreola. Based on a series of discarded radiographs from patients, the project transforms and translates this "dead file" into a series of paintings accompanied by poems that excavate the stories of illness, pain, and death behind the abandoned images. In this way, the two forms are enclosed in the same space and form an example of "explicit" intermedial production whereby, "more than one media are present synchronously or within one object" (Bowskill and Lavery 14). In some ways this impulse to write to these dead, and to write about this "dead file", is a way to rebuff the notion, first expressed by Diogenes but widely sustained in cultural narratives in contemporary Mexico, that the dead do not matter.[1] Through this eloquent paean to

[1] Laqueur writes that, "Diogenes became the great spokesman for the dead body as fundamentally profane, unenchanted, a part of nature, mere matter, carrion" (36).

their existence, the poet (López Colomé) and the painter (Arreola) together reconstruct these bodies into a community of memory that simultaneously honors them at the same time as it mourns the collective pain occasioned by the explosion in the number of violent deaths in Mexico since 2006. This allegorical impulse is voiced explicitly by the poet when she says, "the reality in Mexico is so horrific, it is inescapable. What we are living at the moment in Mexico is so extreme that it is inside me; it is inside my poems. When I talk about the body's pain, I am also talking about the pain inflicted on the country's body" (Finnegan).[2] Mónica González's award-winning multimedia project, *Geografía del dolor* (*The Geography of Pain*) (2011) sees González step beyond her photojournalistic role to engage with a multiplicity of media that co-exist within the one narrative arc: traditional postcard writing, music, photography, interactive web tools, and documentary film in order to narrate the stories of fourteen families affected by "desaparición forzada" ("forced disappearance") in Mexico since 2007. González clarifies the scope and ambition of the project when she writes that, "our intention was to reach all possible audiences and thus the project was conceived in a transmedial format. Aside from the web, which offers free access to anybody, we also produced a book made up of the postcards and set up an exhibition of photography with images from the stories featured in the project" (Rojo).[3] Like *Via Corporis*, therefore, and notwithstanding her problematic assertion that the web offers free access to anybody, this project constitutes another example of "explicit" intermedial production and we can see how the political charge of the project, with its attention to aesthetics, ethics, and storytelling, is embedded within its innovative conjoining of forms.

In keeping with the other contributions to this volume, I preserve the term, "multimedia," as the best way of approximating both projects though it is important to distinguish between López Colomé's work which might best be situated within a rubric of "expanded literature" with González more comfortably accommodated within a paradigm of digital multimedia culture (Sánchez Mesa and Baetens). Nevertheless, in my analysis of both projects, I am particularly interested in exploring the notion of the expanded book as a boundary object (Hellström Reimer et al.), a framework that enables us to approach the multiplicity of meanings and modalities that they generate in ways that unsettle but also illuminate. Ideas around modes and multimodalities feature prominently in discussions of intermedial practice (Elleström); indeed Kozak in this volume speaks of the importance of a multimodal perspective as one that pays attention to the visual, sonic, haptic, and verbal (Lavery and Bowskill 206). López Colomé's textural layering of imagery and poetic

[2] Personal correspondence with author (2017).

[3] All translations from Spanish, unless otherwise stated, are by the author.

THE PLACES OF PAIN 187

modalities throughout *Via Corporis* , and the interplay between the sonic, the verbal, and the visual in González's mapping of pain, speak eloquently to this multimodal perspective. Furthermore, I rely on Liliane Louvel's concept of the "iconotext" as a "provisional site punctuated by numerous points of entry and exit" effecting a "pluriform fusion of text and image" (8) as a way of accessing *Via Corporis* 's conceptually difficult exploration of pain. *Geografía del dolor*, while also partaking in the pluriform fusion envisioned by Louvel, is more effectively understood through a theoretical lens informed by work on rhizomatic connectedness, drawing from Deleuze and Guattari but also, in the context of intermedial cultural production, from work by Audran, Schmitter, and Chiani. Focalizing the work performed by both of these projects through this distinct, yet connected set of theoretical prisms, allows us to see both artists as part of an emerging "crosscurrent" of practitioners engaging in multimedia practices, the subject of discussion in this volume.

BODILY JOURNEYS

Via Corporis has its origins in a file of X-rays labeled, *archivo muerto*, or "dead file," found by the painter Guillermo Arreola behind Hospital Siglo XXI, the former site of the Centro Médico-Hospital General which was destroyed by the major earthquake in Mexico City in September 1985 and subsequently rebuilt. Taking these X-rays as his starting point, Arreola produced a haunting, unsettling series of acrylics painted on strips of radiographic film some of which involve the conceptualization of body fragments, others that are more approximate to full-body portraits, in a collection of images entitled, *Sursum corda* ("Lift our hearts"). López Colomé's poems respond directly to the paintings and emerge from the attempt in López Colomé's own words "to unearth, to "unpaint" so to speak what Guillermo had covered with his oil work on top of the X-rays" (López Colomé, Email, 5 February 2020). In this way, the project becomes multimedia as it moves from X-ray to painting to poetry and a curious intermedial relationship of inter-dependency is forged between the two forms, the text interweaving with the image, often in direct dialogue with it.[4] There are a number of theoretical frames that will

4 López-Colomé explains the sequencing of the art in relation to the poems in the following terms: "Some of the paintings were done first, and therefore inspired the poems. Some poems were written separately, then shared with Guillermo Arreola who subsequently did the art work. And then some were done simultaneously, as though in the same frequency, which filled us with the utmost awe at the obvious connection of our views." In addition, it is interesting to note that the images have been exhibited without any relation to the poems. The precise combination shown is thus unique to the book though some poems were published by magazines that

help us through the analysis of this challenging text. In the first instance, we might tentatively define the project as transliterary in terms imagined by Ana Clavel in this volume when she writes of the ways in which the written text is both supplemented and enhanced by the presence of images. We might also read the interrelationship between the two media – painting and poetry – as creating the "resonance or tension necessary for dialogic activity" (Hellström Reimer et al. 3). It is perhaps through the dialogic possibilities sparked by the interrelationship between poetry and painting here that the political possibilities of creativity are realized. In this way, the collection activates Ginette Verstraete's ideas when she argues that the interaction between media, "is such that they transform each other and a new form of art, or mediation, emerges" (9).

Furthermore, as a text-image project, *Via Corporis* participates in the time-honored tradition of *ut pictura poeisis*, initiated by the poet, Horace, in his *Ars Poetica* which ignited a longstanding debate about the dialectic relationships between painting and poetry. While a full discussion of *ut pictura poeisis* is necessarily outside the scope of this chapter, the binary opposition of image/text suggested by the philosophical debate on the subject is contested by the approach adopted in *Via Corporis* that showcases the particular kinship between both genres, challenging the possibility of any easy binary distinction or opposition.[5] In the Mexican context, Shirin Shenassa reminds us of "the close proximity of writing and painting as expressed by the Mexica term *amoxtli*" (257). *Amoxtli*, the Nahuatl word for "book," is more commonly translated as "codex" in the large body of scholarship that has unearthed this mode of expression with its combination of symbology, pictography, and script. López Colomé's work responds to the European philosophical project while seeking a space within those national historiographies that privileged a more pluriform

also published some images alongside. Quotations in the text and notes are from personal correspondence with Pura López Colomé.

5 The inter-relationship between poetry and painting originates with the Roman poet, Horace, through his coining of the phrase *ut picture poeisis* 'as is painting, so is poetry' and Plutarch employed the association to laud historians who wrote such imagistic prose that readers could "see" the moments they were reading. For a complex evaluation of the debate as it moved through the work of Aristotle and Plato through to the later work of the sixteenth to eighteenth centuries demonstrated by Lomazzo, du Fresnoy, Dolce, and Francisoco de Hollanda, among many others, in their attempts to establish an integral, fraternal relationship between the two art forms, see Wendorf. W. J. T. Mitchell, the renowned art theorist, deals with the question in terms of the theorization of abstract art and advances the debate into the twenty-first century in "Ut Pictura Theoria". Overall, it is fair to say that *ut picture poeisis* has acquired a new currency in the discourse examining the relationship of word to image in media expressions.

THE PLACES OF PAIN 189

approach and that, crucially, were subject to a colonizing process of violent erasure. If we accept this lineage of painting combined with writing, it prompts questions about the interplay of text and image, about function, about texture, and about meaning. Following this line of argument, then, *Via Corporis* may be located within a genealogy of intermedial practice captured by the historical tradition of *amoxtli*, the combination of image and text embedded within the structural violence of conquest. In a similar way, the thirty-six poems in *Via Corporis* also engage with questions of structural and historic violence and choose also the dialogic of text/image as the most effective way of capturing their nuances. In my exploration of *Via Corporis* , I would like to isolate certain recurring tropes or figures present in the collection as a way of showing how López Colomé offers an "iconotext" (Louvel) via a poetics that allows the reader to enter and exit the text through different registers, media, and modes. These tropes include the opposition or dichotomy set up in the text between exteriority/interiority as well as the consideration of the relationship between the human and the non-human. Fluidly moving between these considerations, the text(s) – both verbal and visual – are heavily invested in texture, sound, and color as modalities that allow the reader/spectator to encounter these eviscerating excavations of violence, death, and illness.

OUTSIDE IN: CORPOREAL MOVEMENTS

It is perhaps not surprising that a collection that takes the radiograph as its starting point, might engage with ideas of inside/outside or that it would juxtapose exterior surfaces against bodily interiors. Indeed, if we examine the historical roots of this technology, we can see that the X-ray is the quintessential signifier of bodily interiority, exemplifying that "dualist construction of bodily being," and revealing "the development of a mechanistic medical science in which the corporeal body could be mapped, measured, and experimented on without moral impediment" (Shildrick 17). In this regard, the collection serves to question that dualist construction and the radiograph paintings illuminate that which cannot be mapped or measured, moving instead to consider what cannot be logical, subsumed, understood, or even represented. On the one hand, then, the poems perform a dissection of the self in parallel with searing portraits of bodily interiors, both physical and metaphysical. On the other hand, however, poem after poem pays attention to exteriors, to wounds, to blood, to the process of doing violence, as the accompanying images show the death and violence etched directly on the bodies of the dead. In addition, the poems constantly question the boundaries and the limits between the human and the non-human (frequently animals) weaving

190 NUALA FINNEGAN

their questioning of these dualist constructions through a sensuous evocation of sound, color and texture.

The juxtaposition of inside/outside perspectives is frequently expressed as motion and movement both outwards and inwards as in the poem, "El prójimo: la herida soñada" ("The Neighbor: The wound from a dream") which plays with the idea of centrifugal motion. It can be seen also in the poem, "Hemorragia interna" ("Internal Hemorrhage") which delights in the delicate opposition between the word, "FROM" (or DESDE, capitalized throughout) and the Latin preposition "ad" meaning "to" (*ad hominem/ ad libitum/ad nauseam/ad maiorem gloriam/ad*). In "Ceguera Primaveral" ("Spring Blindness"), the painting accompanying the poem is of a face bathed in a blue hue, disfigurement in one eye clearly visible. Such is the blueness in the painting that it appears like a death mask – central to traditional images of death in Mexico – but also, a literal surface, like the film of the body part produced by the X-ray. The text accompanying the painting delves immediately, however, beyond the surface echoing Verstraete again and her insistence on the capacity of the different media to question but also to transform each other. Addressing the dead figure in the painting directly:

> you,
> the one who went
> and the one who hasn't managed to cross
> *from outside to inside*
>
> <div align="right">(Via Corporis 22 my emphasis)</div>

Here the poetic address seems to gesture to a soul, a being still struggling, not yet at the point "inside." Switching to third person, the battle between inside/outside is reversed: "he, divided self / split in two, / *in transit from inside out*" (*Via Corporis* 22 my emphasis). This ambiguous image conjures up the idea as something unfolding, in motion, in a state of splitting, tracking the movement of the body from the interior outwards. In this way, the sequence draws our attention to the process of division as well as to the rupturing of the integrity of the body both through the painting of disfigurement and through the messy confusion generated from the indistinct boundaries between inside/outside.

Images of light and sight perforate the poem in a gentle back and forth motion connected through the central motif of the disfigured cornea/eye. Certainly, the notion of focus is central to the collection overall as photographic terms such as "backlight" cement the connection with X-ray technologies and underline the eyes and their connotation with seeing as the central organizing metaphor. Later in the poem, the eye disfigurement prompts a set of questions and reflections: "What's on your face, what happened to you/" (*Via Corporis* 22) with the poet likening the wounds to those inflicted by an animal. The

THE PLACES OF PAIN 191

poem's final lines inform that the body has had its eyelids sutured together
because of their mysterious tendency to open spring-like on their own after
death: "It was necessary to sew up the eyelids because, who knows why, they
continued to open on their own, as though there were a spring concealed
inside." (*Via Corporis* 23). Furthermore, this process of violent suturing of
the eyes is rendered poetically in sonic form: "the person who carried out the
tru-tru with thick thread knew the secret" (*Via Corporis* 23). It is with the
shutting down of the eyes therefore, where the poem's dialogic movement
between inside and outside reaches its climactic point. Here, then, is where
the possibility of fluidly moving between seeing/unseeing, is forever sealed
off signaling the end point of a process of undoing (of bodily integrity, of
humanity), that is communicated throughout the poem.

This process of undoing is ongoing; indeed, the poem is permeated with
words about falling apart or about things coming away. Utilizing the Spanish
prefix, *des*, already a transformative connector, these words signal stripping
away from (*despojar*); undoing (*deshacer*); falling apart (*desmoronar*); and
coming away from (*desprender*). The poet threads these words of undoing
through a series of dialogue or cross-cuts between the poetic voice, as well
as the second and third persons. The reference to moaning underscores the
pain evoked by the process and the simile invoking a pus-infected wound
reveals the quasi-surgical nature of the poetic language, a point underscored
by Lorena Huitrón Vázquez in her insightful review of the project (*Via Corpo-
ris*). I understand these words of undoing as keys that unlock – not an explicit
set of meanings – but rather nodes of signification that thread throughout
the collection. And here, returning to the notion of *amoxtli*, I would like to
extend this connection outwards and suggest that *Via Corporis* might also be
approached as an example of what Hellström Reimer et al. label an "expanded
book." Utilizing the denomination of the book, "as an expanded and interme-
dial 'boundary object'" (3), these authors offer an illuminating paradigm for
the framing of *Via Corporis*. Drawing on an extensive body of scholarship in
their writing, they propose that the expanded book works as

> an artefact affording modes rather than meanings, an intermedial but also
> spatially enabling object with divergent qualities. Similar to a map, it unfolds
> as a de and re-territorializing 'spread', on the one hand "fake" – contesting
> the idea of objective properties – and on the other hand 'blind' – breaking
> the visual authority of the printed text. (8)

Given that the poem ends literally as the corpse is blinded, this analogy seems
particularly apposite. Cherríe Moraga suggested that the codex or *amoxtli*
functioned as a "map back to the original face" (21), forming a striking res-
onance with the poem here and López Colomé's own assertion about the
poems, cited earlier, as an attempt at recovery of the original face beneath

the pain and the sickness. The act of sewing the face marks its final process of undoing and forecloses indefinitely any bridge between inside and outside made possible by the act of seeing.

The dichotomy between exteriority/interiority is present in other poems too. In "Sordera al más allá" ("Deafness into the afterlife"), the poet turns her attention from sight and blindness to another sense – that of hearing. Liliane Louvel's compelling work on "iconotexts" helps us to understand what is perhaps going on in this deathly poetic afterlife when she talks of the "pluriform fusion of text and image," mentioned earlier. Here, there are more images of exterior/interior: "that smile, those bags under the eyes / show us your condition / *inside your face as well as out*" (*Via Corporis* 48 my emphasis). The poem in turn is set beside an image that shows a head and upper torso mostly sketched in white as though enveloped in cloud or smoke. In contrast, the central part of the face around the eyes is black with two eyes barely discernible thereby replicating the visual form of the X-ray with its one-dimensional representation of a flattened, sunken face. This poem opens with an address to fear itself: "Divine terror you are back/ You don't come back: you have come back / Don't breathe, you don't move/" (*Via Corporis* 47). Here the poem displays its deep investment in a carefully calibrated interplay of verbal forms, as though in an echo chamber where the word or phrase returns in mutated and mutating forms, collapsing the difference between tenses. Repeated phrases echo throughout the poem as though in a refrain but, crucially, they also form part of a linear progression building from an emphasis on nothingness to the point of possibility of the *más allá* or the world beyond. In parallel with its title, the poem then moves from deafness – not hearing, not being, not existing – to imaginative possibility through the creative pathway opened up by the invitation to think conditionally, plurally, futuristically. In this way the repeated phrases join the separate poetic parts into a whole effecting a deep fusion at the level of texture, color and word. Here then, is an example of the expanded book, explored earlier, especially in so far as it relates to the possibilities of meaning creation engendered by this process of "pluriform fusion." As Hellström Reimer et al. elaborate, "the expanded book does not necessarily provide new meaning. Instead, it has the potential to function as a 'shifter' or mobilizer, enabling transitions in between locations and scales" (8). These transitions between locations and scales are akin to a process of zooming in and out – so central, of course, to processes of intermedial cultural production – and are linked to the concept of focus, seen earlier in relation to the trope of sight/sightlessness in "Spring Blindness." This zooming in and out is beautifully underscored by the editors' decision to reproduce certain details from the paintings, foregrounding them in close-up and collocating them on additional pages next to the poetic texts and after the original images. In this way meanings are quite literally mobilized in the way imagined in the passage

THE PLACES OF PAIN 193

above, moving in a manner analogous to that occasioned by a digital click that
enlarges the form from one page to the next.

LIFE MATTERS: CELLULAR CONNECTIONS

As already mentioned, many of the poems in *Via Corporis* make use of animal
images or tell stories about animals and, indeed, many of the blurry images
in the paintings seem to belong in a realm somewhere beyond the human.
"Futuro fin, o sin" ("Future end, or without") features a brainless dog, and
"Piel de Zapa" ("Magic Skin") meditates on ideas of skin and skinning with
reference to multiple reptiles such as crocodiles, caimans, lizards, and iguanas.
The collection's opening poem "Herida provocada" ("The inflicted wound")[6]
takes the image of the plucked pheasant as a starting point from which to
contemplate the colors of death brought into being through a vivid interplay
of snowy whiteness, black, and blood red. Accompanied by an image with thin
rivulets of blood linked into bodily matter that is barely distinguishable, the
poem through the central image of the wound, takes the reader on a journey
that is almost cellular. From "*The* color / of death," it moves immediately to
texture, we learn that, "it's the saliva too, / thick substance, / with trapped
bubbles, /," leading to a temporal collapse of a sort, "Now. Then. Before" (*Via
Corporis* 11). The poem proceeds to detail an image of a white snowball thrown
against a tree-trunk, a throw that releases a black saliva, a reminder of the
"life-giving liquid from the other world" (*Via Corporis* 11). Thus, it is at this
cellular level that the pheasant's death is processed through words that shift
from color (red; black; white) to texture (thick, sticky) to feeling. Here, the
poem sinks into pure texture in which time and space collapse and in which
the "other world" takes precedence, a world that is full of color (whiteness),
liquid (saliva) and air (trapped bubbles). And suddenly, the poem switches
tonal register again returning us to Louvel and her idea of the written text as
network: "a provisional site punctuated by numerous points of entry and exit
and crossed by infinitely superimposed perspectival lines and journeys" (8).
In this regard, the perspectival line that cuts across our cellular experience of
death through the image of the pheasant, the blood, the snow, and the saliva
is the rather simply expressed desire for the poem to participate in a process
of healing, "In this text I want to revive you," as the poem segues to a further
register – that of gentle humor – to end quietly.

In "Pulmón de mar" ("Jellyfish"), another animal-centered poem, the poet
ruminates on the organic dissolution of the self: "Your best moment. When

[6] I am indebted to both Pura López Colomé and Martín Veiga for their conversa-
tions about the poems and for their help with translation.

you were no longer (you)" (*Via Corporis* 39). Set against an image of a blacked out, crouched body with arm outstretched, this unsettling opening paves the way to a profound examination of self in which, as Huitrón Vázquez notes, "the distinct and fluctuating registers of the text are similar to the pulse and the flowing blood of a living organism." This being is physically charged, "In your electric personhood/ I see my own. / And that's a saying./ I finish the sentence and immediately / am absorbed by that."/ (*Via Corporis* 39). Here, and elsewhere, the poem registers concern with undoing and bodily fragmentation: "Bit by bit, little pieces of you have come away, pieces of you that now float in the background" (*Via Corporis* 39). In the following passage, it leads to a complete dissolution of the poetic "I" as it disappears into an entirely fictive domain:

> one time, that time, I was a character in a story. There was once a jellyfish who had left its imprint in someone's arm, not mine (I was nobody). Evil, poisonous, vaporising jelly-fish with its tulle skirts, taking over the dance floor. And I (nobody), no less a person than myself, trapped it, kept it in a jar, and horrified, saw that it continued to swim – half-dead, showing its beauty, its cilia, its gelatinous tentacles, its white and cellular deformation. However here was a cadaver – a real corpse – even if I thought there was still life there, it was losing parts as each day passed. (*Via Corporis* 40)

This astonishing passage transports the reader to another poetic world in which a jellyfish has bitten someone leading to its being trapped, but still struggling. Contemplating an allegorical interpretation of the gelatinous mass of the jellyfish inflicting wounds on the body politic is but one of the myriad interpretative possibilities offered here as the final image of the disintegrating jellyfish body operates as a troubling requiem for the lives slowly extinguished in Mexico as each day passes. Returning to the notion of boundary objects, Hellström Reimer et al. write that:

> Boundary objects would allow actors to negotiate topics, to reframe contexts and to "travel" in between perspectives and approaches, affording interme- diary mobility, much like a relational and interactive map, applicable for use in different discursive terrains. (4)

We can see how this process is reflected in the passage above through the dis- appearance of the person into a fictive universe that enables him/her to travel through a perspective that affords a glimpse at death. And in exactly the same way as an interactive map, as though the reader were to click on the jellyfish in the first image, it is enlarged in close-up on the next page to accompany the detailed description of its death. Through such imaginative sleight of hand is the death-world of *Via Corporis* evoked and sustained.

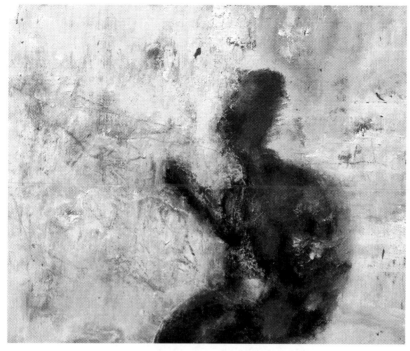

25. *Pulmón de mar (Jelly Fish)*.
Image courtesy of Pura López Colomé and Guillermo Arreola.

In this necessarily brief examination of *Via Corporis* then, it is possible to see how the abstract universes of the poems conjoin with the social relations evidenced by the X-rays to question the dualist construction of being that is laid bare by the X-ray technology as well as the more fundamental questions concerning life, self-hood, and violent death. In this next section, I would like to examine the very differently conceived project, *Geografía del dolor* which evinces a similar concern with the place and the spaces of pain and death but which are configured via a very different, if similarly intermedial, approach.

GEOGRAFÍA DEL DOLOR (THE GEOGRAPHY OF PAIN): AN AGITATED ENCOUNTER

Geografía del dolor (2011) (*The Geography of Pain*), conceived by journalist, activist, and writer, Mónica González, unlike *Via Corporis*, is a multimedia project, following the terms of our discussion outlined earlier, incorporating video, music, photographs, oral, and written testimony. It also constitutes a more literal approach to mapping with the project's homepage conceived

as a large map of Mexico from which it is possible to see the geographical locations of the stories chronicled. Clicking on a point on the map takes the user into harrowing narratives or vignettes of disappearance, despair, death, and destruction narrated through postcards, photographs, and short videos featuring oral testimonies. In this way the vignettes are chronicles of personal pain but an indelible line of connection is also traced between the stories and their shared histories of impunity, poverty, marginalization, and fear. Rejecting a linear, teleological format, it is possible to read this project – which has won multiple awards for its creator Mónica González – in terms of an "agitated encounter" with pain and violence (Hellström Reimer et al. 3). We might interpret this agitation on multiple levels, the agitation engendered by the content of the stories with their emphasis on emotional pain as well as the agitation provoked by the negotiation of multiple formats and the insistent violin music that forms the backdrop to every story. Indeed, the multiplying forms – the postcards, the photographs, the aural testimony, the videos, the unsettling music – become part of a mediatized landscape that might be described as hypermedial, explained in the following way as:

> distinct from the change expressed by the prefix multi-, the hyper does not necessarily refer to a multiplication of forms, but to an intensification of action. Hyper- has a clear agency connotation, actualizing not only the merging of different media but also the surplus energy or friction that is its result: the stimulation, excitation or even irritation. (Hellström Reimer et al. 3)

It is this notion of an enhanced agency that is of most interest in exploring the affective power of *Geografía del dolor*, as it relies on a certain kind of "restless fusion" (Hellström Reimer et al. 3) as a way of projecting the viewer/ spectator/participant into an unsettling relationship with the project protagonists. Hypermedia, as understood by this volume, is the general description of linked digital media content. Here, it is the understanding of hypermediality as intensified situated agency that offers such a suggestive approach to *Geografía del dolor*, and, as a way of testing this interpretative pathway, I would like to isolate one of the project's many heart-breaking stories to demonstrate the ways in which the project brings this hyper mediated intensification of agency sharply into focus.

Opening this deeply moving story from San Luis Potosí with the thematic thread, "Incertidumbre" ("Uncertainty"), the protagonist of the film, Graciela Pérez from Tamuin, San Luis Potosí, tells of the disappearance of her thirteen-year-old daughter, Mylinali Piña Pérez, from the stretch of highway between Tamaulipas de Xico and Ciudad Mante as she was returning home with four other members of her family all of whom disappeared with her. Graciela opens the segment with an eloquent overview of the impossibility of her situation:

THE PLACES OF PAIN 197

"Uncertainty firstly of not knowing where they are, uncertainty of not knowing where to look, uncertainty of what you're going to face, uncertainty of who will help you."[7] Following this succinct appraisal of the aftermath of her daughter's disappearance and holding a framed photograph of her daughter while staring resolutely at the camera, Graciela details the painstaking, futile search for answers that takes her on a frustrating journey between different state and federal authorities. These include a visit to the city of Mante where she experiences the cold indifference of the residents there in response to her request to put up flyers. Next, she tries the office of the State Prosecutors of Tamaulipas and goes as far as the Office of the Attorney General of the Republic (PGR) where she is further met with indifference and inaction, and where she learns that no proper investigation has been or will be carried out. When, finally, a lead is opened up, Graciela is told that her family were intercepted by a group of armed men and a young woman, and that her daughter was handed over to the notorious cartel in the region, the Zetas. She also learns that her daughter is still alive. From this point onwards, the horrors of everyday life in the region (including the disposal of multiple corpses) are slowly uncovered by Graciela and the film documents the process of her movement towards and into action. Rather than showing horror at the discovery of mass illegal graves in her neighboring state, she uses this information as a basis for furthering the investigation into her daughter's disappearance clamoring for DNA results and challenging the authorities to identify the many bodies discovered. This "intensification of action" as referenced earlier (Hellström Reimer et al. 3) is mirrored by shots of her holding placards and assuming an activist identity as she commences what she describes as a "detailed account" of what was happening in the area where her daughter disappeared. Mostly shot from inside a moving vehicle as it traverses the road where (it is inferred) Mylinali was kidnapped, it mirrors the journey undertaken by Graciela as she moves from "door to door to door to door" in search of answers.

We can chart, therefore, in linear filmic terms, Graciela's pathway towards a position of active citizenship; along which she becomes engaged and informed. In a marked change of tone, she describes the process of finding answers in relation to the kidnapping of her daughter. At one of the film's pivotal moments, she explains how she came to understand the futility of approaching the State Attorney Office ("for what purpose?") and goes on to outline her empowerment through information-gathering that means that she is the one who can explain what is going on to the Office of the Attorney General of the Republic (PGR): "you show up and you tell them. It happened

7 The project is narrated in Spanish with English sub-titles. I have used the sub-titles throughout the chapter but have inserted punctuation where appropriate and rephrased in places where it aids comprehension.

this way. [And they ask] How do you know? [and you say] *Because I was there*" (my emphasis). The film, then, focuses on the slow forging of consciousness as Graciela starts to connect the different pieces of information to form a more complete picture of the disintegrating social landscape that surrounds her. It is through this process of piecing together, that Graciela's transformation into an active citizen is realized. Moreover, this disentangling of information on parallel and simultaneous levels reveals a pattern of connectivity through which the dangers of the region, the disappearance of her daughter, the presence of the Zetas, and the incompetence and indifference of state authorities, like the many doors that she knocks on, cumulatively come together to reveal a tiny piece of the broken social fabric that has taken her life from her. Speaking without emotion throughout the film that is almost eleven minutes long, the video ends with an almost unbearable final sequence:

> I suffer my daughter's absence though she is suffering more.
> I have nothing left but to search for her. I have nothing to lose, I am a single Mum, she is my entire family, she is everything I have.
> Even if it takes me a lifetime, I will keep on looking for her. I will recover her. This is my story.

The singular power of this intervention by Graciela exemplifies the notion of a hyper intensification of agency that we have seen earlier with the emphasis on action and intervention. What is more, set among and alongside the other fourteen narratives that form part of this project, and which feature similar statements of resilience and resoluteness, we can begin to understand how they form a pattern or network of meanings that can be described as rhizomatic in the way that is theorized by Deleuze and Guattari (1980) to mean multiple, non-hierarchical points of entry. This is evident at the thematic level whereby all of the stories are connected through a singular narrative of normalized violence underpinned by an indifferent and incompetent state. It is notable also on an emotional level as each protagonist unfolds their tale of pain and loss as when Luz María Davila asks, "where is our pain?" It can be seen again when the mother of the four Trujillo brothers disappeared in Guerrero, María Herrera Magdalena, affirms, "this is something that physically, socially and morally destroys you." In statements such as these, the interlocutors bear witness to the transformative nature of forced disappearance and death and enable us to see how a pattern of transversal connectedness resonates throughout the project with its concerted emphasis on resilience and activist engagement, voiced by Diana Iris García when she says, "the pain turned into strength."

Drawing on the well-known work of Deleuze and Guattari, much has been written about the rhizomatic qualities of intermediality which categorizes intermedial cultural production as ideally suited to channeling the kind of non-binary energy imagined by these philosophers in their work. Linked

THE PLACES OF PAIN 199

to this idea is the importance of a consideration of multi, hyper, or intermedial work that might be epitomized by the prefix "trans." According to Audran and Schmitter, "*trans* suggests a movement that is horizontal, nomadic, rhizomatic, that creates new connections: new networks that are continuous and stripped of hierarchies" (4). For Miriam Chiani, "to use the particle 'trans' is to emphasize movement itself, the process" (7). This emphasis on process seems to capture Graciela's journey – as shaky as the camera moving in the car – as she lurches from indifference, hostility, and resistance initially to move through revelation towards an activist consciousness that is alert and poised for action, beyond the limits and the barriers that are constantly thrust in her face. Through this horizontal, nomadic movement, then, Graciela is transformed.

The notion of rhizomatic connectedness extends throughout the project from the stories of people in pain and, in a number of stories, it extends outwards and transversally into the inhabited landscapes that have housed, sheltered, and in some cases, facilitated the crimes of violence described. This post-human dimension in contemporary conceptualizations of violence in Mexico has been eloquently analyzed by Lucy Bollington ("Reframing Excess"). It is central to the project's testimonies that focus in particular on the destruction of communities and land, as part of the widespread fear experienced by citizens on the peripheries of Mexican society. The story narrated by Jesús Isabel Parra is a case in point and details the terrorizing of the tiny rural community of San José de los Hornos by a group of up to fifty armed men later understood to be working for either the Beltrán Leyva cartel or the Zetas. When they burn down many of the houses and kill some of the members of the community, the 350 inhabitants in the village are forced to sleep for a time in the woods with many eventually fleeing to either Mazatlán, Guamúchil, or Culiacán. Absent from this vignette are accounts of bodily horror; instead, this narrative focuses its attention almost exclusively on the destruction of landscape. Taking this into consideration, it forms a poignant lament for the erosion of a way of life that involved growing corn and beans, raising cattle around the traditional *ejido*, adopting the shared land cooperative model, or working in the local sawmill.

The nine-minute oral testimony from Jesús propels us into another agitated encounter and is intercut with images that cross-cut from shots of natural landscape – the hills, the trees, the flowers, the animals – to shots of ruined, burned-out buildings. In this regard, the built landscape constitutes a metaphor for a kind of foundational destruction and is underscored by the final minutes of the film which feature shots of buildings with paint flaking and holes where windows once were. It then cuts to a shot of the narrator, Jesús, filmed beneath a sign for the (now burned-out) library. Functioning metonymically as the emblem of civilization, the library's destruction signals the totality of the collapse of the community and its way of life. In these final

minutes, Jesús attests to the fact that sometimes their youngest child sleeps between them at night, asking his parents to take care of him. The scene in which he breaks down as he recalls this – the only moment of obvious emotion in the film – implies a powerful reminder of the complete destruction of family structures and the concomitant erosion of parental functions and responsibilities. Through the scene then, we witness another example of the rhizomatic connectedness between landscape, nature, family, and community that the project lays bare throughout. This shot of the library is one of many examples from the films that privilege images of writing or visual representation of written signs in various forms as mechanisms for intervention. Indeed, from placards, to letters to libraries, the project isolates writing and the power of the written word to effect change and to channel the forging of consciousness echoing Verstraete's ideas, referenced earlier, about the transformative potential of intermedial practice. In this next section, I would like to chart the ways in which this process occurs through the use of postcards that frame and contain the individual stories.

POSTCARDS OF PAIN

Each of the stories chronicled in *Geografía del dolor* features a digital postcard on which the basic facts of the cases outlined including names, age, as well as dates of disappearance, are printed alongside a few lines from the family members. In a project that seeks to map a geography of pain, the inclusion of postcards seems an appropriate device. Postcards – connecting people across distance and unequivocally connected to place – serve as points in a cartographic constellation including many of those Mexican states frequently associated with violence such as, for example, Tamaulipas, Michoacán, and El Estado de México. The history of postcards in Mexico dates from 1879 but postcard production reached its apogee during the dictatorship of Porfirio Díaz (1897–1910) with a flourishing of publishing houses investing in their mass publication, and a boom in reputable and established photographers producing images for use on postcards (Vilches Malagón and Sandoval Cortés 5). While the production of postcards decreased from the 1950s onwards, they remain a rich historical source in terms of the evaluation and assessment of cultural history and identity. As has been amply documented, the information contained in any postcard provides an insight into national identity given the postcard's investment in a particular space and time so that, as Osorio writes, "the snapshots capture fragments of the present which, if not captured in this way, would be devoured by the inexorable future of development" (21). In this regard, postcards have historically functioned in Mexico, as elsewhere, as, quite literally, glimpses of a nation at a particular moment in time. By

THE PLACES OF PAIN

placing postcards at the center of *Geografía del dolor*'s narrative, and as part of its mosaic of pain then, González seeks to reanimate their historical function. The postcards are starkly simple in their conceptualization: eschewing stamps, images, they simply reproduce in handwritten form, the facts about the cases, placing the information alongside brief and often very distressing expressions of grief, pain, and loss from the family members featured in the films and photographs. The combination of the (in some cases almost child-like) hand-writing with the emotions expressed, means that this aspect of the project reconnects the stories of pain to earlier forms of communication and shows how they might participate in a project of commemoration and mourning. Unlike the videos/films, the postcards limit themselves to pure emotional expressions of pain leaving the processes of activism, consciousness-forging, and agency to the films. González writes about the use of postcards in the project saying that "the writing functions as a part of the body of the person affected in a way that is more tangible, more real, and more connected than that which is mediated by the screen and captured through the film" (Rojo). Whether this is the case is probably a moot point: what is important here is the way in which the body of the families is inscribed into the project through their handwriting, allowing us to see, but also to touch, to perceive, literally to "read" their pain as it is recorded by their own fingers in a reference to the multimodal perspective favored by the project. I would like to examine one example by way of illustration. The first pertains, again, to the story of Mylinali referenced earlier.

The words in the right column of the postcard read:

My love,

May the moon guide your return home, may the sun's rays warm you in your absence so that you can resist. I know that I will find you even if it is the last thing that I do in this life. Without you, there is no life. I love you. Your Mama.

In this segment, we see the centrality of the elements – the moon, the sun – as modes through which Milynali's safe return home might be navigated. Here it is interesting to note that Graciela's maternal expression of love is bound together with her need to act ("I will find you"). Historically, maternal love has always been a culturally valued property, contributing to the creation of maternal archetypes such as the self-sacrificing Mexican mother so brilliantly revealed in the work of Mexican writer, Rosario Castellanos, among others.[8] Moreover, since the 1970s, the concept has been directly linked

[8] See Castellanos' short story, "Lección de cocina" from the collection, *Álbum de familia*. See also, "La abnegación." This article by Castellanos was based on the speech

in the Americas with a long tradition of maternal political mobilization and activism, most famously associated with the Madres de Plaza de Mayo in Argentina during the so-called Dirty War (1976–83).[9] This is to say, the connections between maternal love and political change are highly developed and are mobilized here too.

As is often pointed out in scholarship on affect, the word, "emotion," is derived from the Latin, *emovere* (to move, to move out) and it is this moving outward (in ways very similar to those documented in *Via Corporis*), that the project charts with such clarity and conviction. The emotional relationship between sender and addressee that underpins postcard dissemination in the modern era, whereby the desire by the sender for contact with the addressee (encapsulated in the clichéd English expression "wish you were here"), locks the sender in a certain place and space in time. In the same way here, the sender is also locked but in a radically different way, paralyzed by grief and trapped in a kind of eternal present in which no connection with the addressee is possible. Thus, the project dismantles the traditional function of postcards conventionally understood as the connection and communication between sender and addressee. Instead, it re-positions them as repositories of feeling and emotion in a way imagined by Cvetkovich (*An Archive of Feeling*), as well as harnessing their political potential through the recording of stories and names. In this way, they function also as repositories of memory. Furthermore, they are boundary objects as defined earlier, functioning as, "interfering props or tactical devices that can adapt to changing circumstances and that can mediate between disturbance and experience or between friction and expression from within a certain situation" (3). The postcards take on this function in the sense that they mediate between the experience of loss and its expression and potential dissonance with hegemonic or oppositional perspectives, such as those of the authorities (as we have seen in Milynali's case) or the landscape (as we see in the vignette on San José de los Hornos). Furthermore, the handwriting demonstrates how the emotional power of the utterance is transmitted through a script that has literally been formed by the bodies of the family members left behind. Following this, the postcards form a bodily connection with the readers of the site, forging a corporeal bridge with the disappeared and the dead and their interlocutors in the land of the living.

In a similar fashion as to that found in *Via Corporis* then, the intermedial juxtapositions in *Geografía del dolor* operate in a kind of "restless fusion" (Hellström Reimer et al. 3), activating the space and place of pain but also dissonance, activism, and crucially, love. In this regard, *Geografía del dolor*

she delivered as part of the celebrations of International Women's Day in 1971.

9 For an evaluation of the tactics deployed by the Madres de Plaza de Mayo in terms of developing maternalism as a strategy for political change, see Diana Taylor.

THE PLACES OF PAIN 203

highlights the problems with hegemonic historiographies that diminish the testimonies of the relatives and the value of the lives of their loved ones. Much has been made of the plasticity afforded by the use of intermedial forms, as well as their "potential to produce new media historiographies that elucidate the unstable relation of media to each other, and the historicity of these relations" (López 137). *Geografía del dolor* is certainly an example of a new media historiography, one that challenges binary forms of thinking and insists on the multimodal registers of pain and loss. Bowskill and Lavery contend that "multimedia practice involves the pollution of binary forms of thinking and cultural expression" (x). Such puncturing of binary understanding and thinking is critical to this project as it foregrounds the emotional and political complexities that underpin the stories of violent death and disappearance but also its political potential.

THE POETICS OF DEATH

Thus concludes a necessarily brief journey through two very different intermedial experimental texts. López Colomé and Arreola's work, with their focus on anonymity and death, seeks to capture a transcendent sense of subjectivity, of self-hood. In this sense, the linguistic texture of the project, works to evoke this moment, so as best "to achieve the transcendence of the individual, projecting it towards a world shared by everyone" (Finnegan 2017). Refusing linearity and oscillating between prose and verse forms, the hybrid intermedial fusion of *Via Corporis* constructs a multi-faceted array of affective and intellectual registers to the stories of pain and death that is worthy of study for what it can tell us about art's role and responsibility in the transmission of the narratives of cruelty and violence of contemporary Mexico. Here, then, lies an alternative community of the dead whose subjectivity slowly emerges through the painstaking interweaving of words and image. A similar impulse may be detected in *Geografía del dolor* as it charts a way through those invisible violences that render the contemporary moment in Mexico unbearable for many. These include violence done to the bodies of loved ones, structural violence that impedes the search for truth, as well as symbolic violence that dismisses and diminishes the voice and the testimony of those left behind among many others. While López Colomé writes through a series of polyphonic echoes, dismantling both language and form, González mobilizes distinct forms of expression from postcards through music, video, and oral testimony. If there is a common understanding of multimedia in both projects, it is perhaps not so much about a definition of multi, trans, or inter but rather the profound sense of kinship that is established between the different forms that are mobilized. This kinship allows the disparate forms to work both together and in

dissonance with each other at the same time, but always through a shared sense of fraternal solidarity. And it is perhaps in this evocation of a collaborative textual space in which a future can be imagined without violence that the creative potential of the multi, trans, and intermedial works by both authors might be most effectively harnessed.

16

Words, Memory, and Space in Intermedial Works by Gabriela Golder and Mariela Yeregui

CLAUDIA KOZAK

Contemporary Argentine artists Gabriela Golder (1971) and Mariela Yeregui (1966) have built – working as individuals and together – robust career paths within the fields of video, performance, installation, and new media art. One distinctive aspect of their *oeuvre* is the prominence of the literary/poetic evident in the way they deploy verbal resources. However, this literary dimension, being as it is part of the intermedial nature of their overall multimedia works, has often been neglected by critics. The reason might lie in the artists' backgrounds as they have been identified with visual and audio-visual arts.

Although contemporary art practices usually deny genre and disciplinary borders, it can be said in a broad sense that Golder has roots in videoart and Yeregui has been for a long time primarily involved in the development of electronic arts in Argentina.[1] But in both instances a considerable part of their work has a literary thrust. The works to be analyzed in this chapter are installations, performances, urban interventions, and net art projects that can also be related to literary genres and practices such as poetry performance, electronic literature, and urban visual poetry interventions. These multimedia, multimodal, and literarily oriented works engage intermedially with "literature"

[1] Video art is also electronic, but given that its international and local development has been previous to the consolidation of a quite separate field of electronic art (many times referred to as "new media art"), I make the distinction here. For the Argentine case, this argument is developed by Adler.

by either generating "new" verbal texts, or, as it will be shown here when analyzing specific works, appropriating other texts including print-medium literary/poetic genres.

Intermediality will be considered here as a way in which several languages and media intertwine in order to develop a different artistic experience only possible in the "in between." Works that can bear intermedial nuances interweave not only different media, for instance cinema, video, photography, books, or the Internet, but different languages or modes of discourse: verbal, visual, sonic, haptic, etc. It is usual to speak then of multiple media and languages in terms of a multimedia and multimodal perspective (Kress and van Leeuwen). One step further, intermediality can be seen as a particular way of understanding this multiplicity.

Given that intermediality has been widely discussed alongside other terms such as multimediality and transmediality (Clüver; Higgins, Intermedia; Kattenbelt; Rajewsky, Intermeidality; Schröter, Vos; Wolf) and also taking into account that there are different and often incompatible approaches to the matter, it is worth noting that intermediality will not be understood here in an additive sense, that is, where one form of media is added to another; rather, the chapter subscribes to an approach that understands "intermediality" in terms of the protean amalgam of perceptions and meanings created as a result of the interweaving of each form of media and language. In terms of Dick Higgins' famous definition of "intermedia," the relevant point would be the "conceptual fusion" created by intermediality (Intermedia 53). But I would rather not use intermedia as a noun, as Higgins does, but as an adjective to refer to the intermedial quality of the works to be analyzed here. In the words of Kiene Brillenburg Wurth, when analyzing digital poetry: "Intermediality would then be a destabilizing moment in a multimedial setting [...] the intermedial could here be imagined as an event (rather than an inherent quality) that occurs when the verbal, spatial, and visual become dispersive processes" (12). As the author is referring in particular to some works of digital poetry, the notion of "multimedia setting" in her quotation needs to be understood specifically as referring to digital multimedia. But it applies to multimedia in a broader sense. Whenever multiple media and languages/modes coincide in a work, the intermedial quality *can* emerge, but this is not a given. Brillenburg Wurth points to this emergence as a destabilizing *event*. I find this description suitable in that a real event is not a mere fact or essence with its attributes, but a disruptive moment created by a relationship between "manners," as Gilles Deleuze ("Lógica") said about Gottfried Wilhelm Leibniz's monad, which trigger multiple processes. In that sense it is also the moment when something new and unpredictable can happen in a "disjunctive diversity," another Deleuzian concept ("El acontecimiento").

Despite the approach chosen in this chapter stressing the literary dimension of the works of Golder and Yeregui, their intermedial quality allows the poetic function of verbal language to be re-signified in the mixture with other semiotic systems. From this perspective, the aim of this chapter is to contribute to the study of the works by these two artists as a complement to other kinds of approaches that do not pay much attention to the literary impulse of their works. This chapter could be then seen as focusing on a set of specific works, which can dialogue with the notion of expanded (intermedial) literature ("literatura [intermedial] expandida") (Gache; Kozak "Literatura expandida"; Pato), although thinking of them as literature, in the sense of single-authored print-medium literature for example, could seem quite odd.

Given that some of the works of Golder and Yeregui are the result of a collaborative process, it is worth mentioning the fact that collaboration/multi authorship is another aspect of their work which challenges the established idea of a literary or artistic text as being a closed system. The expansion in our understanding of literature in the context of "literature in expansion" also happens then in regard to the collaborative notion of authorship.

In addition, another distinctive characteristic of works by Golder and Yeregui is the exploration of memory as a key to producing disruptive experiences, both in a cognitive and perceptual sense. As philosophy and literature have already taught us, from Henri Bergson to Marcel Proust and Deleuze, memory is a heterogeneous kind of matter, not reducible to the linearity of homogeneous sequences of time and facts. In Bergson's theory, this heterogeneous nature of memory whereby each fragment is qualitatively different from the other, is the very condition of creativity, given that when time is understood as a linear sequence of homogenous elements, it means that they are identical and nothing really new can happen (16).

In these works by Golder and Yeregui, words offer themselves as phantom traces charged with dispersed, fragmented, and yet powerful memories. Either oral or written, the words link to specific places, bodies, and moments and create additional meanings because they enter into these relations. Moreover, one of the preeminent conditions of memory in contemporary digital societies is its instability due to phenomena such as digital obsolescence and mutability (Brea). Not all the works by these two artists are digital, but many of them are or have some digital components. And as we will see, there is ample reason to read them as a comment on the fluidity of memory nowadays; paradoxically, in the sense of a protean materiality which could enable enriched experiences but also as a slippery ground to grasp those same experiences.

VOICES AND PLACES OF MEMORY

In *Despojos* (*Remains*)[2] by Golder and *Inventario de bienes* (*Inventory of Assets*) by Golder and Yeregui, rooms in an abandoned hotel or the premises of a former prison provide the settings for words that seem to travel in time to capture traces of an ever elusive past, which nevertheless is also present. In both cases, the oral materiality of verbal language creates a bias whereby different accents and tones of voices give a sense of intimacy, confrontation and/or factual description in dialogue with the abandoned locations.

Remains is a performance and two-channel video installation that took place in Hotel Central in the city of São Paulo in 2009. Several volunteers had been previously invited by the artist to read, in different rooms of the abandoned hotel, fragments of texts they had chosen themselves with the sole requirement that the text must refer to a hotel or to traveling. Volunteers included actors, writers, and photographers with whom Golder was in touch at the time. She issued an open call among them and those who volunteered chose texts they had written but also well-known literary works such as *Tropic of Cancer* (1934) by Arthur Miller or *Motel Chronicles* (1982) by Sam Shepard.

Videos were made of the readings performed on the first day. On subsequent days, visitors to the hotel were able to watch traces of the first day performances as they could listen to and see the video recordings on old TV sets placed in each room. Although the texts chosen covered different subjects and were written in different styles, a certain introspective tone pervaded the majority of the performances. The curatorial text that presents the work on Golder's website, written by Brazilian new media artist Lucas Bambozzi, outlines that the words "talk(ed) about lack of affection, errors and misunderstanding." But there was also a sort of ambivalent atmosphere and a counterpoint between the intimate and the anonymous.

For instance, in one room, people could watch a Brazilian woman reading with emotion, in Spanish, excerpts of Sam Shepard's *Motel Chronicles*; in another room, a young girl was lying face down on a bed wearing a tight summer dress, reading with a vivacious voice in Portuguese and in another room a young man was reading in English a numbered list of hotel regulations regarding the behavior of employees, detaching himself from the introspective scene. Most of the readings were in Portuguese, but there was also a coexistence of several languages, something not infrequent in Golder's work, which gave the whole piece a defamiliarizing linguistic feature. Thus, the intermedial quality emerged not only from mixing media – performance, video, books – and modes of discourse – visual, sonic, spatial – but national languages too giving the work an intermedial *and* interlingual quality.

[2] All translations from Spanish sources are by the author unless otherwise stated.

There was also a counterpoint between the inside of each room, where visitors were very close to the performers, reinforcing the introspective atmosphere, and the outside since people walking around the hallways produced a constant anonymous mumbling that invaded – and was invaded by – the individual readings.

Frequently, performance as a contemporary format or genre is associated with the visual arts – because it is often performed in a gallery space – but it is more obviously linked to theater. The association with the latter is the reason why verbal language in some sort of interpretative way is frequently involved in performance. But several other aspects conferred on *Remains* a specifically literary impulse: first, performers read from written texts, among them excerpts of autobiographical novels or genre hybrid texts by recognized authors. This created a specific association with literature. Second, some of the texts implied self-referential literary devices which were accentuated in performance. For example, one of the performers not only read a text about literature but wrote it while performing – at some points he stopped reading, sat down on the bed and transcribed the text or rewrote it. The scene of writing enacted during the performance – in a self-referential manner, as *mise en abyme* in relation to literature – pointed then to a primary scene of literature, when someone can be seen as a writer of the text and pointed to the process of writing itself. At the same time, by duplicating this moment of the origin of the text the performance complicates the concepts of the solo author. Finally, words – and bodies, of course – occupied empty, uninhabited, spaces as if filling the voids of a blank page. In that sense, words occupied the rooms of the abandoned hotel restoring life and sometimes memories of past experiences in an otherwise deserted place. As Bambozzi points out, the work played with the ambivalence of the word "despojos" ("discard") that in Spanish refers "to garbage, to things without value, rubble, waste, refuse" but also means, as a verb, "to steal, take, loot." Like archaeological ruins, these "despojos" were at the same time pieces of a fragmented past that could have taken place and newly rediscovered gains.

We can also think of the excerpts read during the performance as literary residues that went beyond the boundaries of print-medium literature, giving new life to it because of intermediality. The intermedial nature of *Remains* enhances each language and media in its association with the others. In a way, voices, and words could be understood as restoring past and absent stories not only because of what they convey but because of the present – and spatial – perception of the abandoned hotel, where the sonic texture of each particular voice was blended with visual and haptic perceptions of rooms only illuminated by bed-side lamps, with flaky walls, unmade beds, and misplaced drawers. At the same time, the texts that were read gained new meanings

because of their proximity to a place that was far removed from the context to which they may have referred.

The bond between words, memory, and ruins is even more striking in *Inventory of Assets* (*Inventario de bienes*), a work by Golder and Yeregui, with close connections with *Remains*. On Golder's website, *Inventory* appears under the tag of interventions/site-specific works, and is also described as a two-channel video installation. *Inventory* was shot and shown as part of the exhibition *Territories of Disaster* in 2015, at Espacio de Arte Contemporáneo, an art venue currently located in the former Prison of Miguelete, the first "modern" Uruguayan prison, opened in 1888 and shut down in 1998. The prison was built following the panoptic model; inmates were usually men, but a few women were also confined there in the first years, in subterranean cells (Cipriani López).

The video screen is divided in two vertical panels. On the right side a woman, seated alone in the middle of a hallway between the abandoned cells, reads a report of the visual examination of the prison's entrance and the cells that she has written in her capacity as notary. The text has been written in the present tense and presents itself as an objective and detached description of the infrastructure's ruined conditions and an inventory of the found objects considered as remains. A detailed description of each item is provided. Given that a notary is legally "authorised to provide authentication and a secure record for almost any sort of transaction, document or event" (The Notary Society), her role in the video installation seems to be at the same time to witness the state of the premises and to provide an estranged perspective in tension with the feelings that the images of ruined spaces could provoke in the spectator. The notary's voice is monotonous but not in extreme since some slight pitch variations are present as well, and prevent the work from falling into a Manichaean perspective. Sounds coming from the surrounding area are occasionally heard, in particular bird chirps as windows are broken or missing. This enables a tension to be established between the outside – where everything sounds alive – and the confined inside.

On the left side of the screen, images of the places and the objects described by the notary are shown. Words and images are not synched and most of the time we do not see what we hear. In general, words depict in quite an indifferent way the traces of traumatic and oppressed past experiences which remain visible: small cells with broken beds, clogged toilets, thick bars, small windows without glass, flaky, or knocked down walls are all described by the notary in terms of data, including measurements and the kind of building materials employed.

However, while the words the notary pronounces are removed from the object of the description, the images cannot help to reintroduce a bit of a phantom life to the whole – in particular, when the camera reveals the presence

WORDS, MEMORY, AND SPACE IN INTERMEDIAL WORKS

of scattered books in some cells or newspaper and magazines pages. In a way, these printed words – which nevertheless the spectator cannot read – are more alive than the spoken words of the notary. The notary only lists some graffiti on the walls, old newspaper pages, or a magazine on the floor of some cells but not the books, while the video shows not only some of these books sitting on precarious shelves on the wall but also a pile of debris comprised of all sorts of papers, magazines, wood, and books as well. In fact, this pile is the initial frame of the video and reappears as the video starts over. The second frame shows a small bookshelf on a wall, with several dusty old books on it. Why did the notary not include the books in her report? Not only printed words but books, with their association with knowledge and literature, seem to remain here as shreds of life that resist being dispossessed of their own territory by a detached voice. In some respects, these silent books prevail as mute but powerful voices that confront the notary's voice with her inability to engage in any significant way with the manner in which memory has been shaped by the prison.

THE VISUAL MATERIALITY OF WORDS

Another set of intermedial works by these two artists emphasizes not so much the oral but the visual materiality of written, frequently literary, language – in this case the written language we can actually read, with or without an association to sound and again in relation to memory and space. Regarding this aspect, a corpus of works can be identified including, on the one hand, *Postales* (*Postcards*) (2000), *Itinerarios posibles para volver a casa* (*Possible Ways to Return Home*) (2011) and *Rescate* (*Rescue*) (2012) by Gabriela Golder; and on the other hand, *Epithelia* (1999) and *Hay cadáveres* (*There Are Corpses*) (2014) by Mariela Yeregui.

Escrituras (*Writings*) (2014–17), produced by both artists in collaboration with others, can also be seen as part of this trend. Before considering each of the individual works within this corpus, it is worth briefly commenting on this collaborative work, because it extended collaboration to people other than the two artists, blurring the boundaries between producers and recipients in relation to artistic practices, adding then another dimension to the already blurred boundaries of the intermedial experience.

Writings consisted of a social, participative, and performative territorial intervention through open-source cartographical strategies that produced new – *other* – ways of inhabiting the city. The project had several phases that comprised fieldwork and the building of a website that documents and keeps alive the project's findings. Fieldwork entailed different workshops – held before and after exploring urban spaces – where participants prepared the

212 CLAUDIA KOZAK

activities to be done and reflected upon them afterwards. The project created feelings of estrangement in specifically urban territories: sonic landscapes, written words, visuality, and new ways of perceiving bodies emerged through urban drifts – as used by Sadie Plant (58), taking her cue from the situationist notion of *dérive* – and were the subject of debate, recombination, and replacement in the urban terrain in the form of written neon signs placed by the participants of the project on the top of some buildings.

Like lighted poetic graffiti, close to an urban visual poetry (Kozak, "Literatura visual"), these signs condensed a differential approach to the ways people build meaning in everyday urban experience. In general, in everyday life, we walk big city streets without focusing on what they have to offer to us in terms of sounds, texts, and bodies. They are usually non-places we pass by in order to get where our daily obligations take us. But these particular poetic graffiti opened up alternative universes of meaning, and were even more enigmatic because of their urban placement. They could have been part of a poem in a book, but they were not. In that sense, they reveal the potential for literature to be everywhere and beyond the book. "Es imposible el silencio" ("Silence is impossible"); "Eternos por día, por hora, por mes" ("Everlasting for day, month, hour"); and "Se corrió el sol y cambió el límite" ("The Sun moved and the border changed") are some of the phrases placed on the surface of the public space, re-signifying it as a differential collective memory of an estranged urban experience.

GABRIELA GOLDER

Postcards is an interactive net art work that can be read as a piece of electronic literature due to the prominence and treatment of the poetic word in it. Owing to technological obsolescence – a frequent concern in digital culture, which invites us to pose questions about ephemerality and conservation of digital art – some of the work's features no longer work properly. Halfway between a personal and travel diary, the work was comprised of 220 screens, the "postcards" of the title. The work speaks a language of an alien status, a language of alienation which captures the experience of being an outsider, while raising questions about identity and memory. It presents a minimalistic aesthetic based on a black screen; letters and lines in white, red, or gray; black and white or dull-colored pictures and videos. Within this sensorial frame, texts (in Spanish or French), pictures and videos build, in semi-random interactive paths, a fragmented story of estrangement and exile combined with a (seemingly failed) love story. It is not possible to reconstruct the whole story, which presents itself as autobiographical but distorted. A woman leaves her country, her family, and friends. She travels; she lives in Paris where the love story

occurs. She is afraid of being forgotten or disappearing. She mixes languages: "je vais loin / je traverse des frontiers / j'ai suivi la route / je déchiffre des images" ("I go far/ I cross borders / I've followed the road, I decipher images"); "UNA TRADUCCIÓN / Desespero ante tus ojos" ("A TRANSLATION / I give up hope in front of your eyes"); "TOI/MOI / La même personne indéfiniment multipliée" (YOU/ME/ The same person multiplied to infinity). The visual quality of the texts, which come in different colors, sizes and shapes, stands out, and links this piece with kinetic-digital visual poetry. Although the work suggests a sort of diary – a genre more frequently related to narrative modes – the independence of each postcard, the fragmentary quality of the non-sequenced whole, and the almost verse-shaped texts in many postcards are more akin to poetry.

Another work by Golder, *Possible Ways to Return Home* (Itinerarios posibles para volver a casa), was a site-specific electronic literature installation where Spanish subtitles of the artist's favorite films randomly occupied a vast public space. It was exhibited during the sixth edition of an event named *Cultura y Media (Culture and Media)* at Centro Cultural General San Martín in Buenos Aires. The projection occupied a huge lateral wall at the entrance terrace of the building, close to an escalator. Not only from the ground but from the escalator itself, people were struck by the moving texts that seemed to tell incomplete stories. There were no explicit references to the films from which the texts were taken. We only know that they came from the artist's favorite films because of a statement on her website. Nevertheless, this site-specific installation worked on its own, without further explanations. Film enthusiasts might have recognized excerpts of *Alphaville* by Jean-Luc Godard or *La Notte* by Michelangelo Antonioni. In general, the excerpts dealt with topics such as heartbreak, memory, abandonment, the significance of time or of words – in some ways drawing on a similar semantic field to the one used in *Postcards*. In some cases, the projected texts followed on from one another so that they made full sentences or paragraphs, but in others only isolated words in capital letters – such as SILENCE, MELODRAMA, ITINERARIES – were shown. There were also cases where texts superimposed onto each other with a translucent quality.

On the dark-gray wall, white words in different sizes attracted the attention of visitors as digital graffiti invading and re-signifying the experience of public space, a similar strategy to the one already analyzed in relation to the project *Writings* by Golder and Yeregui, but in digital audiovisual language. The intermedial quality of the artwork was also enhanced given that cinema as a medium was called upon to intervene "outside the cinema." We could think of it in terms of the category of expanded cinema developed by Gene Youngblood. However, this work did not really summon films but only subtitles, a way of giving more presence to the written word in relation to a medium

where – in principle – the spoken word takes precedence. While film spectators in Argentina will be accustomed to watching films with subtitles, the lack of images has the effect of defamiliarizing the experience.

Finally, a work by Golder that turns net art into expanded electronic literature is *Rescue*, an interactive online work and/or site-specific installation where words, retrieved randomly from books censored during the last military dictatorship in Argentina, come back to visibility and so escape oblivion.[3] Although *Rescue* can be linked to other projects developed in Argentina that deal with censored books, the singularity of the work lies in its interactive-intermedial-electronic nature, which makes it closer to digital literature than print-medium literary books.

Thin black moving words in different sizes, pronounced by a monochord voice, appear on a white screen and challenge the interactor to touch them with the cursor. As they come into contact with the cursor, the words come from the back of the screen to the front while their size enlarges and the voice turns into whispers, although they remain audible. Words are then rescued and freed by the interaction of the wreader (whose role is that of both writer and reader), who can thus put together fragmentary and ephemeral visual-sound-kinetic poems. Neologisms such as interactor or wreader tend to be used in the context of interactive hypermedia works, in order to point out some sort of non-differentiation between formerly traditionally distinct roles of writers and readers. Intermediality incorporates in these cases the blurring of borders not only in relation to languages and media, but also to authors and readers.

3 In Argentina, different artistic, library or educational projects have emerged dedicated to restoring the memory of books that were censored, burned or buried (because of their owners' fear) in contexts of dictatorship. Many of these projects compromise intermedial qualities, such as *Biblioteca de Libros Prohibidos* (*Library of Censored Books*) that occupies one of the exhibition rooms at the Archivo Provincial de la Memoria (Provincial Memory Archive) in the city of Córdoba, where we can find not only the books but also documentation relating to the censorship decrees, testimonies of people who had burned or buried books, children's drawings produced in the context of activities held in the library concerning human rights, etc. The project *La biblioteca roja* (*The Red Library*), led by Agustín Berti, Gabriela Halac, and Tomás Alzogaray Vanella is also worth mentioning, as it led to a large number of books being exhumed, which had been buried for forty years in the garden of a family home. The project comprised a group of artists, art/literary scholars and librarians, with the assistance of the Argentine Forensic Anthropology Team, an internationally renowned non-governmental, not-for-profit, scientific organization that applies forensic anthropology and archaeology to the investigation of human rights violations in Argentina and worldwide. As a result, the team published a book in 2017 consisting of essays about the project; they also have exhibited the exhumed parcels of books in gallery venues and are currently editing videos.

WORDS, MEMORY, AND SPACE IN INTERMEDIAL WORKS 215

In *Rescue*, readers turn the isolated words the artist has retrieved from the censored books into new compositions. Readers' actions imply choices: while words appear randomly on the screen, it is necessary to choose which ones will be captured by the cursor. For instance, it is possible to choose only the words most obviously related to contexts of censorship, incarceration, torture, or political commitment, creating then a kind of protest electronic literature. But that is not the only option. It is also possible to choose any other words and create texts that are covertly political. For example, it is possible to create a text in which in the foreground, occupying a big space at the center is the word "VACÍOS" (VOIDS), and surrounding it in a slow dance are words such as "espacios" (spaces), "lluvia" (rain), "cenizas" (ashes), "lengua" (language/tongue), "luciérnaga" (firefly). In that sense, formerly censored words and texts are reborn in a nonlinear and non-unidirectional way. This possibility is already enabled by the words' random appearance, but is reinforced by a kind of inverted relation between the visible and the audible: words that come to the front of the screen are certainly more visible, because they occupy a big space, but they are pronounced in whispers so always reminding us of the time when they were not allowed to be said.

MARIELA YEREGUI

Epithelia was produced by Yeregui between 1997 and 1999. The work has been unavailable for a long time due to the obsolescence of the Netscape 4.0 feature set. But Uruguayan net artist Brian Mackern has recently restored it both in emulated and video navigation versions for the *Net Art Anthology* hosted by rizhome.org. This interactive net artwork gives particular attention to fragmented texts and images which were circulating at the time within digital culture. It has a strong self-referential mark, given the countless pop ups that fill the screens. Pop ups even appear as Chinese boxes (one inside the other), pointing out the fractal dimension of the Internet. At the same time, the work creates a tension between surfaces and depth. The work's title – plural for epithelium – and its contents recall both the surface of the (human) body and metaphorically any kind of interface. The initial screen constantly changes with moving and still texts – in English – and images referring to the body and its parts. In the beginning, a pop up instructs the wreader about the different navigation options, pointing out that it is not only possible to click on each part of the work but also to obtain mouseover events. Eventually the interactor has the option to click on a word with a peculiar spelling – bODY – that hyperlinks to the work's main screen: a large collage of images of a human body not visible as a whole but in parts. It is then possible to click on several parts of this fragmented and

hermaphrodite body – which appears at first glance to be a black woman but presents male genitals – to access interior layers of texts and images relating to each part: head, eye, mouth, heart, genitals, hand, and foot. The fragmented body works as a Frankensteinian main menu, with each part being a chapter with its own content and aesthetic. Bodies and texts speaking about the body, its materiality, and its relation to time and memory recur throughout. Many chapters have the traits of kinetic visual poetry, because they contain multiple quotations from literary and philosophical texts – by Aristotle, Jacques Derrida, James Joyce, Sylvia Plath, Walt Whitman, Jeanette Winterson, among others – deployed in different colors and fonts, alongside different images. In fact, the work can be read as a collective digital text made up of all of these excerpts but it is also collective in the sense that *wreaders* could submit, when it was fully functional, new texts to be added to the work. A new corpus, a new "body of work" (as Mackern playfully calls it in his curatorial statement), could then be added to a work already conceived as a proliferating entity. In *Epithelia* the Internet works as a specific non-place where texts and images build a dispersive memory of absent bodies in a foreign language, given that the language of *Epithelia* is mainly English and not Spanish as we would expect from an Argentinian artist such as Yeregui. As far as we can tell navigating the emulated version, the majority of the texts are written in English. But when the mouth is clicked something changes: fragments of moving texts in red letters appear in the middle of the screen framed by multiple pop ups with images of lips, and the voices that in this case accompany the texts speak in Spanish, although what they say is not completely clear. Language boundaries and even their content are blurred.

In contrast with the globalized operating language of *Epithelia*, in the installation *There Are Corpses*, Yeregui re-elaborates in an intermedial manner the well-known poem "Cadáveres" ("Corpses") (1987) by Argentinian poet Néstor Perlongher. The work is a kinetic sculpture/installation comprising twelve stylized wind vanes. On the top of each wind vane a different metallic letter from the repeated stanzas' final verse – "There are corpses" – had been installed. But the letters, which are sequentially located and then should form the verse "There are corpses," are not still. Instead, they are moved by motors and reflect their shadows onto the wall behind them. While the letters spin round asynchronously, magnifying but disbanding the words of the verse on the wall, the recorded voice of the poet recites his poem in "porteño," the Spanish pronunciation used by inhabitants of Buenos Aires, giving the work an additional intermedial feature. Perlongher's long poem, written in 1982 and published in 1987, had already hinted at an intermedial quality as it was also recorded by him on a cassette edited by Circe/Último Reino. The poem is significant as it has been read and commented on many times as a

WORDS, MEMORY, AND SPACE IN INTERMEDIAL WORKS

paradigmatic political poem about missing people in Argentina during the last military dictatorship, but it is not considered as being part of the tradition of "social poetry," as direct political references are blurred and mixed with the poet's characteristic vocabulary. In the poem, corpses are repeatedly brought to presence by a vertiginous and sexualized language, the material language of "neobarroso" – a play on words due to the similarity between baroque (barroco), and muddy (barroso) – as Perlongher himself conceived his poetic expression. The poem is replete with corpses which appear in different spaces simultaneously and the repetition of "en" at the beginning of many of the verses serves to mirror the syntactic structure of the poem via the use of the poetic anaphor.

The circumstances that led people to die, to become corpses, are more or less blurred in the poem, only half recognizable at times. The same can be said about Argentinian historic and literary references, in some cases replete with irony.[4] They are there but dispersed and veiled. Despite the lack of direct political references, and because of their jumbled nature, these corpses are even more present within the multiplicity of the poem's language. In a way, the minimalistic installation *There Are Corpses* by Yeregui – a half-shadow room only occupied by the kinetic sculpture near the back wall – contradicts the neo-baroque style of the poem. But the contrast between the restrained visual/haptic materiality of the sculpture and the lushness of the poem's orality in the voice of Perlongher creates a powerful effect of immersion in a space that is void but yet full of presence. In Yeregui's installation, due to the asynchronous movement of the letters, the verse appears and disappears on the wall, it assembles and disassembles as an elusive but persistent verse about death, in general, and about missing – disappeared – people, those who were kidnapped, kept in clandestine premises and murdered. Missing people whose corpses had been hidden and whose existence was denied, corpses that nevertheless reappeared by the force of naming them.

4 For instance, as seen in the stanza where a reference to Che Guevara is made by quoting in a ludic manner a well-known song by Víctor Jara that commemorated him after his murder: "En lo preciso de esta ausencia / En lo que raya esa palabra / En su divina presencia / Comandante, en su raya / Hay Cadáveres" ("In the necessity of this absence / In what underlines that speech / In your godly presence / Comandante, in your line / There's corpses" (translation by William Rowe). Anyone who reads the poem, and already knows the song, cannot help, because of its cadence and words, associating this part of the poem to Jara's original song: "Aquí se queda la clara / la entrañable transparencia / de tu querida presencia / comandante CHE GUEVARA" ("Here remains the clear / the lovable transparency / of your dear presence, Comandante Che Guevara").

SOME PROVISIONAL THOUGHTS ON INTERMEDIAL WORDS

Gabriela Golder and Mariela Yeregui would probably not think of themselves primarily as writers. Nevertheless, the analysis of several of their works, as has been formulated in this chapter, undoubtedly bonds their artistic practice to an expanded intermedial literature. In a way, it is all about perspective, that is to say, about ways of viewing. As each different language – visual, sonic, haptic, verbal – enters an intermedial context, it surely transforms and mutates; it becomes *other*. However, it also carries a particular materiality that resists disappearance. When critics use categories like "sculpture in an expanded field" (Krauss), or the already mentioned "expanded cinema" and "expanded literature," they try to grasp new forms of art that cannot be understood in terms of previous categories which existed in each artistic discipline. And yet, the words cinema, sculpture, or literature are still present as part of the new terms we use. For this reason, we could speak about a *weak* specificity that can nevertheless still be discerned in some of these new works that trespass artistic disciplinary borders. In other words, when the intermedial event emerges in a multimedia setting, we cannot think in terms of the specificity of each autonomous language and each medium. But anyway, visual, sonic, haptic, or verbal languages are not all the same. Each one coincides in order to create the intermedial event and produces some kind of specific perspective, which turns out to be *weak* – and not *strong* as, for instance, the presumed verbal specificity of literature in contrast with the visual specificity of painting. This argument does not imply that any kind of specificity completes the universe of meaning in an intermedial event; it only stresses that when analyzing the kind of artworks such as the ones dealt with in this chapter, the focus on some specific language or medium, as literature, books, and verbal language, can provide an enriched yet partial perspective anchored to a specific and not always significantly perceived materiality, awaiting perhaps more integrated readings of this expanded/intermedial art.

17

Fungibility and the Intermedial Poem: Ana María Uribe, Belén Gache, and Karen Villeda

DEBRA ANN CASTILLO

By calling the letter "h" a centaur, Ana María Uribe (Argentina, 1944–2004) evokes the shape of that animal, while the sizes of the letters mimic depth, and their movement across our computer screen in various iterations suggests the majestic travels of a herd across a barren landscape. In another of her series of "Anipoemas," one called "Gymnasium," the "P" stretches itself into an "R" or "I" leaps into a "T" or an "X"; circus jugglers are mimicked by two lower case "i"s exchanging their dots. Spring and winter are evoked by lower case "q" and "p" climbing into each other, then losing their bumps. Belén Gache's (Argentina-Spain, 1960) "Veintidos mariposas rosas" ("Twenty-Two Pink Butterflies" which, indeed, includes twenty-two pink and one blue butterfly) invites the reader to click on butterflies, which flap their way off the page, taking the letter associated with their position with them, and leaving us with a new poem, legible or not. Karen Villeda's (Mexico, 1985) "Poetuitéame" (Poetweetme) gathers reader tweets by way of selected hashtags and converts them into something like cluster poems. Basia Irland (United States, 1946) has a series of mysterious "hydrolibros" created out of rescued ruined paper volumes, or carved out of wood, and another series of "ice books," seeded and released into waterways, evanescent sculptures that may mimic text, but do not contain any words: "a lyrical and ecological poetry," says Lynne Cline on Irland's webpage (https://www.basiairland.com/projects/hydrolibros/index.html).

All of these multimedia pieces call themselves poetry, but it is certainly not poetry as we understand it following the most traditional and minimal of

220 DEBRA ANN CASTILLO

definitions: a rhythmical composition, written or spoken, expressed in imaginative words. What they have in common is a focus on some kind of animation and/or interaction, a commitment to some version of rhythm, and a location on the Internet. In this chapter, I want to look at writers/performers/poets like these, by way of a few examples of Latin American intermedial[1] artistic practice that is generally still called "poetry," but which puts pressure on even the most expanded definitions of the genre. While some of these authors, like Karen Villeda and Belén Gache, have made print versions of some of their work available for purchase (or download as e-books), this is not always the case, and the focus of this discussion will be on these poets' intermedial work, rather than the work available in more traditional print or e-book formats.

By this moment in the third millennium, it has become axiomatic to reference – often in simultaneously celebratory and deprecating ways – how the Internet has created new possibilities for the creation and dissemination of human expression. Because poetry in all its multiple forms has always been widely practiced, and by and large is not very viable commercially, the opportunity offered by cheap or free internet access and free websites has sponsored a boom in expression, as poets of varying talent vie to share their work with an audience that is, potentially at least, extraordinarily large. For this very reason it is almost impossible to talk about poetry on the Internet, or even digital poetry, in a general sense, since the range of work is so vast. The thousands of sites range from basic reproduction of what might otherwise look like simple printed pages or blog pages with modest decorative elements, to elaborate experiments that involve sophisticated coding, extensive use of multimedia, and integral kinetic features. Poetry as it is performed on the Internet can be interactive or not, may include sound (voice, music, or other sounds), static or moving images or video, along with manipulations of font, color, and the use of animation in the text – if indeed text is even used. It can involve constraint of the time of reading/listening by the way words and images are streamed, and will almost certainly have an innovative relation to space and spacing that plays with the suggestive relationships of screen and text as opposed to paper as the media of transmission. Generic lines become quickly blurred when something called "poetry" also includes visual materials, music, gaming, dance, collaborative writing, and computer generated verse.

[1] Like many other scholars, Ginette Verstraete distinguishes multimedia, transmedia, and intermedia. She succinctly and helpfully defines intermediality as: "an interrelation of various – distinctly recognized – arts and media within one object but the interaction is such that they transform each other and a new form of art, or mediation, emerges" (10). Within this general definition, I am particularly interested in performative poetry that requires active collaboration by the reader/viewer, creating unique, time-stamped, iterations of a creative concept.

Many of even the most traditional poets now have their own YouTube channels as well as their almost obligatory websites, where one can hear them read from their works, as well as browse the site for more or less elaborately illustrated and contextualized samples of their work. This is the case for example, with Mexican Gabriela Jaúregui, who – in a now very familiar model – imbeds videos in her basic website. Somewhat more interesting for my taste is the example of Mónica de la Torre (also from Mexico), where on the National Public Radio website, instead of a video, we are offered an audiofile of her poem, "Olímpicamente" in which the lines become successively highlighted as she reads, as if it were a kind of karaoke. Meanwhile, Argentine slam poet Sagrado Sebakis (Sebastián Kizner), in one of his videos, "De por qué la poesía slam y la alt lit son de los más intenso e incredible" (Why Slam Poetry and Alt Lit are the Most Intense and Incredible Forms) implicitly pokes fun at the entire enterprise of high-sheen, high production value video by posting a shaky, webcam (facetime?) recording of himself and a friend reciting a poem/manifesto on why contemporary performance poetry is a more agile and appropriate form of expression for writers like them whose lives are consumed by new forms of communication and expression. Their point, finally – one made in other forms by a wide range of poets and thinkers – is that these newer, more agile poetic genres require a new poetics, a new aesthetics, a new set of concepts and paradigms: in short, a new theory of reading. In each case, however, what they are producing is still recognizably "poetry": these poets are not so much offering new paradigms themselves, as using the advantages of the Internet to expand the audience for public readings of their poetry, with only modest technical effects to support a traditional activity.

The history of the exciting new genre often called "digital poetry" or "cyberpoetry" is relatively brief, despite its vast archive, reaching to the early and mid-1990s, when the researchers in Geneva's European Organization for Nuclear Research (CERN) released to the general public the protocols they had been developing since the mid-1980s for scientific use. Tim Berners-Lee and his colleagues were excited about the potential for bringing together hypertext and the Internet (Berners-Lee gave this project the name "world wide web"). Poets and artists immediately saw its potential as they had already been generating experimental, computer-based work, without any easy means of distribution, since the 1980s with artists like Mexico's Grace Quintanilla, Colombia's Monika Bravo, or Brazil's Regina Célia Pinto (to limit myself to only a few of the prominent women). The advent of the world wide web created a new platform for generating and publishing early interactive poetry in the first wave of enthusiasm, in the mid-1990s, thus migrating from the early computer experiments that could only be shared by physical files like (in those days) floppy disks or CDs. Nevertheless, the real explosion did not occur until the turn of the millennium when the web became ubiquitous, and the rise of

Amazon along with the popularity of the social media applications of Web 2.0 made self-publishing and self publicizing significantly easier. Thus, poets were among the early net.art innovators and participants, who saw the ways in which this new technology offered unexpected possibilities to creators, often in laborious collaboration with programmers, and indeed, while some of this work has been lost to the changes in platforms and software, much of the early exploration remains fresh and important.

For my purposes here, I want to refer to that subset of the vast poetic production available on the Internet, that crucially relies on intermediality as an aesthetic proposition and not just an enhancement for distribution. Here, for example, is a helpful definition of cyberpoetry by Mexican poet Karen Villeda, from her LABO (laboratorio de ciberpoesía) site created for her hypertext book, *Tesauro*: "Ciberpoesía ('poesía electronica,' 'poesía digital') es la rama de la LITERATURA en la que predomina la función estética del lenguaje. Wikipedia. A NIVEL TÉCNICO emplea una variedad de recursos desde el más simple como <hipertexto/> hasta lo más complejo como una interfaz de REALIDAD VIRTUAL" (Cyberpoetry ["electronic poetry, digital poetry] is the branch of literature in which the aesthetic function of language predominates. Wikipedia. On a technical level it employs a variety of resources from the simplest hypertext to the most complex interface with virtual reality").

In this definition, Villeda winkingly references Wikipedia (rather than some other, presumably more prestigious dictionary), highlighting that the poetry that is of interest in this regard has a digital native existence, while demonstrating both literary (i.e., capital letter "LITERATURE") qualities and a primary concern with the aesthetic function of language. These are vague, if traditionally powerful terms for privileged writing that is considered of high (elite) value. Second, while considerations of literary language and literature itself are primary, Villeda points to the necessary collaboration between literary expression and technical effects ranging from hypertext to virtual reality. In between these two extremes, from basic website construction to highly elaborate art projects, she (and we) would include collaborations with programmers for some of the more elaborate effects, or DIY use of macros like flash animation for the simpler ones. Yet Villeda's definition, which can conceivably be read "straight," by the very fact of its choice of font and color scheme interrupts the standard dictionary definition, making aesthetic choices that affect the experience of reading and drawing attention to the various linguistic elements, asking us at the same time to read this as a definition and as another entry in her body of work that riffs on wordbooks like the dictionary and the thesaurus, while playing recombinatory games with Wikipedia. Furthermore, unlike this definition, which I can easily copy and reproduce, the digital native poetic projects that most interest me here cannot be simply transferred to another medium like print or still image: they

FUNGIBILITY AND THE INTERMEDIAL POEM 223

exist in the interaction of software and hardware on the internet-connected computer screen.

It is partly for this reason that this kind of poetry has aroused considerable controversy in the academic realm, where some scholars have criticized it for an overenthusiastic deployment of technical effects to obscure a mediocre poetic content, and others have praised it for its ability to define a new aesthetic that significantly expands the possibilities of literary expression (the scholars and critics are often looking at very different sample sets). Another challenge for scholars is the inevitable privileging of material that is easily accessible and stable in terms of archivable platform. What would happen, for example, if we lost Twitter as a platform? How would libraries archive the poems created with this medium? Is scholarship limited to the archiveable?

Historically, when literary scholars try to place it on a continuum with earlier periods, cyberpoetry has often been understood as an evolution of the kinds of innovatory practices associated with the early-twentieth century Euro-American avant-gardes, and more specifically, as a realization of the potential inherent in such movements as Latin American, particularly Brazilian, concrete poetry (see, e.g., Schaffner; Danci "Digital Poetry"; Di Rosario).

Leading Brazilian concrete poet Augusto de Campos (Brazil, 1931) serves as an excellent case in point. His early work includes the kind of typographic experimentation associated with nineteenth-century poets like Apollinaire and Mallarmé, and refined in the mid-twentieth century *Noigandres* group of poets located originally in São Paulo, Brazil, and prominently including himself and his brother Haroldo. Following upon his earlier concrete poetry experiments, when moving to an online platform Augusto de Campos adds color and variety to his backgrounds and fonts in ways that would make print books prohibitively expensive. He also produced a series of holograms and book-objects as a way to reach into the third dimension, and eventually animated some of his poems by adding a kinetic dimension and sound (references to this entire poetic evolution can be found on his website). Already in 1992 his "poema-bomba (1983–97)" (Bomb-poem) (https://www.augustodecampos. com.br/poemas.htm) Augusto de Campos used animation to explode the letters of the two-word poem/text, along with a flash of light, sound effects, and the spoken words "poema-bomba," manipulating the poetic text in a way that would be impossible with material objects. Likewise, his much more recent "Clip poems" (published 2003, but created in the late 1990s, https://www. augustodecampos.com.br/clippoemas.htm), made with relatively simple and accessible flash animation, continue to develop this line of work into the new millennium. These poems serve as an expression of his hope that experiments with new mediality will create an important new opening for the avant-garde aesthetic project. As he comments in an interview published on his website:

> What Concrete poetry sought was to recuperate the specificity of poetic language itself, the materiality of the poem and its autonomy, beginning with a revision and radicalization of the methods of modern poetry and of the elaboration of a new creative project in the context of new media. … Works of the 80s and 90s are, on the one hand, freer in relation to the orthodoxy of the first years and, on the other, more intensely participatory in the challenge of new technologies, which have produced digitalized poems, graphic and sound animation, and multimedia and intermedia processes. In this way, the "wishful thinking" of the 50s came about with computers, an ideal space for "verbivocovisual" adventures. ("Yale")

In this respect, the Campos brothers echo a familiar argument well-posed by Benjamin in 1936 in his famous essay, "The Work of Art in the Age of Mechanical Reproduction" (or "Reproducibility"): "one of the foremost tasks of art has always been the creation of a demand which could be fully satisfied only later. The history of every art form shows the critical epochs in which a certain art form aspires to effects which could be fully obtained only with a changed technical standard" (237). In this sense, concrete poetry and the early experiments in digital poetry are closely aligned in their aesthetics and their theoretical positions – the challenge of rethinking poetic language called out for new technologies not yet available, but eagerly anticipated. Screen space allows for a more open and flexible use of the arrangement of textual elements on the page, and of enhanced sonic and visual elements, thus fulfilling an ambition inherent in concrete poetry. As Augusto de Campos tells Roland Greene in an optimistic 1992 interview, for himself and other members of Brazil's *Noigandres* group: it is in "the exploration of new technological media … that we will find 'what remains to be done.'"

There is, of course, a continuing rich tradition in Brazilian cyberpoetry as evidenced, for example, in "Ciber & Poemas," a site created by Ana Cláudia Gruszinski and Sérgio Capparelli in 2010 (formerly at: http://www.ciberpoe-sia.com.br/). This site is no longer active, and – as I will explore a bit more below – the very fungibility of the archive for digital native work, as well as the challenge of platform obsolescence, makes it challenging to contribute to scholarship about the evolving qualities of the digital archive. Fortunately in this case, many of the early projects, as well as their continuing work, are still available for viewing on YouTube. Gruszinski and Capparelli are direct heirs of the *Noigandres* school inspired by Haroldo and Augusto de Campos. These are indeed continuing explorations of "what remains to be done" in concrete poetry, and what remains to be done cannot be done with paper alone.

Yet, as Anna Katharina Schaffner incisively argues, while figures like Augusto de Campos provide a powerful argument for the continuity between avant-garde, and especially concrete poetry, there is a significant difference with more recent developments:

FUNGIBILITY AND THE INTERMEDIAL POEM 225

> the signs that the digital poets use are substantially different from the signs that concrete poets used: first, they can move across the screen, they can be animated and programmed to perform a predetermined routine, and thus also gain a temporal dimension. Secondly, they can explore all dimensions of the sign at the same time simultaneously. Thirdly, they are equipped with a halo of technical meaning, and are, in some cases, both message and code at the same time. Fourthly and fifthly, signs are changeable "flickering" images rather than fixedly inscribed marks. And lastly, digital signs gain an additional volumetric dimension: relationships of depth, foreground and background, proximity and distance can be simulated. ("From Concrete to Digital" 8)

While all of these features could arguably be enclosed in Campos' intuition of "what remains to be done" in concrete poetry, Schaffner's focus on text as the distinguishing feature of the earlier genre, and a more multifarious understanding of "the sign" as a hallmark of the latter, underlines a now-familiar debate about the nature of poetry. Likewise, her succinct outline of some of the qualities that most prominently define this intermedial work as a new genre can helpfully move towards a taxonomy of this emergent genre, where the fundamental building blocks of poetry are no longer material, no longer just language, but an unstable visual display, backed by code.

To illustrate these points, I want to look at a few examples of prominent intermedial tendencies, by way of Latin American poets including Ana María Uribe, Belén Gache, and Karen Villeda, who explore in different ways the kinds of qualities Schaffner lays out in her rhetorical analysis. In each case, the poetry is not an accessory to a print book, but rather completely uncontainable by that technology; increasingly, the poetic practice comes to reside in a nebulous and fungible performative space created by the viewer's choices as they accept the challenge to play this particular game. If the poetic incentive exists in the programming and the invitation to play, the poem itself might be said to reside only in this time-bound, unrepeatable tracery of signals across a network.

Ana María Uribe (Argentina, 1944–2004) is best known for a tiny body of work, that continues to excite interest, especially her *Tipopoemas* (written before she had access to a computer) and her *Anipoemas* (created after). Uribe takes the challenges of the concrete poets and carries them further. In her work the role that grammar plays in traditional poetry is completely reshaped since she focuses on the smallest building block of text – the individual letter. While her *Tipopoemas* were limited by the black ink ribbon, the single typewriter font, and the size and position of the page in the typewriter, the computer freed her experimentation in later work, allowing for varying sizes, animation, and (in her last works) color. Except for her very late work, Uribe does not use words at all in her visual poems, relying instead on the

suggestive qualities of the visual shapes of letters as an aesthetic proposition. As Schaffner notes, "The dominant function of letters, to be building-blocks of words and thus particles carrying semantic meaning, is undermined: they are deployed for their visual dimension only, in an iconic fashion" ("Concrete to Digital" 3). Thus, early work like "Catarata" consists entirely of parentheses, arranged on a page to evoke a waterfall, and "bowling" arranges lower case "i"s and a pair of "o"s to surprise us with a minimalist version of a bowling alley. In her "Anipoemas" letters move around, zip and unzip themselves, discard and add fragments that convert them into other letters, travel across the screen in herds.

In a long email posted on her posthumously maintained website she writes that she finds the source of her inspiration, from her earliest works, in the letters themselves, and how they act upon her poetic world: "In *Anipoemas*, the main components are typography and motion, in that order. And once motion is added, rhythm becomes all important, since I work with repetition and short sequences of elements." Her later works add sound, and while it could be argued that even her earliest work has a rudimentary narrative, of sorts, by later work like "Deseo – Desejo – Desire" she more consciously includes a plotline "with a starting point, a climax and a denouement." Of the third, and longest part of this trilingual "erotic" Anipoema, "Desire," says Uribe: "the letters 's' and 'i' in 'desire' join in a tango dance, forming the Spanish word "sí" (=yes), in apparent acceptance. However, on a second reading, 'si' in Spanish also means 'if', so success should not be taken for granted after all." Yet for all her prescience with respect to opening out the genre, Uribe remains fixed in a form of animation that is language-based, and still located within an aesthetic assimilable to concrete poetic endeavors.

Belén Gache (Spain-Argentina, 1960–) provides an excellent example of the poet who immerses herself in a gamer-based understanding of the relation between the writer and the audience and whose work necessarily takes on a more challenging form. Gache is a prolific producer of fiction, poetry, and essays both in traditional print and in expanded forms since 1996, and she is well known for her installations, readings, courses, and other in-person and online performances. As she argues in one of her essays, "La poética visual desafía las reglas de escritura establecidas. Crea alfabetos y, con ellos, nuevas formas de significar. Si escribimos diferente, leeremos diferente y pronto entenderemos el mundo de diferente manera" (Visual poetry defies the established rules of writing. It creates alphabets and, with them, new forms of signifying. If we write differently, we will read differently and soon will understand the world in a different way. "Poética" 150). Her explorations of how to read and write differently have resulted in a significant body of work in many genres, of which the most typical and celebrated forms of her work are multimedia electronic projects. Whether we call them poetry or not is an open question.

Some projects, like her video "Aurelia: Our Dreams are a Second Life" (2007), seems an obvious metapoetic enterprise, by way of a poetic reading. It uses an existing game interface, in this case, as might be expected, Linden Lab's 2003 *Second Life*, a variation on popular MMORPGs (Massively Multiplayer Online Role Playing Games). Nerval's nineteenth-century text provides both the inspiration for the hallucinatory wanderings of the game avatar, as well as the matrix for the material montaged in the film, housed on vimeo.

Gérard de Nerval's wrote "Aurélia" in 1855, shortly before his suicide, and the text begins with travels through streets in Brussels and Paris, then shifting into reveries, dreams, and visions that move through space and time. Nerval's original poem/memoir/autobiography begins: "Dream is a second life. I have never been able to cross through those gates of ivory or horn which separate us from the invisible world without a sense of dread. The first few instants of sleep are the image of death. ... Then the tableau takes on shape, a new clarity illuminates these bizarre apparitions and sets them in motion – the spirit world opens for us" (265). Gache's visual interpretation travels through *Second Life*, with her avatar reading selections from Nerval aloud as she wanders inattentively through Paris streets, flower filled gardens, a disco full of other avatars dancing, multiple isolated landscapes, the bottom of the sea, and ends with her floating in the galaxy, still with her head in the book, oblivious to her surroundings. The visuals, then, add a second poetic layer to the poetic reading.

Other Gache projects invite user interaction in games or game-like interfaces; this is the case with her two *Wordtoy* volumes of electronic interactive poetry (1996–2006), where the reader's intervention is essential to the aleatory development of the poem – I mentioned "Veintidos mariposas rosas" earlier as an outstanding example, as the new poems are created entirely based on the viewer's decision about which butterfly/butterflies to click on, and in which order.

While all of the texts in two Wordtoy volumes are interactive, many of the other poems rely heavily on riffs from traditional poems. In her more meta-moments, as in "El arte de la cetrería" ("The art of falconry") she sets a verse from Góngora's *Soledades* to the background sound of mechanical bird robots and music boxes. "Canon occidental" ("Western Canon") on the other hand, features a group of line-drawn men. Clicking on any one leads to a canned speech beginning, "Cuanto más les grito, más me quieren, cuanto más los desprecio, más me admiran ..." (The more I yell, the more they love me, the more I despise them, the more they admire me). Clicking on a series of the men rapidly leads to a cacophony of canonical male self-indulgence. And there is the by now almost inevitable glitch in the poetic sequence: "El jardín de la emperatriz Suiko" ("The Garden of Empress Suiko") has been for years almost impossible to view: as Gache says in a note on the Wordtoy page dedicated to this poems, as of April 2015 this page could longer be viewed via

the Chrome browser; I was also unable to access it either on Safari or (recommended by Gache) Firefox until her re-engineering of the code in 2021. This obsolescence is, of course, one of the dangers of internet-based projects like these that require stability in our operating systems and browser platforms. Thus, for instance, in the current version of Gache's webpage, the viewer has two options to interact with "Wordtoys": the restored version and the original version. As she notes, the original version required/requires flash and Shockwave, which are no longer supported by modern browsers. The January 2021 restored version has now resolved these longstanding problems, including making "Empress Suiko" accessible once again, and we can enjoy seeing the words turned into flowers at our command.

I want to pause for a moment on the two very different propositions represented by "Aurelia" and "Radikal Karoake." "Aurelia" is somewhat easier to parse; a novel use of an existing platform for an artistic performance, it suggests to viewers ways in which they too can insert avatars into *Second Life* for their own original projects. It opens up a new way of reading a classic poet. This is a form familiar since the mid-1990s when video gamers created their own films using the archive of their purposeful movements through various popular commercial games, along with increasingly sophisticated video editing software, to create machinima films, often distributed exclusively on the Internet. While *Quake, Halo,* and *World of Warcraft* provided early platforms, since the turn of the millennium, in the early 2000s, *Second Life* had been one of the go-to programs for entry-level filmmakers (it too is now considered obsolete). In any case, "Aurelia" – like other machinima – is a curious hybrid; it has a technological sheen, but a very conservative underlying ethos: that of reading/performing poetic texts before an audience. In this case, the audience is doubled: first, in real time, that of other users who happen to intersect with the Gache avatar in the MMORPG, and secondly the ultimate audience of the viewer of the film on vimeo.

"Radikal Karaoke" has a somewhat different relation between performer and audience, although the sample video on vimeo is similar in structure to "Aurelia," in that it involves Gache reading a text while a variety of images succeed each other on the screen behind her. While "Aurelia" uses a game to make a film, "Radikal Karaoke" uses a film to propose a game – albeit a game that is defined by 1960s sing-along technology. It is, of course, the idea of karaoke that makes this a poem of a particular sort – the oft-denigrated effusions associated with popular music and half-familiar lyrics.

This project takes as its point of departure the technological interface of teleprompters and television cameras that mediate contemporary political speeches, as well as our expectations about the respective roles, body language, and interactions of the political performer and her implicit audience. In this case, while the video shows Gache reading one of her randomly generated

FUNGIBILITY AND THE INTERMEDIAL POEM 229

speeches, the invitation is less to watch the video in a solitary experience with our computer, smartphone, or tablet than to see it as a prompt to enter the game itself and to play it ourselves, implicitly, as with musical karaoke, in the company of friends, who would be actually present in the same physical space rather than occupying, as in "Aurelia," the shared space of a MMORPG.

If one context for "Radikal Karaoke" is certainly the immediation of political demagoguery, Gache's experiment both looks back to the net activism of the mid-1990s in the format of its overt political critique, as well as forward to a more contemporary context, involving awareness of increasingly use of technology for surveillance, as well as a later generation's greater experience and comfort with the many forms of screen interaction. The poetry here would be located in some intersection of the audio/visual, the performative, rhythmic repetition of nonsensical phrases that somehow still sound like demagoguery, and algorithmic-based variation on Mallarmé's throw of the dice to generate text.

The audience that would be drawn to Gache's work is necessarily familiar to some degree with gaming culture (though we may not necessarily be gamers), and the way in which paranoia and screen addiction chase each other in Western popular culture. One marker of this cultural change comes by way of what Penix-Tadsen ironically calls "a remarkable milestone" in the portrayal of Latin American history and culture in fall 2010 with the release of *Call of Duty: Black Ops,* the most profitable premier in the history of media in any form, far exceeding any popular film release.[2] At the same time, as Jones reminds us: "we now, in an era of total security, conventionally understand any comparison of reality to video games as an ominous metaphor for techno-hegemony" (271). Gache reproduces this sentiment almost exactly in her descriptive blurb about the "Radikal Karaoke":

> Today, politics worldwide is almost exclusively devoted to rhetoric. Speeches are structured on emphatic and demagogic formulae and linguistic clichés reproducing themselves as viruses. By mechanically repeating slogans we have turned ourselves in[to a] zombie society. ... While in the early twentieth century, politics made extensive use of new technologies such as radio and [loud]speakers to reach the masses, today it uses teleprompters, podcasts and social networks to reach its goals. RK aims to interrogate

[2] The 2010 edition of the game is partly set in Cuba, involving an opening mission to assassinate Fidel Castro. To set the context: according to Penix-Tadsen's figures, the most successful blockbuster film release to date earned $239 million dollars in its first week. *Call of Duty: Black Ops* brought in $360 million on its first day, garnering $650 million in its first five days, and over a billion dollars in six weeks (174). Penix-Tadsen also reminds us of the material conditions for the assembly of these games, often involving maquiladoras in Mexico and Central America (177).

hegemonic discourses. It works with the permanent contrast between utopia and commonplace; revolutionary spirit and scam. These multimedia pieces are constructed departing from a fixed verbal structure incorporating random texts. Nonetheless, voice and body are here inescapable.[3]

In some respect then, Gache looks both to a nostalgic construction of a less clichéd, less mediated relation of body and voice, politicians, and the polis, where noxious media effects are deconstructed, if not canceled out. Thus it is important that the karaoke project, unlike the *Second Life* film, ideally brings in analogue subjects operating in three-dimensional space, in the presence of other analogue subjects. At the same time, the very format of the page and the interface points to an inevitable process by which we are becoming digital subjects (her own videos provide evidence of this evolution) interacting within virtual environments. Gache's project, then, with its multifarious richness and unavoidable contradictions, offers an instance of the process of intermediation that Hayles sees the defining feature of the posthuman, by which functions and modes of categorization become understood as media effects (*My Mother* 7). And yet, for Gache, as for Hayles, the intermediation must always come back to an embodied presence, if not hers, then that of one of the proxy users.

The randomly generated text of "Radikal Karoake" points to other chance-based work, often reliant on algorithms that recombine existent text of the most varied provenance pulled up by search engines and turned into found poetry. Karen Villeda (Mexico, 1985–) is an up-and-coming poet, who has already amassed a significant reputation with poetry translated into English and Portuguese, and publications in Argentina, Brazil, Colombia, Spain, Guatemala, Venezuela, and the United States (she has recently been a fellow at the prestigious Iowa creative writing program). Her body of work ranges widely, though each of her projects is marked as a poem of some sort, generally framed within and speaking to a longer literary/poetic tradition. Thus, for instance her *Babia* evokes the three-dimensionality of Campos' experiments with fold out paper; "Paisaje áereo" (Aereal Landscape) is a close up examination of a piece of chewed gum, filmed as if it were a view of planets in space and speaking within a history of net.art projects; *Dodo*, her most commercially successful project, is both a stop-motion video and a children's book, aggressively defined as a poem.[4] Her earliest project, *Tesauro* is mostly text-based, including mul-

3 The English is from Gache's website (http://belengache.net); clarifications come from reference to the Spanish version in *Instrucciones de uso* that reproduces almost exactly the same text (54).

4 For example from her website: "Ha merecido, entre otros reconocimientos, el Premio de la Juventud de la Ciudad de México 2014, el Premio Bellas Artes de Cuento Infantil 'Juan de la Cabada' 2014, el Premio Nacional de Poesía Joven 'Elías Nandino' 2013 por *Dodo*, el Primer Premio de poesía de la revista 'Punto de Partida' 2008 y

FUNGIBILITY AND THE INTERMEDIAL POEM 231

tiple hidden hypertext links, and frequent animated text movement. She says that this book:

> Es un itinerario exhaustivo de formas poéticas contemporáneas. Me obsesionaba ampliar la colección de los versos de mi libro y llevarlos a la pantalla como una forma poética más, así que opté por yuxtaponer los textos a manera de las listas de un tesauro –que es una red de palabras y sus conceptos– para tener un itinerario de una lectura de tantas posibles. Me interesaba fomentar un nomadismo estético del usuario recipiente impulsado por lo aleatorio y que evadiera lo restrictivo de la página impresa, como las búsquedas en Google, las asociaciones con YouTube, las paráfrasis a partir de páginas web ya existentes, con la finalidad de ampliar el *Tesauro*.

> Is an exhaustive itinerary of contemporary poetic forms. I am obsessed with amplifying the collection of poems in my book and bringing them to the screen as another poetic form, so I opted for juxtaposing the texts in a way similar to the lists in a thesaurus – which is a network of words and concepts – in order to have an itinerary of one reading among many possible readings. I am interested in promoting an aesthetic nomadism in the receiver/user who is compelled by the aleatory and who avoids the restrictions of the printed page, like a Google search or related links in YouTube, the paraphrase based on existing webpages, all with the goal of enlarging the *Thesaurus*.

These are obsessions that she carries forward in more extreme forms in "Poepedia," which draws random bits of text from Wikipedia, and "Poetuitéame," which gathers reader tweets by way of selected hashtags in which the resulting clusters of tweets are presented as the poems.

In these two later projects, she reconceptualizes another avant-garde concern by using only existing pages and junk code; nothing here is "original" except for the concept and the aesthetic impulse that brings them together. Like earlier avant-garde art works based on "recycled" materials, these projects are digital ready-mades, where old junk bits of code and random text are equipped with new functions and parameters.

In her decision to mine Twitter, Villeda also expresses a self-reflexivity about her poetic process by drawing attention both to the material and the technology by which her works have been created. In works like these, even more forcefully than in earlier, simpler experiments by Campos, Uribe, or even Gache, the poet essentially posits that the artificial generation of aesthetic texts through coding can convey a poetics detached from semantic meaning,

el IV Premio Nacional de Poesía para Niños 'Narciso Mendoza' 2005." (I have been awarded, among other recognitions…[followed by a series of prizes].)

eliminating the subjective aspect of poetry, and shifting the aesthetic interest entirely into the purely computational realm. Says Schaffner:

> Perhaps the most important aspect of combinatorial and chance-determined works is the surprise moment: the results of chance productions are unpredictable, they display features which astound even the artists themselves. Chance is effectively deployed as a tool to transgress the subjective powers of imagination, to go beyond the producer's limits of comprehension in an attempt to arrive at results which transcend both cultural, psychological and intellectual boundaries. (Schaffner "Concrete to Digital" 11)

If there is a historical relation to concrete poetry in work like this, it is a distant one, and our reading strategies need to evolve accordingly. In considering works like these, Rita Raley calls for a new type of reading, a new type of analysis acknowledging the semantic significance of spatial design and taking into account the extension of poetic space into the third dimension. She argues that interpretation of those works that integrate the z-axis into their repertoire "requires a fundamental reorientation of spatial perspective," and new critical framework for their analysis – a literal rather than merely figurative "deep reading." She calls this a "volumetric reading" that takes into account all three axes (x, y, and z), "reading surface to depth and back again."

To return to the yearning for a technology-yet-to come that Walter Benjamin intuits and Augusto de Campos locates in the nineteenth-century French forerunners of concrete poetry, the chance-based kinetic poetry of artists like these are actualizing the promise of Mallarmé's dice throw and freeing it from the limits imposed by paper. N. Katherine Hayles notes:

> These works are especially appropriate because they reflect on the materiality of their production. In digital media, the poem has a distributed existence spread among data files and commands, software that executes the commands, and hardware on which the software runs. These digital characteristics imply that the poem ceases to exist as a self-contained object and instead becomes a *process*, an event brought into existence when the program runs on the appropriate software loaded onto the right hardware. The poem is "eventilized," made more an event and less a discrete, self-contained object with clear boundaries in space and time. (181)

It is, she says, a "flickering signifier," more of a temporal process than a durable work.

Where does that leave us, the reader/spectator/participant in digital poetry? Where does it leave the poet? Yves Citton tells us that: "To read is no longer only to decipher, nor merely to reconstruct or deconstruct, but also to reuse, reshape, and overcode. The recontextualization that in the age of interpretation altered the meaning of the text (its content) now reconfigures

FUNGIBILITY AND THE INTERMEDIAL POEM

its signs (its form)" (744). In an article on the digital rhetoric of surface and depth, Schaffner and Roberts put pressure on familiar metaphors reminding us of their updating in a computer age: "the 'screen' used to be something designed to hide, but is now something which discloses (but hides as well?); 'windows' used to be something one looked through are now surfaces one looks at."

Beiguelman recalls the Benjaminian framework of an art before mechanical reproduction, in which memories were archetypally stored on paper, which could become brittle, fade, burn, get eaten by insects, or dissolve in a flood and be lost forever. She contrasts this history with the effect of digital ruins, where we imagine that everything is preserved on a server somewhere, but where in fact memory is something you buy on stick, transfer, delete, lose. Even for memories secured online, there are glitches, browser errors, web crashes, wifi outages, system errors, software obsolescence, 404 errors. She asks: "How to deal with memories so unstable that they become depleted together with the lifespan of our equipment, and whose different types do not correspond to the cataloguing models used by museum and archive collections? What memories are we building on networks, where the more immediate present seems to be our essential time? These are questions that artists are asking themselves."

While I have been focusing on poetic projects that are mostly still accessible to readers of this chapter, the challenge framed by their potential inaccessibility is real, as shown by the example of Gache's "El jardín de la emperatriz Suiko," which was lost for several years before being resolved in a new edition. Likewise, Villeda's "Laboratorio de ciberpoesía" (Cyberpoetry Laboratory) is now available only in archival form, and clicking on the original Gruszinski and Capparelli web address will lead to a 404 error. This presents one kind of problem for the poet, but a different one for the scholar of poetry, where normatively the conditions of scholarship themselves privilege, if they do not actually require, durability, and much of our work is conditioned by an expectation of mass reproducibility.

There is no archive system that can appropriately reproduce an evanescent poem or restore a video that has been taken down (as is the case, for example, in the Sagrado Sebakis video I briefly mentioned in my opening comments). The Sebakis video exists now as a strangely archival and isolated object, downloaded several years ago housed on a single machine (my personal computer) rather than distributed across the world wide web. Likewise, for the many digital productions dependent obsolete software or previous versions of operating systems, even if I were to download and reinstall all the appropriate software, rejigger an operating system to run it, it would be a different project, still interactive, but no longer shared. This is a problem even for text-based work, as we all know from disappearing pdfs of academic articles published online – the reason I had to update all the urls for articles I read for this study (I could

234 DEBRA ANN CASTILLO

now only access Raley through the internet archive's Wayback machine, for instance), and also the reason for the development of the DOI (Digital Object Identifier) system to provide a solution for this familiar problem. DOI offers journals and authors a "technical and social infrastructure for the registration and use of persistent interoperable identifiers, called DOIs, for use on digital networks" (DOI). [5]

Many concerns link the poets of the historical avant-garde to Hayles' flickering signifier, passing through the celebratory modes of digital poetry on their way to the impossible archiving of this massive production, and the apocalyptic undertone of a worry about its inevitable obsolescence. For thinkers like Hayles and Beigulmann, this imminent disappearance is a constituent part of a digital epistemology, the "flickering" quality or the "ruinology" of the art works that needs to be taken into account in our digital aesthetics, is a crucial part of the reading, the overcoding, of a work of art that can only exist in a fungible trace across a screen, and that may not be recoverable tomorrow. And that, to return to another poet whose work I only briefly referenced in the opening paragraph of this chapter, is perhaps the point. While Basia Irland archives images of her ephemeral art on her webpage, there is no pretense that this is the work itself. Some things are meant to be fleeting, and in this sense the fungible trace of the interactive poem offers an aesthetic experience that is perhaps closer to a dance than it is to the printed word. That is a generic constraint, and part of its pleasure, rather than something to mourn.

[5] Digital archives like the Rose Goldsen archive of new media art at my institution, Cornell University, are intended to respond to precisely this challenge of fungibility and shifting platforms.

18

Hypertext and Biculturality in Two Autobiographical Hypermedia Works by Latina Artists Lucia Grossberger Morales and Jacalyn Lopez Garcia[1]

THEA PITMAN

I first discovered the work of Lucia Grossberger Morales and Jacalyn Lopez Garcia in 2010 in the course of my research on Latin(o) American digital cultural production. Inevitably, I found their work via a Google search whose terms I can only faintly recall – I think I was looking for materials to do with cyberfeminism and/or the discourse of *mestizaje* (racial and cultural mixing). I could see from what I found – their artists' websites and links to individual projects – that lots of their work fitted under the rubric of digital art, and some of it also had an autobiographical narrative component. The projects selected for study in this chapter, Grossberger Morales's *Sangre Boliviana* (1994)[2] and

[1] This chapter is an adapted version of Pitman's "Hipertexto y biculturalidad en dos proyectos autobiográficos de las artistas latinas Lucia Grossberger Morales y Jacalyn Lopez Garcia" (*Revista Laboratorio*, 13). The translation of the original article into English and all translations from primary and secondary materials published in Spanish used in the work are Pitman's, unless otherwise stated. Neither artist chooses to write her name with the accents that it would normally have in Spanish. This choice has been respected throughout this chapter.

[2] The work is deliberately written using both Spanish and English (see Grossberger Morales' comments on this subject in her chapter in this volume). Given the importance of not translating the Spanish text in the work to Grossberger Morales, we have conserved the title throughout this chapter in its original Spanish, and with its original (anglicized) capitalization. It means "Bolivian blood" in English.

Lopez Garcia's *Glass Houses: A Tour of American Assimilation from a Mexican-American Perspective* (1997), are really fascinating early incursions into hyperlinked forms of digital art/literature (more precisely, they are hypermedia narratives), intended for distribution and exhibition either via CD-ROM or via the Internet itself.

While "many authors use the terms 'hypertext' and 'hypermedia' interchangeably" (Schoonmaker), hypermedia refers more specifically to "a method of structuring information in different media" where those different "chunks" of media are "connected in the same way as a hypertext" and its particular "hyperlinking" function that connects different textual "lexia" (OED, qtd in Schoonmaker). Both concepts were coined by Ted Nelson in the 1960s. Today, hypermedia forms the lifeblood of the Internet, though most criticism still tends to discuss "hypertext" as the overarching paradigm, in reference to the Hypertext Markup Language that underpins all such materials.[3] Both hypertext and hypermedia may link materials so as to convey a narrative arc, or at least loose paratactical relationships that the reader/viewer must actively try to decipher (cf. Sorapure).

It is in this exclusively digital sense that I originally set out to explore these works' "multimedia" nature. Indeed, in purely digital terms, the fact that they combine different media is quite inconsequential. As Jean-Pierre Balpe notes, "Today a large number of artworks are regularly produced with computers and digital tools," one of the consequences of which is the marked tendency that "these works are multimedia," combining a wide variety of different textual, graphic, and audiovisual materials. Nonetheless, Balpe goes on to argue that, "more interesting is that today all these perceptive differences are only appearances and that, in fact, in a hypermedia work they all belong to the same system of digital codification" (245). He goes on to suggest that what is of more consequence in the study of such works is the way that the hyperlinking works, the possibilities that it affords the creator, the effect that it has on the reader/viewer, rather than any study of their multimedia nature per se. Thus, while in my study of Grossberger Morales and Lopez Garcia's works, I have referenced the combination of different media in the work by means of hyperlinks, and/or the conjunction within any individual "lexia" or "screen" of the work of digital paintings, photography, text, music, Flash animations, and so on, my overarching goal was, however, to understand more about how the new affordances of hypertext to structure such different (digital) materials might allow *mestiza* artists to better represent the complexity of their intersectional identities, their lifestories.

3 For more on "hypermedia narratives" in the context of Hispanic literature, see Chiappe, Pitman, Pano Alamán, and Romero López.

Given this focus, I largely left to one side the fact that some of the digital art was also designed to be run on computers embedded in interactive shrine-like installations, or projected onto moving displays on gallery walls (Grossberger Morales's case), or that the artists saw themselves and their remit as going far beyond the creation of work with new technologies alone. As Lopez Garcia notes,

> An integral aspect that is common in my art involves integrating technology and diverse artistic practices to create reflections of the past and to explore new understandings of the present. […] I enjoy integrating traditional and non-traditional artistic practices (photography, computer art, music, poetry, short stories and video) because they serve as catalysts of memory that allow me to conjure up a variety of social and cultural contexts. ("About the Artist," *Life Cycles*)

For the purposes of the current volume, I have chosen not to try to add on much in the way of "extra layers" to my original analysis of the artists' early hypermedia works in order to embrace the full extent of their multimedia nature, nor to update them to look at the more recent iterations of the works studied that both artists have since produced, nor even to draw in exciting new projects combining digital and analog materials – I could have mentioned Lopez Garcia's *In Search of the Mago* (2010), an interactive website and performance-based multimedia project using social media, or Grossberger Morales's *Love Notes for the Planet* (2018), an interactive performance piece where participants all over the world send in "love notes" electronically to be used in gallery-based performances.[4] Instead I propose this study of pioneering hypermedia works as providing examples of specifically digital multimedia cultural production that may serve as a counterpoint to the more analog or mixed analog/digital multimedia works studied elsewhere in this volume.

In terms of the relationship of hypermedia works to the other key terms used in this volume such as intermedia and transmedia (see Introduction), while the different media within a hypermedia work may ultimately only present an illusion of multimediality (cf. Balpe), if we accept the illusion at face value, what we have are works that quite often combine different media – text and image, for example – within a single "lexia" or "screen" and as such offer a form of "implicit" or "explicit" intermediality (see Introduction). What they do when they keep individual media in separate "lexia" that are then hyperlinked is rather different, and this may perhaps be conceived of as a particular form of transmediality. For the sake of clarity, however, my focus in this chapter remains on the specificities of hypertext/hypermedia and what new

4 Both Grossberger Morales and Lopez Garcia discuss these more recent projects in their chapters in this volume.

THEA PITMAN

possibilities such digital linking of chunks of text and/or other media may afford the artists in question in terms of their exploration of their bicultural identities.

THE AFFORDANCES OF HYPERTEXT

> If feminists and allied cultural radicals are to have any chance to set the terms for the politics of technoscience, I believe we must transform the despised metaphors of both organic and technological vision to foreground specific positioning, multiple mediation, partial perspective, and therefore a possible allegory for antiracist feminist scientist and political knowledge. (Haraway, "The Actors Are Cyborg" 21)

A number of critics have identified hypertext as ideally suited to conveying the complexities of (typically postcolonial) experiences of living with/between two or more cultures, homelands, temporalities, belief systems, aesthetic sensibilities, and so on. Because hypertext, and by extension hypermedia, offers a "non-linear, multivocal, open, non-hierarchical aesthetic involving active encounters that are marked by repetition of the same with and in difference," Jaishree Odin argues that it "is most suited for representing postcolonial cultural experience because it embodies our changed conception of language, space, and time." By means of a hypertextual aesthetic, postcolonial artists/authors can "use strategies of disruption and discontinuity to create visual and textual narratives that are multilinear and where meaning does not lie in the tracing of one narrative trajectory, but rather in the relationship that various tracings forge with one other," thereby "escap[ing] the homogenizing and universalizing tendency of linear time." Indeed, for Odin hypertext and postcolonial are synonymous terms identifying the aesthetic form most suited to representing "the perpetual negotiation of difference that the border subject engages in."

In his seminal series of works – *Hypertext* (1992), *Hypertext 2.0* (1997), *Hypertext 3.0* (2006) – George Landow notes from *Hypertext 3.0* onwards that he owes a debt of gratitude to Odin for making the convergence of hypertext and the expression of postcoloniality clear to him through the above-mentioned essay that she submitted for publication on a website of his entitled *The Postcolonial Web* (also known as *Contemporary Postcolonial and Postimperial Literature in English*) in the mid-1990s. He reiterates her arguments, in this case positioning hypertext as a paradigm rather than as a synonym for postcoloniality:

> The value of hypertext as a paradigm exists in its essential multivocality, decentering, and redefinition of edges, borders, identities. As such, it provides a paradigm, a way of thinking about postcolonial issues, that continually serves to remind us of the complex factors at issue. (*Hipertexto 3.0*, 356)

HYPERTEXT AND BICULTURALITY

In a specifically Latin American context, the debate moves away from the convergence of hypertext and the postcolonial *per se*, to the value of hypertext to capture the multiple and/or hybrid nature of Latin American-ness – an unsurprising move given the reluctance to self-define as postcolonial in the region. For example, the academics Gabriela Coronado and Bob Hodge specifically identify Mexico's "multicultural" *mélange* as a "hypertext" in the title of their book, *El hipertexto multicultural en México posmoderno: paradojas e incertidumbres* (2004). And in a more theoretically sophisticated example, the eminent communications studies scholar, Jesús Martín-Barbero, has argued that, despite his expression of serious misgivings about the potential "disembeddedness" of digital cultural production, hypertext (specifically as a form of literature) can offer a vehicle through which to express particularly Latin American sensibilities:

> Such a transformation [of the written word] encourages an opening out of conventional time which is tied up with official memory, and generates an explosion of temporal continuity in history and fiction, undoing both time and space, making them reversible by detaching their temporalities and the geography of their borders and languages. (xiii)

Nevertheless, the relationship of hypertext and multicultural and/or postcolonial experiences has been perhaps somewhat overstated, particularly in Odin's case where hypertext and postcolonial are deemed to be synonymous. (Landow and Martín-Barbero are arguably more cautious.) As noted in the introduction to *Latin American Cyberliterature and Cyberculture*, "Such a formulation, mapping postcolonial and hypertexual aesthetics onto each other, may be overly optimistic in that it sidesteps aspects of both content and context, as well as avoiding issues of access" (Taylor and Pitman 18).[5] It is quite manifestly the case that hypertext can be used for all sorts of political and/or commercial projects as seen in the ubiquitous deployment of HTML online – indeed, many have feared the rampant growth of the Internet, facilitated by its seemingly universally intuitive hypertextual architecture, precisely because of its potential to impose US culture and values on less dominant groups the world over (see, for example, in a Latin American context, Monsiváis and Trejo Delarbre).

One form of narrative that has boomed with the advent of the Internet and its hypertextual structuring has been life writing, with a shift from the design of discrete "homepages" in the mid-1990s to "blogs," often hosted on large blogging platforms, from the late 1990s onwards. The critic Madeleine Sorapure also notes the hypermedial and ludic nature of some of the most successful of these online life-writing projects:

5 Other critics associate hypertextual forms more readily with the fragmentary, aleatory, non-totalizing nature of postmodernist frameworks for self-representation (cf. Sorapure 499).

240 THEA PITMAN

> In its structure, the online diary might be usefully compared to hypertext fiction [...]. Those online diaries that integrate photographs, illustrations, animation, audio, and other forms of multimedia might be discussed in terms of autobiographical art or performance. As a computer-based mode of expression and interaction, online diaries might be compared to MUDs [multi-user domains, or dungeons] or online role-playing games. (509)

There is thus quite often a slippage in any study of such works between the designations of author and artist (even designer) with many being the work of people who normally self-identify as artists.

Grossberger Morales and Lopez Garcia both authored/created autobiographical hypermedia projects in the early 1990s, and, despite the caveats noted above regarding the potential dangers of hypertext in a Latin(o) American context, identified its new expressive possibilities as most suited to their need to explore their own identities. As Sopradure notes in her conclusions on the boom in the writing/designing of online diaries, more "[R]esearch focused on age, gender, class, ethnicity, native language, and disability in autobiographical writing on the Web" (510) needs to be conducted with a view to identifying what difference this makes to "how people interact with and represent themselves via these new technologies of writing and publishing" (510). This chapter breaks new ground by offering just such a study, focusing on the intersection of ethnicity and gender in these artists' hypermedia explorations of (specifically gendered) biculturality. It considers the artists' express intentions regarding the representation of gendered biculturality in their works and how, in their view, a hypertextual[6] (and possibly also networked) medium is most suited to this. It also examines the various tropes they use to "visualize" their expression of gendered biculturality, particularly with regards to their pertinence to the new media in which they are working and how they seek to resemanticize extant tropes of new media through dynamics of "domestication" and/or "indigenization."

THE ARTISTS[7]

Lucia Grossberger Morales was born in Bolivia in 1952 and emigrated to the United States in 1955 as a result of the Bolivian Revolution. She describes herself in her book of reflections on her artistic trajectory *On the Bridge: Between*

6 Both artists tend to talk about hypertext rather than hypermedia, although in both cases what we are dealing with is, indeed, hypermedial in nature.

7 See chapters by Grossberger Morales and Lopez Garcia elsewhere in this volume for more extensive reflections on their life experiences, their understandings of their own identities, and the relationship of life experiences and understandings of identity with their creative work.

Bolivia and Computers (2009) as one of "the first Latina digital artists" (92).[8] She sold her own house in 1979 to buy her first computer – an Apple II – and became a pioneering designer for Apple and other companies. She is the co-author of the painting and/or design programs *Designer's Toolkit* (Apple, 1982) and *SpaceLace: An Interactive Kaleidoscope* (Great Wave Software, 1987), among others, and she notes that her objective was precisely to try to create a way of expressing herself "digitally" that would capture the combination of her ethnic otherness with her female gender (Grossberger Morales, "Bio," *Cyber chica*, artist's website). She writes: "Much of Lucia's work deals with cross-cultural issues and the experience of being an immigrant and a woman" ("Bio"). As such, where other Latin Americans have complained that digital technology and the Internet respond to a specifically North American worldview and that "there is no Latin American *language* in which to express our specific content in that global hall of mirrors that is the Internet" (Trejo Delarbre 330; original emphasis), Grossberger Morales made an important step towards inventing the kinds of language/software that she felt were necessary to express herself (as an artist primarily, but also as a Bolivian-American and as a woman). She thus provided an *avant la lettre* response to Argentine critic Silvia Austerlic's exhortation of Latin Americans "to invent, identify and define our own principles of technological design" (glossed in Rueda Ortiz 2005).

A key theme in Grossberger Morales's work is the digital remediation[9] of traditional Andean popular cultural production, particularly weaving, as seen in works such as *Pallai: Digitally Weaving Cultures* (2004) and "Khuritos Infinitos" ("Infinite Khuritos"), part of her *Lightbox Mágico* (*Magic Lightbox*) exhibition (Cochabamba, Bolivia, 2009).[10] That said, and despite the cyberfeminist appeal of a concept such as online "netweaving,"[11] most of Grossberger Morales's work, even that which is based on a hypertextual framework, is

[8] *On the Bridge* is now available in an updated version as *Weaving Art with Computers* (2014), as referenced in Grossberger Morales' chapter in this volume. All references to *On the Bridge* in this chapter are to the 2009 edition.

[9] Remediation is a term coined by Bolter and Grusin to refer to the transfer of material in one form of media to another.

[10] *Pallai* or *pallay* is a Quechua term for a particular form of weaving made on a backstrap loom, and also for the typical designs that appear on those weavings. *Khurito* means "little wild thing" or "little monster" in Quechua. See Grossberger Morales' chapter elsewhere in this volume for further detail.

[11] Haraway argued in "A Cyborg Manifesto," a work that started circulating in early versions from the mid-1980s, that, as opposed to corporate networking, "weaving is for oppositional cyborgs" (170). The use of the term "(net)weaving" to name an alternative gynocentric form of socialization has since circulated in much cyberfeminist discourse (see, for example, Wakeford 356–57; or Escaja's interview with Grossberger Morales where she writes, "Hispanic women on the web weave,

designed for "properly" multimedia installations in art galleries where the digitally remediated weavings are viewed on computer screens embedded in artisanal popular Catholic home altars or projected onto the walls and ceiling of the exhibition space for a more fully immersive experience.[12] That is to say, it is not really designed for circulation online. Her website – *Cyber chica* (*Cyber Girl*) – has been online sporadically since 2004 and it has mostly functioned as an advertisement for her offline exhibitions, showcasing only modest amounts of her work, rather than as the portal that gives access to the artworks themselves.[13]

Jacalyn Lopez Garcia was born in the United States in the early 1960s, the daughter of first-generation Mexican immigrants. While her main artistic medium is digital photography, having retrained in the discipline as a mature student in the early 1990s, she describes herself on her website as a "multi-media/artist/storyteller" ("About Jacalyn," artist's webpage), thus evidencing the blurring in her work between (digital) art and literature. In terms of her bicultural identity, she describes herself as "an American multimedia artist of Mexican heritage who was born in Los Angeles, California [and] raised in middle-class neighborhoods of various suburbs of Southern California" (Lopez Garcia, *From the Garden* – Artist Statement, artist's webpage). In fact her family went from poverty in Mexico to a middle-class suburban California lifestyle in just a generation (although not without substantial difficulties) and Lopez Garcia is at pains to capture the way in which her parents encouraged her to seize what they saw as the substantial opportunities afforded by assimilation, nuanced by her own trajectory through feelings of Mexican-ness as a child, to an assimilationist stance as a young adult, to a more radical Chicanista stance from the 1990s (*Glass Houses*). Another of her major projects that seeks to explore the experience of immigration and assimilation is *Life Cycles: Reflections of Change and a New Hope for Future Generations* (2006); a portraiture project, sponsored by the California Council for the Humanities as part of their California Stories Initiative. *Life Cycles* documents the experience of seven immigrant and migrant farm worker families in the Coachella Valley, California; a neighborhood where newly arrived immigrants gain a first foothold. Nevertheless, the project narrates a geography of social mobility

modulate and code. Often working at the intersection of tradition and technology" [my translation]).

[12] Despite the obvious relevance of this multimedia dimension of Grossberger Morales' work for the current volume, my experience of her works has been exclusively in their online manifestations and my interest remains in the affordances of hypermedia narrative for the conveyance of her views on issues of identity.

[13] Since 2013 Grossberger Morales has also had a website which simply bears her own name as its title.

HYPERTEXT AND BICULTURALITY 243

which, sounding a note of quite some optimism, demonstrates how quickly some families achieve successful acclimatization in the United States.

With respect to her articulation of identity in her more autobiographical work, Lopez Garcia defines herself as "a Chicana who depicts the Chicana(o) lifestyle from a perspective that is uniquely different from the inner city and migrant farm worker experience" (Lopez Garcia, artist's profile, *Latina/o Art Community*). This particular perspective is encapsulated in the image of the (white) American suburban house; the kind of house that is the subject of her *Chicanolandia* digital print (1999) or the public art video animation project *Living Large* (2004), created together with Lucy H. G., which explores the frustrations of getting a foothold on the property ladder in Southern California. This focus on the image and the concept of the suburban house in her work is what Lopez Garcia uses to explore what gendered biculturality means to her.

SANGRE BOLIVIANA

Grossberger Morales's *Sangre Boliviana* is a hypermedia work which was originally designed for distribution on CD-ROM and made partially available online.[14] These days we might find it to be very simple in terms of its hypermedia aspects, but we need to bear in mind that Grossberger Morales started the project in 1991 and started exhibiting it from 1992.[15] It cannot be emphasized enough how much this is a pioneering work in the field of hypermedia narrative. In its fragmentary version available online until 2013, the first screen comprises a digitally painted image of the Virgen de Guadalupe de Sucre and offers links to a series of "topics" or "chapters" that the reader can explore without any fixed order: these "chapters" are "Intro," "Mamitalla,"[16] "Emigrating," "Gringa"[17] and "Dream" (reading them counter-clockwise from the right). One of the original chapters that does not appear in the online version was called "Cholera '92: An Arcade Game" and was an interactive

[14] The CD-ROM version of the work has been recently acquired by the Bibliothèque Nationale de France and will be preserved in this format. A partial animated version of the work was available on Lucia's *Cyber chica* website until 2013. Stills from the original work are now available on her refreshed *Cyber chica* website.

[15] In fact she continued working on the project until 2002, but the lion's share of the work was completed between the early and mid-1990s.

[16] *Mamitalla* is a common Quechua interjection meaning "little sweet Virgin" (Rindstedt and Aronsson 733).

[17] This term refers to the way Bolivians saw Grossberger Morales on her visits to her country of origin. After a childhood spent in the United States she was deemed culturally "white" or "Americanized."

game where the player had to shoot at a target that exploded as if it were "diarrhea." The chapters that were made available online were all Flash animations combining pictures, short fragments of text and music that the viewer/reader could explore one after the other, but they did not themselves offer any different pathways to choose from or other possibilities of interactivity. The structure was, as noted above, really quite simple.

Among the chapters there are some that offer basic factual information about the traditions of the Bolivian Andes, foodstuffs, indigenous beliefs, and so on. Others offer narrative fragments of a more clearly autobiographical nature regarding Grossberger Morales's experience of immigration in the United States, her various return journeys to Bolivia as a teenager and adult, and her attempts to juggle the competing cultural influences in her life. As Grossberger Morales has noted, the texts are kept short and poetic, with words being animated in a "technopoetic" remediation of the techniques of Brazilian concrete poets such as Augusto de Campos and others; they also demand bilingual abilities of the viewer/reader as Grossberger Morales sought to replicate her bilingual, bicultural experiences for the reader and refused to narrow things down to just one language. The aspect of the work that most interests me here is Grossberger Morales's attempt to elaborate constructive metaphors for her biculturality which are, furthermore, particularly resonant with the work's hypertextual design (and subsequent partial circulation online). Some of these metaphors also offer (tacit) revisions of the standard, more "masculinist" terminology associated with the way people interact online, such as "networking." They are thus particularly well chosen for expressing a specifically gendered bicultural experience through hypertext/media.

The first set of metaphorical references hinges on the concept of "weaving." Grossberger Morales signs *Sangre Boliviana* as "woven by Lucia Grossberger Morales". In *On the Bridge* she explains:

> I intentionally chose the word "woven" for three reasons. First I am weaving stories together in multimedia. The stories have threads as well as the different threads of multimedia. The second reason is that the word "woven" refers back to the roots of the computer, the [Jacquard] loom. And, finally, there is my passion for Bolivian weavings, which often tell the stories of their culture. (48)

Although, Grossberger Morales does not explicitly offer, in her comments above, a feminist interpretation of her choice of metaphor, her preference for this term is difficult to disassociate from the prevalent discourse regarding the possibilities of "(net)weaving" in much cyborg- and cyberfeminist work that followed on from Haraway's "Cyborg Manifesto." Nevertheless, what Grossberger Morales gains by muting the feminist reading of her references to weaving is an enhanced appreciation in the reader/viewer of the way in

HYPERTEXT AND BICULTURALITY

which her use of weaving as a metaphor seeks to "indigenize" the concept of hypertextual design, thus emphasizing its suitability for her particular narration of bicultural experiences.

The second metaphor that works alongside that of "weaving" is that of the "bridge." Grossberger Morales conceives of herself as balanced on a bridge between her competing cultural backgrounds. While in the online version of *Sangre Boliviana* (available until 2013), perhaps in response to the postcolonialist vogue in the manner of Homi Bhabha for discussions of (happy?) hybridity, the subtitle of the work describes it as "An Exploration of Being a Hybrid," in *On the Bridge*, she argues more subtly that:

> I am not a hybrid, I am an artist processing the conflict between my two cultures. Finding a place to stand is my inspiration, as I search for the techniques, images and words so my two cultures can live together. I believe my art lives precariously on that bridge, telling my stories of Bolivia, using digital tools. Therefore I have finally changed the subtitle to: "Living on the Bridge." (47)

Here, again, it is interesting to note the tacit feminist reading possible of her choice for the metaphor of the bridge: I would suggest that this may come from the way the term has been used by Chicana feminist writers who position themselves as "bridges" between different strands of feminist thought: "First," "(US) Third World," "Transnational" (cf. Cherríe Moraga and Gloria Anzaldúa and their collection *This Bridge Called My Back* [1981]).[18] Nevertheless, the further suggestiveness of the bridge metaphor in hypertextual terms – links between discrete lexia are, after all, a kind of bridge – make it all the more appropriate for its resemanticization by Grossberger Morales.

What unites these two different spheres of metaphorical references is first the fact that neither seeks to envision a bicultural identity as "a new essence" or a linear progression towards a finished state, but rather they suggest that it is a fragile, contingent, and constantly reformed configuration of competing influences (or threads). While the "specific positioning" of living "on the bridge" suggests leaving options open, allowing for competing "partial perspectives" and "multiple mediations" like Haraway (see epigraph to "The Affordances of Hypertext" section), in a woven fabric the strands remain distinct. Thus, equally, weaving allows for the dialogue between different "strands" (of culture) but it does not force them into a reductive, homogeneous *mélange*, and this is precisely Grossberger Morales's standpoint with respect to her identity as a Bolivian-American.

As such, the expression of the bicultural identity envisioned by Grossberger Morales is achieved most successfully via multi-layered/non-linear

[18] For further analysis of the "bridging role" of Chicana feminism, see Román-Odio.

hypermedial forms of narrative. She has been quite pointed in her comments on the subject of the suitability of hypertext/hypermedia for the narration of this kind of identity. As she says of her discovery of computers and the possibilities of digital multimedia art:

> Here, finally, was the tool that could express the complexity of my stories; my experiences, not in a strictly linear way, but using *links*, as well as *layering* of images, text, sound and video. Using multimedia I was able to express the conflicts that I felt being bicultural. (*On the Bridge* 47, original emphasis)

Grossberger Morales's work is thus an important early exploitation of hypermedia to tell complex stories of biculturality in a compelling, occasionally visceral, manner, even if it perhaps errs on the side of some (strategic?) essentialism in its contrast of Bolivia (conceived of as "pure," indigenous, traditional, and part of "her blood") with the United States (conflated with high technology).

GLASS HOUSES

Lopez Garcia's *Glass Houses: A Tour of American Assimilation from a Mexican-American Perspective* is an autobiographical hypermedia project designed specifically for the Internet.[19] (Fig. 26) The work offers the reader/viewer the possibility to explore a house: Lopez Garcia's own home. This is, therefore, an extremely personal project. It is one that she worried about pursuing because of ethical qualms about using her own family and its history/memories as her subject, particularly because of the pain provoked by some of those memories, for instance the deportation of her mother back to Mexico occasioned by a false accusation from a neighbor that she was an illegal immigrant (Lopez Garcia, *Glass Houses* – Artist Statement, artist's webpage). Nevertheless, Lopez Garcia ultimately decided that there was an over-riding value, both artistic and political, to pursuing the project and hence this is where she puts her life "on the line," making the private (and painful) public in a way that notably seeks to elicit empathetic responses rather than simply exhibit or commodify.

Once again, we might find the work to be quite simple in terms of today's online hypermedia art, but Lopez Garcia started to design the work in 1995 and finished it in 1997; that is to say, like Grossberger Morales's work, this really is

[19] The title, Lopez Garcia notes, is a reference to the steel and glass constructions for rich Americans on which her father worked when she was a child and that contrast with her family's humble but improving housing solutions – that is to say, alongside a sense of laying one's soul bare for the houseguest, "glass houses" connotes not so much "precariousness" as aspirations.

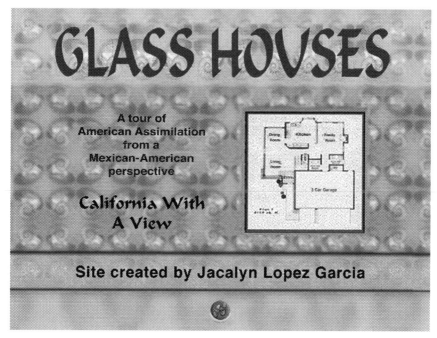

26. Jacalyn Lopez Garcia, *Glass Houses*, homepage.
http://artelunasol.com/glasshouses/.

a pioneering online digital art project.[20] To explore the work, the reader/visitor clicks on the title screen and is taken to a second screen with a welcome letter and a "doormat" which is a plan of the house's layout and instructions on how to explore it. Visitors are told that they are welcome to follow the (limited) links in whatever order they choose, ushered in with a very "Latino" form of hospitality: indeed, the following screen bears the familiar expression in Spanish, "Mi casa es su casa" [lit. "my house is your house"; or "make yourself at home"]. Thus visitors move from room to room gathering multimedia pieces of Lopez Garcia's family history and her personal development through the spectrum of political positions with respect to her understanding of gendered bicultural identity.

Lopez Garcia describes this work as "a vehicle to explore contemporary themes based on the complexities of cultural identity, gender issues, feminist

[20] Lopez Garcia is currently working on a new version of *Glass Houses*, called *Glass Houses: Mi Casa Es Su Casa*. (See her discussion of the updated project in her chapter in this volume.) For the purposes of the current study, I have referred exclusively to the original version of the work because of its status as a pioneer in the field of digital narrative; all quotations and screengrabs used are from that version.

concerns, assimilation, and the fear of becoming disenfranchized from one's cultural roots" (*Glass Houses* – Artist Statement). It is a project that has a quite specific political aim to "create a voice for the 'modern' Chicana living in the suburbs" (*Glass Houses* – Artist Statement), and it is through its exploration of the multivalent concept of the suburban home that it teases out these issues. Does this symbol of assimilation signal opportunity or loss of one's cultural roots? Is this a critique of the dangers of suburbia for Chicanas/os or a suggestion that the "modern" Chicana/o can reach beyond it via the Internet?

A number of critics have written about the way in which the Internet has tended, in many ways, to compound the traditional trap of the suburban home for women. Andrew Wood and Tyrone Adams contend that there is a general "assumption that machines in the modern era have been used to put women 'in their place' – outside the public sphere of work, home alone" (222). Thus computers increase the trend throughout the twentieth century that sees "the modern suburban home" as an isolating, controlling, exploitative, patriarchal construct, "a man-made response to socialist and feminist-collectivist movements of the latter nineteenth century" (Dolores Hayden, glossed in Wood and Adams 222). The creation of homepages and other "homes" online such as Lopez Garcia's *Glass Houses*, can be seen as indicative of the same trend: "In the webbed environment, the metonymic conception of home suggests operational isolation in a theoretical world of community" (Wood and Adams 223–24), where the creators of these sites wait patiently, passively at home for people to visit their sites. They are Haraway's compliant cyborgs. Nonetheless, Wood and Adams argue that a (cyber)feminist approach to this would be to take advantage of the Internet's capacity for reaching out, for "networking," or better still "netweaving," and for revising the tropes with which women conceive of their relationship to new technology.

While Lopez Garcia does not attempt to completely throw out the old patriarchal trope of the domestic home, there is a more positive interpretation of her focus on the image of the suburban home. It is not only a question of seeing the suburban home as aspirational in a Mexican-American context, but in the kitchen Lopez Garcia has a "message center" where she invites visitors to either leave a public message or send her a personal email. Thus, the project offers us some of the new interactive possibilities offered by the Internet, and its goal is to start to create a community that corresponds to the particular experiences of the artist herself. This online community is not just a virtual "interest group" but a community that relates to her offline experiences and concerns and that, through its formation online, can help to address those offline concerns.[21]

[21] In the visitors' book it is evident that the community the project created was mainly made up of other Chicanos/Latinos, as well as other people who identified as

HYPERTEXT AND BICULTURALITY

Glass Houses is, thus, an important work in the context of this study because Lopez Garcia grasps the importance of what hypertext/hypermedia, especially when "exhibited" online, can offer her that other narrative media could not – the possibility to explore an identity that is too complex to be organized through linear narrative and (very importantly) the possibility to create a new community that corresponds to her personal experiences. She explains these two axes of her work in the following passage:

> A major turning point in my art making occurred during the mid 90s when I discovered the Internet had become a new form of artistic expression. [...] Immediately I began investigating the possibilities of creating reflections of the past, while exploring new understandings of the present with the use of new technology (the Internet) and autobiography. [...] I wanted [*Glasshouses*] to be more than just a vehicle for expressing my struggles for personal identity into the public domain of the Internet. I believed I was creating a vehicle that would invite a global dialogue with regard to contemporary themes such as race, class, acculturation, and nationalism [...]. (*Glass Houses* – Artist Statement)

In the first part of the above quotation she gestures towards the complexities of her narrative with respect to questions of temporality; in the second she emphasizes the importance of establishing a "global dialogue" with the community of her creation. She also gestures towards what we might consider to be a "cyberfeminist" perspective in her approach to new technology:

> As a web author I felt motivated to challenge the cold and impersonal environment often associated with the computer. "Is it possible to introduce a private and intimate experience for the houseguest/viewer? Is it possible to offer a critical examination based on the relationship between public and private space with an interactive experience on-line?" It made sense to me that these possibilities did exist after observing (at an art opening) my houseguests that began the tour by selecting the closet, where secrets are hidden [...]. (*Glass Houses* – Artist Statement)

What we have here, then, is essentially a Chicana/Mexican-American cyberfeminist "domestication" of cyberspace, even if it is not without its pitfalls. It does not go as far as Grossberger Morales's work has done in offering alternative conceptualizations of the "despised metaphors" of patriarchal culture and/or new technology, but it does use the Internet to create exactly the

bicultural, and it includes far more women than men. It also includes a mixture of people who already knew Lopez Garcia and/or her work, with others who discovered the work by chance. Elsewhere Lopez Garcia also notes that, even several years after the original launch of the project, she continued to receive even more personal emails than public posts to the visitors' book ("*Glass Houses*").

250 THEA PITMAN

kind of alternative community network that Wood and Adams argued for, and this is the way it has been "read" by critics: Anna Couey, for example, praises Lopez Garcia precisely for "creat[ing] a friendly and intimate space in which to experience her stories," and furthermore, emphasizes that "*Glass Houses* is also a conversation space" where "the power of the work becomes clear in the comments from house guests, many of whom reveal their own struggles with similar issues" ("Restructuring Power" 73). Richard Chabrán and Romelia Salinas, in their brief overview of Chicano/Latino presence online, also note that although "rais[ing] various issues that are left unresolved," the site "provide[s] a record of how race, class, and gender play a role in the construction of community in cyberspace" (327).

CONCLUSION

The critic Lisa Nakamura in her book *Cybertypes: Race, Ethnicity, and Identity on the Internet* (2002), lamented the lack of presence of mixed-race women on the Internet: "More minorities need to weave their own webs, webs in which a *mestiza* or 'other' consciousness can become part of the grain rather than always working against it" (116). While we might take issue with Nakamura's suggestion that, with greater (self-)representation online, ethnic-minority women should cease being contestatory and simply become "part of the grain,", it can, nonetheless, be argued that both artists studied here were already taking advantage of the new possibilities of hypertext to offer some of what Nakamura was struggling to find in terms of alternative presences and ways of being and relating to one another online. To my mind, *Sangre Boliviana* and *Glasshouses* offer excellent examples of an oppositional cyborg/*mestiza* consciousness in the manner of Haraway that is focused on trying to "transform the despised metaphors" of technoscience and offer alternative perspectives and conceptualizations. Indeed, they were included or reviewed in many of the anthologies of "cyberculture" that were published in the first years of the new millennium precisely in order to elucidate the "specific positioning" of women and/or minority groups with respect to new technologies and the Internet.[22]

[22] Grossberger Morales features in Cutting Edge; and Lopez Garcia appears in Malloy and Sturken et al.

19

Dialogues Across Media: The Creation of (New?) Hybrid Genres by Belén Gache and Marina Zerbarini

CLAIRE TAYLOR

This chapter provides a comparative analysis of two of Argentina's leading women writers and artists for whom digital technologies are an integral part of their literary and artistic practice – Belén Gache (b. 1960) and Marina Zerbarini (b. 1952) – and explores how both authors engage with the discourses of new media technologies, and yet also critique these discourses, pointing out their blind spots and failings. It takes up the notion of "intermediality" as outlined by Lavery and Bowskill in the Introduction to this volume, paying particular attention to the way in which differing texts and sources are brought together in the works of these two authors. Rather than suggesting that the authors merge different sources and media to create a smooth, integrated experience for the reader, the chapter argues how they mobilize different media to create a disruptive, uncomfortable experience, and force the reader to ask questions about the very technologies they are employing.

Belén Gache is one of the leading authors of experimental fiction in the Hispanic world, and has published a variety of literary works, in both print and electronic formats, that cross generic boundaries, and explore the literary potentials of new media technologies. Ranging from e-poetry, such as her *Manifiestos robot* (*Robot Manifestos*) (2009), through to literary blogs, such as *Diario del niño burbuja* (*Diary of Bubble Boy*) (2004), Gache's work frequently makes use of digital platforms in order to experiment with literary form.[1]

[1] *Manifiestos robot* (2009) http://findelmundo.com.ar/belengache/manifiestosrobot. htm, *Diario del niño burbuja* (2004), http://bubbleboy.findelmundo.com.ar/.

As a founder member of the *Fin del mundo* (*End of the World*) net.art group, along with Jorge Haro, Gustavo Romano, and Carlos Triknick, Gache has been involved in curatorial projects, as well as contributing significantly to theoretical writings on experimental literature and hypertext.[2]

Gache's *oeuvre* frequently plays with pre-existing literary genres, authors, and texts, ranging from Cervantes through to contemporary authors, in a form of cultural recycling: that is, a process of taking up and re-using pre-existing genres and literary precedents. At the same time, her work is characterized by an overt exploration of digital technologies, their potentials, and their limitations. In this way, Gache does not posit digital technologies as the culmination of a literary trajectory, or as the utopian answer to the limitations of textual culture. Rather, her work is marked by a concern for the uses of new media technologies, and often the most innovative moments come about in the creative *tensions* between digital technologies and experimental literary practice. Far from seeing the use of digital technologies as the ultimate culmination of a prior literary tradition, or as the answer to the failings and limitations of the printed page – as if digital technologies were necessary to correct what print text was unable to achieve – Gache often directs our attention to the failings or limitations of digital technologies themselves, as much as to their potentials.

Góngora Wordtoys, developed by Gache in 2011 and described by her as "digital interactive poetry" (Gache *Góngora Wordtoys*, n.p.)[3] consists of five individual interactive poems, each of which engages with a particular element of, or extracts from, Góngora's *Soledades*, and reworks Góngora's text in a variety of ways, through re-mixings, visualizations, animations, and interactions with the reader-user. In her brief description of the work on her website, Gache highlights the significance that Góngora has for her and for her poetic practice, stating that "in the Baroque period, the well-balanced Classical world gives way to an unstable, decentered world which is hidden behind a multiplicity of signs" (Gache *Góngora Wordtoys*, n.p.).

For Gache, then, the value of Góngora's literary practice lies in its play with form, in its destabilization of norms, and in the excess of the signifier, all elements which, as we shall see, come to the fore in Gache's own poetic practice. Again, Gache engages here in a process of cultural recycling, yet one which is doubly-encoded; in her engagement with Góngora – one of the literary greats of Spain's Golden Age – Gache both pays homage to, and yet potentially desecrates, this canonized text through its fusion and contamination with other art forms and technological interventions.

[2] See, in particular, *Escrituras nómades* (*Nomad Writings*).

[3] All translations of Spanish texts are by the author unless otherwise stated.

DIALOGUES ACROSS MEDIA

For instance, "Dedicatoria espiral" ("Spiral Dedication") reworks Góngora's dedication of *Soledades* (*Solitudes*) in an animated, caligramm-esque format. In this digital poem, Gache's constantly spinning text means that the words cannot be seen in their entirety, and constantly move in and out of view in a way that disrupts our conventional reading patterns – breaking the "representational privilege" of the print text of which Paz Soldán and Castillo have spoken (13). Here, I argue, Gache is attempting to re-create for us the vertiginous sensation that the seventeenth-century reader must have had when faced with Góngora's poetry: everything is not how we expect it to be; the conventional linear reading of the text is disrupted; words are slippery; words constantly move off the page, and refuse to be fixed. Góngora's stylistic excess, his complex metaphors, his overturning of the norms of syntax, his use of catachresis and his neologisms are, in Gache's version, conveyed by a parallel experimentation with the typographical, visual, and procedural presentation of the words across the screen.

Similarly, the poem "En breve espacio mucha primavera" ("A Lot of Spring in a Short Time") reworks disparate words and phrases taken non-sequentially from across the text of the *Solitudes*, via means of hotlinks and pop-up windows. Clicking on the interactive word in each window loads a series of further pop-up windows displaying different lexia, which then launches further windows which, in their turn, contain new lexia with links, and so forth. Gache's word toy – a ludic play with language – here leads us on an intertextual labyrinth, as we click on link after link, only to be constantly pointed towards a further signifier. Instead of each phrase linking to an external signified, or linking to the following line of poetry and so contextualizing it within the poem, the individual phrases instead constantly link to other individual phrases. Here, Gache is drawing a parallel between Góngora's techniques and the potentials of contemporary digital technologies: now, hotlinking is reframed as a potentially Baroque technique. Constantly pointing us towards another signifier, the hotlink provides us with a twenty-first century version of the intricate intertextual and self-referential nature of the Baroque. Moreover, it is worth noting that the phrases that Gache has created in her hotlinking are mashups; just like the text provided in the first image, which was not a direct quotation from Góngora, but a remixing of words taken from lines of his *Solitudes*, so, too, the phrases employed within the work itself are not original citations. Moreover, the links between the lexia themselves do not follow a logical pattern. That the "ivory," underlined in this lexia, links to "so not in love with Leda" illustrates that Gache's hotlinking is not intended to be understood as a straightforward explanatory mechanism. The lexia are neither linked through their location within the poem – "ivory" and "in love" never appear together in the same line of the *Soledades* – nor do they have any obvious semantic or grammatical similarity ("ivory" is not a synonym for

"in love," nor are they the same part of speech). There is, in other words, no immediately obvious connection between the first lexia and the one to which it then leads us. Gache's technique here, in which she forces us to attempt to establish our own connections as we trace these deliberately difficult hotlinks serves to imitate one of Góngora's favored literary techniques, that of catachresis. Catachresis, the figure of speech in which the terms of comparison are implausible, is here enacted for us via these hotlinks, which draw us from one term to another. Here, the reader is forced to create a connection, as they traverse these links in which each lexicon links to a term that is apparently disconnected, and intertextuality itself is laid bare through this process of textual fragments that constantly point to other textual fragments. Thus, as with the "Spiral Dedication" poem, "A lot of Spring in a Short Time" enacts for the twenty-first century reader-user the complexities of Góngora's poetry via the use of digital technologies, in this case enacting a form of catachresis for the twenty-first century, where hotlinks are employed to move us into a seemingly endless chain of signifiers.

Following on from this, the next poem in this collection, "El llanto del peregrino" ("The Pilgrim's Weeping"), again starts off with an introductory text in which Gache highlights the Baroque as "the art of loitering," and notes that she chose the figure of the pilgrim as "a figure with no distinguishing features, a nomad, lost, alone, anonymous and foreign." This introductory text again indicates how the fascination that Góngora holds for her is precisely in the constant connections, tracings, and wanderings that his poetic practice enacts, with the "art of loitering" representing the Baroque, and the slipperiness of the signifier. This Gache then links to her own, twenty-first century poetic practice, where the wordplays of the Baroque are now re-enacted in her digital wordtoy, when she states that:

> Like labyrinthine poems, those linguistic-visual games that were so dear to the Baroque, and taking up the Baroque (and Borgesian) idea of the book as a labyrinth, this wordtoy recreates the text as a metaphor of the man who seems to walk through his life blindly, along tortuous paths in search of his past, his destiny, and his meaning. The pilgrim goes along the complex path of his own circumstances, just as the reader travels through the verses written by Góngora and based on the ramifications and meanderings of language. (Gache, *Góngora Wordtoys*)

Once we launch the work, we see the same pilgrim figure, with several lines of text that appear behind him. Moving the cursors left and right then moves the figure along the lines of text and, if we move him right to the end of the line, we can then move up or down slightly. The text comes from the *Soledad segunda* (*Second Solitude*) and is the words of the pilgrim as he tells of his nostalgia, disillusion, and memories. It is significant, however, that although

DIALOGUES ACROSS MEDIA

Gache has created for us a human figure that can move across the text – the embodiment of the pilgrim – the apparently free movement of this figure is in fact limited and circumscribed. For, although through the movement of the mouse we can make this figure advance across the screen, our movement is ultimately limited. Through left-to-right movement, we can move along the lines of a particular verse, but, if we try to reach previous or later verses, we hit upon a problem. The distance we can make him move upwards and downwards is so minimal that further lines of text are not revealed: we soon hit the top and bottom of the page and instead, all we can see are the glimpses of the top edge of words just beyond the confines of the window frame. We can, thus, move around the text, but only to a certain distance. We cannot scroll higher or lower enough to access other verses of the text, and indeed, we cannot even access the start of the pilgrim's speech, which in fact begins two verses earlier. Gache has thus deliberately set boundaries around her wordtoy, limiting the amount of text to which we have access. While we may be figured as a pilgrim, a purported symbol of wanderings and nomadic behavior, in fact we find ourselves bound in by the limits of the window that Gache has created for us. Deliberately frustrating and inhibiting, Gache's wordtoy here, like many of her other works, plays with our expectations and reveals not just the possibilities but also the limitations of digital technologies.

The second of Gache's poetic works under consideration in this chapter is *Radikal Karaoke*, an online multimedia piece combining text, still and moving images, sound files, and user-generated effects. *Radikal Karaoke*, as the title suggests, engages with the interactive song game, karaoke, that originated in Japan in the 1970s, and became hugely popular worldwide in the 1980s and 1990s. As a cultural performance dependent on technology, the format of karaoke stands, I argue, as a synecdoche for late capitalism: for what Manuel Castells has termed "informational capitalism" in which capitalist restructuring, technology, and corporatism work hand-in-hand).[4] The reference to karaoke, then, indicates the technologically mediated format of the work we are about to enter, but also, and perhaps more importantly, draws out the notion of the unthinking repetition of received content from the system, since karaoke involves the reproduction of words by the user, allowing, in its traditional form, for little or no deviation. As this analysis will reveal, in Gache's critique the system in question is that of late capitalism, and she encourages us to draw parallels between the unthinking repetition of the words of the karaoke system, and the unthinking reproduction of the system of late capitalism.

Gache describes *Radikal Karaoke* as a "poetry collection that is based on the rhetoric of political propaganda" where "collection" refers as much to the

4 Castells, *End of Millennium*.

creative process (the generation of the poetry) as to the collected nature of it. Her insistence on the "rhetoric of political propaganda" frames her poetic endeavor with a critical stance. As we will see below, the way in which these poems are constructed, and the manner in which the reader-user activates them, encourage us to deconstruct hegemonic discourses by means of parody and the shock contrast of sound, image, and text.

After an opening interface which plays with corporate branding techniques, once we enter the work proper, we are presented with three possible speeches to choose from. These are: "Ex Africa semper aliquid novi," "See how Kate shows off her ring" and "We have no past, you have no present." On selecting any one of these three discourses, the interactive interface of *Radikal Karaoke* opens, which is the same whichever speech we select. The main part of the screen is taken up with a video in black and white which shows rows of spectators, applauding, set on a continuous loop and sped up, such that the spectators constantly applaud without respite, and move their hands in a frenetic rhythm as they face us. Beneath the video lies the control panel of the work, consisting of, first, a row of buttons each identified with letters, and, beneath these, the text of the karaoke. In this work the user has to take on an active role in the execution of the poetry – a contrast to the aura of the lone poetic genius, and the authenticity of the singular author. First, our active participation is required to read the text out loud since, as in karaoke, the words of the poem appear in the lower part of the control panel so that the reader-user can speak them. Using the arrow keys of the control panel, the reader-user makes the text scroll forward, and is required to read out a series of commonplaces. That these are commonplaces is immediately made obvious by the opening to the speeches, which recycle a set of clichéd phrases to engage the audience. Whichever speech we select, and however many times we open it, we are always presented with the same opening lines:

> Good afternoon. It is an honor to be here today in front of this audience.
> I would like to make the most of this occasion to say to you …

These same words are reproduced at the start of each of the three speeches: regardless of which speech we choose, we always have the same text, meaning that, once we have played this poetic game more than once, we become alert to the lack of authenticity to these opening lines, a feature which puts us on our guard regarding the text we are entering, and the role we are expected to play. These opening phrases of welcome – "good afternoon" "here today"; "this audience"; "this occasion" – are without context – there are no markers – of time, place or occasion, and can fit any occasion. The speech that we read, then, is full of rhetorical flourishes to draw the audience in, but deliberately lacks originality and sincerity. In this trick, Gache encourages us to consider

DIALOGUES ACROSS MEDIA

the emptiness of corporate and political rhetoric since these same phrases are repeated ad nauseam throughout the work.

After these phrases of welcome, the ones that follow are composed of the remixing and re-combinations of found texts. As Gache explains, these poems are constructed "based on a fixed verbal structure and random texts," and in this way, the poetic value of the work does not lie in the originality of each phrase in itself, but rather in the creative combination – and at times the creative clashing – of these phrases. Such a poetic technique – the creative combination of fragments of texts – is made possible thanks to digital technologies but also, at the same time, borrows from a long literary tradition of recombinant and procedural poetic practices.[5]

If such is the pre-digital tradition informing Gache's work, her creative combination of fragments of texts, is, of course, enabled by digital technologies, and scholars have argued that the techniques of remix and mashup are particularly representative of contemporary digital practice. Early, utopian conceptualizations of remix saw it as offering "active engagement of the user" and "hope for abolishment of producer and recipient (consumer)," promising agency for the user (Sonvilla-Weiss 12). Yet these potentials are largely unrealized (Sonvilla-Weiss 12), and, indeed, the blurring between these roles can often be productively co-opted by global corporations. As Christian Fuchs has persuasively argued, the rise of the "prosumer" enables corporations to reduce their labor costs and exploit consumers who work for free, in effect using "free labour [that] produces surplus value that is appropriated and turned into corporate profit" (143). Such a phenomenon is a version of what Michael Hardt and Antonio Negri, among others, have described as the "immaterial labor" intimately linked to the rise of what they term "informatization," and seen as being central to late capitalism (289–94). Remix as a technique is thus ambiguously located: on the one hand purporting to offer greater agency to the user, and on the other allowing the user to be drawn into creating content for free that can be appropriated by global corporations – and thus the ultimate in surplus value.

Gache makes use of this ambivalently encoded practice of remix by bringing together fragments of slogans, catchphrases, and media hype in order to enable us to glimpse the cracks and contradictions in corporate and political rhetoric. For instance, if we have selected the "We have no past, you have no present" speech, after a series of opening platitudes which fully insert us

5 Notable precursors of Gache's tactics can be found in OuLiPo (Ouvroir de Littérature Potentielle), founded in 1960 by Raymond Queneau and François Le Lionnais and bringing together a loose group of authors, including Georges Perec and Italo Calvino, who were interested in exploring the creation of poetry through constraints, and through combinatorial practices.

into the world of corporate speechmaking, phrases are interwoven which undermine this corporate rhetoric due to their frankness. For example, as we continue in this speech we read that "Our policy has degenerated into a mere lust for money," and "Our policy has been one of gradual progress of falling into the deep well of despair" ("Transgresiones" n.p.). Such phrases, inserted without warning into a stream of apparently bland slogans and catchphrases create unease in the reader through their shock value, and provide glimpses into the harsh realities and material conditions that are deliberately obscured by, and underlie, the glib corporate rhetoric.

This resistance to corporate rhetoric is further encouraged through the interactive elements of the work. If the vocalization of the text is the first level of interactivity that is required of the reader in this work, a second level of interactivity, involving more participation from the reader, is found in the visual aspects of the work. For it is the reader-user who activates the visual poetry of this work, by means of the keys indicated in the control panel which create changes in the video file showing in the main content screen. The seven keys lying at the right-hand side of the control panel – Z, R, G, B, K, A1 and A2 – produce modifications in the video in the main screen, changing its color or speed, while the seven keys on the left (V1–7), change the video completely, and replace it with a new moving image. Using these controls, we can replace the original image – that of the spectators applauding – with: a nuclear bomb exploding (V2); a black and white spiral that constantly spins (V3); a menacing face with red, hallucinating eyes in the form of spirals (V4); an alien who moves quickly across our screen in front of an urban backdrop (V5); or a group of slaves who drag a heavy burden towards the camera (V6). In the same way as the original video, these new videos are repeated on a continuous circuit and their content encourages us to reflect on the words with which we are presented. In this way, the videos function as a sort of metapoetic commentary that makes us question the text that runs across the lower part of the screen and which we are reading out loud. In this instance of intermediality, in which conventionally distinct media are brought together, far from a smooth integration of text and image, the video and the on-screen text below it work productively against one another to create unsettling effects, and generate question for the viewer-player.

For example, if we select V6 – the image of the slaves dragging their heavy burden – the video offers us a pessimistic view of contemporary conditions under twenty-first-century capitalism. The video file depicts a group of slaves arranged into two lines, with each line shouldering a thick rope that stretches back behind them to a large, cumbersome object in the background. Dressed in loincloths and bare-chested, the slaves strain at the rope, moving their burden slowly forward, while the slave driver stands to the right of the frame. Since the video is presented on a continuous loop – in reality, the video lasts

barely three seconds, and then starts again – we see the slaves advance a few centimeters, making a great effort, only to return once more to their starting place and begin anew. Gache's video offers up to us our own image: our roles as individuals trapped within a continuous cycle with no let-up, enslaved by the large corporations and late capitalism of the twenty-first century. The original image of a prior form of alienated labor (slavery) is here mobilized to create an image of twenty-first-century alienated labor, and thus historical violence is reconfigured as structural violence. Moreover, the fact that the video is set on a loop immediately references the contemporary trend of memes and GIFs which are circulated with ever greater frequency, and which (inadvertently) flag up our own entrapment in limited cycles of news, media, and systems. This reconfiguration of historic violence as surface – as a looped video – implies that we must now be attuned to contemporary forms of (structural) violence which are exerted on the individual via the corporate practices of late capitalism.

Similarly, the other videos provide for us images of alienation and enslavement: V5, presents a very short black-and-white animated sequence, lasting some three seconds, depicting an extra-terrestrial figure with a withered body, an enlarged head, and black holes for eyes; V4, depicts red, staring, hypnotized eyes, with the pupils replaced by a vertiginous, ever-moving spiral.

In all of these video files, then, Gache engages in a critique of the technological advances that underpin her own poetic practice. Far from presenting us with a utopian vision of a technologically-enhanced world, Gache makes us question the same digital technologies on which her work is based, and here suggests the dangers of allowing ourselves to be hypnotized by digital technologies in the service of late capitalism. In this way, as we read the texts and manipulate the images, we become aware that Gache's aim is to question neoliberalism and the powers of large corporations, to question political rhetoric, and to question the indiscriminate consumption of social media.

Yet it is striking that we are, of course, situated as ventriloquized participants here, and the degree of our agency is deliberately restricted: all we are permitted to do, if we remain within the rules of the game/system, is to repeat the rhetoric of the system. And indeed this stance we are forced to adopt – of clones repeating the branding rhetoric – will take on a particular significance when we reach the final button of the game. For, when we activate the last of the videos, V7, after having passed through a series of slaves, of aliens, of cybernetic entities, what appears on the screen is our own image. That is, *Radikal Karaoke* has captured the image generated by the webcam of the user, and projects it onto the screen in front of us: what we see on screen is our own face, as we sit at the computer, reading out the text. In this way, the user finds him/herself implicated in the work, and the oft-cited feature of interactivity

260 CLAIRE TAYLOR

at the heart of electronic literature finds a particularly unsettling enactment.[6] We are interpellated into the game not through an avatar on the screen in our stead, but through the *direct representation of ourselves* on screen.

What Gache is indicating to us here is that *we too* are clones, hypnotized and trapped in the system. Just as with the other characters seen in the earlier videos, so we too are enslaved by the corporate system. Our insertion into this line of alienated figures thus forces us to consider how we, too, may be robbed of our agency by the workings of late capitalism. It is this shock moment which is perhaps the most powerful in this piece: Gache is playing with the norms of interactive literature, and her exploration of the potentials of digital technologies finds its culmination in this moment in which she breaks the fourth wall to bring us directly into the game that we thought we were playing as an external observer. Now we find ourselves to be one such player within the game/system; by encouraging us to reflect upon our imbrication in the game, Gache, by extension, encourages us to reflect upon, and critique, our imbrication within the systems of corporate models and global capital. In sum, this ludic but thoughtful piece enables a series of serious reflections on the status of the individual under late capitalism and corporatism, and the way in which this very notion of "the individual" may be a product of corporate and branding practices. Undertaking a defetishizing critique, Gache aims to unmask and denaturalize the hegemonic discourses of corporate capital, strip away the fetishistic aura of the brand, and enable her reader-player to see through the spectacle.

Gache's contemporary, Marina Zerbarini, has undertaken a variety of experimentations involving digital technologies and their integration into artistic and literary practice, engaging in an intermedial practice as she constantly brings together texts, images, and sounds from multiple sources. Two particular works of Zerbarini's will be analyzed here: *Eveline, fragementos de una respuesta* (*Eveline, Fragments of a Reply*), and *Tejido de memoria* (*Memory Weave*).[7] The first of these shares several concerns with Gache's work, while the second has a much more specific focus on Argentine memory practice and sociopolitical concerns.

In the case of *Eveline, Fragments of a Reply*, Zerbarini builds on source texts, in a similar way to Gache's engagement with Góngora described above.

6 Interactivity, and the different ways in which is enabled, has been one of the key areas of debate within studies of electronic literature; see, for instance, Glazier (*Pequeño Digital Poetics*), Montfort (*Twisty Little Packages*) and Hayles (*Electronic Literature*).

7 Zerbarini (*Tejido de memoria*) http://www.marina-zerbarini.com.ar/tejido/dememoria.swf and (*Eveline, fragmentos de una respuesta*) http://marina-zerbarini.com. ar/evy/.

DIALOGUES ACROSS MEDIA

Zerbarini notes that she takes inspiration in this piece from two short stories by another canonical male author, James Joyce – "Eveline," and "A Painful Case" – both of which were included in the collection *Dubliners* (1914). In this work, Zerbarini engages in a strategy of remix, first as regards the source texts themselves, and second as regards the images and sounds comprising the work. In so doing, she takes to an extreme the early modernist practices of Joyce's "original," and yet also problematizes some of the notions underpinning Joyce's work, using the figure of Eveline to pick apart the structural coherence of the "original," and to make us ask metaliterary questions about the text.

In particular, Zerbarini takes up two Joycean traits which are then pushed to their limit: Joyce's narrative gaps, and his unresolved endings. Regarding the first of these, Joyce's short stories are noted for their "textual gaps," with "Eveline" being a particular case in point.[8] Zerbarini's remixed version of Joyce mobilizes a variety of technologically-enabled "gaps," such as hyper-linking, fragmentary lexia, images which are partially obscured, to produce for us an updated version of the silences and ellipses which Joyce's reader had to fill when reading in the early twentieth century. Zerbarini's story, as I will illustrate below, makes much more explicit these gaps, and inserts creative, playful content into these gaps.

Regarding the second Joycean trait, the issue of the inconclusive ending of "Eveline" has often been commented on by scholars, with some arguing that the ending is a let-down, while others argue that it demonstrates "an almost perverse act of will" (de Voogd). The problem of the ending in Joyce's story is Eveline's final actions, and whether she ends up complying with the social mores that prevent her from making her own choices in life. If this is the unconventional ending in the original, Zerbarini's new version of "Eveline" problematizes even further the notion of the ending, since it refuses narrative closure in its enactment; there is no longer a clear narrative arc that culminates in a satisfying conclusion. If, in Joyce's original short stories, endings are unexpected, and questions left unanswered, in Zerbarini's narrative, this sense of uncertainty, and of searching for meaning, is re-enacted procedurally,

[8] Balakier has discussed narrative gaps as a technique throughout the short stories included in *Dubliners*, and argues that "Joyce experiments with textual gaps throughout *Dubliners*. Through ellipses, dashes, spaced rows of periods, explicit silences, and other devices he contrives to engage readers." James Balakier, "Inevitable Omissions" (p. 239). (Meanwhile Wright, focusing on *Eveline* more specifically, argues that *Eveline* furnishes the first example in the collection of Joyce's use of textual gaps, through the use of ellipses and other strategies; as a result of which "they are drawn to our attention and designated as modes of absence by the use of the narrative gap and disclosed as symptomatic by the precise echo of the gap in 'Eveline.'" (Wright "Dots Mark the Spot," 154).

262 CLAIRE TAYLOR

as the reader has to undertake a journey through multiple sources to piece together the narrative. The Joycean notion of the unresolved ending is thus pushed to its limit in this piece where prior textual norms of the print era meet new media; Zerbarini's short story, through its randomized presentation of its contents, does indeed have no ending, since there is no final point, thwarting narrative structure and refusing narrative closure.

Zerbarini achieves this effect of narrative gaps and inconclusive endings through the remixing of content that is randomized and activated in different ways each time the work is opened, and each time the reader interacts with it. On entering the work, an interface loads which consists of multiple images, often including a close-up of a particular part of the human body, most frequently part of the face, or the hands, and rendered in such extreme close-up that the image becomes pixelated, with the individual pixels visible. Yet there is no one, single interface to the work, because the images, sounds, texts, and interactive buttons comprising this work are presented to us randomly, and each time we open the work, we witness a different version. Zerbarini here has enacted a tactic of remix, making use of the potentials of algorithms to generate multiple versions of the narrative. As Zerbarini herself explained in the blurb to this work, the underlying structure is based on "randomness," in which the initial organization of ten different files is created at random, without the user being able to choose, and each one of these in itself contains five or six links, in turn linked to other randomized entry points, that in themselves then produce ten further possibilities, and so forth. As she explains, this "double and triple randomness allows dynamic relations between the data, in which it is virtually impossible that the same relation between image, touch, and sound will be reproduced" (Zerbarini n.p.).

In this way, *Eveline, Fragments of a Reply* undertakes an updating of Joyce and his modernist techniques. Since the chronological order of the files is not pre-set, the reader has to piece together the story from multiple stimuli, as they read disparate blocks of lexia, views images, watches videos, and listens to sounds. These files are varied, although certain thematic or stylistic features unite them, including, as mentioned above, human figures, in particular hands and faces, and graphic (drawn) images of maps, transport, and signals. The sound files comprise mostly orchestral music taken frequently from Philip Glass – a composer known for his use of repetitive structures, and metallic sounds. The text files comprise extracts from the two Joyce source texts which have either been cut or, in some cases, deliberately blurred so that it is impossible to read them.

Thus, there is not one single introductory page to the work, and, in fact, different combinations are generated each time we activate the work. For example, in one possible combination, we may open the work to reveal an extreme close-up of part of the human hand, across which four buttons appear

DIALOGUES ACROSS MEDIA 263

to the left: clicking on these buttons then brings up a 6 × 7 grid of small buttons, each of which in turn loads new content. The image of the hand still remains partially visible in the middle section of the screen, with a repeated mosaic of a leaf and stones in the rest of the screen, and a moving image video in bottom center, set on a loop.

The bottom line of these buttons all load external content, related in one way or another to James Joyce, including opinion pieces about his work, a site providing *Finnegan's Wake* one page per day, a biographical piece discussing the inspiration for *Ulysses*, and a discussion board dedicated to the writer. In so doing, Zerbarini integrates external content into her work, making use of the potentials of hyperlinking to go beyond the confines of the work in itself; this, I argue, is one of the techniques by which Zerbarini activates the "narrative gaps" that characterized Joyce's original short story, with the content of these links being one of the possible fillers for these gaps.

The next line of buttons uploads a series of videos and animations. These include an animation in which red and gray circles flash on and off; as we move our mouse over a circle, it disappears, and beneath it a photographic image is partially revealed that moves across or downwards, and out of view. We thus are only given brief, tantalizing glimpses of a partially visible image, which we can just discern is of a dry, dusty landscape, with a tower in the background, and ripples of water. After playing around with the cursor, we can probably surmise it is some sort of seaside scene, but we are unable to see it in its entirety. Thematically, it links to the ending of "Eveline," and the character's failed attempt to set off across the sea for a new life.

In summary, the buttons along this line each load a video or animation which occupies the center of the screen; these are all in some way partially obscured, difficult to view in their entirety, or distorted. In each case, there is no overt link made between each video and the next; rather, we establish connections as we explore them, such that, for instance, we make a semantic connection of water across some of the videos. Also, the immediate relevance to Eveline's story is not spelled out for us; there are, for instance, no titles for each video which might relate it to a particular part of the original short story. Instead, we have to establish these thematic connections – such as the water-front, which is the scene of her momentous decision at the end of the story.

If these buttons give us access to mostly visual stimuli, another gives us access to textual input, with the buttons opening up blocks of lexia taken at random from the text of Joyce's "Eveline" and "A Painful Case." These lexia appear in the top third and bottom third of the screen, with the top in Spanish and the bottom in English, and are in white font, superimposed over the image of the hand (Fig. 27):

It is important to note that we are not given these lexia in the order in which they appear in the original stories, nor is there any indication of which

27. Marina Zerbarini, *Eveline, Fragments of a Reply* (2004).
Image courtesy of Marina Zerbarini.

of the two stories they originally belonged to. Thus, we construct our own narrative arc from the piecing together of the lexia; in Zerbarini's story here, the classic structuralist distinction between story (the events) and discourse (the plot), is troubled, since the plot itself is not fixed. Rather, the plot is constantly remixed each time the work is opened and the reader selects different links to follow.

In this way, Zerbarini's narrative is deliberately put together in such a way as to force the reader-user to construct their own discourse. Yet *Eveline* is more than just a remixing of content for, in its lexia, sound files, and images, it also undertakes a metatextual commentary on its own process of construction. This is notable through the frequent images, sounds, and textual fragments that make reference to signals, codes, and pathways. In all of the cases, these are accompanied by interactive and multimedia features, including deliberately jerky animations, and sound files, often of metallic sounds or ringing. Zerbarini's deliberate foregrounding of signals, pathways, and routes throughout whichever of the intricate routes we take through *Eveline* is of course a metapoetic commentary on the branching structure of hypertext itself – the very structure that underpins her work. In this way, these multiple images of signals, train tracks, and routes relate not just to the plot of the short story (Eveline's thwarted journey), but also recall the routes within a virtual system based on hyperlinking and branching, thus representing the possible tracks or routes within this very hypertext short story itself. Thus, through her use of multiple sources and algorithmic structure, Zerbarini ensures that her narrative is constantly remixed, and has no clear start or end. Taking the Joycean techniques she identified in the short stories to their extreme, Zerbarini's

DIALOGUES ACROSS MEDIA

hypertext and intermedial fusion narrative refuses any satisfactory ending, and overtly flags up the predominance of its own narrative gaps.

If "Eveline" undertook a literary play with pre-existing texts that were not immediately rooted in an Argentine context, Zerbarini's 2003 work, *Memory Weave* is an interactive online work which undertakes a critique of Argentina's recent past but also directs its critique at the country's present inequalities, and, at the same time, problematizes any straightforward access to memory. Defining *Memory Weave* as a "work in progress," Zerbarini explains the notion, stating that a memory can be read as a "weave that constructs and reconstructs" the present in relation to the past (Zerbarini *Memory Weave*).[9] In this sense, Zerbarini's work indicates, as will be analyzed below, that there is no transparent access to the recovery of a simple, singular memory, and instead produces a complex process by which the viewer/user must engage in the active production of memory.

This memory is evoked through the background screen which appears throughout this work, comprising the same black-and-white image repeated several times in a mosaic format: a photograph of the interior of a building, with bare walls, concrete columns, and high windows. The image here is of ESMA – the Argentine Navy's Mechanical School – in Buenos Aires, the most notorious of the dictatorship's torture centers where an estimated 5,000 people were detained, tortured, and killed[10], and which has become, as Di Paolantonio has argued, "vested with a particular memorial charge, which is fraught with complex and often contesting attempts to give representational content to the past victimization" (26). This repeated background suggests the omnipresence of the detention centers, and the lingering memory of them in the Argentine national imaginary.

Other features of the interface also bring to the fore the issue of memory, such as the scrolling date which appears in the top left-hand corner of the screen, and which rapidly and constantly scrolls forward, from 1977 to the present day (2003, at the time the work was produced), and then re-starts at 1977. Again, this scrolling date hints at an obsessive return to the past: 1977 is of course one year after the installation of the dictatorship, but also, more importantly in the context of this work, the year of the establishment of the *Mothers of the Plaza de Mayo*. 2023, meanwhile, as well as being the date of production of *Memory Weave*, is also the year in which then president Néstor

9 See Pitman in this volume for more on the metaphor of weaving as it relates to new media technologies.

10 Di Paolantonio sets the figure of those detained and tortured at ESMA at 5,000 (25). It is worthy of note that shortly after Zerbarini made *Tejido de memoria*, the ESMA was turned into an "space of memory" to commemorate the lives of those who were disappeared during the *Guerra sucia*.

266 CLAIRE TAYLOR

Kirchner made the first steps towards repealing the *Due Obedience Law* and
the *Full Stop Law*, and thus is a significant date in terms of bringing to justice
the perpetrators of the crimes of the dictatorship.[11] The scrolling date thus
is doubly-encoded; first, it serves as a reminder of past traumas which are
constantly re-emerging in the present, and how the logic of the dictatorship
still impinges upon the present day – a feature we see explored throughout
this work. Second, it functions as a commemoration of the setting up of the
Mothers of the Plaza de Mayo association and indicates how this association
still has relevance in present day, post-dictatorship Argentina, a fact which,
again, is constantly enacted throughout *Memory Weave*.

In addition to this, the work contains a wealth of named links, and other
un-named links, which are hidden in the visuals, which then link to the main
content of the work, all of which engage in reworking and recycling con-
tent. In this practice of explicit intermedia, Zerbarini presents content that
is drawn from multiple sources, with meaning generated through the creative
combination – and juxtaposition – of the same. This content takes the form of
video files, still photographs, texts, graphs, and text comments based on user
input, and our navigation through them is deliberately difficult, due to the use
of un-named links, of icons which are constantly fluctuating, and the fact that
the mouse cursor disappears at periodic intervals.

For instance, each screen contains a rolling cycle of images in the bottom
third of the screen, each cycle combining iconic views and monuments of
Buenos Aires with oppositional images which contest the accepted mean-
ing of the cityscape. For example, one rolling cycle starts with an archetypal
image of modern Buenos Aires: a panoramic shot of the Buenos Aires water-
front with the skyscrapers of the Puerto Madero district reflected in the Río
de la Plata. The image of the port has long functioned as a shorthand for
Buenos Aires itself, with the term for the city's inhabitants – *porteños* (literally,
port-dwellers) – reflecting this elision, and the particular image here – the
modern Puerto Madero district – reflects that district's regeneration following

[11] The *Ley de punto final* (law 23,492) was passed in December 1986 to put an end to
 prosecution of those accused of violence during the dictatorship, while the *Ley de
 obediencia debida* (law 23,521), passed in 1987, stated that neither officers nor sub-
 ordinates could be legally punished for crimes committed during the dictatorship
 since they were acting out of "due obedience." Kirchner and the Argentine legisla-
 ture took the first steps towards repealing both laws in 2003, leading to two years of
 legal debates, at the culmination of which, in 2005, the Argentine Supreme Court
 declared these amnesty laws unconstitutional, thus paving the way for future judi-
 cial proceedings. The repealing of these laws was largely seen as a victory for human
 rights, and led to the re-opening of cases against the perpetrators of torture and
 other human rights abuses. For more on the repealing of these laws, see Roehrig.

DIALOGUES ACROSS MEDIA

267

huge injections of foreign investment in the 1990s, as a result of which finance and communications companies, among others, were relocated there. Yet this image is then undercut by a series of other images which flash over it quickly before disappearing: an extreme close-up shot of a humanoid face with red eyes; a black-and-white photograph of a fountain; an image of several bald, alien-like figures supporting large spheres; and a black-and-white photograph of a person pedaling a bicycle cart.

These various images, set in the context of the main Puerto Madero image which frames them, function to contest the accepted meanings of the cityscape. The fountain, for instance, is the fountain located in the Plaza de Mayo, seen in this image with the national bank and other government buildings visible in the background. The image is seen only fleetingly, as it moves swiftly up the screen before fading out, but even from this brief glance it is clear that the image has been altered, since the water in the fountain appears to run pink. Establishing a metonymical link to the preceding image of the face with red eyes, and to the subsequent image of alien bodies, this image functions as a commentary on both the dictatorship and on the contemporary neoliberal era in Argentina. The location of the fountain – the Plaza de Mayo – is clearly a highly-charged setting in terms of the dictatorship, and the pink water suggests the blood of those who were tortured and disappeared by the regime. This image provides an implicit critique of the panoramic shot of the Puerto Madero district which serves as its backdrop: if Puerto Madero, as Pírez has argued, is one instance of the increasing fragmentation of Buenos Aires due to privatization (Pírez), then the image of the bleeding fountain with the major financial corporation in the background serves as an image of finance capitalism bleeding the country dry. The conjunction of these images thus establishes a link between the two regimes: between the human rights abuses of the dictatorship, and between the social stratification enacted by the neoliberal reforms of the Menem era and which continues up to the present day.[12]

The figure with the bicycle cart, meanwhile, while ostensibly providing a traditional image of the street vendors of Buenos Aires, is, in post-crash Argentina, a much more highly-charged image.[13] The image of the street

[12] Carlos Menem, President of Argentina from 1989–99, was famous for ushering in a raft of neoliberal reforms, including the wholesale privatization of state-run companies, including such big names as Entel, Aerolíneas Argentinas, and Yacimientos Perolíferos Fiscales, among many others, the mass dismissal of thousands of state employees, the slashing of billions of dollars off government social spending, and the opening of the Argentine economy to international markets.

[13] The reference here is to the Argentine financial crisis of 2001, which culminated in the *corralito* (freeze on bank accounts) and the crash in December of that year.

vendor/recycler with bicycle cart has become synonymous with the *cartoneros* or waste recyclers,[14] the many thousands of people who, as a result of the crash in 2001 (and the preceding years of *menemista* privatization and neoliberal policy which paved the way for the crash), were forced to make a living sorting through the rubbish of the wealthier areas of the city.[15] The image is thus emblematic of the harshness of life for many in modern Buenos Aires, and comments upon the neoliberal and privatization policies of the *menemista* and post-*menemista* years which forced many to make their living in the gray economy and which saw an increase in inequality in Argentina. Again, the significance of this image being set as it is against the backdrop of the Puerto Madero waterfront, is paramount: if the official meaning of the Puerto Madero is of the triumph of privatization and the insertion of Buenos Aires into global circuits of finance capital, then the image of the *cartonero* which fleetingly moves across it represents the rising inequalities and social stratification which these same policies of privatization would disavow. In this way if, as Themis Chronopoulos has put it, "the presence of *cartoneros* is one of the most visible and lasting effects of the 2001–02 economic crisis of Argentina" (Chronopoulos 167), then *Tejido de memoria* works to make tactical use of this visibility, re-signifying the streets, and making visible the *cartoneros* over the official images of the cityscape.

If such is the effect of the cycles of images within *Memory Weave*, the other sources and links within the work also engage in a similar process of bringing forth the memory of the dictatorship, and also linking it to present-day inequalities. The video files in each screen, for example, open up short films, some of which are artistic/fictional works created by Zerbarini, and others of which are extracts of interviews with María del Carmen de Berrocal, one of the founding members of the *Madres*, and subsequently a member of the committee of the *Mothers of Plaza de Mayo Association*.

Similarly, there is another, un-named section of the work, in which eighteen individual documents taking various formats – some text, some graphic, and some photographic – provide supplementary information about the dictatorship, the *Mothers of Plaza de Mayo* and contemporary inequality in

[14] While the exact number of *cartoneros* is hard to specify, according to a survey cited in Schamber and Suárez, there were an estimated 10,800 *cartoneros* and street vendors in the city of Buenos Aires in 2002 (6), while according to Chronopoulos, an estimated 100,000 people in Buenos Aires and Gran Buenos Aires rely on the income generated from this work (Chronopoulos, "The *Cartoneros* of Buenos Aires").

[15] While the surge in numbers of the *cartoneros* took place after the 2001 crash, Chronopolous argues that the seeds were sown in the Menem era, since, according to his research, the *cartoneros* are composed primarily of people who were "displaced from the formal economy due to neo-liberal reforms in the 1990s" (171).

DIALOGUES ACROSS MEDIA

Argentina. These are accessed via a series of icons at the left-hand side of the screen, icons which include a cassette tape, a CD, a clipboard, a document, and recycling bin, and which reference both pre-digital, analog formats (the cassette, the clipboard), as well as digital ones, again suggesting equivalences between earlier forms of government (the dictatorship) and present ones (the informational capitalism of the menemista and post-menemista era). These icons constantly fluctuate, flickering on and off, and, regardless of whichever is clicked, bring up the same image: a chess board with icons of people rather than chess pieces. Clicking on each individual person brings up a different document: these range from graphs and tables covering statistics on infant mortality, maternal mortality rates, poverty, and unemployment in Buenos Aires; texts about the dictatorship and contemporary issues such as poverty and malnutrition in Argentina; and two photographic images.

If the still images, video files, graphs, and texts interweave a variety of sources in order to contest established meanings of the cityscape, another section of the work, entitled "Communication'" opens up a further space for the integration of new sources through the opportunity for interactivity. In this section, users are invited to add their comments to the site, which can then be accessed under the section "Writings." Crucially, the user input here is through a pre-programmed format starting with the word "denounces"; the experience of the user here is immediately cast as that of denouncing injustices, whether these be past or present ones, and there are multiple entries from users doing so.

Despite the differences in subject matter, both writers analyzed in this chapter share a common interest in the recycling of pre-existing fragments, whether these be textual, visual, or sonic, and both envisage their works as part of a longer, pre-digital heritage of literary-artistic experimentation. The two examples of works by each author explored here function in different ways: the first piece described is concerned more with literary play with a literary precedent (Góngora for Gache, Joyce for Zerbarini), while the second is an example of more politicized play (faceless corporatism for Gache, dictatorship for Zerbarini). Both of them manipulate digital technologies in the creation of literary works through their intertextual and intermedial interventions, and at the same time, dialogue with existing literary genres, and remix existing written, pictorial, or sonic fragments. Yet neither does so in a utopian gesture to praise the potentials of digital technologies for the creation of new literary genres, or to provide for liberatory experiments with literary form. That is, neither of them subscribes to technological determinism, nor wishes us to understand technology as liberating or creative per se. Rather, both authors, in their different ways, use the digital tools with which they work to caution against technological determinism and e-topian views of technology.

Bibliography

Aarseth, Espen. *Cybertext: Perspectives on Ergodic Literature*. Johns Hopkins UP, 1997.

L'Abécédaire de Gilles Deleuze, avec Claire Parnet. Dir. Pierre-André Boutang, trans. and notes Charles J. Stivale, 1996, <https://deleuze.cla.purdue.edu/sites/default/files/pdf/lectures/en/ABCMsRevised-NotesComplete051120_1.pdf>. Accessed 30 March 2023.

Acevedo, Pilar. "Outcry." 13 February 2011, <http://www.pilaracevedo.com/blog/category/outcry>. Accessed 23 January 2023.

Adler, Jazmín. *En busca del eslabón perdido: Arte y tecnología en Argentina*. Miño y Dávila/Centro cultural de España en Buenos Aires/EDUNTREF, 2020.

Anderson, Benedict. "Exodus." *Critical Enquiry*, vol. 20, no.2, 1994: pp. 314–22.

——. *Imagined Communities: Reflections on the Origin and Spread of Nationalism*. Verso, 1991.

Anzaldúa, Gloria. *This Bridge Called my Back*. Persephone Press, 1981.

Appadurai, Arjun. *Modernity at Large: Cultural Dimensions of Globalization*. U of Minnesota P, 1996.

Artishock. "Rebeldes: laboratorio experimental de practices feministas." *Artischock*, 5 July 2022. REBELDES: LABORATORIO EXPERIMENTAL DE PRÁCTICAS FEMINISTAS – Artishock Revista, <https://artishockrevista.com/2022/07/05/rebeldes-practicas-feministas/>. Accessed 23 January 2023.

Audran, Marie, Gianna Schmitter, and Miriam Chiani, "Appel a contribution. Primera Circular. TransLiteraturas I: Transmedialidades en la literature hispanoamericana, 2000–2017," <https://transliteraturas.wordpress.com/transmedialidadestransmedialites/>. Accessed 23 January 2023.

Augsburg, Tanya. "Interdisciplinary Arts." *The Oxford Handbook of Interdisciplinarity*. Ed. Robert Frodeman, Julie Thompson Klein, and Roberto C. S. Pacheco. 2nd ed. Oxford UP, 2017. 131–43.

Austin, Michael. "Why I Read *War and Peace* on a Kindle (and Bought the Book When I Was Done)." *The Edge of the Precipice: Why Read Literature in a Digital Age?* Ed. Paul G. Socken. McGill-Queen's UP, 2013. 13–26.

Baetens, Jan, and Domingo Sánchez-Mesa. "Literature in the Expanded Field: Intermediality at the Crossroads of Literary Theory and Comparative Literature." *Interfaces: Image Text(e) Lang(u)age*, vol. 36, 2015: pp. 289–304. DOI: https://doi.org/10.4000/interfaces.245.

Balakier, James. "'Inevitable Omissions': The Art of the 'Unsaid' in James Joyce's *Dubliners*." *International Journal of the Humanities*, vol. 8, no. 4 2010: pp. 237–46.

Balderston, Daniel, Mike Gonzalez, and Ana M. López. "Introduction." *Encyclopedia of Contemporary Latin American and Caribbean Cultures*. Ed. Daniel Balderston, Mike Gonzalez, and Ana M. Lopez. 3 vols. Routledge, 2000, I, A–D. xix–xxii.

Balgiu, Alex, and Mónica de la Torre. *Women in Concrete Poetry: 1959–1979*. Primary Information, 2020.

Balpe, Jean-Pierre. "Reflections on the Perception of Generative and Interactive Hypermedia Works." *Media Poetry: An International Anthology*. Ed. Eduardo Kac. Intellect, 2007. 245–49.

Bambozzi, Lucas. "Despojos." 2009, <gabrielagolder.com/despojos.htm>. Accessed 23 January 2023.

Barbosa, Emilia. "Performing Feminicide and Violence against Women in 279 Golpes." *Latin American Perspectives*, issue 194, vol. 41, no. 1, 2014: pp. 59–71.

Barthes, Roland. *El placer del texto*. Siglo XXI editores, 2003.

Batalla, Juan. "Raiza Revelles, la reina mundial de los booktubers: 'la gente cree que somos pokemones'" *Infobae*. 12 May 2017, <www.infobae.com/tendencias/2017/05/12/raiza-revelles-la-reina-mundial-de-los-booktubers-la-gente-cree-que-somos-pokemones/>. Accessed 23 January 2023.

Baudrillard, Jean. *Cultura y simulacro*. Kairós, 1978.

Beiguelman, Giselle. "Corrupted Memories: The Aesthetics of Digital Ruins and the Museum of the Unfinished." *Uncertain Spaces: Virtual Configurations in Contemporary Art and Museums*. Ed. Helena Barranha and Susana S. Martin. Instituto de História da Arte, Faculdade de Ciências Sociais e Humanas – Universidade Nova de Lisboa, 2015. e-book. Web, <http://unplace.org/sites/default/files/uncertain_spaces.pdf>. Accessed 24 January 2023.

Benjamin, Walter. "The Work of Art in the Age of Mechanical Reproduction." *Illuminations*. Ed. Hannah Arendt. Schocken Books, 1968. 217–51.

Bergson, Henri. *Memoria y vida*. Altaya, 1994.

Bernheimers, Charles. "Manet's Olympia: The Figuration of Scandal." *Poetics Today*, vol. 10, no. 2, 1989: pp. 255–77.

Bollington, Lucy. "Reframing Excess: Death and Power in Contemporary Mexican Literary and Visual Culture." Diss. University of Cambridge, 2018.

Bolter, J. David. *Writing Space: Computers, Hypertext, and the Remediation of Print*. Routledge, 2011.

Boler, J. David, and Richard Grusin. *Remediation: Understanding New Media*. MIT Press, 1999.

Bonsiepe, Gui. *Del objeto a la interfaz: mutaciones del diseño*. Ediciones Infinito, 1998.

Borges, Jorge Luis "Del rigor en la ciencia." *Obras completas*, vol. II. Emecé, 2002.

Bourriaud, Nicolas. *The Radicant*. Sternberg Press, 2009.

Bowskill, Sarah E. L. "Bearing Witness to Child Abuse and Trauma in Pilar Acevedo's Multimedia 'Fragmentos' Exhibition." *Bulletin of Spanish Visual Studies*, vol 2. no. 1, 2018: pp. 105–36.

BIBLIOGRAPHY

273

——. *The Politics of Literary Prestige. Prizes and Spanish American Literature.* Bloomsbury Academic, 2022.

——. "Eli Neira: Pursuing Community and Interconnectedness Against the Commodification and Institutionalization of Culture in Chile." *Bulletin of Spanish Visual Studies*, vol. 4, no. 1, 2020: pp. 93–124.

Brachetti Peretti, Nicole. "Latin American Art in Lockdown." *Aesthetica*. 18 June 2020, <https://aestheticamagazine.com/latin-american-art-in-lockdown/>. Accessed 23 January 2023.

Brea, José Luis. *Cultura_RAM*. Gedisa, 2007.

Brillenburg Wurth, Kiene. "Multimediality, Intermediality, and Medially Complex Digital Poetry." *RiLUnE, Rivista di Letterature dell'Unione Europea*, no. 5, 2006: pp. 1–18.

Bruhn, Jørgen. "Heteromediality." *Media Borders, Multimodality, and Intermediality*. Ed. Lars Elleström. Palgrave Macmillan, 2010. 225–36.

Bruhn Jensen, Klaus. "Intermediality." *The International Encyclopedia of Communication Theory and Philosophy*. Ed. Klaus Bruhn Jensen and Robert T. Craig. John Wiley and Sons Inc., 2016. 1–12. Web, <https://doi.org/10.1002/9781118766804.wbiect170>. Accessed 23 January 2023.

Bunz, M. *La utopía de la copia. El pop como irritación.* Interzona Editora, 2007.

Burke, Peter. *Cultural Hybridity.* Polity, 2009.

Bustamente, Maza. *La imagen-tiempo. Estudios sobre cine 2.* Paidós, 1987.

Bustamante, Verónica. "La transliteratura de Ana Clavel." *Milenio Diario*. 18 May 2017, <https://www.milenio.com/blogs/qrr/la-transliteratura-de-ana-clavel>. Accessed 24 January 2023.

Campos, Augusto de. *Clip poemas.* Web, <http://www2.uol.com.br/augustodecampos/clippoemas.htm>. Accessed 23 January 2023.

——. Interview. "From Dante to the Post-Concrete: An Interview with Augusto de Campos." By Roland Greene. Web, <http://www.ubu.com/papers/greene02.html>. Accessed 23 January 2023.

——. "Questionnaire of the Yale Symposium on Experimental, Visual, and Concrete Poetry since the 1960s (5–7 April 1995)." Web, <https://www.augustodecampos.com.br/yaleeng.htm>. Accessed 24 January 2023.

——. Web, <http://www2.uol.com.br/augustodecampos/poemas.htm>. Accessed 23 January 2023.

Canclini, Néstor García. *Hybrid Cultures: Strategies for Entering and Leaving Modernity.* Trans. Christopher L. Chiappari and Silvia L. López, foreword by Renato Rosaldo. U of Minnesota P, 1989.

Casey, Edward. "Between Geography and Philosophy: What Does It Mean to Be in the Place-World?" *Annals of the Association of American Geographers*, 2001, vol. 91, no. 4, 2021: pp. 683–93.

Castells, Manuel. *End of Millennium.* Wiley, 2010.

Castellanos, Rosario. "La abnegación: una virtud loca." *Debate Feminista*, vol. 3, no. 6, 1992: pp. 287–92.

——. "Lección de cocina." *Álbum de familia.* Fondo de Cultura Económica, 1971.

Castillo, Debra. *Redreaming America: Toward a Bilingual American Culture*. SUNY, 2005.

———. *Talking Back: Toward a Latin American Feminist Literary Criticism*. Cornell UP, 1992.

Castillo, Debra, and M. S. Tabuenca Córdoba, *Border Women: Writing from La Frontera*. U of Minnesota P, 2002.

Cerón, Rocío. "Imperio." Web, <http://www.rocioceron.com/imperio.html>. Accessed 23 January 2023.

———. *Imperio/Empire*. Trans. Tanya Huntington, FONCA, 2009.

———. Interview. "Entrevista Rocío Cerón. Para la escritora y editora la poesía puede encarnar en acción y dialogar con otras disciplinas." By Jesús Pacheco. *Reforma*, 23 September 2011. Accessed via Nexis UK.

Chabrán, Richard, and Romelia Salinas. "Place Matters: Journeys through Global and Local Spaces." *Technological Visions: The Hopes and Fears that Shape New Technologies*. Ed. Marita Sturken, Douglas Thomas, and Sandra Ball-Rockeach. Temple UP, 2004. 305–38.

Chacón, Hilda, ed. *Online Activism in Latin America. Studies in New Media and Cyberculture*. Routledge, 2018.

Chiani, Miriam, ed. *Poéticas trans. Escrituras compuestas: letras, ciencia, arte*. Katatay, 2014.

Chiappe, Doménico. "Creative Processes in Hypermedia Literature: Single Purpose, Multiple Authors." *Latin American Cyberculture and Cyberliterature*. Ed. Claire Taylor and Thea Pitman. Liverpool UP, 2007. 216–26.

Chronopoulos, Themis. "The cartoneros of Buenos Aires, 2001–2005." *City*, vol. 10, no. 2, 2006: pp. 167–82.

Cipriani López, Carlos. "130 años de una cárcel que dio paso al arte y la historia natural." *El País*, 2 March 2018, <elpais.com.uy/informacion/anos-carcel-dio-paso-arte-historia-natural.html>. Accessed 23 January 2023.

Cisneros, David J. "Contaminated Communities: The Metaphor of 'Immigrant as Pollutant' in Media Representations of Immigration." *Rhetoric and Public Affairs*, vol. 11, no. 4, 2008: pp. 569–601.

Citton, Yves. "Learning to Read in the Digital Age: From Reading Texts to Hacking Codes." *PMLA*, vol. 130, no. 3, 2015: pp. 743–49.

Clark, T. J. "Preliminaries to a Possible Treatment of Olympia in 1865." *Modern Art and Modernism A Critical Anthology*. Ed. Francis Frascina, Charles Harrison, and Deirdre Paul. Sage, 1982. 259–74.

Clavel, Ana. *El amor es hambre*. Alfaguara, 2015.

———. *Cuerpo náufrago*. Alfaguara, 2005, <https://www.cuerponaufrago.com>. Accessed 23 January 2023.

———. <https://anaclavel.com/index.html>. Accessed 23 January 2023.

———. *La cultura de la imagen*. (The Culture of the Image), <https://www.academia.edu/34988237/La_cultura_de_la_imagen._La_imagen_como_signo_en_la_literatura_mexicana>. Accessed 3 April 2023.

———. "La transliteratura de Ana Clavel, *Milienio*, 18 May 2017.

BIBLIOGRAPHY

——. <https://www.violetasfloresdeldeseo.com/>. Accessed 23 January 2023.

——. *Las ninfas a veces sonríen*. Alfaguara, 2012.

——. "Soy totalmente visual." *Ciencia Ergo Sum*, vol. 16-1, March–June 2009: pp. 101–2. <http://www.redalyc.org/html/104/10416114/index.html>. Accessed 23 January 2023.

——. *Las violetas son flores del deseo*. Alfaguara, 2007.

Clüver, Claus. "Intermediality and Interarts Studies." *Changing Borders: Contemporary Positions in Intermediality*. Ed. Jens Arvidson, Mikael Askander, Jørgen Bruhn, and Heirdrun Führer. Intermedia Studies Press, 2007. 19–37.

"Contaminación," *Diccionario de la Real Academia Española*. Web, <https://dle.rae.es/contaminación>. Accessed 23 January 2023.

Coronado, Gabriela, and Bob Hodge. *El hipertexto multicultural en México posmoderno: paradojas e incertidumbres*. Centro de Investigaciones y Estudios Superiores en Antropología social, 2004.

Correa-Díaz, Luis. *Novissima verba: huellas digitales y cibernética en la poesía latinoamericana*. RIL Editores, 2019.

Correa-Díaz, Luis, and Scott Weintraub, eds. "Latin American, Spanish, and Portuguese Literatures in the Digital Age (New Technologies and the Literary)." Special issue of *Arizona Journal of Hispanic Cultural Studies*, vol. 14, 2010. e: <https://www.elamoreshambre.com/site/ana_clavel_el_amor_es_hambre_entrevistas.html>. Accessed 3 April 2023.

——. eds. "Dossier de poesía digital / electrónica latinoamericana: muestrario creativo y crítico." Special issue of *AErea, Revista Hispanoamericana de Poesía*, Year X, no. 10. 2016, <http://litelat.net/dossier-de-poesia-digital-latinoamericana-en-revista-aerea/>. Accessed 23 January 2023.

Couey, Anna. "Restructuring Power: Telecommunication Works Produced by Women." *Women, Art, and Technology*. Ed. Judy Malloy. MIT Press, 2003, 55–85.

Covid E-Lit: Digital Art During the Pandemic. Dir. Anna Nacher, Søren Pold, Scott Rettberg and Ashleigh Steele, 2022, <https://vimeo.com/544980228>. Accessed 23 January 2023.

Cruz Arzabal, Roberto. "Hechos diversos de Mónica Nepote." Revista Crítica, <http://revistacritica.com/contenidos-web/hechos-diversos-de-monica-nepote-por-roberto-cruz-arzabal>. Accessed 1 February 2018.

——. "Participación del cuerpo y de la imagen en el poema." Máquinas de sentido, Tierra Adentro, 21 May 2015, <www.tierraadentro.cultura.gob.mx/16700/>. Accessed 23 January 2023.

——. "Writing and the Body: Interfaces of Violence in Neoliberal Mexico." *Mexican Literature in Theory*. Trans. Robin Myers. Ed. Ignacio M. Sánchez Prado. Bloomsbury Publishing, 2018. 243–60.

Cullen, Deborah. "Arte≠Vida: Actions by Artists of the Americas, 1960–2000." 2008, <http://www.elmuseo.org/wp-content/uploads/2014/03/Arte-No-Es-Vida-Press-Release.pdf>, pp. 1–3. Accessed 23 January 2023.

Cusicanqui, Silvia Rivera. *Sociología de la imagen. Miradas ch'ixi desde la historia andina*. Colección Nociones Comunes, Ciudad Autónoma de Buenos Aires, 2015.

Cutting Edge. *Digital Desires: Language, Identity, and New Technologies*. Ed. The Women's Research Group. I. B. Tauris, 2000.

Cvetkovich, Ana. *An Archive of Feelings: Trauma, Sexuality, and Lesbian Public Culture*. Duke UP, 2003.

Danci, Monica. "Digital Poetry at the Beginning of the Third Millennium." *Echinox Journal*, vol. 20, 2011: pp. 220–25.

Davis, Cynthia J. "Contagion as Metaphor." *American Literary History. Contagion and Culture*, vol. 14, no. 4, 2002: pp. 828–36.

De la Torre, Mónica. "Olímpicamente," <http://www.npr.org/2012/07/31/157289 718/olimpicamente-in-praise-of-feistiness-and-big-feet>. Accessed 23 January 2023.

Deleuze, Gilles. "Conversaciones con Claire Parnet." (1988). Video including translation into Spanish, <http://estafeta-gabrielpulecio.blogspot.com/2009/08/gilles-deleuze-abecedario-entrevistas.html>. Accessed 23 January 2023.

———. "Cours Vincennes – St Denis: el acontecimiento – Whitehead." *Les cours de Gilles Deleuze*, <webdeleuze.com/textes/141>. Accessed 23 January 2023.

———. "Cours Vincennes – St Denis: Lógica del acontecimiento." *Les cours de Gilles Deleuze*, <webdeleuze.com/textes/149>. Accessed 30 October 2018.

———. *La imagen-tiempo. Estudios sobre cine 2*. Paidós, 1987.

Deleuze, Gilles, and Félix Guattari. *A Thousand Plateaus. Capitalism and Schizophrenia*. U of Minnesota P, [1980] 2009.

De Voogd, Peter. "Imaging Eveline, Visualised Focalisations in James Joyce's *Dubliners*." *European Journal of English Studies*, vol. 4, no. 1, 2000, pp. 39–48.

Díaz, Ella. "Seeing is Believing: Visualizing Autobiography, Performing Testimonio: New Directions in the Latina/o and Chicana/o Visual Aesthetic." *Chicana/Latina Studies: The Journal of Mujeres. Activas en Letras y Cambio Social*, vol. 11, no. 1, 2011: pp. 36–83.

Di Paolantonio, Mario. "A Site of Struggle, a Site of Conflicting Pedagogical Proposals: The Debates over Suitable Commemorative Form and Content for ESMA." *Journal of the Canadian Association for Curriculum Studies*, vol. 6, no. 2, 2008: pp. 25–42.

Dorantes, A. "*El amor es hambre* de Ana Clavel." 2015, <http://dosdisparos.com/2015/11/18/resena-de-el-amor-es-hambre-de-ana-clavel/#.WZVS-rv-WzIU>. Accessed 3 April 2023.

Douglas, Mary. *Purity and Danger. An Analysis of Concepts of Pollution and Taboo*. Routledge, 2003.

Druxes, Helga. *Resisting Bodies: The Negotiation of Female Agency in Twentieth-Century Women's Fiction*. Wayne State UP, 1996.

Elleström, Lars. "Media. Modalities and Modes." *Media Borders, Multimodality, and Intermediality*. Ed. Lars Elleström. Palgrave Macmillan, 2010. 11–48.

BIBLIOGRAPHY

Escaja, Tina. "Ciber/reflexiones." *Luke*, no. 69, 2005, <http://www.espacioluke.com/2005/Diciembre2005/tina.html>. Accessed 23 January 2023.

Espinosa Miñoso, Yuderkys, Gómez Correal, Diana, Ochoa Muñoz, Karina. *Tejiendo de otro modo: feminismo, epistemología y apuestas descoloniales en Abya Yala*. Universidad de Cauca, 2014.

Evans, M. D. R., Jonathan Kelley, and Joanna Sikora. "Scholarly Culture and Academic Performance in 42 Nations." *Social Forces*, vol. 92, no. 4, 2014: pp. 1573–1605.

Faesler, Carla. "Espejo." Ed. Marc Brouhat. YouTube, <www.youtube.com/watch?v=Oio7kQ2FeZo>. Accessed 23 January 2023.

——. *Formol*. Tusquets, 2014.

——. *Impulso*. Ed. Raphaël Tiberghien. YouTube, <www.youtube.com/watch?v=L-9d-wkyipc>. Accessed 23 January 2023.

——. "Preguntas sobre Formol." 4 November 2017. Email.

——. Personal conversation. Gainesville, Florida, 9 October 2016.

——. "Poesía y arte en México después de Octavio Paz." *Ínsula: Revista de Letras y Ciencias Humanas*, vol. 707, 2005: pp. 9–13.

——. *Tiza persona*. Drawing Carmen Mariscal. Ed. Raphaël Tiberghien. YouTube, <www.youtube.com/watch?v=aEfxZLApqus>. Accessed 23 January 2023.

Fajardo-Hill, Cecilia. n.d. "The Invisibility of Latin American Women Artists: Problematizing Art Historical and Curatorial Practices." Digital Archive. Radical Women: Latin American Art 1960–1985. *Hammer Museum*, <https://hammer.ucla.edu/radical-women/essays/the-invisibility-of-latin-american-women-artists>. Accessed 23 January 2023.

Feministas Biobio. No title. YouTube, <https://www.youtube.com/watch?v=bRzJ20FC90k>. Accessed 23 January 2023.

Field, Terri. "Is the Body Essential for Ecofeminism." *Organisation & Environment*, vol. 13, no. 1, 2000: pp. 39–60.

Finnegan, Nuala. Interview with Pura López Colomé. 17 February 2017. Unpublished.

Finnegan, Nuala, and Jane E. Lavery, eds. *The Boom Femenino in Mexico: Reading Mexican Women's Writing*. Cambridge Scholars Publishing, 2010.

Freeman, Matthew, and William Proctor. *Global Convergence Cultures. Transmedia Earth*. Routledge, 2018.

——. "Introduction. Conceptualizing National and Cultural Transmediality." *Global Convergence Cultures. Transmedia Earth*. Ed. Matthew Freeman and William Proctor. Routledge, 2018. 1–16.

Friedman, Ken. "Intermedia: Four Histories, Three Directions, Two Futures." *Intermedia: Enacting the Liminal*. Ed. Hans Breder and Klaus-Peter Busse. Dortmunder Schriften zur Kunst, 2005. 51–62.

Frodeman, Robert. "The Future of Interdisciplinarity: An Introduction to the Second Edition." *The Oxford Handbook of Interdisciplinarity*. Ed. Robert Frodeman, Julie Thompson Klein, and Roberto C. S. Pacheco. 2nd ed. Oxford UP, 2017. 3–8.

Frow, John. *Genre: The New Critical Idiom*. Routledge, 2005.

Fuchs, Christian. "The Political Economy of Privacy on Facebook." *Journal of Television and New Media*, vol. 13, no. 2, 2012: pp. 139–59.

Fuentes, Marcela. "Performance Constellations: Memory and Event in Digitally Enabled Protests in the Americas." *Text and Performance Quarterly*. vol. 35, no. 1, 2015: pp. 24–42.

——. *Performance Constellations: Networks of Protest and Activism in Latin America*. U of Michigan P, 2019.

Fuller, Stephen. "The Military-Industrial Route to Interdisciplinarity." *The Oxford Handbook of Interdisciplinarity*. Ed. Robert Frodeman, Julie Thompson Klein, and Roberto C. S. Pacheco. 2nd ed. Oxford UP, 2017. 53–67.

Gache. Belén. *Escrituras nómades*. Editorial Trea, 2006.

——. *Góngora Wordtoys*, <http://belengache.net/gongorawordtoys/gongorawordtoys.html>. Accessed 23 January 2023.

——. "La poética visual como género híbrido." doc.mx, <https://xdoc.mx/documents/la-poetica-visual-como-genero-hibrido-en-las-fronteras-entre-el-leer-5f6d6d9fc0357>. Accessed 4 April 2023.

——. *Radikal Karaoke*, <http://belengache.net/rk>. Accessed 23 January 2023.

——. "Transgresiones y márgenes de la literatura expandida." Posgrado virtual lectura, escritura y educación. FLACSO, 2011. Web, <belengache.net/flacso.htm>. Accessed 24 January 2023.

——. *Wordtoys*, <http://www.findelmundo.com.ar/wordtoys/>. Accessed 23 January 2023.

Gainza, Carolina, and Carolina Zúñiga. "Solicitud de colaboración para proyecto de investigación sobre literatura digital latinoamericana." 28 August 2018. Email.

Galindo, Regina José. *Conversation: Regina José Galindo*, Kettle's Yard, Cambridge. 6 March 2018, <http://www.kettlesyard.co.uk/events/conversation-regina-jose-galindo/>. Accessed 23 January 2023.

——. <www.reginajosegalindo.com>. Accessed 23 January 2023.

Galloway, Alexander R. "The Cybernetic Hypothesis." *Differences: In the Shadows of the Digital Humanities*, vol. 25, no. 1, 2014: pp. 107–31.

——. *Protocol: How Control Exists After Decentralization*. MIT Press, 2004.

García Santamaría, Inti, "Mónica Nepote – Hechos Diversos," <https://www.youtube.com/watch?v=r5JQtuRhtss&t=2s>. Accessed 23 January 2023.

Gentic, Tania, and Matthew Bush. "Introduction: Mediatized Sensibilities in a Globalized Era." *Technology, Literature, and Digital Culture in Latin America: Mediatized Sensibilities in a Globalized Era*. Ed. Matthew Bush and Tania Gentic. Routledge, 2016. 1–20.

Glazier, Loss. *Pequeño Digital Poetics: The Making of E-Poetries*. U of Alabama P, 2002.

Golder, Gabriela. *Despojos*, <http://www.gabrielagolder.com/despojos.htm>. Accessed 30 October 2022.

BIBLIOGRAPHY

——. *Inventario de bienes*, <http://gabrielagolder.com/inventario%20de%20 bienes.htm>. Accessed 23 January 2023.

——. *Itinerarios posibles para volver a casa* (gabrielagolder.com). Accessed 23 January 2023.

——. *Postales*, <http://postal.free.fr/>. Accessed 23 January 2023.

——. *Rescate*, <http://gabrielagolder.com/rescate%20inst.htm>. Accessed 23 January 2023.

Golder, Gabriela, and Mariela Yeregui. *Escrituras*, <http://proyectoescrituras.net>, 2014. Accessed 23 January 2023.

González, Mónica. *Geografía del dolor*, 2011, <www.geografiadeldolor.com>. Accessed 23 January 2023.

Grossberger Morales, Lucia. *Cyber chica*. Artist's webpage, c. 2004, <http://www. cyber-chica.com/>. Accessed 7 June 2013 [Site no longer available].

——. *Love Notes for the Planet*, 2018, <https://www.facebook.com/pg/notasdea-moralplaneta/posts/>. Accessed 23 January 2023.

——. *Lucia Grossberger Morales*. Artist's webpage, 2013–, <http://luciagrossberger-morales.com>. Accessed 23 January 2023.

——. *On the Bridge: Between Bolivia and Computers*. Published by the author with CreateSpace Independent Publishing Platform, 2009.

——. *Sangre Boliviana*. Partial version available online, 1992–2002, <http://www. cyber-chica.com/sangre/index.html>. Accessed 7 June 2013. Now available at: <https://luciagrossbergermorales.com/sangre-boliviana.html>. Accessed 24 January 2023.

—— *Weaving Art with Computers*. iBook Store, 2013.

——. *Weaving Art with Computers*. Published by the author as an iBook, 2014, <https://itunes.apple.com/ec/book/weaving-art-with-computers/id8237 74566?mt=11>. Accessed 23 January 2023.

Grosz, Elizabeth. *Chaos, Territory, Art: Deleuze and the Framing of the Earth*. Columbia UP, 2008.

——. *Volatile Bodies: Toward a Corporeal Feminism*. Indiana UP, 1994.

Groys, Boris. "From Image to Image File – and Back: Art in the Age of Digitalization." *Art Power*. MIT Press, 2008.

Gruszinski, Ana Cláudia, and Sérgio Capparelli. *Ciber & poemas*. http://www. ciberpoesia.com.br/ [Website used flash and is no longer available].

Haraway, Donna. "The Actors Are Cyborg, Nature Is Coyote, and the Geography Is Elsewhere: Postscript to 'Cyborgs at Large.'" *Technoculture*. Ed. Constance Penley and Andrew Ross. U of Minnesota P, 1991. 21–26.

——. "A Cyborg Manifesto: Science, Technology, and Socialist-Feminism in the Late Twentieth Century." *Simians, Cyborgs, and Women: The Reinvention of Nature*. Free Association Books, 1991. 149–81.

——. *Simians, Cyborgs, and Women*. Routledge, 1991.

Hardt, Michael, and Antoni Negri. *Empire*. Harvard UP, 2000.

Hayles, N. Katherine. *Electronic Literature. New Horizons for the Literary*. U of Notre Dame P, 2008.

——. *My Mother Was a Computer: Digital Subjects and Literary Texts.* U of Chicago P, 2005.

——. "Print is Flat, Code is Deep. The Importance of Media-Specific Analysis." *Transmedia Frictions. The Digital, The Arts, and The Humanities.* Ed. Marsha Kinder and Tara McPherson. U of California P, 2014. 20–33.

——. "The Time of Digital Poetry: From Object to Event." *New Media Poetics.* Ed. Adalaide Kirby Morris and Thomas Swiss. MIT Press, 2006. 1181–210.

Hayles, N. Katherine, and Jessica Pressman, eds. *Comparative Textual Media: Transforming the Humanities in the Postprint Era, Electronic Mediations.* U of Minnesota P, 2013.

Hellström Reimer, Maria et al. "Blind and Fake – Exploring the Geography of the Expanded Book." *Nordic Design Research*, no. 4, 2011: pp. 68–76, <http://www.nordes.org/opj/index.php/n13/article/view/105>. Accessed 23 January 2023.

Hernández, Selva. *Léme. Selva Hernández.* Ediciones Acapulco, <http://www.edicionesacapulco.mx/prensa/selva-hernandez-ediciones-acapulco/>. Accessed 23 January 2023.

Hidalgo, Emilse B. "The Historical and Geographical Imagination in Recent Argentine Fiction: Rodrigo Fresán and the DNA of a Globalized Writer." *New Trends in Contemporary Latin American Narrative. Post-National Literatures and the Canon.* Ed. Timothy R. Robbins and José Eduardo González. Palgrave Macmillan, 2014. 105–31.

Higgins. Dick. "Intermedia." *Something Else Newsletter*, vol. 1, no. 1, 1966, <http://www.primaryinformation.org/oldsite/SEP/Something-Else-Press_Newsletter_V1N1.pdf>. Accessed 23 January 2023.

——. with an appendix by Hannah Higgins, "Intermedia." *Leonardo*, vol. 34, no. 1, 2001: pp. 49–54.

Higgins, Dick. "Statement on Intermedia." 1966, <http://www.artpool.hu/Fluxus/Higgins/intermedia2.html>. Accessed 30 October 2023.

Hills, Matt. "The Justified Ancients of Mu Mu's 'Comeback' as a Transmedia Undertaking." *Global Convergence Cultures. Transmedia Earth.* Ed. Matthew Freeman and William Proctor. Routledge, 2018. 20–37.

Hind, Emily. *Dude Lit. Mexican Men Writing and Performing Competence, 1955–2012.* U of Arizona P, 2019.

Holbrook, J. Britt. "Peer Review, Interdisciplinarity, and Serendipity." *The Oxford Handbook of Interdisciplinarity.* Ed. Robert Frodeman, Julie Thompson Klein, and Roberto C. S. Pacheco. 2nd ed. Oxford UP, 2017. 85–97.

Horn, Maja. "Bodily (Re)Marks: The Performance Art of Regina José Galindo." n.d., <http://artpulsemagazine.com/bodily-remarks-the-performance-art-of-regina-jose-galindo>. Accessed 23 January 2023.

Huitrón Vázquez, Lorena. "Via Corporis by Pura López Colomé." *Latin American Literature Today*, vol. 1, no. 2, 2017, <https://latinamericanliteraturetoday.org/book_review/corporis-pura-lopez-colome/>. Accessed 24 January 2023.

Ilich, Fran. "La pregunta del style vs. substance en el ciberespacio." *Tekné 1.0: Arte, pensamiento y tecnología.* Conaculta, 2004, 91–106.

BIBLIOGRAPHY

Irland, Basia. "Ice Books" and "Hydrolibros," <http://www.basiairland.com/projects/index.html>. Accessed 23 January 2023.

Iser, Wolfang. "La estructura apelativa de los textos." *En busca del texto. Teoría de la recepción literaria*, Ed. Dieter Rall. UNAM, 1993. 99–119.

Jameson, Frederic. "Postmodernism and Consumer Society." *The Anti-Aesthetic: Essays on Postmodern Culture*, Ed. Hal Foster. Bay Press, 1983. 111–25.

Jáuregui, Carlos. "Writing Communities on the Internet: Textual Authority and Territorialization." *Latin American Literature and Mass Media*. Ed. Edmundo Paz-Soldán and Debra A. Castillo. Garland, 2001. 288–300.

Jaúregui, Gabriela. *Controlled Decay*. Black Goat, 2008.

——. Poetry at Amsterdam Café. YouTube, <https://www.youtube.com/watch?v=2Pc2D9FHDCY>. Accessed 23 January 2023.

Jauss, Hans Robert, ed. *Historia de la literatura como una provocación*. Gredos, 2013.

Jenkins, Henry. *Convergence Culture. Where Old and New Media Collide*. New York UP, 2006.

Jenkins, Henry "Transmedia 202: Further Reflections," <http://henryjenkins.org/blog/2011/08/defining_transmedia_further_re.html>. Accessed 17 March 2023.

Kattenbelt, Chiel, "Intermediality in Theatre and Performance: Definitions, Perceptions, and Medial Relationships." *Cultura, lenguaje y representación. Revista de estudios culturales de la Universitat Jaume I*, no. 6, 2008: pp. 19–29.

Kim, Hyomin. "Reconstructing the Public in Old and New Governance: A Korean Case of Nuclear Energy Policy." *Public Understanding of Science*, vol. 23 no. 3, 2014: 268–82.

Kinder, Marsha. "Transmedia Networks." Marsha Kinder Legacies, <http://www.marshakinder.com/concepts/o11.html>. Accessed 23 January 2023.

Kinder, Marsha, and Tara McPherson, eds. *Transmedia Frictions: The Digital, the Arts, and the Humanities*. U of California P, 2014.

Kozak, Claudia. "Literatura expandida en el dominio digital." *El Taco en La Brea*, no. 6, 2017: pp. 220–245, <bibliotecavirtual.unl.edu.ar/ojs/index.php/ElTacoenlaBrea/article/view/6973>. Accessed 23 January 2023.

——. "Literatura visual urbana." *Deslindes. Ensayos sobre la literatura y sus límites en el siglo XX*. Ed. Claudia Kozak. Beatriz Viterbo, 2006. 141–51.

——. *Tecnopoéticas argentinas. Archivo blando de arte y tecnología*. Caja Negra, 2015.

Kozak, Claudia, and Inés Laitano. "Multimedia." *Tecnopoéticas argentinas. Archivo blando de arte y tecnología*, Ed. Claudia Kozak. Caja Negra, 2021. 180–83.

Krauss, Rosalind, "Sculpture in the Expanded Field." *October*, no. 8: 1979: pp. 30–44.

Kress, Gunther, and Theo van Leeuwen. *Multimodal Discourse. The Modes and Media of Contemporary Communication*. Arnold, 2001.

Kristeva, Julia. *Powers of Horror: An Essay on Abjection*. Trans. L. S. Roudiez. Columbia UP, 1982.

LaBelle, Brandon, *Lexicon of the Mouth: Poetics and Politics of Voice and the Oral Imaginary*. Bloomsbury, 2014.

Lagarde, Marcela. "Una feminista contra el feminicidio." *Revista Envio*, no. 278, 2005, <https://www.envio.org.ni/articulo/2888>. Accessed 23 January 2023.

Landow, George P. *Hypertext: The Convergence of Contemporary Critical Theory and Technology*. Johns Hopkins UP, 1992.

———. *Hypertext 2.0: The Convergence of Contemporary Critical Theory and Technology*. Johns Hopkins UP, 1997.

———. *Hypertext 3.0: Critical Theory and New Media in an Era of Globalization*. 3rd ed. Johns Hopkins UP, 2006.

Laqueur, Thomas. *The Work of the Dead: A Cultural History of Mortal Remains*. Princeton UP. 2015.

Lavery, Jane E. *The Art of Ana Clavel: Ghosts, Urinals, Dolls, Shadows, and Outlaw Desires*. Legenda, 2015.

Lavery, Jane E., and Sarah Bowskill. "Eli Neira: Pursuing Community and Interconnectedness Against the Commodification and Institutionalization of Culture in Chile." *Bulletin of Spanish Visual Studies*, vol. 4, no. 1, 2020: pp. 93–124. https://doi.org/10.1080/24741604.2020.1726066.

Lavery, Jane E., and Sarah Bowskill. "The Representation of the Female Body in the Multimedia Works of Regina José Galindo." *Bulletin of Latin American Research*, vol. 31, no. 1, 2012: pp. 51–64.

Ledesma, Eduardo. "Close Readings of the Historic and Digital Avant-Gardes: An Archeology of Hispanic Kinetic Poetry." *Hybrid Storyspaces*. Ed. Christine Henseler and Debra Castillo. Hispanic Issues Online, 2012. Web, <http://hispanicissues.umn.edu/HybridStoryspaces.html>. Accessed 23 January 2023.

———. "The Poetics and Politics of Computer Code in Latin America: Codework, Code Art, and Live Coding." *Revista de Estudios Hispánicos*, vol. XLIX, no. 1, 2015: pp. 91–120.

———. *Radical Poetry: Aesthetics, Politics, Technology, and the Ibero-American Avant-Garde (1900–2015)*. SUNY, 2016.

Lessig, Lawrence. *Free Culture: How Big Media Uses Technology and the Law to Lock Down Culture and Control Creativity*. Penguin, 2004.

———. *Remix: Making Art and Commerce Thrive in the Hybrid Economy*. Penguin, 2008.

Lippard, Lucy R. *Mixed Blessings: New Art in a Multicultural America*. Pantheon, 1990.

Loebell, Ricardo. "Repeso de un ensayo: a propósito de la narrativa de Eugenia Prado." *Literatura y Lingüística*, vol. 12, 2000: pp. 167–81.

Longhurst, Robyn. *Bodies: Exploring Fluid Boundaries*. Routledge, 2001.

López, Ana. "Calling for Intermediality: Latin American Mediascape." *Cinema Journal*, vol. 54, no. 1, 2014: pp. 135–41.

López Colomé, Pura. *Via Corporis*. Fondo de Cultura Económica. 2016.

———. Email to the author. 15 October 2018. Email.

Lopez Garcia, Jacalyn. *Chicanolandia*. Latina/o Art Community Website. 1999, <http://www.latinoartcommunity.org/community/ChicArt/ArtistDir/JacGar.html>. Accessed 23 January 2023.

BIBLIOGRAPHY

——. *Glass Houses: A Tour of American Assimilation from a Mexican-American Perspective*, 1997, <http://artelunasol.com/GHstatement.html>. Accessed 23 January 2023.

——. "Glass Houses: A Tour of American Assimilation from a Mexican-American Perspective." *Leonardo*, vol. 33, no. 4. 2000: 263–64.

——. "Jacalyn Lopez Garcia." Artist's profile, Latina/o Art Community, <http://latin oartcommunity.org/community/ChicArt/ArtistDir/JacGar.html>. Accessed 23 January 2023.

——. *Jacalyn Lopez Garcia*, artist's webpage, c. 2002–. Accessed 23 January 2023.

——. *Life Cycles: Reflections of Change and a New Hope for Future Generations*. U of California, Riverside, 2006. Web, <https://web.archive.org/web/20210211000249/http://lifecycles.ucr.edu/>. Accessed 24 January 2023.

——. and Lucy H. G. *Living Large*. 2004, <http://artelunasol.com/Living_Large/video.html>. Accessed 23 January 2023.

Louvel, Liliane. *Poetics of the Iconotext*. Trans. Laurence Petit. Ed. Karen Jacobs. Ashgate, 2011.

Ludovico, Alessandro. *Post-Digital Print: The Mutation of Publishing Since 1894*. Onomatopee, 2012.

Lugones, María. "The Coloniality of Gender." *World and Knowledges Otherwise*. 2 (Spring), 2008: pp. 1–17.

——. "Heterosexualism and the Colonial/Modern Gender System." *Hypatia*, vol. 22, no. 1, 2007: pp. 186–209.

——. "Toward a Decolonial Feminism." *Hypatia*, vol. 25, no. 4, 2010, pp. 742–59.

Mackern, Brian. "Epithelia." *Net Art Anthology*, <https://anthology.rhizome.org/epithelia>. Accessed 23 January 2023.

Maldonado, Tryno. Review of *Urbe probeta*, Knfrt Recs, <www.discoskonfort.com/index.php/urbe-probeta>. Accessed 23 January 2023.

Malloy, Judy, ed. *Women, Art, and Technology*. MIT Press, 2003.

Manovich, Lev. *The Language of New Media*. MIT Press, 2001.

——. "Post-Media Aesthetics." *Transmedia Frictions. The Digital, the Arts, and the Humanities*, ed. Marsha Kinder and Tara McPherson. U of California P, 2014. 34–44.

Marino, Mark. "Code." *The Johns Hopkins Guide to Digital Media*. Ed. Marie-Laure Ryan, Lori Emerson, and Benjamin Robertson. Johns Hopkins UP, 2014.

Martín-Barbero, Jesús. "Latin American Cyberliterature: From the Lettered City to the Creativity of its Citizens." *Latin American Cyberculture and Cyberliterature*. Trans. Claire Taylor. Ed. Claire Taylor and Thea Pitman. Liverpool UP, 2007. xi–xv.

Marx, Karl. *Elementos fundamentales para la crítica de la economía política (Grundrisse) 1857–1858*. vol. 2. Siglo XXI, 1972. 216–30.

Matrix. Dir. Andy and Larry Wachowski. Warner Bros, 1999. Film.

Medeiros-Lichem, M. T. *La voz femenina en la narrativa latinoamericana: una relectura crítica*. Trans. M. R. Schachinger. Editorial Cuarto Propio, 2006.

Menabrea, Luigi Federico. *Sketch of the Analytical Engine Invented by Charles Babbage, Esq*. With Notes Upon the Memoir by the Translator Ada Augusta, Countess of Lovelace. Bibliothèque Universelle de Genève, no. 82, 1842.

———. <https://www.fourmilab.ch/babbage/sketch.html>. Accessed 23 January 2023.

Mejias, Ulises A. *Off the Network: Disrupting the Digital World*. U of Minnesota P, 2013. Kindle file.

Mencía, María, ed. *#WomenTechLit*. Computing Literature. West Virginia UP, 2017.

Merrifield, Andy. *The Amateur: The Pleasures of Doing What You Love*. Verso, 2017.

Mitchell, Peta. C*ontagious Metaphor*. Bloomsbury, 2012.

Mitchell, W. J. T. "'Ut Pictura Theoria': Abstract Painting and the Repression of Language." *Critical Inquiry*, vol. 15, no. 2, 1989: pp. 348–71.

Monjour, Servanne. *Mythologies postphotographiques: l'invention littéraire de l'image numérique*. Les Presses de l'U de Montréal, 2018.

Monsiváis, Carlos. "Del rancho a Internet." *Letra Internacional*, vol. 4, no. 53, 1997: pp. 4–13.

Montfort, Nick. *Twisty Little Passages: An Approach to Interactive Fiction*. MIT Press, 2003.

Moraga, Cherríe. *Chicano Codex: Encountering Art of the Americas*. Duke UP, 2011.

Moraga, Cherríe, and Gloria Anzaldúa, eds. *This Bridge Called My Back: Writings by Radical Women of Color*. Persephone Press, 1981.

Morales, Natalia Plaza. "La cultura de la imagen. La imagen como signo en la literatura mexicana." *Crítica. Cl. Revista Latinoamericana de Ensayo*, Santiago de Chile, año IX, 2015. Web, <critica.cl/artes-visuales/la-cultura-de-la-imagen-la-imagen-como-signo-en-la-literatura-mexicana>. Accessed 23 January 2023.

Mori, Masahiro. *The Buddha in the Robot: A Robot Engineer's Thoughts on Science and Religion*. Trans. Charles S. Terry. Kosei Publishing Co., 2011.

Motín Poeta, <http://motinpoeta.blogspot.com/>. Accessed 23 January 2023.

Nakamura, Lisa. *Cybertypes: Race, Ethnicity, and Identity on the Internet*. Routledge, 2002.

National Museum of Mexican Art. "Rastros y Crónicas. Women of Juárez," <http://nationalmuseumofmexicanart.org/exhibits/rastros-y-cr%C3%B3nicas-women-juarez>. Accessed 23 January 2023.

Neira, Eli. *Abyecta*. Al Margen Editores, 2003.

———. *Corazón inmaculado*, <http://elizabethneira.blogspot.co.uk/2014_02_01_archive.html>. Accessed 23 January 2023.

———. *El enemigo interno*, <http://videoselineira.blogspot.co.uk/2012/06/blog-post.html>. Accessed 1 December 2018. As of January 2023 the video now displays as restricted access.

———. *La flor*. Ediciones Poesíaaccion Abyecta Ediciones Rabiosamenteindependientes, 2014.

BIBLIOGRAPHY

——. "Hacia una po-etica de la acción (parte 1): intentos de una personal historia sobre la performance." *Escáner Cultural*, 13 December, 2012, <http://revista.escaner.cl/node/6660>. Accessed 23 January 2023.

——. *Hago el amor conmigo misma*. Duniaska ediciones and Poesíaacción Abyecta Ediciones Rabiosamenteindependientes, 2017.

——. <https://facebook.com>. Accessed 23 January 2023.

——. "Minimanifiesto escatológico." Saturday, 9 June 2012, 12:15 pm. Web, <http://elizabethneira.blogspot.co.uk/2012/06/minimanifiesto-escatologico.html>. Accessed 1 December 2018 [page subsequently removed].

——. Personal email. 5 February, 2018. Email.

——. Personal email. 21 February, 2018. Email.

——. Personal email. 10 May, 2018. Email.

——. "La tiendita de arte," <http://abyectalatiendita.blogspot.co.uk/?zx=7d49b-95cdd5d286d>. Accessed 23 January 2023.

——. and Feministas Biobio. No title. YouTube. <https://www.youtube.com/watch?v=bRzJ20FC90k>. Accessed 23 January 2023.

Neira Eli, and Fede Eisner. *Poesía para señoritas*, CasAcción, Santiago Chile. YouTube, <https://www.youtube.com/watch?v=-5BETKTRqwI>. Accessed 23 January 2023.

Nepote, Mónica. *@Articulaciones del silencio / Soledades / CCEMX*. Manipulación de audio en tiempo real Cinthya García Leyva. *Soledades. Lecturas sonoras del imaginario gongorino. Curation by Fernando Vigueras. Articulaciones del Silencio. Ciclo de conciertos y jornadas de reflexión alrededor de la música improvisada.* Centro Cultural de España en México, Mexico City, 30 September 2014, Video Mónica García Rojas, <https://www.youtube.com/watch?v=jlzBCfP-KKdE>. Accessed 23 January 2023, <https://www.youtube.com/watch?v=EIf-6cYe6h7k>. Accessed 4 April 2023.

——. "De la selfie a la voz común, hacia la visibilidad de la crítica en literatura en el aquí y el ahora." *Crítica y rencor*. Ed. Luis Bugarini, Alejandro Badillo, Geney Beltrán Félix, Gabriela Damián Miravete, Guillermo Espinosa Estrada, Miguel Ángel Hernández Acosta Eduardo Huchín Sosa, Mónica Nepote, Jezreel Salazar, and Ricardo Sevilla. Cuadrivio, 2015. 75–82.

——. "De la voz común, hacia la visibilidad de la crítica en literatura en el aquí y el ahora." *Crítica y rencor*. Ed. Luis Bugarini, Alejandro Badillo, Geney Beltrán Félix, Gabriela Damián Miravete, Guillermo Espinosa Estrada, Miguel Ángel Hernández Acosta, Eduardo Huchín Sosa, Mónica Nepote, Jezreel Salazar, and Ricardo Sevilla. Cuadrivio, 2015. 75–82.

——. @Desbordiamentos I "Mi voz es mi pastor." Performance de Mónica Nepote en el marco de la exposición "Soledades, lecturas sonoras del imaginario gongorino" y el ciclo de música improvisada. "Articulaciones del silencio" realizados en el Centro Cultural de España en México.

——. *Hechos diversos*. Acapulco Ediciones, 2014.

——. *Mi voz es mi pastor* – performance de Mónica Nepote en el marco de la exposición "Soledades, lecturas sonoras del imaginario gongorino" y el ciclo de música improvisada 'Articulaciones del silencio' realizados en el Centro

Cultural de España en México, <https://vimeo.com/119616965>. Accessed 4 April 2032.

——. Personal email. "La voz es mi pastor." 18 July 2018.

——. Personal interview. Centro de Cultura Digital, Mexico City, 14 December 2016.

——. Proyecto E-Literatura del Centro de Cultura Digital, <https://editorial.centroculturadigital.mx/>. Accessed 23 January 2023.

——. "Roswell." Taimado sioux. Oficina de proyectos aparenciales e imaginarios neponita, 27 September 2013, <http://taimadosioux.tumblr.com/post/62422898518/roswell-video-colaboración-con-luis-felipe-ortega>. Accessed 23 January 2023.

Nerval, Gerard de. *Selected Writings*. Trans. Richard Sieburth. Penguin, 1999.

Nochlin, Linda. "Why Have There Been No Great Women Artists?" *1971. Women, Art, and Power and Other Essays*. Harper & Row, 1988. 145–78.

Notary Society, The. "What a Notary Does," 2023, <https://www.thenotariessociety.org.uk/_>. Accessed 23 January 2023.

Odin, Jaishree K. "The Performative and the Processual: A Study of Hypertext/Postcolonial Aesthetic." *Contemporary Postcolonial and Postimperial Literature in English*, n.d., <http://www.postcolonialweb.org/poldiscourse/odin/odin1.html>. Accessed 23 January 2023.

Orozco, Fátima, 30 min de maquillaje y libros. LasPalabrasDeFa. YouTube, <www.youtube.com/watch?v=sTKg4Ne_VAY>. Accessed 23 January 2023.

——. "El abrigo rojo." *No te calles: seis relatos contra el odio*. Ed. Fa Orozco and Javier Ruescas. Penguin Random House, 2018. 167–89.

——. About on YouTube. LasPalabrasDeFa, YouTube, <www.youtube.com/user/laspalabrasdefa/about>. Accessed 23 January 2023.

——. *¿Conozco mi librero? ¿O soy puro cuento? LasPalabrasDeFa*. YouTube, <www.youtube.com/watch?v=yrg3UIG6fko>. Accessed 23 January 2023.

——. *Coordenadas en mis estanterías. LasPalabrasDeFa*. YouTube, <www.youtube.com/watch?v=FDYdMqotiJ8>. Accessed 23 January 2023.

——. *Cuentos de buenas noches para niñas rebeldes. LasPalabrasDeFa*. YouTube, <www.youtube.com/watch?v=jyuZ2mYlvsU>. Accessed 23 January 2023.

——. *Metáforas de "bajo la misma estrella" (TFIOS Metaphors) John Green. LasPalabrasDeFa*. YouTube, <www.youtube.com/watch?v=NnovJMlbzmo&t=985s>. Accessed 23 January 2023.

——. *Mis ediciones de Peter Pan, LasPalabrasDeFa*. YouTube, <www.youtube.com/watch?v=WNR67jltq3w>. Accessed 23 January 2023.

——. La Pequeño Pony @FaOrozco. Twitter, <https://twitter.com/FaOrozco>. Accessed 21 September 2018.

——. Personal communication. "Estudio tu obra desde la Universidad de Florida." 5 December 2017. Email.

Orr, Mary. *Intertextuality: Debates and Contexts*. Polity, 2005.

——. "Intertextuality." *Encyclopaedia of Literary and Cultural Theory: Vol. II, Literary Theory from 1966 to the Present*. Ed. Michael Ryan and Robert Eaglestone.

BIBLIOGRAPHY

Blackwell, 2011. 1–4. Web, <http://www.literatureencyclopedia.com>. Accessed 23 January 2023.

Osorio, Olave A. *Postales del centenario: imágenes para pensar el porfiriato.* UAM, 2009.

Pano Alamán, Ana. "Hypermedia Narratives: Paratactic Structures and Multiple Readings." *Literatures in the Digital Era: Theory and Praxis.* Ed. Amelia Sanz and Dolores Romero. Cambridge Scholars, 2007. 297–303.

Pato, Ana. *Literatura expandida. Arquivo e citação na obra de Dominique González-Foerster.* Edições Sesc/Associação Cultural Videobrasil, 2012.

Paz, Octavio. *The Labyrinth of Solitude and Other Writings.* Trans. Lysander Kemp. Grove Press, 1985.

Paz, Octavio. *The Monkey Grammarian.* Peter Owen, 1989.

Paz, Octavio. *El mono gramático.* Seix Barral, 1974.

——. <http://www.elem.mx/obra/datos/8815>. Accessed 4 April 2023.

Peláez, Sol. "Counting Violence. Roberto Bolaño and 2666." *Chasqui*, vol. 42, no. 2, 2014: pp. 30–47.

Pérez Camacho, Carmen, and Andrés López Ojeda. "Los usos sociales de la lectura: del modo tradicional a otras formas colectivas de leer." *Hacia una antropología de los lectores.* Ediciones Culturales Paidós, Fundación Telefónica, UAM Iztapalapa, 2015. 39–104.

Perlongher, Néstor, "Cadáveres." *Alambres.* Ediciones Último Reino, 1987.

——. "Corpses." Trans. William Rowe. *The Argentina Reader: History, Culture, Politics.* Ed. Gabriela Nouzeilles and Graciela Montaldo. Duke UP, 2002. 457–64.

Pírez, Pedro. "Buenos Aires: Fragmentation and Privatization of the Metropolitan City." *Environment and Urbanization*, vol. 14, no. 1, 2002: pp. 145–58.

Pitman, Thea. "Hypertext in Context: Space and Time in the Hypertext and Hypermedia Fictions of Blas Valdez and Doménico Chiappe." *Latin American Cyberculture and Cyberliterature.* Ed. Claire Taylor and Thea Pitman. Liverpool UP, 2007. 227–43.

Plant. Sadie. *Situacionism: The Most Radical Gesture. The Situationist International in a Postmodern Age.* Routledge, 1992.

Pollock, Griselda "Women, Art, and Art History: Gender and Feminist Analyses." *Oxford Bibliographies*, 2020, <https://www.oxfordbibliographies.com/view/document/obo-9780199920105/obo-9780199920105-0034.xml>. Accessed 23 January 2023.

Plummer, David, and Pol Dominic McCann, "Girls' Germs: Sexuality, Gender, Health and Metaphors of Contagion." *Health Sociology Review*, vol. 16, no. 1. 2007: pp. 43–52, DOI: 10.5172/ hesr.2007.16.1.43.

Prado, Eugenia. *Asedios.* Unpublished, 2017.

——. *Hembros*, <http://hembros-eugeniaprado.blogspot.com/>. Accessed 23 January 2023.

——. "Hembros, asedios a lo posthumano, 2004." Creación, *Revista Laboratorio de Escrituras* (2016), <https://laboratoriodeescrituras.udp.cl/hembros/>. Accessed 24 January 2023.

———. "Hembros, asedios a lo posthumano, novela instalación." Nota. *Revista Laboratorio de Escrituras*, 2016, <http://www.laboratoriodeescrituras.cl/wp-content/uploads/2016/09/Hembros_Asedios_a_lo_Posthumano.pdf>. Accessed 23 January 2023.

———. Interview. "Deambulo por las redes, porque escribir es político y para mí lo micro función." By Carolina Gainza, 2016, <http://culturadigitalchile.cl/wp-content/uploads/2017/03/Entrevista-Eugenia-Prado.pdf>. Accessed 23 January 2023.

Piglia, Ricardo. *La ciudad ausente.* Random House Mondadori, 2013.

Radrigán, Valeria. *Corpus frontera. Antología crítica de arte y cibercultura.* Mago Editores, 2011.

———. *Yto: del pigmento al electrón.* Editorial 8 Libros, 2018.

Rajewsky, Irina O. "Border Talks: The Problematic Status of Media Borders in the Current Debate about Intermediality." Ed. Lars Elleström. Palgrave Macmillan, 2010. 51–68.

———. "Intermediality, Intertextuality, and Remediation: A Literary Perspective on Intermediality." *Intermédialités*, no. 6, 2005: pp. 43–64.

Raley, Rita "Editor's Introduction: Writing 3D." Iowa Review, vol. 8, no. 3, 2006: pp. 1–6, <https://elmcip.net/node/1445>. Accessed 23 January 2023.

Ramírez, Josué. "La fantasía del contraste: Anábasis maqueta, de Carla Faesler." *Letras Libres*, vol. 68, 2005: p. 79.

Rindstedt, Camilla, and Karin Aronsson. "Growing Up Monolingual in a Bilingual Community: The Quichua Reviltalization Paradox." *Language in Society*, vol. 31, no. 5, 2002: pp. 721–42.

Roehrig, Terence. "Executive Leadership and the Continuing Quest for Justice in Argentina." *Human Rights Quarterly*, vol. 31, no. 3, 2009: pp. 721–47.

Rojo, César. "Geografía del dolor, un mapa de la violación a los derechos humanos en México." Diagonal. 3 March 2015, <www.diagonalperiodico.net/culturas/26034-geografia-del-dolor-mapa-la-violacion-derechos-humanos-mexico.html>. Accessed 23 January 2023.

Román-Odio, Clara. *Sacred Iconographies in Chicana Cultural Productions.* Palgrave Macmillan, 2013. 19–49.

Romero López, Dolores. "From Analogue to Hypermedia Texts in Hispanic Literatures." *Neohelicon*, no. 36, 2009: pp. 463–75.

Rosario, Giovanna di. "For an Aesthetic of Digital Poetry." *Revue des Littératures de l'Union Européenne/Review of Literatures of the European Union*, vol. 5, 2006; pp. 1–13, <http://digital.casalini.it/10.1400/102333>. Accessed 23 January 2023.

Rovira Sancho, Guiomar. "Constelaciones performativas y multitudes urbanas: el activism en red: la sensibilidad feminista y la contrainsurgencia." *Descatos* vol. 61, 2019: pp. 40–55.

———. "El devenir feminista de la acción colectiva. Las multitudes conectadas y la nueva ola transnacional contra las violencias machistas en red." *Teknokultura*, vol. 15, no. 2, 2018: pp. 223–40.

BIBLIOGRAPHY

289

Rueda Ortiz, Rocío. "Apropriación social de las tecnologías de la información: ciberciudadanías emergentes." Foro: comunicación y ciudadanía. *América Latina en movimiento*, 28 November 2005, <http://www.movimientos.org/foro_comunicacion/show_text/php3?key=5930>. Accessed 23 January 2023.

Russell, Diana E. H. "The Origin and the Importance of the Term Femicide." December 2011, <https://www.dianarussell.com/origin_of_femicide.html>. Accessed 23 January 2023. Lecture.

Ryan, Marie-Laure. "Story/Wolds/Media. Tuning the Instruments of a Media-Conscious Narratology." *Storyworlds Across Media. Toward a Media-Conscious Narratology*. Ed. Marie-Laure Ryan and Jan-Noël Thon. U of Nebraska P, 2014. 25–49.

Ryan, Marie-Laure, and Jan-Noël, Thon. *Storyworlds Across Media*. University of Nebraska Press, 2014.

Sadin, Éric. *La humanidad aumentada*. Caja negra, 2017.

Sánchez, Leticia. "Ana Clavel: la censura como fuente de creación artística." *Milenio*, Cultura, 20 de septiembre de 2005, 43.

Sánchez-Mesa, Domingo, and Jan Baetens. "La literatura en expansión. Intermedialidad y transmedialidad en el cruce entre la literatura comparada, los estudios culturales, y los New Media Studies." *Tropelías. Revista de Teoría de la Literatura y Literatura Comparada*, vol. 27, 2017: pp. 6–27.

Sánchez Sánchez, María. "La joven mexicana que consigue que 200.000 personas se interesen por el Conde Lucanor." *El País* [Madrid], 24 July 2015, <verne.elpais.com/verne/2015/07/23/articulo/1437656337_736972.html>. Accessed 21 September 2018.

Sánchez Vásquez, Adolfo. "De la estética de la recepción a la estética de la participación." *Real/virtual en la estética y la teoría de las artes*. Ed. Simón Marchán. Editorial Paidós, 2006. 17–28.

Sandoval, Chela, and Guisela Latorre. "Chicana/o Artivism: Judy Baca's Digital Work with Youth of Color." *Learning Race and Ethnicity: Youth and Digital Media*. Ed. Anna Everett. MIT Press, 2008. 81–108.

Sax, David. "Our Love Affair with Digital Is Over." *Sunday Review. Opinion. The New York Times*, 18 November 2017, <www.nytimes.com/2017/11/18/opinion/sunday/internet-digital-technology-return-to-analog.html>. Accessed 23 January 2023.

Schaffner, Anna Katherine. "From Concrete to Digital: The Reconceptualisation of Poetic Space." From Concrete to Digital. Georg Brandes School, Copenhagen University, 9–10 November 2006. Paper presentation.

Schaffner, Anna Katherine, and Andrew Michael Roberts. "Rhetorics of Surface and Depth in Digital Poetry." *Revue des Littératures de l'Union Européenne/Review of Literatures of the European Union*, vol. 5, 2006: pp. 37–48, <http://www.rilune.org/mono5/5_schaffner_roberts.pdf>. Accessed 23 January 2023.

Schamber, Pablo J., and Francisco M. Suárez. "Actores sociales y cirujeo y gestión de residuos: una mirada sobre el circuito informal del reciclaje en el conurbano bonaerense." *Revista Realidad Económica Buenos Aires*, vol. 190, 2002:

pp. 1–11, <https://www.iade.org.ar/noticias/actores-sociales-y-cirujeo-y-gestion-de-residuos-una-mirada-sobre-el-circuito-informal-del>. Accessed 23 January 2023.

Schoonmaker, Kara. "Hypermedia." Media Theory blog. The Chicago School of Media Theory, 2007. Web, <https://lucian.uchicago.edu/blogs/mediatheory/keywords/hypermedia/>. Accessed 23 January 2023.

Schröter, Jens. "Discourses and Models of Intermediality." *Contents of CLCWeb: Comparative Literature and Culture*, vol. 13, no. 3, 2011; pp. 2–7, <doi.org/10.7771/1481-4374.1790>. Accessed 23 January 2023.

Scolari, Carlos. *Narrativas transmedia: cuando todos los medios cuentan*. Deusto Ediciones, 2013.

Scolari, Carlos A., Mar Guerrero-Pico, and María-José Establés. "Emergences, Strategies, and Limitations of Spanish Transmedia Productions." *Global Convergence Cultures. Transmedia Earth*. Ed. Matthew Freeman and William Proctor. Routledge, 2018. 38–68.

Sebakis, Sagrado (Sebastián Kirzner). *De porque la poesía slam y la alt lit son de los más intenso e increíble*. YouTube, <https://www.youtube.com/watch?v=xQU-4_oRuf0>. [Video set to private as of January 2023].

Segato, Rita Laura "The Virtues of Disobedience." 2019, <https://www.rosalux.de/en/publication/id/40778/the-virtues-of-disobedience>. Accessed 28 May 2022.

Shenassa, Shirin. "The Lack of Materiality in Latin American Media Theory." *Latin American Literature and Mass Media*. Ed. Edmundo Paz-Soldán and Debra A. Castillo, Garland, 2001. 249–69.

Shildrick, Margrit. *Leaky Bodies and Boundaries: Feminism, Postmodernism and (Bio)ethics*. Psychology Press, 1997.

Soldán, Paz Edmundo, and Debra A. Castillo, eds. *Latin American Literature and Mass Media. Hispanic Issues 22*. Garland, 2001.

Sonvilla-Weiss, Stefan. 2010. "Introduction: Mashups, Remix Practices, and the Recombination of Existing Digital Content.", *Mashup Cultures*. Ed. Stefan Sonvilla-Weiss. Springer. 8–23.

Sorapure, Madeleine. "Screening Moments, Scrolling Lives: Diary Writing on the Web." *The New Media and Cybercultures Anthology*. Ed. Nayar K. Pramod. Wiley-Blackwell, 2010. 499–514.

Spielmann, Yvonne. "Synesthesia and Intersenses: Intermedia in Electronic Images." *Leonardo*, vol. 34, no. 1, 2001: pp. 55–61.

Springer. J. M. "Imaginar el deseo masculine desde lo femenino y viceversa: Cuerpo naúfrago de Ana Clavel." Réplica21. 17 October 2005, <https://www.replica21.com/archivo/articulos/s_t/384_springer_clavel.html>. Accessed 23 January 2023.

Staudt, Kathleen, and Howard Campbell. "The Other Side of the Ciudad Juárez Femicide Story." Revista. Harvard Review of Latin America, Winter 2008, <https://archive.revista.drclas.harvard.edu/book/other-side-ciudad-ju%C3%A1rez-femicide-story#:~:text=One%20teen%2Daged%20worker%20

BIBLIOGRAPHY

was,law%20enforcement%20and%20judicial%20institutions>. Accessed 23 January 2023.

Sturken, Marita, Douglas Thomas, and Sandra Ball-Rockeach, eds. *Technological Visions: The Hopes and Fears that Shape New Technologies.* Temple UP, 2004.

Taylor, Claire. Entre "'Born Digital' y herencia literaria: el diálogo entre formatos literarios y tecnología digital en la poética electrónica hispanoamericana." *Tropelías: Revista de Teoría de la Literatura y Literatura Comparada*, vol. 27, 2017: pp. 79–90.

——. "From the Baroque to Twitter: Tracing the Literary Heritage of Digital Genres." *Comparative Critical Studies*, vol. 13, no. 3, 2017: pp. 207–329, <https://doi.org/10.3366/ccs.2016.0208>. Accessed 23 January 2023.

——. "Virtual Bodies in Cyberspace: Guzik Glantz's Weblog." *Latin American Cyberculture and Cyberliterature.* Ed. Claire Taylor and Thea Pitman. Liverpool UP, 2007. 244–56.

Taylor, Claire, and Thea Pitman. "Introduction." *Latin American Cyberculture and Cyberliterature.* Ed. Claire Taylor and Thea Pitman. Liverpool UP, 2007. 1–30.

——. *Latin American Identity in Online Cultural Production.* Routledge, 2013.

Taylor, Claire, and Niamh Thornton. "Modern Languages and the Digital: The Shape of the Discipline." *Modern Languages Open*, 2017, <https://www.modernlanguagesopen.org/articles/10.3828/mlo.v0i0.156/>. Accessed 23 January 2023.

Taylor, Diana. *The Archive and the Repertoire: Performing Cultural Memory in the Americas.* Duke UP, 2003.

——. *Disappearing Acts: Spectacles of Gender and Nationalism in Argentina's Dirty War.* Duke UP. 1997.

Torres, Rui. "Digital Poetry and Collaborative Wreadings of Literary Texts." 2004, <https://telepoesis.net/papers/dpoetry.pdf>. Accessed 23 January 2023.

Trejo Delarbre, Raúl. "La Internet en América Latina." *Las industrias culturales en la integración latinoamericana.* Ed. Néstor García Canclini and Carlos Juan Moneta. Grijalbo / Sistema Económica Latinoamericana, UNESCO, 1999. 311–56.

——. *Urbe probeta.* Knfrt Recs. 2003, <www.discoskonfort.com/index.php/urbe-probeta>. Accessed 23 January 2023.

Uribe, Ana María. *Anipoemas*, <http://www.vispo.com/uribe/anipoemas.html>. Accessed 23 January 2023.

Verstraete, Ginette. "Intermedialities: A Brief Survey of Conceptual Key Issues." *Acta Universitatis Sapientiae, Film and Media Studies*, vol. 2, 2010: pp. 7–14, <http://www.acta.sapientia.ro/acta-film/C2/film2-1.pdf>. Accessed 23 January 2023.

Vilches Malagón, Cecilia, and Martín Ramiro Sandoval Cortés, "La tarjeta postal como fuente de información para entender la historia de un país." Universidad Nacional Autónoma de México, Dirección General de Biblioteca, <www.girona.cat/sgdap/docs/a72sk0dc-vilches-text.pdf>. Accessed 23 January 2023.

Villeda, Karen. Laboratorio de ciberpoesía, <http://www.poetronica.net/LABO/ver_mas.htm>. Accessed 23 January 2023.

——. *Poetrónica*, <http://www.poetronica.net>. Accessed 23 January 2023.

——. *Tesauro*. Mexico: CONACULTA, 2010.

Vos, Eric. "The Eternal Network. Mail Art, Intermedia Semiotics, Interarts Studies." *Interart Poetics. Essays on the Interrelation of the Arts and Media*. Ed. Ulla-Britta Lagerroth, Hans Lund, and Erik Hedling. Rodopi, 2007. 325–36.

Wakeford, Nina. "Networking Women and Grrrls with Information/Communication Technology: Surfing Tales of the World Wide Web." *The Cybercultures Reader*. Ed. David Bell and Barbara M. Kennedy 1997. Routledge, 2000. 350–59.

Walkowitz, Rebecca L. *Born Translated: The Contemporary Novel in an Age of World Literature*. Colombia UP, 2015.

Weibel, Peter. "Foreword." *The Art of Science Interface and Interaction Design*. Ed. Christa Sommerer, C. Lakhmi, and Laurent Migonneau. Berlin, Heidelberg: Springer-Verlag, 2008.

Weintraub, Scott. *Latin American Technopoetics: Scientific Explorations in New Media*. Routledge, 2018

Wendorf, Richard, ed. *Articulate Images*. U of Minnesota P, 1983.

Werner Wolf. "(Inter)mediality and the Study of Literature." *Contents of CLCWeb: Comparative Literature and Culture*, vol. 13, no. 3, 2011, <doi.org/10.7771/1481-4374.1789>. Accessed 23 January 2023.

William and Mary. "What is Decoloniality," Decolonising Humanities Project, <https://www.wm.edu/sites/dhp/decoloniality/index.php>. Accessed 17 March 2023.

Williams, Linda. "A Provoking Agent: The Pornography and Performance Art of Annie Sprinkle." *Social Text*, no. 37: 1993, pp. 117–33.

Williams, Raymond. "B. From Reflection to Mediation (1977)." *Sociology of Art: A Reader*. Ed. Jeremy Tanner. Taylor and Francis e-library, 2004. 81–84.

Winocur, Rosalía. "Digital Culture." *Dictionary of Latin American Cultural Studies*. Trans. Ruth Halvey. Ed. Robert McKee Irwin and Mónica Szurmuk. UP of Florida, 2012. 131–41.

Wood, Andrew F., and Tyrone L. Adams. "Embracing the Machine: Quilt and Quilting as Community-Building Architecture." *Cyberghetto or Cybertopia? Race, Class, and Gender on the Internet*. Ed. Bosah Ebo. Praeger, 1998. 219–33.

Wright, David. "Dots Mark the Spot: Textual Gaps in Dubliners." *James Joyce Quarterly*, vol. 41, no. 1–2, 2003: pp. 151–59.

Wright, Melissa W. "Public Women, Profit, and Femicide in Northern Mexico." *South Atlantic Quarterly*, vol. 105, no. 4. 2006: pp. 681–98.

Yeregui, Mariela. *Epithelia*, <anthology.rhizome.org/epithelia>. Accessed 30 October 2018.

——. *Hay cadáveres*, <https://marielayeregui.com/cadaveres/>. Accessed 23 January 2023.

BIBLIOGRAPHY

Young, Iris Marion. "Abjection and Oppression: Dynamics of Unconscious Racism, Sexism, and Homophobia." *Crises in Continental Philosophy.* Ed. Arleen B. Dallery and Charles E. Scott. SUNY P, 1990. 201–13.

Younglebood, Gene. *Expanded Cinema.* Dutton, 1970.

Zalce, G. Martínez, "La apropiación y sus formas: las Violetas de Ana Clavel." *Nada es lo que parece. Estudios sobre la novela mexicana, 2000–2009.* Ed. Miguel Rodríguez Lozano. UNAM, 2012.

Zerbarini, Marina.

——. *Eveline, Fragments of a Reply.* 2004, <https://youtu.be/J0W_iyV7_wg>. Accessed 30 October. 2018.

——. *Memory Weave / Tejido de memoria.* 2003, <https://youtu.be/r4B4-D7jIKI>. Accessed 23 January 2023.

——. *Net Art. Obras 1997–2013: Multimedia, net.art, instalaciones electrónicas, objetos.* Artists' website, <https://www.marina-zerbarini.com.ar/WordPress/net-art/>.

Zurita, Raúl. "Tracing Empire." *Imperio/Empire.* Trans. Tanya Huntington. Ed. Rocío Cerón. FONCA, 2009. 183–88.

Index

Amoxtli/Codex 9, 188–9, 191
Abuse 17, 21, 24, 73, 112, 146, 160–2, 266–7, 272
Acevedo, Pilar 1, 3–4, 18, 21, 24, 26, 73–9, 145–64
Active Reader 17, 19, 150
Activism 18, 19, 21, 23, 31, 159, 201, 202, 229
Adler, Jazmín 205, 271
Aesthetics 21, 26, 28, 35, 42, 58, 84, 111–12, 119–20, 123, 125, 129–30, 132, 136, 137–41, 144, 151, 153, 176, 178–9, 182, 186, 212, 216, 221–3, 226, 231–2, 234, 238–9
Affect 196, 202–3
Algorithm 100, 130, 133–5, 143–4, 229–30, 262, 264
Álvarez Sanabria, Carlos Aarón 150
Amateur 19–20, 25, 26, 34, 147, 165–75, 180–3
Anderson, Benedict 158, 271
Animals 59, 65, 95, 103, 114, 116–18, 189–90, 193–5, 199, 219
"anxiety of influence" 19
Anzaldúa, Gloria 7, 245, 273
Apollinaire, Guillaume 41, 223
Appadurai, Arjun 149, 272
Araujo S., Laura 94
Archive 114, 185, 202, 214 n.3, 221, 223–4, 228, 233–4
Arreola, Guillermo 21, 27, 185–7, 195, 203
Artificial Intelligence (AI) 17, 132, 140
Artishock 7, 271
Artist (artistic) 1–6, 8, 11–14, 18–31, 34–6, 45, 48, 49 n.6, 551, 53 n.1, 56, 59, 63–4, 72, 74, 78, 83, 90, 92–5,

97, 99, 101, 106–8, 110–12, 115, 117, 120, 122–3, 125–7, 130, 131 n.7, 136, 139, 141, 145 n.2, 147, 149–50, 154, 158–61, 164–5, 167, 170, 172–6, 182–3, 185, 187, 205–8, 211, 213, 214 n.3, 215–16, 218, 220–1, 228, 232–3, 235–8, 240–3, 245–6, 248–51, 260, 268–9
Artivism 159
 see also activism
Assemblage 26, 67, 73–7, 144, 146, 158–60
Audran, Marie 15–16, 187, 199, 272
 see also Chiani and Schmitter
Author (writer) 1–11, 13, 18–25, 27–9, 30, 31, 33–8, 41–2, 44, 47, 48, 51, 56, 59, 70, 72, 76, 81, 93, 96, 108, 110, 115, 122, 127, 129–30, 133–5, 138–9, 140–3, 145, 147, 149, 154, 161, 164, 169, 172–3, 175, 180, 182, 191, 195, 201, 204, 206–9, 214, 218, 220–1, 226, 234, 236, 240–1, 245, 249, 251–2, 256, 257 n.5, 261, 263, 269
Autobiography 28, 89, 92–3, 209, 212, 227, 235–50
Avatar 141, 227–8, 260
Ayotzinapa 68

Babbage, Charles 100
Back-to-the-book 48, 166
Baetens, Jan
 Expanded liteature ('literatura en expansión') 9, 11, 186
 and transmedial processes / transmedia 15, 49

and intermediality 165–6, 186, 271, 289

see also Mesa, Domingo Sánchez

Balderston, Daniel 9, 272

Balgiu, Alex 5, 272

Bambozzi, Lucas 209, 272

Barbosa, Emilia 114–15, 272

Barthes, Roland 16, 22, 139, 272

Bassi, Eugenia Prado 1, 17, 19, 23, 26, 31, 37, 53–8, 129–36, 138–42, 144, 145 n.2, 153 n.13

Baudrillard, Jean 87, 272

Bellatin, Mario 6, 37, 42

Benjamin, Walter 224, 232–3, 272

Bergson, Henri 207, 272

Bhabha, Homi 272

Biculturality 28, 92, 235, 238, 240, 242, 243–7, 249

Binaries (esp. breaking down of) (binary) 19, 26, 85–6, 108, 111, 167, 172–4, 182–3, 188, 198, 203

Blog 28, 37, 42, 56, 59, 108, 114–15, 118, 122, 130, 131, 133–4, 137–9, 141, 145 n.2, 146 n.4, 158–9, 166, 180, 220, 239, 251

Body 20, 24, 26, 35–7, 44, 54–6, 58, 59, 63, 70–2, 82, 84–5, 92, 94, 96–7, 109–12, 115–20, 122–5, 141–2, 156, 165, 170, 174–5, 177, 185 n.1, 186–91, 194, 201, 215–16, 222, 225–6, 228, 230, 259, 262

see also corporeal

Bodies 2, 6, 224, 27, 37, 51, 53–4, 56, 58, 65, 71–2, 85, 109, 116–18, 123, 140–2, 147, 154, 170, 174–5, 183, 186, 189, 197, 202–3, 207, 209, 212, 216, 267

see also corporeal

Booktube 165, 169–70, 178–83

Borders (boundaries, border-crossing, boundary object) 1–4, 9, 10, 14–15, 26, 29, 31, 55, 87, 90, 110, 117–19, 125–7, 142, 146, 147–9, 150, 153–4, 156, 158, 159, 163, 168, 173,

186, 189–91, 194, 202, 205, 209, 211, 213–14, 216, 218, 232, 238–9, 251, 255

Borges, Jorge Luis 13, 16, 87, 254, 272

Bourriaud, Nicolas 26, 148–51, 153–4, 156–7, 160–2, 164, 272

Bowskill, Sarah 1–32, 1, 3, 4, 8, 13, 14–16, 18–20, 26, 29, 107–9, 111, 120, 125, 145–64, 175, 185–6, 188, 203, 251, 272–3

("contamination between artistic languages") 145

Brachetti Peretti, Nicole 31, 273

Bravo, Monika 221

Brea, José Luis 27, 207, 273

Breton, André 41

Brillenburg Wurth, Kiene 166, 206, 273

Bruhn Jensen, Klaus

"implicit intertextuality" and "explicit hypertextuality" 14, 17, 111, 22, 273

Bruhn, Jørgen 13, 29, 149

Buenos Aires 25, 81–8, 216, 265–8

Burke, Peter 9

cultural hybridization 109, 273

Bustamante, Verónica Maza 48, 273

Butler, Judith 111, 117

Byron, Ada 100

Cada 125

Campos, Augusto de 223–5, 230, 231–2, 244, 273

Canclini, Néstor García, and 'impurity' 9, 149, 273

Canon 1, 6 n.4, 9, 18, 83, 108, 118, 125, 172, 227, 252, 261

Capitalism 56, 58, 182, 255, 257–60, 267, 269

Carroll, Lewis 40–1

Cartels 197–9

Cartoneros (including *cartonera* movement) 18, 125, 172, 268

Castellanos, Rosario 201, 273

INDEX 297

Castillo, Debra 4–6, 9, 12, 16–17, 19, 25, 27, 107, 108, 146, 157, 166, 180, 221–34, 253, 274
Cerón, Rocío 1, 26, 29, 37, 145–56, 158, 162–4, 174, 274
Chacón, Hilda 21, 274
Challenger, Tamsyn 163
Chatbot 129
Chiani, Miriam 15–16, 187, 199, 271
Chicano / Chicana 25, 28, 90, 92, 242–3, 245, 248–50
Childhood/children 21, 24, 33, 59, 73, 78–9, 90, 120–1, 145 n.3, 150, 161–2, 200–1, 214 n.23, 230, 242, 243 n.17, 246 n.19
Cisneros, David J. 18, 274
Ciudad Juárez 156–7,159,162
Clavel, Ana 1, 3–4, 11, 15, 17–18, 20–1, 33–52, 107–11, 114–17, 120–1, 125–7, 172–7, 188
Clüver, Claus 12, 17, 206, 275
Code (including as language) 18, 22, 85, 93–4, 97, 130, 132, 134–9, 144, 173, 176, 178, 225, 228, 231, 241 n.11
Cohen, Leonard 76
Colectivo CAIN 130
Collaboration 2–3, 19, 21, 23–5, 27, 42, 47 n.4, 48, 51, 54, 72, 81, 83, 94, 96–7, 110, 119–20, 122–3, 130 n.4, 150, 154, 166, 168, 173–4, 176, 185, 204, 207, 211, 220, 222
Collage 24, 73, 77, 101, 104–5, 109, 117–18, 125, 158, 215
Communication 3, 9, 13–14, 56–8, 86, 129, 201–2, 221
Community 7, 17, 21, 24, 82–8, 102–3, 109, 123–4, 152–4, 158, 162–3, 179, 186, 199–200, 203, 248–50
Computer 12, 20, 25, 53, 56, 90, 92–4, 99–106, 177, 219–21, 223–5, 229, 233, 236–7, 240–2, 244, 246, 248–9, 259

Concrete poetry 5, 25, 27, 38, 41, 157, 223, 224–5, 232
see also poetry
Contamination (including as metaphor) 19, 58, 107–8, 145 n.2, 147, 154, 163, 252
see also pollution
Coronavirus pandemic see COVID-19
Corporeal 82, 107, 109, 117, 121, 182, 189, 202
see also body, bodies
Correa-Díaz, Luis 9, 275
Cortázar, Julio 16–17, 41, 63, 139
COVID-19 17–19, 30–1
Crisis 15, 21, 30, 33, 58, 107, 123–4, 267 n.13, 268
Crosscurrent 1–2, 5, 10, 14, 29, 110, 117 n.6, 187
Cruz Arzabal, Roberto 67, 145, 155–7, 166, 167, 175, 183, 275
Cullen, Deborah 6, 126, 127, 275
Cultural recycling 4, 16, 18, 25, 28, 117–21, 126, 139, 159, 252
Cusicanqui, Silvia Rivera 60, 276
Cyberfeminism 235, 241, 244, 249
Cyborg 28, 56, 58, 142, 144, 238, 241 n.11, 244, 248, 250

Dance 25, 76, 90, 121, 123, 130 n.4, 157–8, 167–8, 173–5, 177, 183, 194, 215, 220, 226, 234
Davis, Cynthia J. 18, 276
De la Peña, Isabel 96
De la Torre, Mónica 5, 221, 227
Deleuze, Gilles 27, 85, 133, 206–7, 271, 276
Deleuze, Gilles and Guattari, Félix (Deleuze and Guattari) 27, 133, 187, 198, 276
Desnos, Robert divinatory art 41
Destabilize (including unstable, instability) 19, 26–7, 37, 110–13, 117, 132, 141, 144, 148–9, 151, 155, 177–8, 203, 206–7, 225, 233, 252

Díaz, Ella 126, 276
Dick, Higgins 14, 30, 126, 163, 206, 280
Dictatorship 61, 116, 123–4, 200, 214, 217, 265–9
Digital art (digital artist) 2, 18, 26, 31, 72, 108, 117, 159 n.22, 170, 172, 212, 235–7, 241, 248
Digital condition (the) 26, 130–44
Digital literature 3, 9, 16, 109 n.2, 137–8, 140–1, 178, 214, 236
Digital obsolescence (updated, fungibility, durability, obsolete) 17, 25, 27–8, 31, 87, 93, 107, 125, 179, 207, 212, 215, 219–34, 237, 241 n.8, 247 n.20, 261
Disappearance 21, 27, 186, 196–8, 200, 203
Disciplines (including transdisciplinary, cross-disciplinary, interdisciplinary) 3–4, 10, 20, 83, 112, 123, 138, 141, 166, 172, 205, 218
DIY 105, 173, 222
Documentary 5, 27, 89, 94–5, 97, 159, 186
Domestic violence 73
Dorantes, Amaranta 121, 276
Douglas, Mary and 'pollution ideas' 18–19, 147, 276
Drift art 83
Druxes, Helga 125, 276
Duchamp, Marcel 34, 36, 41, 111, 117, 120
Dunbar, Paul Laurence 74, 76
Duras, Marguerite 70, 153

Electronic art 86, 173, 205
Electronic Literature 138 n.10, 212–15, 260
 see also digital literature
Elleström, Lars 13–14, 186, 273, 276, 288
Emotion (emotional, including specific emotions e.g. grief,

love) 38, 49, 51, 54, 60–1, 68, 73–4, 90, 101, 105–6, 107, 177, 179, 196, 198, 200–3, 208, 212, 227, 253–4
Environment (urban, nature, natural, planet, built landscape) 1, 5, 17, 21, 23–7, 30, 61, 81–8, 105–6, 109, 117, 121–4, 126–7, 176, 178, 185 n.1, 199–200, 205, 211–12, 219, 227, 230, 258
Escena de Avanzada 125
Expanded (Intermedial) Literature / expanded book 9, 27, 186, 191–2, 207

Fabric see weaving
Facebook (social media) 9, 17, 56, 95–6, 115, 122, 130
Faesler, Carla 1, 4, 24, 26, 67–70, 151, 165–80, 183
Fajardo-Hill, Cecilia 6, 277
Family 25, 73, 78, 90, 95, 104, 162, 177–8, 180 n.12, 196–8, 200–2, 212, 214 n.3, 242, 246–7
Fantastical (fantasy) 73, 96, 113, 130
Feder, Eisner, *Orchestra of Poets* (*Orquestra de Poetas*) 6, 119
Feminicide 156–7, 159, 161–3
Feminism / Feminist 6–7, 10, 21, 23, 30, 59, 61, 90, 115, 118–19 n.8, 122–3, 127, 165, 238, 241, 244–5, 247–9
 see also cyberfeminism
Field, Terri 122, 277
Finnegan, Nuala 7–8, 19, 27, 107–8, 186–204, 277
Fluxus 96, 280
FONDART (Chile) 130
 see also funding bodies
Fragmentary (fragment, fragmented, fragmentation) 28–9, 37 n.2, 54–5, 69, 78, 103, 131–3, 136–7, 151, 187, 194, 200, 207–9, 212–16, 226,

239 n.5, 243–4, 254, 257, 261, 264, 267, 269
Freeman, Matthew 15, 149, 159, 277, 280, 290
Friedman, Ken 18, 278
Frow, John 108, 278
Fuentes, Marcela 21, 278
Funding bodies 45, 55, 78, 146, 154
 see also FONDART

Gache, Belén 1, 16–18, 28, 37, 207, 219–20, 225–31, 233, 251–60, 269
Gainza, Carolina 3–4, 22, 26, 129–44, 278, 288
Galindo, Regina José 1, 3, 4, 5, 15, 18, 20–1, 24, 63–5, 107–17, 121–7
Gallery 20, 22, 96, 103, 164, 209, 214 n.3, 237
 see also institutions
Galloway, Alexander 135–6, 166, 182, 278
Games (including online, MMORPG, Second Life, Call of Duty, videogames) 38, 86, 130–1, 165, 174, 178, 181, 222, 227–9, 240, 254
García Canclini, Néstor 9, 159, 273, 291
Garcia, Carlos 94
Garcia, Rex 94
Gender 1, 4, 6–8, 14, 21, 23–6, 28–30, 71, 90, 96, 109–12, 117, 119–24, 126–7, 142, 147, 161, 172, 174–7, 180–82, 240–4, 247, 250
Gendered violence 21, 109, 111–12, 117, 123
 see also feminicide
Genre 7, 9, 23, 25–7, 58, 108, 110–12, 114–15, 117, 119–20, 123, 125–6, 132, 141, 159, 175–6, 178, 180, 183, 188, 205–6, 209, 213, 220–1, 225–6, 252, 269
Gerber, Verónica 6, 37
Godoy, Cecilia 53–4, 130
Golder, Gabriela 1, 18, 21, 205, 208, 210, 212–14, 218

Golder, Gabriela and Yeregui, Mariela 24–5, 27, 81–8, 176, 207–8, 210–11, 213, 218, 252 n.2, 278–9
 see also Yeregui
Góngora, Luis de 28, 227, 252–4, 260, 269, 278
Gonzalez, Mike 9, 272
González, Mónica 1, 21, 27, 108, 185–7, 195–6, 200–1, 203, 279
Gordillo, Gabriela 72
Graffiti 9, 211–13
Grossberger Morales, Lucia 1, 4, 16, 18, 20, 25, 28, 30, 99–106, 235–7, 240–6, 249, 250 n.22
Grosz, Elizabeth 84–5, 182, 279
Grupo de Arte Callejero (Street Art Group) 85
Guattari, Félix 27, 133, 187, 198, 276
 see also Deleuze and

Hack (hacking, hacker) 26, 134, 139–40, 144, 165–83
Haptic 13, 186, 206, 209, 217, 218
Haraway, Donna 28, 142, 238, 241, 244–5, 248, 250, 279
Hardt, Michael and Antonio Negri 153–4, 257, 279
Hashtag 220, 231
Hayles, N. Katherine and Pressman, Jessica 9, 10, 12, 22, 111, 178, 280
Hayles, N. Katherine 9, 10, 12, 16, 22, 28, 111, 138, 178, 182, 230, 232, 234, 260, 279–80
Hegel, Georg Wilhelm Friedrich 153
Hellström Reiner et al. 27, 186, 188, 191–2, 194, 196–7, 202, 280
Higgins, Dick 30, 126
 and Intermedia(lity) 14, 163, 206, 280
Hind, Emily 4, 20, 22, 26, 147, 151, 165–84, 280
Horn, Maja 126, 280

HTML (hypertext markup language) 93, 236, 239
Hybrid (hybridity, hybridization) 9, 16, 19, 24, 41, 54, 59, 108–9, 111–12, 117, 119, 125, 141–4, 203, 209, 228, 239, 245, 251
Hyperlink 16, 22, 25, 100, 133, 215, 236–7, 261, 264
Hypermedia 4, 11–12, 16, 17, 21–2, 27–9, 38, 42, 45, 139, 196, 214, 235–40, 242 n.12, 243, 246, 249
Hypertext 4, 14, 16–19, 28, 37–8, 41, 44, 93, 114, 132–3, 137–41, 221–2, 231, 235–41, 244–6, 249–50, 252, 264–5

Iconoclasistas (Iconoclassicists Group) 85
Identity 6, 23–5, 37, 55, 58–60, 82, 84, 90, 92, 95–6, 101–2, 106, 108, 111, 122, 126, 134, 141–3, 146 n.5, 149, 158, 162–3, 170, 177, 179–80, 197, 200, 212, 236, 238, 240, 242–3, 245–7, 249–50
Ilich, Fran (concept of techné) 173, 280
Image/text 69, 108, 188
Imagination 9, 69, 73, 95, 130, 178, 232
Indigenous (people/communities) 8, 19, 24, 59, 65, 99, 102–5, 113, 121–2, 124, 127, 244, 246
Instagram 9, 56, 151
see also social media
Installation 18, 21, 25, 27, 34–7, 44, 47, 49–51, 53, 55, 57, 83, 96, 103–5, 108, 110–11, 120–1, 127, 141, 172–3, 205, 208, 210, 213–14, 216–17, 226, 237, 242, 265
Institutions 6, 96, 115, 125–7, 154
see also gallery, museum, funding bodies
Interactive 16–17, 21–2, 25, 27, 36, 51, 73, 86–7, 90, 92–4, 96–7, 100–4, 106, 114, 126, 130–5, 137–41, 143–4, 155, 159–60, 176, 181, 186, 188, 194, 212,

214–15, 220–1, 223, 227–30, 233–4, 237, 240, 243–4, 248–9, 252–3, 255–6, 258–60, 262, 264–5, 269
Interface 28, 58, 72, 86–8, 130, 165–6, 171, 175–6, 178–80, 182–3, 215, 222, 227–8, 230, 256, 262, 265
Intermedia (intermediality) 4, 11, 13–17, 19–20, 25–30, 34, 38, 48, 82–3, 87, 107–8, 110–12, 114–15, 117–25, 127, 163, 165–7, 171–3, 176, 181, 185–7, 189, 191–2, 194–5, 198–200, 202–9, 211, 213–14, 216, 218–20, 222, 224–5, 230, 237, 251, 258, 260, 265–6, 269
Internet 12–13, 16–17, 20, 22–3, 25, 35, 44, 58, 89, 90, 92–4, 96, 101, 105–6, 134, 136, 141, 169–71, 173, 176, 186, 206, 215–16, 220–3, 228, 233–4, 236, 239–41, 246, 248–50
Intertextuality 4, 14–19, 109, 120–1, 148, 153, 253–4, 269
Irland, Basia 219, 234, 281

Jameson, Frederic 125, 281
Jáuregui, Carlos 19, 281
Jaúregui, Gabriela 221, 281
Jenkins, Henry 15, 26, 148, n.148, 149–50, 281
Joyce, James 28, 68, 216, 261–4, 269

Kattenbelt, Chiel 206, 281
Kinder, Marsha 21, 26, 148, 280
Kozak, Claudia 4, 12–15, 27, 131, 186, 205–18, 281
Krauss, Rosalind 218, 281
Kress, Gunther 13, 206, 281
Kristeva, Julia (abject; abjection; abjectness) 117–18, 122, 124, 281

Labelle, Brendon 71, 181
Laitano, Inés 131, 281
Landow, George P. Hypertext (as synonym of Hypermedia) 16, 138, 238–9, 282

INDEX

301

Lavery, Jane E. 1–3, 7–8, 13–16, 18–20, 23, 29–30, 34, 47, 107–28, 109, 111, 118, 120–1, 125, 145, 166, 172–3, 180, 185–6, 188, 203, 251, 276, 282

Layers 16, 25, 59, 73, 82–6, 90, 94, 100–1, 103, 113, 125, 136, 150, 160, 186, 216, 227, 237, 245–6

Ledesma, Eduardo 9, 12, 146, 282

Leon, Darren J. de 94

Lessig, Lawrence 166–7, 182, 282

Literature (literary) 1–6, 8–16, 18–20, 22, 24–30, 33–8, 41–2, 47–9, 51, 54, 58, 67, 73–4, 78, 94, 97, 108, 109 n.2, 110–11, 114–15, 117, 120–1, 125–6, 130, 131 n.7, 132–5, 137–41, 144, 146–7, 149, 159, 164, 166, 169–72, 175–6, 178, 180, 182, 205–9, 211–12, 214–18, 222–3, 230, 236, 239, 242, 251–2, 254, 257, 260–1, 265, 269

Longhurst, Robyn 116, 282

López Colomé, Pura 1, 18, 21, 27, 108, 185–9, 191, 193 n.6, 195, 202–3

Lopez Garcia, Jacalyn 1, 4, 12, 20, 25, 28, 89–98, 159, 235–7, 240, 243, 246–50

Louvel, Lliane (iconotext) 27, 187, 189, 192, 193, 283

Lugones, María 7 n.5
and Decoloniality 8, 283

M. Lopez, Ana 9

Mackern, Brian 215–16, 283

Madres de la Plaza de Mayo 202, n.9, 202, 265–6
see also activism

Maldonado, Tryno 176–7, 183, 283

Mallarmé, Stéphane 16, 223, 229, 232

Manipulation 34, 45, 118, 132, 133–4, 136–7, 139, 143–4, 167–8, 220, 223, 259, 269

Manovich, Lev 13, 133–4, 138–9, 283

Map (including cartography) 83, 85, 86–8, 187, 189, 191, 194–5, 196, 200, 239, 262

Marino, Mark 136, 183

Martínez, César 36

Marx, Karl 130, 173, 283

Materiality 117, 124, 141, 144, 166, 168, 175, 207–8, 211, 216–18, 224, 232

McCann, Pol Dominic 18 n.11, 287

McPherson, Tara 18, 280

Mediation 14, 18, 72, 83, 86–7, 110, 125–7, 131, 188, 220, 230, 238, 241, 244–5

Mejias, Ulises A. 22, 284

Memory 5, 27, 29–30, 41, 42, 54, 59, 73, 78, 82, 84, 86–7, 92, 102, 133, 152, 154, 162, 177, 186, 202, 205, 207–13, 214 n.3, 216, 233, 237, 239, 246, 254, 260, 265–6, 268

Mencía, Maria 3, 10, 284

Merrifield, Andy 166, 170, 172–3, 284

Mesa, Domingo Sánchez and Jan Baetens
Expanded liteature ('literatura en expansión') 9, 11, 186
and transmedial processes / transmedia 15, 49
and intermediality 165–6, 186, 271, 289

Mestizaje (mestizo/a) 28, 59, 60, 108, 235–6, 250

Mitchell, Peta 107, 109, 116, 127, 284

Mode (modalities) 13, 25–7, 37, 108–12, 117, 185–9, 191, 206, 208, 213, 230, 234

Monjour, Servanne 11 n.9, 284

Moraga, Cherríe 191, 245, 284

Morales, Natalia Plaza 35, 284

Motín Poeta 107, 145, n.2 145, 154, 173–6, 284

Multiauthorship 19

302 INDEX

Multimedia (definitions and problems) 1–31
 see also hypertext, hypermedia, intermedia, intertextuality, mode, multimodal, transmedia, transliterary
Multimodal 4, 11, 13, 27, 29, 41, 42, 108, 186–76, 201, 203, 205–6
Multisensory 73
Murillo, Luis Alberto 150
Museum 56, 89, 96, 104, 159, 233
Music (musical) 2, 12, 23, 25, 27, 37, 42, 53, 55–6, 68, 90, 94, 96, 100, 108, 110, 116, 118– 19, 121–2, 130, 133, 136, 138, 141, 146 n.4, 150, 170 n.10, 176–7, 179, 186, 195–6, 203, 220, 227–8, 237, 244, 262

NAFTA 162
Narrative 4, 21, 24, 28, 35, 37–8, 41–2, 44, 51, 73–4, 79, 83, 86, 90, 92–5, 97, 131, 141–2, 144, 148–9, 152, 154, 159, 162, 178, 185–6, 196, 198–9, 201, 203, 213, 226, 235–6, 238–9, 242 n.12, 243–6, 247 n.20, 249, 261–5
Negri, Antonio 153–4, 257, 279
 see also Hardt, Michael
Neira, Eli 1, 3–4, 7, 15, 17–19, 21, 23–4, 31, 37, 59–62, 107–12, 114–23, 125–7
Neobarroso 217
Neoliberalism (neoliberal) 58, 140, 172, 259, 267–8
Nepote, Mónica 1, 4, 9, 21, 24, 26, 71–2, 145–51, 154–6, 158–9, 162–4, 165–80, 183
Net.art 27, 205, 212, 214, 215
Net literature 2
 see also digital literature, electronic literature
Netweaving see weaving
Network 3, 15–18, 23, 27–8, 30, 42, 54, 58, 82, 95, 134–6, 138–40, 148, 193,

198–9, 225, 229, 231, 233–4, 240, 241 n.11, 244, 248, 250
Non-linear 69, 137–8, 153–4, 238, 245
Novel 2, 4, 9, 11, 14, 23, 26, 33, 35–8, 41–2, 44–5, 47–8, 51, 54, 57, 108, 110–11, 120–1, 126, 129–32, 134–6, 138, 141–2, 148, 170, 172, 177–8, 181, 209, 228
Novelist 1–2, 37, 41, 172, 176
 see also writer, author

Objets trouvés (found objects, found footage) 73–4, 95, 125, 159, 210
Olalquiaga, Celeste 125
Olmedo Zamudio, Eduardo 150
Open-ended (as characteristic of text/ refusal of closure) 25, 93, 148, 151–2, 261–2
Orozco, Fátima 26, 165, 167, 169–74, 178–83
Orr, Mary 17, 286
Ortega, Luis Felipe 155, 286

Pachamama (Earth Mother) 104, 105
Painting 2, 11, 26–7, 34, 41–2, 68, 73–4, 78, 90, 99, 102–5, 108, 117–18, 132, 153, 158–62, 172, 185–90, 192–3, 199, 218, 236, 241, 243
Pato, Ana 207, 287
Paz, Octavio 41
Performance 2, 17–18, 20–2, 24–8, 30–1, 35–7, 44, 48, 53, 59–63, 65, 84–6, 96, 105, 108–26, 130–1, 133, 138, 141, 150, 154, 156, 167–8, 172, 175, 182–3, 205, 208–9, 211, 220 n.1, 221, 225–6, 228–9, 237, 240, 255
Perlongher, Néstor 216–17, 287
Photography (photograph, photographer) 2, 12–13, 27–8, 33–5, 37, 41–2, 44–5, 47, 73–4, 76,

INDEX 303

89–90, 92, 94–7, 108, 111, 117, 120,
 122, 168, 185–6, 190, 195–7, 200–1,
 206, 208, 236–7, 240, 242, 263,
 265–9
Piglia, Ricardo 129–30, 288
Pinto, Regina Célia 221
Pitman, Thea 4, 9, 12, 16, 19, 22–3, 28,
 147, 149, 235–50, 265 n.9
Plant, Sadie 212, 287
Plummer, David 18 n.11
 see also McCann
Poetry (poem, including slam
 poetry, performance poetry,
 poetry readings, digital poetry,
 cyberpoetry, concrete poetry,
 videopoetry) 4, 5, 18, 24–7, 37,
 41, 62–3, 71, 74, 76–7, 101, 111 n.5,
 112, 114, 118–19, 122–3, 133, 135,
 145–6, 150–60, 162, 164, 167, 171,
 174, 176–7, 183, 185, 187–95, 212,
 214, 216–17, 219, 221–8, 230–4,
 252–4, 256–7
Politics (Political) 1, 6–8, 10, 17, 21,
 25–6, 29 30, 55, 59–60, 71, 90, 107,
 109–10, 114, 116, 119, 123, 126, 157,
 159, 161, 163, 173, 186, 188, 194,
 202–3, 215, 217, 228–30, 238–9,
 246–8, 255–7, 259–60, 269
Pollock, Griselda 8, 287
Pollution (polluted; polluting) 18–19,
 26, 107–11, 114, 117–18, 121, 123,
 147, 203
 see also contamination, contagion
 contagion (contagious) of genres; of
 bodies 18–19, 107–9, 115–17, 121,
 126–7, 145, 147
 see also pollution, contamination
Popular culture 92, 148, 229
Postcolonial 7, 238–9, 245
Posthuman 53, 55–7, 199, 230
 see also cyborg
Post-medium 26, 145–9, 151–61, 163–4
Postnational 23, 149–50, 152–3, 158,
 162–4

Pressman, Jessica 9–10, 12, 22, 111,
 178, 280
 see also Hayes, Katherine N.
Print (print-medium) 9, 12, 16–17,
 20, 22, 25, 27, 38, 69, 92–4, 108,
 109 n.2, 110–12, 114, 119, 122,
 132–3, 137–8, 141, 150–2, 155,
 165–71, 176–9, 182, 191, 206–7,
 209, 211, 214, 220, 222–3, 225–6,
 231, 234, 251–2, 253, 262
Prizes (awards, competition,
 premio) 135, 136 n.7, 154, 168,
 175, 186, 196 230 n.4, 231
Proctor, William 15, 149, 159, 277
 see also and Freeman
"proto-hypertexts" 16
Proust, Marcel 207
Publishing (publishers, self-
 publishing) 6, 12, 20, 33–5, 63,
 93–4, 115, 138, 151, 154, 166–8, 170,
 172, 187 n.4, 200, 214 n.3, 221–2,
 233, 240, 250–1
Pure (purity, impurity) 2, 9, 12, 13, 19,
 24, 59, 60, 108, 110–11, 117, 246

QR code 25, 93–4, 97
Quintanilla, Grace 221

Race (racial) 1, 8, 14, 19, 21, 23–4, 26,
 107, 109–10, 112–13, 116–17, 121–3,
 126–7, 235, 249–50
Radicant see post-medium
Rajewsky, Irina O 13–14, 206, 288
Reader 4–5, 16–17, 19, 21–3, 25–7,
 29, 35, 37–8, 42, 48, 51, 70, 92–4,
 114–15, 117, 120, 125, 132, 134,
 136, 138–9, 141, 146 n.3, 149–53,
 157–8, 160, 162–3, 165, 169–70, 176,
 178–80, 182, 188 n.5, 189, 193–4,
 202, 214–16, 219, 220 n.1, 227,
 231–3, 236, 243–4, 246–7, 251–4,
 256, 258, 260–2, 264
Recycling (including cultural
 recycling) 4, 16, 18, 25, 28–9, 74,

95, 103, 109, 117, 119, 121, 124–6, 139, 159, 231, 252, 256, 266, 268–9
Religion (including Catholicism, Buddhism, spirituality) 8, 19, 26, 59, 68, 96, 102–6, 109, 118–19, 168, 242
Remediation see mediation
Remix 28, 139, 140 n.14, 253, 257, 261–2, 264, 269
Rewrite 49, 72, 95, 134, 139–40
Rhizome (rhizomatic) 18, 27, 42, 133–4, 140, 187, 198–200
Rivera Garza, Cristina 6, 42
Romero López, Dolores 12, n.3 236, 288
Rovira Sancho, Guiomar 21, 23, 288
Ryan, Marie-Laure 13, 148, 283
 see also Thon, Jan-Noël

Sánchez, Leticia 36, 289
Schaffner, Anna Katharina 223–6, 232–3, 289
Schmitter, Gianna 15–16, 187, 199, 272
 see also Audran and Chiani
Schröter, Jens 14, 206, 290
Scolari, Carlos 151 n.10, 290
Sculpture 2, 30, 34, 36, 68, 99, 103, 159–60, 162, 172, 216–19
Sebakis, Sagrado (Sebastián Kizner) 233, 290
Sebald, Winfried Georg 41–2
Segato, Laura 7–8, 5 n.5
Sex (including sexism and sexuality) 7, 8, 18, 20–1, 36, 58–9, 73, 96, 109–13, 117–20, 122, 126–7, 147, 157, 161, 172, 174, 183, 217
Short story 9, 28, 43, 63, 96, 112, 145, 158, 169–70, 201 n.8, 237, 261–4
 see also narrative
Slaves/Slavery 55, 258–9
Social media 9, 17, 22, 118, 151, 222, 237, 259

see also Instagram, Twitter, Vimeo, Facebook, YouTube
Paz Soldán, Edmundo 108, 166, 180, 253, 281
 see also Castillo, Ana
Solidarity 7, 162, 204
Sontag, Susan 68
Sound (sonority, sonic) 9, 12–13, 29, 53–5, 68, 71–3, 77, 82, 92, 96, 101, 116, 131, 134, 137, 140, 150, 158, 167, 177, 179, 186–7, 189–91, 209–12, 214, 218, 220, 223–4, 226–7, 229, 246, 255–6, 260–2, 264, 269
Space (literal and figurative) 8, 21, 24–5, 28, 36–8, 47, 49, 51, 54–6, 58, 72, 81–4, 86–8, 90, 96, 102, 104–5, 110, 116, 120, 135–6, 140, 149, 151–2, 154, 166, 168, 173–4, 179, 182, 185, 188, 191, 193, 195, 200, 202, 204–13, 215, 217, 220, 224–5, 227, 229–30, 232, 238–9, 242, 249–50, 261 n.8, 265 n.10, 269
 see also map and territory
Spielmann, Yvonne 4 n.10, 290
Springer, José Manuel 48–9, 120–1, 290
Sprinkle, Annie, "subversive repetitions" 117
Sterne, Laurence, *Tristram Shandy* 38–9, 51
Storytelling 12, 15, 24–5, 73, 76, 78, 90, 92–4, 96–7, 139, 148–50, 155, 159, 164, 186
Streeter Ralph, John 53, 56, 130, n.4. 130

Taylor, Claire 3–4, 9, 12, 17–19, 22–3, 28, 147, 149, 251–70, 291
 see also Pitman, Thornton
Taylor, Diana 114, 202 n.9, 291
Technology 12, 13, 17, 24–5, 27–9, 31, 34, 53–6, 58, 72, 83, 86, 88–90, 93, 97, 101, 104–6, 108–10, 114, 131–4, 140, 141–2, 144, 146 n.5, 158, 166

n.1, 168, 176, 189–90, 195, 212, 222, 224–5, 228–9, 231–2, 237–8, 240–2, 246, 248–55, 257, 259–61, 265 n.9, 269

Territory (including deterritorialization) 25, 34, 38, 49 n.6, 59, 81–8, 112, 148, 153, 158, 191, 211–12

Testimony (including testimonio) 65, 195–6, 199, 203, 214 n.3
see also witness

Theatre (theatrical, play) 23, 37, 54, 131, 168, 181, 209

Thon, Jan-Noël 13, 148, 283
see also and Ryan, Marie-Laure

Thornton, Niamh 3–4, 291

Transliterature (transliterary) 23–5, 29, 33–4, 38, 48–9, 51, 54, 107–8, 110–12, 114–15, 117, 119–27, 188

Transmedia (transmediality) 4, 11, 15–16, 18, 23–6, 29, 34, 47–9, 51, 53, 55, 73–4, 76, 90, 94, 97, 130–4, 136–7, 139–40, 142, 144–52, 154–5, 158–9, 163–4, 186, 206, 220 n.1, 237

Transmuted literature 48–9

Transnational 15, 146, 163, 245

Transtextual 131

Trauma 21, 73, 79, 146 n.3, 150–1, 210, 266

Twitter 9, 42, 56, 70, 170 n.9, 179, 223, 231
see also social media

Uribe, Ana María 1, 37, 219, 220, 225–6, 231, 291

User (of website) (and visitor) 21–2, 42, 93, 131–2, 134, 138–40, 141, 143–4, 150, 167, 169, 176, 179, 196, 208–9, 213, 227–8, 230–1, 240, 247–8, 249 n.21, 252, 254–9, 262, 264–6, 269

Ut pictura poeisis 29, 108, 188

van Leeuwen, Theo 13, 206, 281

Vega, Marcelo 53–4, 130 n.4, 118, 190, 200, 220 n.1

Verstraete, Ginette 12–14, 111, 291

Video 2, 4–5, 12–13, 18, 26, 28, 34, 36–7, 44–5, 47, 54, 56, 68, 76, 94–6, 100–3, 106, 108–15, 120–1, 130–5, 137–9, 141, 146 n.4, 150–6, 158–9, 164–5, 167–73, 175–83, 195–6, 198, 201, 203, 205–6, 208, 210–12, 214–15, 220–1, 227–30, 233, 237, 243, 246, 256, 258–60, 262–3, 266, 268–9

Vigueras, Fernando 72, 167, 285

Villeda, Karen 1, 37, 219–20, 222, 230–1, 233, 225, 230–3, 292

Vimeo 62, 70, 141 n.15, 159, 227–8
see also social media

Violence 21, 37, 59, 73, 81, 109, 111–12, 114, 115–17, 123–4, 151–3, 155–8, 162–3, 175, 186, 189, 191, 195–6, 198–200, 203–4, 259, 266 n.11

Weaving (interweave, netweaving) 25, 29, 42, 73, 83, 86, 95, 99–100, 102–6, 187, 189, 203, 206, 241–2, 244–5, 248, 250, 265, 269

Weibel, Peter 87, 292

Weintraub, Scott 9, 275, 292

Williams, Linda 117, 292

Williams, Raymond 126, 292

Witness (witnessing) 24, 73, 146 n.3, 150, 163, 198, 210
see also testimony

Woolf, Virginia 42, 44

World Wide Web see Internet

Wreader 16, 21, 26, 214–16

Writer see Author

Yeregui, Mariela 1, 5, 21, 24–5, 27, 81–8, 176, 205–8, 210–11, 213, 215–18, 279, 292

see also Golder

Young, Iris Marion 122, 293
Younglebood, Gene 213, 293
YouTube 4, 9, 26, 45, 47, 56, 61, 106, 120, 133, 151, 155 n.15, 156 n.17, 165–7, 169–71, 179, 182–3, 221, 224, 231

see also social media

Zalce, G. Martínez 35, 293
Zerbarini, Marina 1, 21, 28, 251, 260–6, 268–9
Zúñiga, Carolina 3, 278
Zurita, Antonio 53–4

Tamesis

Founding Editors
†J. E. Varey
†Alan Deyermond

General Editor
Stephen M. Hart

Advisory Board
Andrew M. Beresford
Zoltán Biedermann
Celia Cussen
Efraín Kristal
Jo Labanyi
María E. López
José Antonio Mazzotti
Thea Pitman
Julius Ruiz
Alison Sinclair
Isabel Torres
Noël Valis

Printed in the United States
by Baker & Taylor Publisher Services